Newcastle

ABOUT THE AUTHOR

A. W. (Bill) Purdue was, until his retirement, Reader in British History at the Open University. He is now Visiting Professor in Modern History at the University of Northumbria. Born in North Shields, he lives in Allendale, near Hexham. He has written extensively on the history of Newcastle and the North East. His books include: *The Ship That Came Home: The Story of a Northern Dynasty, Merchants & Gentry in North East England 1650-1830: The Carrs & the Ellisons, The Second World War*, and, with J. M. Golby, *The Making of the Modern Christmas*.

Newcastle
The Biography

A. W. PURDUE

AMBERLEY

Cover image: Courtesy of T. W. Yellowley.

First published 2011

Amberley Publishing
The Hill, Stroud,
Gloucestershire, GL5 4EP

www.amberleybooks.com

British Library Cataloguing in Publication Data.
A catalogue record for this book is available from the British Library.

ISBN 978 1 84868 498 0

Typesetting and Origination by Amberley Publishing
Printed in Great Britain

CONTENTS

FOREWORD

Newcastle upon Tyne is one of England's great cities.

A powerhouse of the world in the nineteenth and early twentieth centuries, it was a city of inventors and entrepreneurs. This was the place where George Stephenson built the *Rocket*, where Joseph Swan invented the electric light, where Sir Charles Parsons invented the steam turbine, and where Sir William Armstrong created his armaments and naval empire.

Following post-war decline in heavy engineering, mining and shipbuilding, a new generation of entrepreneurs in cultural industries, in medical science, in renewable energy and in digital media is now helping to rebuild our city's economy. We are earning a reputation across the world for our ability to transform our city and the economy that underpins it.

Newcastle's long and proud history began in Roman times with Hadrian's Wall and Pons Aelius establishing Newcastle as a settlement. With its 'new castle' built by the Normans, Newcastle grew from being a military town to becoming a major port, with its coal and wool exports, its merchant venturers, its guild system and its strong connections with the Baltic and northern Europe.

Our city has many surprises. There are medieval street patterns still visible today by the river. There's *Grainger Town*, the streetscape created by Richard Grainger and John Dobson with Grey's Monument at its heart standing as a proud testament to Newcastle's reforming and radical past. There's the Town Moor, one of the earliest 'green belts' protected by statute, with its herds of cows grazing peacefully close to the heart of the city centre. There's the old and the new side by side, such as the main-line railway viaduct built in Victorian times between the Castle Keep and the Black Gate – it would never get planning permission today!

Newcastle upon Tyne lies at the heart of Tyneside. Bill Purdue's book tells the story of how it grew in importance. It complements and extends existing histories of our city and makes our past accessible to a wide readership.

Bill Purdue has earned a major reputation for all his books and articles on the North East. He retired as Reader in British History at The Open University in 2006 and is now Visiting Professor in History at the University of Northumbria. His books include *Merchants and Gentry in North East England 1650–1830: The Carrs and the Ellisons* (1999) and *The Ship That Came Home: The Story of a Northern Dynasty* (2004).

John Shipley
Lord Shipley; Leader, Newcastle City Council 2006–2010,
previously Director, The Open University in the North

INTRODUCTION

Newcastle has been a city in the formal sense for more than a century since its principal church, St Nicholas's, was elevated to a cathedral in 1882. The term, however, doesn't suit it. One of England's most important cities, by any realistic measure, from the medieval period, it remains to its inhabitants, and those of its hinterland, the town.

Newcastle's whole history has been bound up with the Tyne on whose north bank it stands. It owes its origins to its position as the best bridging point on the river's lower reaches and to its crossroads position on the key north–south and east–west routes, while control of its trade was the basis of its later prosperity. The Tyne is not an easy river for bridge builders because of the shortage of solid rock along its banks. At Newcastle a ridge of stone on either bank provided the opportunity for engineers as early as Roman times.

Despite its potential as a bridging point, what is now Newcastle would have seemed to a modern developer to have had few advantages as a site for a major settlement. Even today, it's a hilly town. Much of its charm resides in this: in the views of the Tyne and its bridges as you turn round after a trudge up Dean Street or The Side or walk through the tunnel beside the Central Station and find yourself in Clavering Place. It presents a challenge to the architect or builder and these steep streets must have been the tribulation of many a carter, never mind his horse, over the centuries. Until the 1930s draught horses could be hired at the Sandhill to assist in pulling horse-drawn traffic up into Grey Street and the Bigg Market.

The tributaries that still make made their way to the Tyne – the Skinner, Lort (or Lork), Pandon and Ouse Burns – ran through steep denes or valleys so that, in addition to the banks running down to the river, the area that was to become

9

the town was intersected by further banks and burns. The Lort, Pandon and Ouse Burns all had their own tributaries. Much of their final journey to join the Tyne, of all but the Ouse Burn, is now beneath the streets and buildings of the town. The central section of modern Newcastle is built over subterranean streams, which once had to be bridged to afford access from one part of the town to another. High Bridge and Low Bridge are obvious examples and still survive as street names. The enduring parish boundaries, which separate St Nicholas, All Saints, St John and St Andrew, respect the lines of these watercourses. Some of the valleys were very steep with the Ouse's tributary the Sandyford Burn being 36 feet deep and 45 feet wide at what is now the junction of Sandyford and Grantham Roads. The Pandon Burn was about 140 yards wide near the present east end of Northumberland Road. Much of the history of the town's development is concerned with first bridging and then culverting over the burns and filling in their valleys.

If the topography was to challenge the ingenuity of the successive generations that built the town, it had many advantages for early inhabitants. The valleys with their steep sides were an aid to defence, the higher points – primarily the castle hill – lent themselves to fortification, while the mouths of the Lort and Pandon Burns provided harbour for seagoing ships and river craft.

Newcastle upon Tyne has been one of England's most important towns for many centuries. William Gray's short but colourful and perceptive *Chorographia* (1649) was the first real history of the town and the eighteenth and nineteenth centuries were to see fuller and more detailed studies. Two major eighteenth-century works were those by two Newcastle clergymen, the Reverend Henry Bourne and the Reverend John Brand. Both brought to their work the urge to retrieve Newcastle's past at a time when the town was changing rapidly. Both, however, employed a topographical, rather than a chronolological, approach to the town's history, as did Eneas Mackenzie's early nineteenth-century study and R.J. Charleton's *Newcastle Town* (1885). Recent work has, for the most part, taken the form of specialist enquiry resulting in essays, articles in academic journals, and monographs. Two excellent volumes of essays, *Newcastle upon Tyne: A Modern History* (2001) and *Newcastle and Gateshead before 1700* (2009), have expanded knowledge of the city's history. S. Middlebrook, *Newcastle upon Tyne: Its Growth and Achievement* (1950) is one of the few books to attempt a history of Newcastle

from its origins and, excellent though it is, it is necessarily dated in terms of its mid-twentieth-century perspective.

This book aims to provide a history of Newcastle that is accessible to the general reader but is reliant on the scholarship of the many experts who have written on aspects of the town's history.

I am most grateful to Tony Barrow, Tom Faulkner, Don Macraild, Norman McCord and John Shipley for reading and commenting upon all or sections of my manuscript and to Sarah Mulligan and Pamela Wilson of Newcastle Central Library for their informed assistance in my choice of illustrations.

Dr Tom Yellowley has been most generous in allowing me to include many of his excellent colour photographs of modern Newcastle.

THE EARLIEST ORIGINS OF NEWCASTLE

For a town which by 1377 was to be the eleventh most important town in England, Newcastle was a late developer. Its history until the building of the castle by Robert Curthose, William the Conqueror's eldest son, is obscure. It was the site of a Roman fort, which was part of the wall built by the Emperor Hadrian, but little is known of its history or place in Anglo-Saxon Northumbria. Literary sources for Newcastle before the Normans are few and, though archaeologists have found some evidence for the existence of a settlement, it is unclear whether it had a continuous existence or was of any importance before 1080.

When human occupation began is uncertain. The Tyne valley was settled in the Neolithic and Bronze ages but, although artefacts and evidence of agricultural activity have been found, there is no surviving evidence of a settled community at Newcastle beyond the discovery of a single late round house, carbon-dated to the late Bronze Age,[1] before the building of a bridge and a fort by the Romans. In the first century BC, the land from south Yorkshire to the Tyne was controlled by the Brigantes, a Celtic tribe, whose aristocratic leaders usually controlled an area from a number of forts with the bulk of the population living in scattered farms. It seems probable that the north-east frontier of Brigantia extended north of the Tyne as analyses of British settlements in Northumberland have revealed a dissimilarity between those in north and those in south Northumberland, suggesting a divide between the rule of the Votadini and the Brigantes.[2] There is evidence of pre-Roman settlement a few miles north of Newcastle but not in Newcastle itself. Lack of evidence does not rule out some sort of Brigantian presence in Newcastle but makes a long-term and concentrated habitation seem unlikely. Why, in that case, the best crossing of the lower Tyne, which was probably fordable at times, should not have become a fortified site is a mystery.

The Roman bridge was built around AD 122 as part of the Emperor Hadrian's ambitious scheme to consolidate the northern frontier of Roman Britain and it was named, after the Emperor's family name, Aelius, Pons Aelius. Under the governorship of Agricola, the Romans had in the eighties of the first century AD advanced far beyond the Tyne to the foothills of the Scottish Highlands and had criss-crossed the Tweed–Tyne region with a network of roads, supply bases and forts. Roman governing strategy in the frontier region was, however, to oscillate over time between a forward strategy, with an occupation deep into Scotland, and a more cautious position along a line from the Tyne to the Solway. Whether because of native risings or shortage of troops, Hadrian, a great proponent of fixed frontiers throughout the Empire, decided on the massive frontier fortification that bears his name, Hadrian's Wall. Pons Aelius was part of this great enterprise and the bridge was the first part of the military and administrative complex to be built.

Knowledge of Roman Newcastle is meagre. Most authorities on Roman Britain and even studies of Hadrian's Wall give Pons Aelius only a couple of mentions. There are only a handful of literary sources and we are largely dependent on the evidence produced by archaeological excavations. As well as exposing the extent of the fort and the outlines of the Wall, these have revealed remains which give support for a bridge on the site of the present Swing Bridge and the probability of a Roman waterfront beside the Lort Burn. The bridge and fort at Newcastle were originally intended to be at the most easterly point of the Wall, though it was later decided to extend it to Wallsend (Segedunum).

The design of the bridge was simple: a timber roadway was supported by stone piers. A shrine containing two altars to Neptune and Oceanus and a stone inscription commemorating the safe arrival after a sea voyage of the VI legion may well have adorned it. They were dredged from the river near to the site of the present Swing Bridge. This legion, with Hadrian and the new governor of Britain, A. Platorius Nepos, crossed the North Sea from Germany and disembarked at what is now Newcastle in AD 122. The sea link between the Rhine estuary and the mouths of the Humber and Tyne was of considerable strategic importance as it enabled troops to be exchanged between two frontier zones[3] and a further stone inscription survives commemorating the landing of legionary reinforcements from the German provinces in AD 158. A journey across the Northern Ocean was

frightening to the Roman mind, not just because of the obvious physical danger but because it meant crossing the stream of water which, personified as Oceanus, surrounded the known world. The protection of Neptune and Oceanus was required for such a crossing and the altars express gratitude for a safe landing.[4]

The stone-walled fort was built in the late second century in the best defensive position overlooking the bridge from the high ground – the same place where the Norman castle would later be built. It seems not to have been part of the original plan for Hadrian's Wall and it was built some eighty years later, but like other forts it was attached to the wall which ran along its northern side. To the west the adjacent stretch of the wall with turrets ran along what is now Westgate Road and traces of a milecastle have been found between Clayton Street and Grainger Street. The course of the wall to the east ran eastwards towards the fort of Segendum.

Since the 1960s, excavations have increased our knowledge of the Roman fort. Piecing together the history of its development over the years of its occupation is difficult for this is a complex and many-layered site: the medieval sits on top of the Roman; above it there were once the shops and housing of later centuries; the new County Court was built there in the early nineteenth century and was followed by the intrusion of the arches supporting the railway. The remains of the central range of fort buildings consist of the western half of the headquarters building, part of the commanding officer's house, an alley between the two buildings and part of what was probably the main street or *via principalis*.[5] The buildings were built of stone on the site later occupied by the castle and constructed no earlier than the late second century but it almost certainly replaced an earlier fort, while the Romans subsequently made substantial alterations to the fort's layout and added new buildings. Roman military architecture tended to be symmetrical and uniform throughout the Empire but the topography of the site at Newcastle resulted in an irregularly shaped fort. The keep of the castle was later to be built over much of the administrative Roman buildings but the positions of the headquarters building and the granary can still be seen from cobbles laid out after the twentieth-century excavations. The Wall itself probably formed the northern wall of the fort. A small harbour around the mouth of the Lort Burn, near to the bridge, was established and there was also a civilian settlement outside the fort. The garrison in the early third century seems to have been the First Cohort of

Trajan's Own Cugerni though a later garrison was the First Cohort of Cornovii[6], a regiment recruited from a British tribe.

The Roman fort at Newcastle had strategic significance, especially as the wall was originally intended to end at Newcastle. It remained, so long as Roman rule continued, an integral part of the defensive and administrative network but it was not a major bulwark. It is a comment upon the nature of Roman power, its potential adversaries and its technical ability that, while subsequent regimes relied firstly upon their ability to control the western and eastern coastal routes, the main artery of Roman power was close to the central hills along the highway of Dere Street from York (Eburacum) to Corbridge (Corstopitum) and northwards. The garrison town of Corbridge was, for much of the Roman period, of far greater significance than Newcastle. In the later years of Roman rule when the possibility of attack from the sea became more threatening, Pons Aelius may, along with other defensive and signalling posts on the lower Tyne and its mouth, have increased in importance.

There was a Roman or mixed Romano-British settlement on both sides of the river and, according to a distinguished early historian of Newcastle, the Reverend Henry Bourne, they were known together in the later years of the Empire as Gabrosentum, a corruption of the British for Goat's Head, and referred to as Caprae Caput by some medieval writers. In an early instance of a favourite Newcastle pastime, putting Gateshead down, Bourne wrote, agreeing with that pioneer of English history, Camden, that Gateshead was not an earlier town than Newcastle but had merely retained the old name and that moreover:

> Gatefide could but at moſt have been a part of *Gabroſentum,* and the meaneſt part of it too; a Sort of Suburbs to it.[7]

Recent excavations, prior to the construction of the Hilton Hotel at Gateshead, have, however, revealed the existence of a temporary Roman fort which appears to have pre-dated that at Newcastle by some thirty years. Whatever the relationship with Gateshead, Roman Newcastle must have been for most of its history a relatively secure place and part of a network of Roman bases for there was a fort, Condercum, at nearby Benwell to the west as well as at Wallsend (Segedunum) to the east.[8]

If little is known about Roman Newcastle, there is even less evidence as to the town's history from the time of the Roman withdrawal from Britain until the building of a castle in 1080 by Robert of Normandy. Historians of Newcastle differ as to whether we have a township with a continuous history beginning with Pons Aelius or alternatively should date the town's real foundation from 1080. Certainly the sources for the first millennium of Newcastle's supposed history are scanty and we have to resort to assumption and probability rather than certainty.

The first decades of the fifth century saw the end of the effective Roman presence on the northern frontier as in Britain as a whole. Pons Aelius is not mentioned in any document after AD 400 but the fort and vicus must have shared the general fate of Roman Britain as troops were withdrawn and the province left to fight for its own survival. Roman withdrawal may not have been followed by an immediate descent into disorder and barbarism. For Pons Aelius the most likely scenario is that it shared the fortunes of several forts along the Wall, which became fortified villages, 'slowly declining, rather than the proud bastions of an imperial frontier that they once had been'.[9] The economic and social effects were a sharp decline in living standards and in security, while the political impact was one of fragmentation. Frontier regions in particular had enjoyed under Roman rule an inward investment from richer areas of the Empire as money was pumped in to build, then to maintain, fortifications and to pay for troops. This had facilitated a standard of living that was out of all proportion to the resources and culture of the regions themselves. The collapse of a system of coinage is perhaps only the most obvious manifestation of decline.

After AD 410, the frontier army was inadequate for the task of protecting the Wall and the frontier collapsed. It is thought improbable that any recognisable units of the Roman army still occupied posts on the frontier by AD 420. Shortly afterwards, the last Roman garrisons were withdrawn from Britain. For more than a generation, Pictish and Scottish raiders were able to penetrate far into the south beyond the Wall. By about 450, however, the British had reformed themselves into independent tribal communities capable of military action. There followed a shifting pattern of successor states under brutal but forceful rulers. By the early sixth century, such rulers were increasingly threatened by Anglo-Saxon, soon to be known as English, invaders. By the late sixth century the expanding kingdom of Bernicia, covering by 580 more or less modern Northumberland and Tyne and

Wear and Durham, by then under English rulers, emerged. What happened to the British or Celtic inhabitants has been a matter of some debate. The traditional view was that they were displaced westwards or killed but a more recent view argues that it was most likely that much of the Celtic community of Northumberland and Tyne and Wear was integrated and Anglicised within a few generations. A Germanic influence may have already been present due to links across the North Sea and the Roman use of German auxiliary troops. The results of DNA testing of many of the present population may yet go a long way to settle this debate. Certainly by AD 600, whatever settlement there was at Newcastle would, like the surrounding areas, have been to all intents homogeneously English and part of the Northumbrian kingdom, formed by the union of Bernicia and Deira, south of the Tees, which lasted from the early seventh century until the middle years of the ninth century.

Most accounts, including those of Newcastle's earliest historians, have argued that the civil community remained after the Roman withdrawal and that the settlement, first Romano-British and then English, was known as Ad Murum and then Monkchester. Bede referred to a royal estate, Ad Murum, on the Wall and some 12 miles from the sea, while Bourne assumed that Monkchester took its name from a monastic settlement within the Bishopric of Hexham founded towards the end of the seventh century. He made the best of the somewhat shaky evidence and, relying on Holinshed[10] and conjecture, considered that:

> When it is now confidered that the Bufinefs of Religion went on fo briskly throughout the whole kingdom of the Northumbers; it is rational to fupport that this Place, as it was not only convenient for the monaftical Life as to retirement, but alfo a Security to it too (being at that time a garrifoned Fort) was certainly as early inhabited by the Monks as the abovementioned Time [678 when Hexham became a bishopric]; and befides if we consider the Veneration it is mentioned with by many historians for the fevere rigid Lives of its Monks; how it was the moft eminent Place in the North, for the monaftical Life, fo very famous on that account, as to change its former name to that of *Monkchefter*. There can fcarfe be allowed it a later Time to arrive at such a Pitch of Eminency and Glory.[11]

He assumed that it was largely destroyed by the Vikings in 875 AD and remained in ruins until late in the eleventh century. He tells the story of a group of monks from

Evesham, who, having heard of the monks of Northumbria and their great sanctity, journeyed north in 1074 to find the 'City of the Monks' but found 'not any remains of its former Sanctity, no Footsteps of the Religious People who had formerly *dwelt there*'.[12] The main source for the existence of Monkchester is the writings of twelfth-century chroniclers on which Holinshed and then Bourne based their evidence. Bede does not mention it and archaeologists have to date found no evidence of monastic buildings there. R.A. Lomas suggests, however, that there is sufficient evidence for the existence of some sort of Anglo-Saxon religious foundation.[13]

Until the mid-nineteenth century, historians generally accepted the existence of a Saxon town on the site of or near to Pons Aelius and a more or less continuous history of a settlement from Roman times. Some have suggested that Ad Murum or Monkchester vied with Bamburgh and Yeavering as a royal town. Bede refers to Ad Murum as 'a famous royal villa', close to the wall and twelve miles from the sea, at which the baptisms of Peada (son of Penda, King of Mercia) and his followers took place prior to his marriage to Elfleda, daughter of Oswiu, King of Northumbria, and also that of Sigebert, King of East Saxons in about 653. From the mid-nineteenth century, Newcastle's historians tended to become more sceptical and argued that prior to the foundation of the castle in 1080, Newcastle was of little importance and enjoyed at best a spasmodic existence.

The foremost mid-twentieth historian of Newcastle was dismissive of the supposed Saxon Newcastle:

> The buildings in the Roman station were almost certainly abandoned or destroyed during the dark days of the Saxon conquest, though the bridge may have survived longer and a settlement of some sort grown up around its northern end. But there is no evidence for this; no evidence even for the existence of a monastery, which might have formed the nucleus of such a settlement. This silence of contemporary records on the site is a little baffling...[14]

Contemporary written sources pointing to a Saxon 'Newcastle' are, indeed, scarce and a recent study of Newcastle by historical geographers has concluded:

> The Saxon name Munecaceastre (Monkchester) suggests, as *castrum* name endings usually do, at least the ruins of a Roman fort but the only archaeological evidence

consists of burial graves. If the Anglian settlement, Ad Murum, did exist here then it is likely that it was destroyed and rebuilt many times.[15]

If there was a Saxon borough at Newcastle, the onset of Viking raids must have posed a considerable threat to it. From the late eighth century there were frequent raids on the coasts of Northumberland and Durham by Scandinavian seafarers from the Norwegian fjords and from the 830s Danish fleets posed a more substantial threat. The arrival of a vast Danish army, the Great Army, in AD 867 led to the collapse of the Northumbrian kingdom and threatened the whole of England. A settlement at Newcastle would have commenced a precarious existence. R. J. Charleton portrayed the apprehension of the townsfolk imaginatively:

> The trembling inhabitants of Monkchester heard with dismay the tidings of the spread of the invasion, and one day saw the Danish fleet under the dreaded Raven Banner appear, threading its way between the wooded banks of the Tyne. The town was probably at this time still enclosed by the old Roman walls. The story of its capture is not told in history, but certain it is that in the year 875, the fleet of Halfden was anchored at the mouth of the Teams, a tributary of the Tyne, only a mile away, and that soon that Danish chieftain ruled over the kingdom of Northumberland.[16]

Half of the Great Army under Halfdan certainly wintered on the Tyne in 875 AD and campaigned in Bernicia or northern Northumbria. The West Saxon chroniclers who provided most of the records for this period were naturally more interested in the conflict between the other half of the Great Army, led by Guthrum, and King Alfred. Literary sources as to the fate of Northumberland and Durham are therefore scanty, but it would appear that Bernicia was not effectively colonised by the Danes. The Viking kingdom of York was a major power but Scandinavian settlement does not seem to have occurred north of the Tyne, which must have remained one of the most homogeneously Saxon areas of the North. The further Norse invasion of the early tenth century saw two major battles near Corbridge, while northern Northumbria or Bernicia has been described as practically ungovernable throughout the eleventh century.[17]

Evidence for the town's existence during the Saxon period comes from archaeology and the clues contained in early medieval charters. Recent

archaeological excavations have found Anglo-Saxon burials in the castle–cathedral area, and many skeletons found in the castle ditch, which was probably along the line of the outer wall of the Roman fort, seem to have been those of eighth- or ninth-century inhabitants. In addition, evidence of field patterns converging on White Cross points to a Saxon settlement. Some historians have made a distinction between Newcastle proper, meaning the area within and around the Roman fort or the medieval castle, and adjacent areas. They have argued that Pandon, nearby to the east, may have had a Saxon existence or that there was probably a Monkchester based on the area around St Andrew's church, but that there was no Saxon Newcastle.[18] This seems a rather fine distinction and the main question is surely whether a settlement of any sort had a continuous existence from the end of the Roman occupation through at least the greater part of the Saxon period.

Building upon the evidence of Saxon cultivation around what was to be later the Newgate area of Newcastle during the Saxon period, it has been suggested that the village of a Saxon township with its houses or tofts arranged around a green was located there, with great common fields to the south of it, pastures called leazes to the north-west and a large common or moor to the north on which the villagers' cattle were turned.[19] This may well have been the case but the existence of such a township relies largely upon intelligent supposition, the existence of the moor and leazes in subsequent times, and the assumption that St Andrew's is the oldest of the town's churches.

At the time of the Norman Conquest, Newburn, a royal borough upstream from Newcastle at a spot where the river could be forded, appears to have been the most important settlement on the Tyne's lower reaches. The bridge at Newcastle may well have been in ruins, though references to its being in a ruined state at particular times do not rule out a series of repairs and their destruction. Saxon coins have been found in sufficient numbers to suggest habitation but insufficient to provide evidence of a thriving trading centre and or the centre of a Saxon estate. There are perhaps too many references to a post-Roman and then a Saxon settlement at Newcastle for one not to have existed and too few to suggest one of much importance over a lengthy period of time. Further archaeological work may yet yield definite answers but there is also, as we shall see, persuasive if inconclusive evidence based upon an analysis of the medieval town's earliest privileges and customs which points to a pre-Conquest Newcastle.

MEDIEVAL NEWCASTLE

The rise of Newcastle to become one of England's most important towns took place in an extraordinarily short period of time, though in the early twelfth century it appeared for a time that it might become a Scottish town. By 1300 it was not only an important border fortress and the centre for mustering armies when war with Scotland approached but it had become a prosperous trading town with wealthy merchants and a population that has been reckoned at 4,000.

If the history of Newcastle did begin with the building of a wood and earth castle by William I's eldest son, Robert Curthose, in 1080, then its rise was spectacular. The building of the castle was not so much the result of William's victory at the Battle of Hastings as of his difficulty in conquering England after the battle. This involved a hard, bloody harrying lasting almost half a century in which there were few pitched battles but, alternatively, resistance and attrition. The problems involved in putting down the Saxon earls of the North were compounded by a Danish threat in 1069, by the perennial ambitions of the Scots and the rebellion of a great vassal, Robert Mowbray, Earl of Northumbria. William was in the north twice, ruthlessly ravaging Tyneside in 1069–70 and marching south to the Tyne after defeating Malcolm III of Scotland in 1072. On this latter occasion he was said to have been, for a time, unable to cross the Tyne because it was in flood, which suggests that the bridge at what was not yet Newcastle was unusable though it seems unlikely that a bridge of sorts did not exist.

Whatever the size and nature of the settlement of Newcastle, the inhabitants would it appears have had a horrendous time of it in the eleventh century. Northumbria was in turmoil well before the Conquest as Anglian Bernicia quarrelled with the Anglo-Scandinavian rulers of York and kings of England

exercised only a tenuous authority, while the Kingdom of Strathclyde expanded into Cumbria and the Scots into Lothian. This was a period of blood feuds and assassinations. King William's problem in the north was much the same as that of Saxon kings, whether to entrust the rule of Bernicia to Northumbrians who could inspire loyalty to themselves or to outsiders who might be loyal to the king. Two bloody events occurred close to what was soon to become Newcastle. Copsig, William's first choice as earl, was attacked by his rival Oswulf in 1067 as he was feasting in his hall at Newburn; he fled to a church which was set on fire and, escaping from the fire, was hacked down and decapitated by Oswulf. Bisop Walcher, a Norman appointed to the see of Durham by William, was brutally murdered at Gateshead in 1080 (he too took refuge in a church which was set alight and he was cut down as he emerged). Walcher's death was followed by the 'Harrying of the North' by William's half-brother, Odo, bishop of Bayeux.

The first castle has often been assumed to have been a motte and bailey castle but if there was a motte it has not been identified. The position of the castle with its natural defences on three sides as a result of the steep banks below it may have made its builders feel that they could dispense with a motte in favour of a banked and ditched enclosure. Whatever its defences, the castle was unable to withstand the siege of 1095 when the Earl of Northumbria, Robert de Mowbray, who might as a Norman have been expected to be a safe pair of hands, rebelled and the castle fell to William Rufus's army.

In the immediate post-Conquest period, there is little recorded indication that there was a town of any importance. Even after the building of the castle, what was to become Newcastle was in status simply another part of the possessions of the Earl of Northumberland. When the castle was captured by William Rufus, it and what settlement there was around it became royal property.

As a Victorian historian of the town, R. J. Charleton, put it, 'When Mowbray fell, Newcastle rose.' Within 200 years, the town was conducting a flourishing trade in coal and lead and in 1275 it was ranked sixth among England's wool-shipping ports. It possessed a mint before the death of Henry I in 1135. Population estimates for the medieval period are notoriously vague but the population of Newcastle has been estimated as being around 5,000 in the late thirteenth century. Central to this economic and population growth seems to

have been improvements in agricultural practice in the north during the twelfth century. Not only did the town achieve rapid economic growth but it, just as swiftly, acquired the privileges and trading monopolies which facilitated further growth. By the twelfth century it was known as a borough, which has been defined as:

> A town or village, which was or had been fortified in some way, occupied by a settled community of free men who possessed special privileges and which was recognised as distinguished by those privileges from other towns and villages whose inhabitants did not possess them.[1]

The rapidity of its growth can be attributed to a number of factors, its advantageous trading position, its military importance as town close to the border, royal patronage and the prosperity of the border region in the twelfth and thirteenth centuries, but it still remains puzzling that a town which barely existed at the time of the Conquest should have grown so rapidly and have so quickly developed its institutions and customs. This again raises the question as to whether a more substantial Saxon township than we know of might have existed.

In the twelfth century, it was uncertain whether Newcastle would remain English or become part of Scotland. The civil war, which raged in England after Stephen seized the throne from Henry I's daughter Matilda, gave an irresistible opportunity to King David I of Scotland, who declared his support for Matilda. Stephen was forced to buy off David. By the Treaty of Durham of 1139, the Scots not only kept Cumbria but David's heir Henry was created Earl of Northumberland as Stephen's vassal and was given possession of the county with the exception of the towns of Bamburgh and Newcastle. King David seems, nevertheless, to have treated Newcastle as if it was his.

This brief period when Newcastle was in a Scottish sphere of influence had some advantages for the town. Considerations of defence became for the moment unimportant and the town spread away from the shelter of the castle. Two religious establishments, the Hospital of St Mary the Virgin and the Nunnery of St Bartholomew, had already been founded and were situated, respectively, to the west of the town, and to the north on the western bank of the Lort Burn. In this

peaceful time, houses and shops were built in the neighbourhood where Newgate Street now is.

While Matilda's eldest son, Henry of Anjou, the future Henry II, was attempting to wrest the throne from Stephen, he was prepared to use Newcastle as a bargaining counter for support from Scotland. It was only the deaths in rapid succession of David's son, Henry, David himself and then Stephen, which took from the Scots their recent acquisitions. The deaths of David and his son plunged Scotland into internal disorder, while Stephen's death facilitated Henry II's accession to the English throne. Once Henry had acceded to the throne, he disputed the rights of the kingdom of Scotland to the earldom of Northumberland and resumed possession of the county. The border counties continued to be disputed between England and Scotland for centuries but Newcastle's future was to be not only firmly English but also fiercely anti-Scottish.

It was a sign of Henry II's determination that Newcastle should remain English and become a cornerstone of the defences against Scotland that in 1168 the rebuilding of the castle in stone began and the work was completed in 1178. The central building and ultimate redoubt was the keep, a massive rectangular tower, built by a specialist, Maurice 'the Engineer', who also built Dover Castle. Despite many later modifications – including nineteenth-century battlements, the flat roof over vaulted ceilings (which replaced the original pitched roof) and the fireplaces – the keep is substantially still the great tower built in the twelfth century. The bailey was enclosed by a curtain wall interspersed by towers and there were two main gateways to the north and west. Formidable but uncomfortable, the castle lacked living quarters fit for a king or a king's representative until in the reign of King John a hall was built within the bailey. The weakest point of the castle was the western approach where no steep bank protected it. Here in the mid-thirteenth century during the reign of Henry III the Black Gate was erected in front of the existing western gate together with a ditch between the two. This was in accordance with advancing military architecture which turned the weakest point of a castle's defences into a strong point. The Black Gate, completed in about 1249, was in effect a second keep, dominating and securing the castle's outer defences.[2]

The town's significance was based upon its position as a crossing point over the Tyne and the castle's strategic importance was consequently linked to its defence

of the bridge over which it towered. It seems almost certain therefore that there must have been a bridge, however basic, during the first century of Norman rule. Some historians have suggested that a wooden superstructure was erected on the stone piers of the Roman bridge, but that this was destroyed in a great fire that swept the town in 1248 and that a new stone bridge was erected immediately afterwards[3] but a recent authority has stated that the stone bridge was probably built earlier, in the later part of the twelfth century.[4] The stone bridge was to last, albeit with periodic damage from floods and a major disaster in 1339 when much of it was swept away, until the late eighteenth century. It had twelve arches, three of them on land, and three towers, the southern one with a drawbridge, and shops and houses on each side of the road.

The town's steady rise was marked by increased independence from the earldom of Northumberland and from the county. A series of royal charters gave or confirmed its privileges and monopolies in 1175, 1213, 1400 and 1490. Although the borough's earliest royal charter was granted by Henry II in 1175, two earlier documents suggest that the privileges of the town and its freemen were recognised before that date. The first document, known as *Customs of Newcastle*, was, probably, drawn up in the reign of King Stephen. It begins, 'These are the laws and customs which the burgesses of Newcastle upon Tyne had in the time of Henry the King of England and ought to have.' 'Henry' would, if the document was indeed drawn up in Stephen's reign, have been King Henry I. The *Customs* was probably drawn up for King David I of Scotland after Stephen conferred the earldom of Northumberland upon David's son Henry in 1139. Despite the fact that the Treaty of Durham had excluded Newcastle from the earldom, which his son held as a vassal of Stephen's, King David seems to have treated the town as one of his possessions and to have based his laws for his Scottish boroughs – Edinburgh, Roxburgh, Berwick and Stirling – on the *Customs*. David's *Leges Quattuor Burgorum* closely follows the Newcastle model. The *Customs* document must, therefore, be dated some years before David's death in 1153.

The *Customs* document is important, not only because it gives us a date for the existence of many of Newcastle's privileges earlier than Henry II's charter, but also because the nature of the customs point to them having been long enjoyed by the town. In a closely argued analysis the legal historian Robert Fulton Walker has argued that:

They were current before, or at least at the very beginning of, the period of the boroughs
created by royal or seigniorial charter. Their content betrays evidence of Danish, Saxon,
Celtic and even perhaps Roman origin or connections.[5]

This evidence that Newcastle's customs have a long and near continuous history,
argues Walker, both substantiates arguments for a post-Roman and pre-Conquest
Newcastle and goes some way to explaining why it has been seen as 'the most
mysterious as well as the most successful of all the "new towns" of post-conquest
England'.[6] Yet, could a pre-Conquest town of any significance have remained
hidden from history, leaving little physical or literary evidence of its existence?

From the time of Henry I's *Customs*, which was essentially an early form of
municipal charter, Newcastle possessed its own officials, common seal, laws and
customs. As Bourne put it, King Henry II 'confirm'd their Eftates to them [the
burgesses]' rather than granted the estates. Nevertheless, the charter granted by
Henry in 1175 is the town's earliest surviving formal royal charter and in it the
King exempted the town from a number of tolls and duties. The essence of royal
charters was to underwrite a town's urban nature as distinct from the surrounding
countryside and its direct relationship with the monarch and consequent freedom
from the rule of feudal intermediaries between King and citizens.

Newcastle, nevertheless, was to remain part of the county of Northumberland
until it gained the status of a separate county in 1400. This meant that it still
came under the legal authority of the King's sheriff, who could act within its
bounds. This authority was, however, sometimes flouted, as on the occasion when
an attempt by the sheriff to levy distraints within the town was met by a force
estimated at 500 horse and foot which routed the sheriff's, leaving some for dead.
The town had also some peculiar legal privileges that it enjoyed under the 'Laws
of Winchester' but with its own variants. Assize of mort d'ancestor could, for
instance, not be enforced over the possession of land when it conflicted with
the rights of a burgess to sell his property, while instead of land belonging to a
woman married more than once passing to the eldest son of whichever marriage,
it passed to a daughter of the first marriage, if there was no son by that marriage,
instead of to a son by the second marriage. A wife was also required to appear at
the Guildhall when her husband desired to dispose of her property to testify that
she approved of the transaction.[7]

There were advantages for both parties when medieval kings granted towns special status. The King received the town's taxes directly, while the burgesses ceased paying feudal dues to the local lord and the sheriff of the county, were free to choose the town's government and could administer justice in their own courts rather than the sheriff's. In King John's reign successive charters both re-confirmed Newcastle's status *and* raised the taxes or fee farm it paid for it. Bailiffs were appointed to collect this annual rent, which was set at £100 by the charter of 1213.

Newcastle moved swiftly towards a system by which the burgesses or freemen governed the town and, just as importantly, managed its economy. The history of the town, it has been asserted, is to a very large extent 'the history of its freemen'.[8] The status of freeman or burgess was intimately related to trade and crafts and membership of the guilds into which they were organised. Freemen were full citizens and able to play a part in the commercial and political affairs of the town. They were, however, always a minority, albeit a substantial one, of the town's inhabitants. Influence and power in Newcastle can, until the eighteenth century, be seen as arranged in a series of concentric circles: a wide ring included all burgesses; a narrower one the members of the principal trades; and an inner one the elite of merchants. Among the privileges of the burgesses or freemen was that of selecting and electing the town's MPs. From the reign of Edward I, the town regularly sent two burgesses to represent it whenever a parliament was summoned.

Local government office and positions as leaders of merchant associations went hand in hand. By the mid-thirteenth century, Newcastle was governed by a mayor and a council of twenty-four burgesses elected annually by the leading guilds or 'misteries' of the borough. Daniel, son of Nicholas, is usually regarded as the first mayor, though royal approval of the title did not come until 1251 when Peter Scott was mayor.

In 1216 in his fifth charter to Newcastle, King John provided for the control of the town's trade to be vested in a society of free merchants or 'Gild Merchant'. Merchant guilds developed in Newcastle, as elsewhere in England, during the second half of the twelfth century as those burgesses who were shopkeepers or warehousemen got together to protect by union their rights and privileges as traders. They sought exemption from tolls and taxes in their own towns and

other towns in which they did business, the imposition of taxes upon others, and a monopoly of trade for members of the Gild as opposed to other inhabitants.

Historians of the merchant companies, which in the sixteenth century banded together to create the Merchant Adventurers' Company, have argued for a direct descent of that company from the Gild Merchant.[9] Others, including the author of a history of the freemen of the town, who asserts that any burgess could be a member of the Gild, have denied this.[10] To some degree, both interpretations draw upon the arguments between the merchant elite and the craft guilds as they struggled for dominance in the fourteenth century. What seems certain is that the merchants were from the beginning the wealthiest and most influential sections of Newcastle society.

The charter granted by King John to Newcastle in 1216 gave the Gild Merchant special privilege and protection. Its members were to be exempt from tolls and dues in all his seaports and they had the right to reparations for any tolls and customs wrongly exacted from them, which they could extract by distraining the goods in Newcastle belonging to those who violated their privileges. The historian of the Newcastle Merchant Adventurers, F.W. Dendy, concluded that, 'Within a century after the gild merchant in Newcastle, its members had evidently formed an exclusive class', adding that 'a distinction had grown up between the burgesses generally and the burgesses who were merchants'.[11]

Town Council and Gild Merchant alike, for they were substantially the same people, had the overriding aim of furthering the interests of the town and therefore of themselves by establishing a monopoly over the right to trade with ships entering the Tyne. The main opponents were the Prior of Tynemouth and the Bishop of Durham, both of whom had ports and markets on the Tyne. The burgeoning port of North Shields was a particular irritant to the Newcastle burgesses. In 1268 a case was brought to the justices concerning the seizure by the burgesses of a ship belonging to the Prior that was laden with coal. In 1290 Newcastle petitioned Parliament against the trading activities of North Shields, using the argument that the Crown was losing taxes as Newcastle's trade was suffering, and the Prior was ordered to dismantle his jetties.

The Bishop of Durham was a more formidable opponent and the claim of the bishopric to lordship over the southern reaches of the Tyne contested Newcastle's most important interest. There were repeated wrangles over fishing nets and the

loading and unloading of ships on the southern bank. In this quarrel Newcastle had the support of the county of Northumberland but was not always able to count on the support of the Crown. In 1314 Edward II upheld the rights of the bishops and their subjects to trade freely in the Tyne along the boundaries of the bishopric and in the 1380s Bishop Fordham was granted a royal charter that proclaimed the rights of ships to moor and load and unload coal on the southern side of the river. Newcastle responded by building a tower on the south side of the bridge and removing the stones which had demarcated Newcastle's part of the bridge from Durham's but the town, exhilarated by its new county status, had overreached itself and in 1416 the Corporation was ordered to demolish the tower and re-lay the 'Cuthbert stones' which gave the bishopric one third of the bridge.

The perpetual dispute between Newcastle and the bishops of Durham can be depicted as the unfair attempt by the town to achieve total hegemony over the river at the expense of the economic development of Gateshead and other settlements on the south bank, but from Newcastle's point of view the bishopric and its subjects had unfair advantages which threatened Newcastle's prosperity. The town might come under the spiritual direction of the bishopric but its lay powers and privileges were deeply resented. Durham was exempt from royal taxation while Newcastle paid almost as much as York. 'To the northern neighbour of the bishopric, therefore, Durham was a tax haven.'[12] There were also fears that it could prove so attractive to Newcastle merchants that they might move to Gateshead; thus, Newcastle strove, generation after generation, to stamp out Gateshead's market.

As trade became more specialised the Gild Merchant became organised into three sections, the woollen merchants (drapers), the corn merchants (boothmen) and silk merchants (mercers). There were, however, other interests in the town and manufacturers did not have identical concerns to those of the merchants. Cordwainers (shoemakers), skinners and other craftsmen were more worried about protecting the price of their products than the encouragement of trade. The craft guilds challenged the rule of the merchants and Newcastle was to be divided periodically by a clash between these opposing interests.

By the early thirteenth century, many craft guilds had been established and at a full meeting of the Gild or Guild in 1342, nine companies, in addition to

the three merchant companies, were enumerated in the articles of government which were subsequently confirmed by a royal charter. These were the Skinners, Tailors, Saddlers, Bakers, Tanners, Cordwainers, Butchers, Smiths and Fullers. Together with the merchant companies they made up the twelve 'misteries'. We can perhaps see these nine craft companies as a second tier of privilege, for there were a host of other companies, 'bye trades', ranging from Masters and Mariners to Shipwrights, Coopers and Barber Surgeons. That such bye trades included Goldsmiths,[13] who were unlikely to be among the poorest tradesmen, suggests that numbers as well as wealth counted in determining a society's influence in the town. The overall picture remains, nevertheless, one of dominance by the wealthy and the wealthiest sector of Newcastle society was made up of merchants.

That there was a tight urban oligarchy is suggested by the fact that two leading families of wool merchants, the Scots and the Carliols, dominated the mayoral office until 1300, though after this other leading wool merchants were appointed. The export of wool to the growing cloth-making centres of Italy and Flanders became in the thirteenth century Newcastle's most profitable export and made it the sixth most important wool-shipping port. If 'wool to England' was as much a paradox in the reign of Edward I as 'coals to Newcastle' was to become later, the export of wool, woolfells and hides represented but a part, if the most important, of the economic activity of the town and port of Newcastle. There was a considerable import trade as ships did not usually arrive in ballast but brought with them timber and timber products, grain, wine, furs, fish, oils and metals. They also brought small cargoes of other customable goods away with them.[14] This was a busy port.

Wool became even more profitable in the fourteenth century when, as one of the England's ten staple towns, Newcastle enjoyed a monopoly on the export of northern wool. The staple began as an attempt by English merchants to compel the Flemish to buy wool in one place outside Flanders but in 1313 it was ordered by royal command that English wool could only be sold in one town, first of all St Omer but later Bruges, Antwerp and Calais. In 1353 Edward III brought the staple to England, granting it to ten English towns including Newcastle. Eventually, however, the staple became permanently based at Calais. The northern wool exported from Newcastle was of inferior quality and fetched a lower price than wool from further south in England but it was produced in

large quantities. It did not sell well in Calais and Newcastle was successful in its petition to be allowed to sell wool to any foreign port except Calais, provided the wool originated from between the Tees and the Tweed.

In addition to the wool trade, cloth was made, dyed and retailed in Newcastle while leather was also important with over 15,000 hides exported annually in the 1280s. Coal was significant as early as 1214 and during the fourteenth century the coal trade began to rival wool as the town's principal export; by 1378 it had overtaken it. Lead and grindstones had also become valuable exports. The great advantage Newcastle enjoyed when it came to coal was that the seams close to the town were near to the surface, making good-quality coal easily exploited. One of the effects of the wars with Scotland during the fourteenth century was the interruption in the supply of hides and wool to Newcastle and this encouraged merchants to turn to the coal trade, and particularly the London market, to maintain their profitability.

Another trade that was to endure was also beginning in the thirteenth century, the Baltic trade, as the towns of the Hanseatic League began to export to Newcastle. The League was a trading confederation whose origins lay in co-operation between Hamburg and Lubeck; they were joined by other north German towns, by the major Baltic ports and by Cologne and other Rhineland towns. During the fourteenth century the Hansa controlled much of Europe's trade and established permanent *entrepots* or *kontore* in Bergen, London, Bruges and Novgorod. Hanseatic merchants began to supply eastern English ports with herrings, timber, furs and other products. A subsidiary *kontor* was set up in Newcastle and by the end of the century Newcastle merchants were trading regularly with the Baltic, exporting woollen cloth and importing timber. The Hanseatic League excluded English ships from the Baltic and so the cargoes were carried by foreign ships until the sixteenth century when the Danish Sound was opened to English ships.[15] Nevertheless, by the time of the decline of the League in the sixteenth century and its demise in the seventeenth, Newcastle's trading links with ports such as Gdansk (Danzig), Tallinn (Reval) Rostock, Riga, Stockholm, and Hamburg were well established.

The bulk of the export trade in wool was in the hands of English and especially Newcastle merchants though a number of smaller shipments were made by foreign merchants, mainly from Flanders, and some bigger shipments were made

by the Italian trading societies who were prominent in the thirteenth century. The ships which carried the goods, usually small craft of less than 100 tons, were, however, more often foreign.

The early prosperity of the town was illustrated when King John ordered a levy of a fifteenth on the goods of alien merchants in twenty-four seaports; the return from Newcastle was £158 5s 11d. There were Italian merchants resident in Newcastle in the thirteenth century and one, Hugh Gerardino of Lucca, married a local widow and settled in the town as a trader in wool and hides. He and his wife shipped 110 sacks and 520 woolfells in 1292–97.[16] Foreign merchants were in an unenviable position, being seen as a milch cow for taxation, not always popular in the towns they worked from, and enjoying an uncertain status. The *Carta Mercatoria* of 1303 improved the legal status of alien merchants but taxed then more. All their trade was taxed henceforth. In comparison to some southern towns, however, Newcastle had few foreign merchants and only a small proportion of the national foreign trade.

Prosperity and new taxes continued to go hand in hand and in addition to the existing taxes on exports of wool, woolfells (sheepskins) and hides, further duties on imports and exports were imposed during the fourteenth century. Edward I tried to extend the taxation of alien merchants to denizen or native English merchants. This met with some resistance and two prominent merchants, Peter Graper and Richard Embleton, who represented Newcastle in an Assembly, rejected this proposal, calling the increase in wool custom a 'maltote' and resisting any addition to the 'due and established customs of old'.

Customs duties were heavy. They consisted of the duty and subsidy on wool set up in 1275, 'the great or ancient custom' as it became known; a further custom introduced in 1303 and known, together with a duty on imported cloth introduced in 1347, as the 'petty custom'; and the taxes on the tonnage of wine and a duty of 1/-, 'poundage', imposed on all goods not included in other taxes.[17] There was, however, benefit to the town in becoming a customs port. The Newcastle collectors were responsible for all ports from Berwick to Scarborough and this provided some employment which, along with the Mint, established in 1249, emphasised Newcastle's position as by far the most important port on the North East coast.

Newcastle's growth was stimulated by the town's strategic importance as a border fortress as well as by its growing prosperity. Its military significance

depended largely on the bridge and the castle which overlooked it and the two explain the royal favour that enabled a town nine miles up a not easily navigated river to dominate the entire river and impose its will on the harbours at the river's mouth. The military importance of the town and its need for adequate defences resulted in the replacement of the wooden castle by the stone castle built in Henry II's reign and by the construction of the town's walls in the following century. The town was frequently visited by kings and their representatives and enjoyed economic advantages as the supplier of goods to Berwick and English bases in Scotland and as the victualler to commandeered ships commissioned on the Tyne.

The castle and the bridge were the pivotal points for the physical development of the town. They were linked by The Side, a steep and narrow ascent, which provided the shortest route between what became the two main commercial areas of the town, the level river bank to the east of the bridge, and the area north of the castle and the church of St Nicholas. Although the castle and its garth were formidably defensible, the town itself remained without walls until the second half of the thirteenth century when the long task of surrounding it with walls was begun.

Religion was integral to the life of medieval towns and permeated almost every institution. It determined the civil as well as the religious organisation of Newcastle. By the late twelfth century, Newcastle had four churches: St Nicholas's, St John's, St Andrew's and All Hallows. These became, for both ecclesiastical and civil purposes, four parishes. Just outside the town lay the suburb of Pandon but in 1299 a charter of Edward I enabled the town to purchase Pandon from Lord Robert de Byker and add it to Newcastle.

Religious orders existed either to provide for lives of prayer and contemplation or to preach and care for the poor. They were fuelled, however, by charitable donations of the rich. It was a thus a sign of the growing wealth and importance of the town that so many religious orders set up foundations there. Newcastle had no monastery, though it had its Nunnery of St Bartholomew, but many orders of friars established themselves in the town. The orders of friars which came into being in the late thirteenth century did much of their work, which was to preach and care for the sick, among the urban poor. They were to maintain themselves by the charitable gifts of the laity and were themselves to live plain and simple lives.

The Dominicans or Black Friars, sometimes called the 'Shod-Friars' to distinguish them from the barefoot Franciscans or Grey Friars, settled near to the west wall in 1261. One of the earliest mayors of the town, Peter Scott, who held office from 1245 to 1251, is said to have invited them to the town. They appear to have enjoyed royal patronage and Edward II stayed at the friary, while Edward Balliol paid homage to Edward III there. The Franciscans arrived in 1274 and their house was a little to the south of where today there is High Friar Lane. It was a wealthy merchant family, the Carliols, who endowed the house. Nearer the river was the house first inhabited by the Carmelites or White Friars when they first arrived in 1278, Wall Knoll, between Pandon Gate and Sand Gate. The Carmelites later moved to the south-west corner of the town to a site previously occupied by yet another order, the Friars of the Sac, where the White Friars' Tower took their name. The Augustinian order or Austin Friars had their friary where the Holy Jesus Hospital at Manors was later built. The friary was founded in 1290 by Lord Ros, baron of Wark-on-Tweed. The Trinitarians, who had strong links with the Holy Land and the Crusades, took over the old house of the Carmelites at Wall Knoll in 1360 at the invitation of William de Acton. Distinguished by the red and blue cross on their white robes, they were known as the 'red friars'. Fenham, outside Newcastle, was owned by the Knights Templar and they may have been some members of the order in Newcastle itself for, when it was suppressed on the charge of heresy, a writ was sent in December 1307 to the Sheriff of Northumberland directing him to bring ten men to Newcastle to take into custody all Knights Templar.[18]

The medieval town was largely confined to the riverside and to the area around the castle. The river and riverside were originally very different to what we see today. The river cut a narrow channel below the castle but widened out below it. The more or less constant distance between the riverbanks from the area below the castle to what is now the quayside was the creation of man, or more particularly of the medieval inhabitants of Newcastle. Between the twelfth and fourteenth centuries a process of land reclamation was under way. The spaces between a cluster of piers would gradually be filled in and new piers built from the new riverbank. There was a programme of deliberate dumping of sand, soil and stone, most of which seems to have been from ballast cargoes in order to increase the area of land. Thus, from the castle a series of steep stairs such as Break Neck

and Dog Leap descended to the river but at the east of the town, where Dog Bank had originally risen over the riverside, there was by the fifteenth century a series of narrow lanes or chares stretching back to Dog Bank from the river. Largely connected to shipping and seafaring they contained merchants' houses and warehouses, ship chandlers' shops and inns and lodging houses. A market was held at Cale Cross[19] on the north side of the Sandhill, a rather oddly named area as, rather than a hill, it was a low-lying sandy space by the waterside. This area of the town was literally expanding as land was reclaimed from the river and a new riverbank was formed. To the west of the bridge such a process resulted in a new street, The Close; it was soon home to the town's principal merchants and was where several of the aristocracy and county gentry had town houses; it eventually became the seat of the mayor and Corporation when the Mansion House was built there.

The bridge was an integral part of the lower town. Two-thirds of it belonged to Newcastle and a third to the Bishop of Durham; towards its southern end was a blue stone demarcating the boundary between Newcastle and the Palatinate of which Gateshead was a part. The width between the parapets of the bridge was 15 feet but this was reduced in places to 9 feet by houses, shops, the Chapel of St Thomas the Matryr and a prison for 'lewd and disorderly persons'. The bridge was maintained until 1417 by a keeper, originally the priest of the chapel, who was responsible for the collection and allocation of money. The funds the Corporation had for its maintenance came from a variety of sources: indulgences to those who provided cash or labour, contributions from the guilds, fines for offences, such as abusive language or accepting a Scot as an apprentice, and occasional grants from the Crown. You could live most of your life on the bridge for, in addition to houses, it had shops and taverns. Death need not result in a speedy move, for near the north end was a charnel house where your body would be left to rot for a while. The world passed by with its kings, merchants, prelates, pilgrims and armies. It was also the place for awful warnings and, if it was on London Bridge that Sir William Wallace's head and mangled body was displayed after his execution in London in 1305, his right arm was sent to Newcastle and adorned its bridge for a while.

North of the castle, houses and shops spread from St Nicholas's towards White Cross and the Dominican Friary along the line of the Lort Burn and the western

edge of the Nunnery. Here a number of specialist markets for cloth, flesh, meal, barley (the Bigg market) and oats (the Groat market) developed. The buildings facing these markets had plots of land (burgage plots) behind them, which soon became a jumble of warehouses, workshops and residential accommodation. There were two main routes from the quayside: one was up the steep bank of The Side to the castle, while, to the east of the Lort Burn, Butcher Bank led to Pilgrim Street, its lower slopes crowded with houses. Both these northward routes – which led, once beyond the city walls, to Jesmond with its shrine to Our Lady – met at Barras Bridge the site of the Hospital of St Mary Magdalene. This hospital looked after the lepers of the town, who had land at Spital Tongues allocated to them so they could be kept separate from the town. The main street leading westwards towards Corbridge and Hexham was Westgate and beside it stood the Hospital of St Mary the Virgin, where travellers could be accommodated.

If Newcastle was distinguished from the surrounding countryside by its special borough status and from the early fourteenth century by the town walls, it retained an agricultural dimension with the freemen continuing to own cattle, which were kept within the town overnight and sent out to graze on the extensive Town Moor during the day. Many houses within the walls had large gardens producing vegetables.

The size of the total population must remain a matter of guesswork, though a tax record, the *Northumberland Lay Subsidy Roll* for 1296, contains a list of taxed householders in each township of the county and demonstrates both the great size of Newcastle's taxpayers, 295 in all, compared to surrounding townships and the relative wealth and size of the taxpaying populations of the town's parishes. St Nicholas's parish was clearly the wealthiest and St Andrew's the poorest, for in contrast to many other towns the wealthier people tended to be concentrated in the centre near to the castle and principal church. In 1334 the town was reckoned to be the fourth largest in England. After the Black Death, which exacted a high death toll, the town was only the twelfth largest town in England, but the 1377 poll tax returns listed 264 taxpayers and point to a population of about 4,000, though a further outbreak of the plague in 1380 reduced this.[20]

The building of the town walls took place in the thirteenth and early fourteenth century with increasing urgency as the town's need for defence increased due to

the deterioration of Anglo-Scottish relations. Edward I's attempt to dominate Scotland led to a prolonged period of intermittent border warfare. The great campaigns and battles are well known: Edward I's victory over William Wallace at Falkirk (1298); Edward II's defeat at Bannockburn (1314); the English victory of Halidon Hill (1333); the defeat and capture of King David at Neville's Cross (1346); and the final great border battle at Flodden in 1513 when James IV and much of the Scottish nobility perished. There were long periods of uneasy peace but when one side felt strong enough, or the Scots saw an opportunity when England was at war with France, armies would cross the border.

The effects of the wars on both sides of the border were considerable. The English and Scottish border counties were remarkably similar in their economies and in their racial and social composition; the mass of the population was Saxon and the landholding upper class had come with the Norman Conquest. During the twelfth and thirteenth centuries trade and agriculture had prospered and there had been considerable cross-border landholding, with the King of Scotland being Lord of the Liberty of Tynedale and many Northumberland lords holding estates in Scotland as Scots lords did in Northumberland. All changed after Edward I's attempted conquest of Scotland and war made such cross-border landholding untenable. Even when no state of war existed, the border became an unsettled and violent frontier. The border region became organised into Marches on both the English and Scottish sides. On the English side the three Marches, East, West and Middle, were each under their own Warden with uneasily subordinate Keepers responsible for the feudal liberties such as Tynedale and Redesdale. They constituted a unique form of government designed for defence and a rough and ready form of law and order. In the East and West Marches this form of government delivered its aims but in Tynedale and Redesdale the population, too large for its subsistence economy and remote from authority, proved a perennial problem with its incessant feuding and raiding across and on its own side of the border. Periodic war with Scotland thus made for a border region out of step with the rest of England. Fortification remained a primary consideration of architecture for the rich and poor alike at a time when the manor built for comfort became the norm further south. Instability meant that agricultural progress faltered a few miles north of the Tyne.

The effects upon Newcastle were mixed. The town gained something from its strategic importance as a major military base. This gave it some security and royal favour which resulted in relief from taxes in recognition of the burden of maintaining not only the walls of the town but also the castle. The inconvenience and expense of quartering royal troops and contributing towards the frequent royal commissions that were held in the town must have been considerable though offset for tradesmen by the expenditure of the sovereign at such times. Overall, however, the advantages must have been greater for, as the nineteenth-century historian Welford commented, 'It is noticeable that in all this history of border warfare there is hardly a mention of an attack upon Newcastle.'[21]

As important as the threat from Scottish armies was, the depredations of border reivers were feared almost as much. Well back from the border though the town was, Newcastle was vulnerable to border thieves whether English or Scottish. Lawless Tynedale was uncomfortably close and as late as 1554 the Merchant Adventurers of Newcastle forbade members from taking on apprentices: 'as is or shalbe borne or brought up in Tyndall, Ryddisdall, or any such lyke places'.

It was, indeed, the kidnapping of a prominent merchant, who was taken while seated in his counting house and returned only after the payment of a ransom, that first concentrated the minds of the citizens on the need for encircling walls in the mid-thirteenth century. They took nearly one hundred years to complete. In many southern English towns, walls were built more to demarcate the legal boundary than for their ability to withstand a serious siege but Newcastle's were built for a military purpose. When complete the walls stretched for over two miles, were strengthened by towers and were pierced by seven gates and a number of posterns. The need to protect the various religious houses, which had been founded mainly on the outskirts of the town, meant that the walls were extended further than the most populated area. Thus, to the north-west the wall ran round the Dominican Friary, to the north the Nunnery and the Franciscan Friary, and to the east encompassed the Austin Friary and the Carmelite (later the Trinitarian) Friary. Pandon, as we have seen, had recently become part of Newcastle and the need to defend this new part of the town necessitated an eastwards extension of the wall completed in 1307. From Sandgate to the Close Gate the wall ran along the riverside.

Her walls served Newcastle well. Scottish invaders usually baulked at besieging such a well-fortified town. William Wallace pillaged Hexham, Corbridge and

Ryton but found an attack on Newcastle too daunting. In 1342 King David II attacked the town but failed to penetrate the walls and in 1346 his army passed by Newcastle before being defeated at the Battle of Neville's Cross. A Scottish army under James, Earl of Douglas, ravaged as far as Durham in 1388 and on its return harried the neighbourhood of Newcastle but did not attempt to break through the walls of the town although the inhabitants were able to watch the personal combat between Douglas and Harry Hotspur from the walls. Hotspur was unhorsed but dragged back inside the walls by his followers after which he pursued his adversary to Otterburn, where a moonlit battle took place at which the Scots were successful, Douglas was killed and Hotspur taken prisoner.

With the completion of the walls, the physical shape of Newcastle that would last for several centuries was largely determined. Development would take place within the walls to be followed by some expansion beyond them though there was a clear distinction between areas within and without the walls. Sandgate was to become a densely populated suburb outside the walls and Gallowgate and Percy Street were to be built in the early seventeenth century, while, eventually, nearby villages would become satellites. It was not, however, until the mid-nineteenth century that Newcastle itself spread far beyond the frame provided by its walls.

An important asset of the town was the extensive Town Moor to the north. Covering around 900 acres it was acquired by charter from King John in 1213 on payment of £100 a year. The town's walls might seem to have marked a sharp division between town and country but cattle were kept overnight in the city and driven out via Cowgate to their pastures on the Moor at daybreak when horns were sounded to give warning of their passage. Castle Leazes and the Forth were also grazing areas just beyond the town walls, while within the town were gardens and many townsfolk kept pigs and ducks.

Burgeoning prosperity resulted in the emergence of a wealthy elite of wool merchants, local gentry and royal officials. We find Newcastle merchants making loans to Edward II and to Scottish earls. As we have seen, civic and economic powers were intertwined with the mayor and four bailiffs being selected by the Merchant Gild. The dominance of the merchants was, however, challenged by the craft guilds representing craftsmen rather than traders who contested the right of the Merchant Gild to run the affairs of the town. This dispute became so fierce and violent in the 1340s that Edward III twice took away the town's privileges and

reinstated direct rule. The burgesses who were not merchants objected to the re-election of John Denton in 1341. He has been described in one recent study as 'a war profiteer and an opportunist',[22] was unpopular with craftsmen and, crucially, with several of his fellow merchants. After his election by the members of the Gild, a rival candidate was chosen by the burgesses as a whole. At this point the King took the town back under his control.

The context of the Denton affair was the coming together of three factors: a split within the elite, the ambitions of the craft guilds and war with Scotland. Despite the opposition of the craft guilds to the merchants' dominant position, the main conflict in the fourteenth century was within the inner circle of wool traders.[23] From 1300, new families began to rival the position of the Scots and Carliols, who had dominated not only the wool trade but the mayoralty of the town. Men like Richard Embleton, Peter Graper, Richard Acton and Adam Galloway were newcomers but quickly gained a hold on much of the lucrative commerce. Many of the major wool merchants also gained positions from the Crown as customs officers. Their twin roles as exporters and the men responsible for taxing exports were somewhat incompatible and several, including John Denton, who was mayor several times and represented Newcastle in Parliament in 1331, engaged in smuggling; Denton was fined 250 marks for exporting uncustomed wool in 1340–41 and William de Acton was fined 200 marks for the same offence.

Things came to a head with the mayoral election in Michaelmas in 1341; Denton's re-election was hotly contested and a faction among the burgesses declared his opponent, Richard Acton, mayor and seized the gates of the town. Denton was clearly a wheeler-dealer who had acquired much of his wealth and property in suspicious circumstances but much the same could be said of his opponent. Denton had proved useful to King Edward III, even though it was asserted that he had had pocketed the money raised to repair the town walls. It seems unlikely that he had, as was rumoured, covertly sent supplies to the Scottish army that had briefly threatened the town earlier in the year. Probably the main reason he had become unpopular was that he collected the hated wool tax. The King took control of the town and ordered an enquiry into the election to be opened by burgesses suggested by Denton. Lesser burgesses took the opportunity to press for a new charter, which was adopted in the following year and included weekly statements of the town's accounts and a formal system of

election. The latter was enormously complex with each of the twelve mysteries electing two men and the resultant twenty-four electing four men who co-opted another eight. The consequent group of twelve elected, in their turn, another twelve and this final group of twenty-four elected the mayor. Byzantine in its complexity, this system gave plenty of scope for pressure and influence but in renewing the town's charter Edward III accepted it.

This was far from the end of the matter. Denton's opponents were determined to get him. Galloway and his supporters won the election in 1343 but, not content with their victory, had Denton arrested in 1344 on a charge of assisting the Scottish army. Denton refused to plead before a jury consisting of his enemies and died in prison, probably being deliberately starved to death. The King then took over the government of the town, ordered its liberties to be confiscated, removed the mayor from office and set up a hunt for Denton's murderers. In the following October he restored the town's liberties and allowed the election of Robert Shilvington but insisted on a new and equally complicated election procedure by which the mayor and four bailiffs elected seven men and this group of twelve elected four after which the procedure of 1342 was followed. This system lasted until 1371 when the 1342 system was restored. It is clear that these complex election systems were designed to find a compromise between oligarchy and a cautious degree of democracy but that it was oligarchy that persisted.

The later medieval period witnessed, therefore, a partially successful revolt of the craft guilds against the political and economic dominance of the merchants. In the long run, however, Newcastle was to remain governed by a close oligarchy of merchants whose greater wealth counted. In 1512 the merchant guilds, recognising that the old Merchant Gild was defunct, formed themselves into the Company of Merchant Adventures. They maintained the threefold division into Boothmen, Mercers and Drapers but essentially they both dominated the town's government and controlled all exports and imports.

If the merchant companies constituted the town's elite, they and the nine powerful craft guilds made up the twelve mysteries and formed a wider circle of influence. Outside this circle some twenty-one craft companies struggled for a share of civic power. But the most important division was that between the members of companies and those who belonged to no company. A man could only be a full citizen of medieval Newcastle in any proper sense if he was a

member of a company. Originally the term 'burgess' had simply designated any inhabitant of the town who contributed to the charges as a 'scot and lot' payer and was prepared to play a part in its defence, but by the thirteenth century it had come to be limited to a member of a trade company. The company to which a person belonged was perhaps the most important part of his identity. As in every town in Europe, only members of the appropriate company could work at a particular trade but rather more widely membership of a company regulated and encompassed most of life. You drank and ate with your fellow members, you assisted in the performance of the specific mystery play, the performance of which was the special duty of your company, and you paid fines and penalties to your company if you broke its rules. Your company was your and your family's security. It looked after you when you were sick, provided fine dinners for you on certain occasions, paid your funeral expenses if you died poor and looked after your widow and children if you died young.

It was a system with many advantages for those within it. The 128 members of the Barber Surgeons Company may well have felt well satisfied when they rose from the table after a company dinner in October 1478 having consumed 2 loins of veal, 2 loins of mutton, 1 loin of beef, 2 legs of mutton, 1 pig, 1 capon, 1 rabbit, a dozen pigeons, a goose, a gross of eggs, 2 gallons of wine and 8 gallons of ale at a cost of three farthings each. It did, however, make for a protectionist economy and a conservative society. The town's interest was to preserve its monopolies and the interest of most of its inhabitants was to preserve their own little monopolies. As a means of entry to a company was by patrimony, it is unsurprising that cordswainers tended to beget cordswainers and butchers, butchers. The other means of entry to a trade, apprenticeship, gave lofty mercers and humble fullers and dyers alike a patronage to be bestowed upon the sons of cousins or friends. Every company had regulations about who could not be taken on as an apprentice; unsurprisingly there was invariably a ban on apprenticing a Scot.

A great day for the town and the incorporated companies was Corpus Christi when each company performed its own miracle play. Corpus Christi was the culmination of the Easter cycle of fast and celebration. Though first instituted by Pope Urban IV in 1264 in honour of the Eucharist, the popularity of the feast followed a proclamation by Pope John XXII in 1317 emphasising its importance and it became a major festival in the fourteenth century. It took place on the

second Thursday after Whitsun and its principal feature was the bearing through the streets of a consecrated host enclosed within a shrine. It was very much an urban feast and its celebration became embellished with tableaux, pageants and plays performed by members of the guilds. By the late fourteenth century the feast and its rituals had become firmly established in the major English towns including Newcastle with, in corporate towns, the councillors marching behind the clergy. In Newcastle the play of the Weavers was 'The Bearing of the Cross', that of the Merchant Adventurers 'Hog Magog', while the Shipwrights performed 'Noah's Ark'. When the Goldsmiths, Glaziers, Plumbers, Pewterers and Painters were incorporated into one company in 1536, they agreed to maintain the play 'The Three Kings of Coleyn (Cologne)'. Despite their religious themes, the plays seem to have been lewd and sensational with lead characters often performing naked. Fines were levied on members of companies who did not turn up to parade, perform their plays and feast which suggests that, as well as a day of religious observance, Corpus Christi in Newcastle was a day for the companies or mysteries, a day when new members were admitted and the general membership publicly affirmed their brotherhood. The mixed elements of Corpus Christi Day, piety, feasting, bawdiness and corporate business do not seem to have been paradoxical to the medieval mind.

In 1400 Newcastle's status was further increased when Henry IV created it a county in its own right and separated the town, but not the castle and its precincts, from Northumberland. Newcastle was now able to appoint its own sheriff and Justices of the Peace and dispense justice. The town now had the same status and independence as Bristol and York. It continued to be dominated by wealthy merchants during the fifteenth century. The Harding family provided mayors in three generations, while Johyn Rhodes was mayor several times and his son, Robert, was elected MP for the town on eight occasions. In accordance with its new status, the town was beginning to acquire grand buildings, secular as well as religious. Roger Thornton, a merchant of great wealth, built the Maison Dieu at the Sandhill in 1412. He has been hailed as the town's 'Dick Whittington':

At the Westgate came Thornton in

With a hap, and a halfpenny, and a lambskin.

In reality, he came from a landed family but he certainly became wealthy enough. On his death in 1429, his will listed houses and property in Newcastle, a London house in Cheapside and estates in Northumberland of which the finest was Netherwitton.[24] To provide for his soul in the next world and burnish his reputation in this one, he was a generous benefactor to the town. According to some accounts, he was also responsible for the Guildhall. The Maison Dieu was a hospital or almshouse but the Corporation were able to use its hall and kitchen for banquets. Before the fifteenth century, the Guildhall or Town Hall was probably situated in the Hospital of St Mary. The building of the new Guildhall at Sandhill next to the Maison Dieu represented the increased importance of the lower town as the port expanded. It was not just the seat of civic government but also of justice for courts were held there, the Mayor's and Sheriff's courts, the Admiralty or River Court and the Court of Pyepowder. This latter sat at times when fairs were held and its role was to try charges involving itinerant tradesmen and entertainers.

It is difficult for us to imagine the way of life of medieval Newcastle, never mind enter into the mindset of its inhabitants. Medieval Newcastle was certainly no 'Merrie England' but nor was life simply nasty, brutish and short, though much of it was indeed that. No medieval town was capable of maintaining its population level without immigration. Piles of rubbish, open sewers and the whiff of decay from one's late neighbours lying in the charnel house next to the Maison Dieu were one aspect of the environment. The houses of well-to-do merchants were grand enough but far from comfortable, while the poor lived in wretched abodes. An apprentice from a prosperous family would find his bed under the table in the counting house. Pestilence and disease were no respecters of rank or wealth, while violence and cruelty were ubiquitous and the staples of entertainment. Executions, the 'carting' of adulterous women and the 'ducking' of scolds would be sure to draw large crowds.

The Quayside area was reputed to be the most crowded part of the kingdom though there must have been plenty of competition from areas of London and others towns for this dubious honour. The geography of the town made this crowding inevitable. The Quayside was the centre of business and work and the steep banks rising from it concentrated housing close to the river, while much of the land above the banks was occupied by the buildings and grounds of the

religious houses. As the river frontage was widened in the fourteenth century, the houses of merchants moved closer to the river and behind them the artisans and craftsmen worked and lived on the steep stairs from The Close to the castle and up the alleys or chares,[25] most so narrow that the top storeys of the houses nearly touched each other, especially those that were built between the Sandhill and the mouth of the Pandon Burn.

There were constant reminders of death, the fear of which might not be assuaged by the hope of afterlife when damnation might so easily await one. Religion, as we have noted, pervaded the life of the town. Whether it maintained its hold through fear or love, superstition or genuine piety we cannot know. Certainly, the portrayals of hell in medieval art are more powerful and convincing than portrayals of heaven. The Church was powerful and could intercede between man and a vengeful god. Taking the sacraments, saying prayers and giving to the Church might save one's soul. The Black Death, which reached England in 1348, made the wall between life and death seem thin indeed. The concept of purgatory became widespread in the wake of the plague and led to the building of chantry churches. Chantries were built with donations given in advance of death by those who felt they had not had time to prepare themselves; the donations would cover the cost of masses said for the souls of the deceased.

Attitudes to the Church seem to have been ambivalent. The sacrament, ritual and the priesthood were seen as essential to salvation, though by the late fourteenth century John Wyclif was already questioning this. The Church's role in caring for the sick and the poor provided society's main welfare mechanisms but the wealth of the Church was great and it was often seen as greedy and grasping.

There is much to be said for the view that there are constants in human needs, behaviour and affections and it may be condescension to exaggerate the brutalising effects of a harsh environment. People married, had children, nursed ambitions and found time for pleasure. In good times the standard of living of even the Newcastle poor was probably higher than that of the rural peasantry and their work less arduous. Fish was cheap and plentiful with salmon being thought of as an everyday food and Newcastle was the North's granary. Storms and poor harvests could, however, suddenly reverse this. The street life of the town provided daily entertainment especially at the many markets: the Bigg

(barley), Flesh, Meat and Cloth markets north of St Nicholas's, the Cale Cross Market, the Milk Market near the Sandgate and the cattle market at White Cross. The bustle and the crowds and the vendors shouting their wares could be enlivened by pedlars, a man with a performing bear or a cockfight. The Sandhill was a place for recreation and one where itinerant entertainers performed. On high days and holidays there were fairs reflecting the religious or agricultural calendar and, of course, there was drink. Already, there was something distinctive about Newcastle's approach to pleasure. It was grab it while you can.

Roger Thornton was, perhaps, lucky in living through a period of prosperity for there was a widespread depression in fifteenth-century Europe from the 1420s. The population was in decline because of epidemic disease while there was a chronic shortage of bullion due to the working out of mines of precious metals. England faced special problems. The Wars of the Roses made for weak government at home and loss of power abroad. The weakness of Lancastrian governments after the death of Henry V led to a deteriorating trading position that must have had implications for Newcastle. English merchants were excluded from the Baltic, Gascony was lost and the hegemony of Burgundy created problems for traders in Low Countries. Some English merchants were forced to seek trade with Iceland. Newcastle, like other east coast towns, was affected by the increase in London's trade at its expense. One historian has concluded that the North East 'passed through an extended economic crisis during the later middle ages'.[26] Newcastle wool exports declined sharply and even the coal trade was disappointing.

The picture of Newcastle in decline in the late medieval period may well have been exaggerated and indeed some historians have argued that Newcastle escaped the fate of other towns. Newcastle's merchant community was protected to some extent by a consolidation of its special privileges. It had exemption from sending all wool through the Company of the Staple at Calais. A licence awarded in 1452 as a reward for the 'defence of our seide town against the Scots' set the duty on inferior fleeces shipped from Newcastle at the low rate of a shilling in the pound. An Act passed in the reign of Edward IV ordered that all wool from the northern counties had to be shipped from Newcastle. A burgeoning coal trade may well have mitigated any decline in the export of wool and there is evidence that many Newcastle merchants were prepared to engage in the high risk enterprise of the

import of a wide range of goods, including Spanish iron and expensive sweet wines.[27]

Despite vicissitudes of fortune, Newcastle maintained its status as one of England's principal towns[28] but the sixteenth century would see its importance greatly enhanced. For centuries coal had played a part in the town's economy but the coal trade was about to become the basis of its prosperity and reputation.

3

TUDOR NEWCASTLE

The last years of the fifteenth century saw an improvement in Newcastle's fortunes with the wool trade, for long the town's most important trade, receiving assistance from royal edicts. During the century, however, the prime importance of the coal trade was to become firmly established, and Newcastle's importance to the national economy grew as its position as the major supplier of coal to London became established. The Henrician Reformation was to radically alter the town's culture and must have been experienced by its inhabitants as a dislocation in psychological terms as it affected their views on the meaning of life and death, the latter ever closely present as outbreaks of plague made for periodic peaks in a death rate that was already high due to crowded and insalubrious conditions. Overall, however, the Tudor period saw Newcastle become more prosperous, more populous and more important.

At the start of Henry VII's reign Newcastle did well, enjoying complete exemption from wool subsidy and customs. In 1488–89 and in 1489, the town's merchants received a licence by which northern wool was to pay subsidy and duty at a quarter of standard rate. The king, said the letters patent, was informed that 'wool of the said counties is so coarse and of so little value that the ordinary duties thereon are excessive and the trade is carried on at a loss'. A license granted in 1504 by Henry VII allowed Newcastle merchants to buy wool in Northumberland, Durham, Cumberland, Westmoreland, Allerton and Richmondshire, but not Berwick, and ship it to Flanders, Brabant, Holland, Zealand or any foreign parts in two annual shippings, paying 10 shillings in duty for every sack of wool or 10 shillings for every 240 woolfells. With wool exports enjoying their last profitable years and the coal trade finding new continental customers, Newcastle's export trade prospered once more. Probably most important was the shipment of coal to other English ports, primarily London, though Tyne coal also went abroad and

many French industries relied upon it by the sixteenth century.[1] Lead also became significant with Newcastle becoming a prominent export centre for lead mined and smelted in the northern Pennines. The business-like approach of Thomas Wolsey, while Bishop of Durham in the 1520s, towards the revenue of the bishopric led to a greater exploitation of lead interests on the episcopal estates as well as to the development of small iron-mining works. A further extractive industry, the quarrying of grindstones, expanded its production and shipments from the Tyne increased. The town's position as the dominant distribution centre for the North East was also crucial to its economic success, while salmon from the Tyne found a market in London due to their transport by relays of fast packhorses.[2]

By 1547 the population of Newcastle was between 7,000 and 10,000, such is the variation of estimates made by historians. Plague, which came to Newcastle five times in the seventeenth century, must have caused severe dips in the numbers: in 1579 2,000 are said to have died, in 1589 1,700, and in 1597 the outbreak was so bad that people died in the streets. Only immigration can have ensured that there was no long-term decline in population. Everyday diseases as well as plague took a great toll of families living in a crowded and unhealthy environment. That plague seems to have made little distinction between rich and poor reflects the facts that richer dwellings were not usually more sanitary than those of the poor, that both partook of the same water supplies and that, with exceptions, rich and poor lived, as they had in the medieval period, cheek by jowl. There was a tendency for the wealthiest merchants to live in The Close, Sandhill and at the lower end of Pilgrim Street, the eastern side of the Cloth Market and to the west of the castle. Segregation by wealth was, however, limited with particular trades rather than degrees of wealth distinguishing certain areas, and also because employees lived beside employers, with the result that areas where wealthy families lived had as high a degree of population density as many poorer areas.

There was no constant upward curve in the economy any more than for the population in the first half of the sixteenth century and at mid-century there were accounts of decayed merchant houses in the Cloth Market and on the Quayside, but during Elizabeth's reign London's increased demand for Tyneside coal made the town more prosperous than ever before.

The most important developments of the sixteenth century for Newcastle were the expansion of the coal trade; the impact of the Henrician Reformation; the

ever tighter domination of the town by the merchant elite; the high standing of the town in the eyes of central government; and its ability to increase its control of the Tyne. There was considerable linkage between these developments.

The formation of the Merchants Adventurers Company in 1512 has been seen by some as a new development distinct from the old Gild Merchant while other historians have emphasised the links with the Gild Merchant. These links seem obvious enough with the threefold division of the Merchant Adventurers into Drapers, Mercers and Boothmen, which had prevailed in the Gild Merchant, continuing in the new organisation. By far the most influential of the three sections was the Mercers' Company and mercers were to provide the great majority of the governors of the Merchant Adventurers, mayors of the town and MPs for the next three centuries. In this Newcastle was not unusual. The historian of the Merchant Adventurers of York has pointed to the way in which, in York, the mercers had captured the government of the city as early as 1420 and the offices of Master of the Company and Mayor of the City had become interdependent.[3] The London Merchant Adventurers' Company was closely associated with the Mercers' Company and shared Mercers' Hall until it was burnt down in the Great Fire in 1666; the London Mercers rivalled the Staplers' Company which specialised in wool exports. Specialisation between merchants had never been watertight and had increasingly broken down, but mercers were well placed both to exploit the booming trade in finished cloth and, as they had always been involved in general trades, take advantage of expanding trades, particularly the coal trade.

It is clear that the formation of the Merchant Adventurers' Company was no independent Newcastle initiative and it was to a large extent formed as part of that general movement of English merchants to protect their interests when trading abroad, which resulted in the formation of the London Merchant Adventurers. The Newcastle Company came to have links with the London Company and was to some degree under its auspices, as is seen in the agreement in 1519 to pay a due of £8 per annum for goods sent beyond the sea. In 1547 in the reign of Edward VI the same privilege of buying and selling wool as had been granted by Henry VII was reaffirmed in a charter under which the company took the title of 'The governor, assistants, wardens and fellowship of Merchant Adventurers of the town and county of Newcastle upon Tyne'. It is significant, however, that the charter of Edward VI reaffirmed by Queen Mary,

Queen Elizabeth and James I refers to the Newcastle Merchant Adventurers as being 'now of the Fellowship of Merchant Venturers in Brabante in the parts of beyond the seas'. The 'Fellowship in Brabante' was a reference to the London Company, which had obtained privileges from the Duke of Brabant at the end of the thirteenth century. Spreading its influence to other European towns, it progressively sought to exclude other English merchants from trading in such towns unless they joined its fellowship and by the early sixteenth century had taken the title Merchant Adventurers of England. A charter of Henry VII enjoined all merchant adventurers to come into the freedom of the fellowship.

All English merchants were thus forced to join the London Company as indeed the Newcastle merchants did along with the companies of York, Hull, Norwich, Exeter and other towns. Even though the Newcastle Company achieved its own charter in 1547, it continued to pay its £8 a year to the London Company with which it had a quarrelsome relationship. In 1549, Thomas Appleyard, Governor of the York Merchant Adventurers, wrote to John Fargeon, Governor of the Merchant Adventurers of England at Antwerp, about the due or assessment, York was to pay, asking that 'you do not charge hous over and above the some that the town of Newcastle is sessyed at, considering they be of greater trade and abyllite than we be of'.[4] Thus, although the Newcastle Merchant Adventurers' Company was a reformation of the previous Merchant Gild and could justly claim to be an independent company, it had for pragmatic reasons been compelled to enter into arrangements with the London Company and recognise to a degree the latter's superiority.

Accepting even a vague suzerainty of the Merchant Adventurers of England was a dangerous course, but one which was necessary in the context of early sixteenth-century trade. It would have been all but impossible for Newcastle merchants to find markets for their cloth and wool in Antwerp or Hamburg without the authority of the Merchant Adventurers of England. By the seventeenth century the demands of the London company that the Newcastle Company recognise its status as a subsidiary was to lead to conflict but by then the expansion of the coal trade had placed the Newcastle merchants in a far stronger position.

Newcastle's status and position was transformed and given new power and prosperity by the expansion of the coal trade. Coal had been part of the economy

of Tyneside since the thirteenth century and had subsequently developed into a substantial export trade during the fourteenth and fifteenth centuries with shipments to France and the Low Countries as well as to London. It was during the sixteenth century, however, that coal came to dominate Tyneside's and Newcastle's trade. Demand for coal increased and Newcastle was able to furnish its supply.

The main demand for coal came from London. By 1500 there was increasingly a shortage of wood in its vicinity as more and more woodland had been chopped down to provide wood for fuel and shipbuilding and supplies had to be transported over long distances. London saw from the middle of the century a vast expansion of its population; already huge by contemporary standards with around 50,000 inhabitants in 1550, the population was to double and redouble in the following century and a half, reaching around 600,000 by 1700. Londoners had no great desire to replace wood with coal as the means of heating their houses and cooking their meals, finding the fumes and the dust unpleasant, but the shortage and cost of wood gave them little option. Although domestic demand was very important, the demands of London's industries – smiths, glass makers, brick makers, distillers and brewers – added to the city's demand for coal. In 1306 a proclamation had been issued against the burning of coal in London, calling it 'a great annoyance' and pointing to the 'danger of contagion growing by the stench of burning sea-coal'. But London needed fuel and only coal could replace wood. The greater part of London's coal was to come from Tyneside.

The great advantage of Tyneside coal lay in the ease and cost of its transportation. The carrying of coal, as of wood, by land was exceedingly expensive but transport by ship was much cheaper and Tyneside had coal seams which were not only close to the surface but close to the river. The profitable coal mines lay to the west of Newcastle on both sides of the river and Newcastle's opportunity and problem was to gain from the coal trade by ensuring that the town maintained a monopoly of the export of coal. This is where the Henrician Reformation was economically beneficial. Tyneside's ability to meet the new demand for coal was facilitated by the Reformation in that the church and monasteries had restricted the output of the mines they owned and when such mines passed into lay hands an immediate increase in production was possible. Newcastle was in a good position to monopolise the coal trade of the Tyne for it stood high in royal favour.

From 1460 to 1540, the volume of shipping from Newcastle increased fivefold though as coal was a low-profit bulk cargo this did not mean a commensurate increase in profitability. The great majority of the ships that carried Newcastle coal were not built at Newcastle or indeed on the Tyne but came from East Anglian shipbuilding towns, such as Harwich, Ipswich and Woodbridge, specialising in colliers. The export trade was dominated by foreign vessels; these had been mainly ships from Flanders in the fourteenth century but later they came from Holland and Zeeland. Gradually, however, more of the coastal trade came to be carried by ships that were Newcastle owned though not necessarily Newcastle or Tyneside built. 'By 1550, the town's ships were valued at some £4000 with individual ships valued at well over a hundred pounds, whilst some merchants had several hundred pounds invested in ships.'[5]

It might have been expected that, as the Tyne's main export shifted from wool to coal, an existing elite would be displaced. The great achievement of Newcastle's merchant elite was that, as the wool trade declined and was replaced by the coal trade as the leading sector of the economy, the merchant companies and particularly the Mercers maintained a tenacious grip on power. The Hostmen's Company grew up under the umbrella of the merchant companies that exercised the right to export coal until the sixteenth century at which time the Hostmen formed themselves into a separate company, though they were not incorporated until 1600. When incorporation took place the majority of members were also merchant adventurers. It was easy enough to become a hostman, both before and after incorporation, but hostmen were nearly always members of another company as well and the most prominent and wealthiest were usually mercers.

An illustration of the changing patterns of trade can be found in the career of Edward Baxter, a prominent Merchant Adventurer who was mayor four times. In 1499 he was to be found shipping wool and hides to the continent and in 1505 he was one of several Merchant Adventurers who had consignments of wool and lead on board the *Julean* which sailed from the Tyne bound for northern France. He diversified his interests, becoming involved in the coal trade and owning ships, and was referred to as a hostman as well as a Merchant Adventurer. A hostman was essentially a go-between, acting for foreign traders in Newcastle in their trading relations with the town's authorities and its merchants. While Baxter specialised in hosting vessels from northern France, John Brandling

looked after ships from the Netherlands and other hostmen were involved with the coastal trade.[6]

The relationship between monarchs and substantial towns was influenced not only by the commercial importance of major trading centres and their contribution to the wealth of kingdoms but by the political significance of towns as a third force in the often uneasy relations between kings and great nobles. It was in the interests of monarchs to give special privileges to an important town like Newcastle, especially when its strategic position in relation to Scotland was so important. Henry VII spent some time at Newcastle while conducting negotiations with the Scottish court. The centralising ambitions of Tudor monarchs made them eager for close relations with important towns and it was also very much in the town's interests to display loyalty to king and central government.

The dependency of Newcastle upon royal goodwill may explain the relative acquiescence of the town during the dissolution of the monasteries. Newcastle, as we have seen, had a great number of religious foundations which, even if much decayed by the sixteenth century, provided both the charity that kept the poor alive and much work for servants, artisans and labourers. The five friaries were dissolved and taken over by the Crown in 1539 as was the Nunnery of St Bartholomew a year later. The King retained Austin Friary, which became known as King's Manor; Black Friars was sold to the Corporation which then leased it to the nine most important craft guilds; and the rest passed into private hands. The hospitals and chapels were allowed to continue with the mayor and Corporation retaining their right to appoint the masters. There was little resistance to Henry VIII's edicts from the 'great and the good' of Newcastle though many of the ordinary inhabitants may have been disturbed by the dissolution of institutions which, however inadequately, provided charity and care. The countryside of the North, led by the great noble families, may have given overt or tacit support to the Pilgrimage of Grace of 1537 but Newcastle, or at least its ruling elite, remained loyal to the Crown. Sir Ralph Sadler, who was sent by the government to report on the extent of disaffection, wrote back to Thomas Cromwell that the mayor and aldermen were:

> honest, faithful and true men to the king; for albeit the commons of the town, at the
> first beginning of the tumult, were very unruly, and as much disposed to sedition and

rebellion as they of the country were; yet I assure your lordship the mayor and aldermen and other heads of the town did so with wisdom and manhood handle the commons of the same, that they did fully reconcile them, and so handled them, that, in fine, they were determined to live and die with the mayor and his brethren in the keeping of the town to the king's use against all his enemies and rebels, as indeed they did.[7]

Newcastle indeed gained much from the dissolution of the monasteries which meant the end of a dangerous adversary in the shape of the Prior of Tynemouth, who had owned rich coal seams at Elswick as well as at the coast north of the Tyne, and the dissolution also weakened the power of the Bishop of Durham, who had owned the collieries at Gateshead and Whickham. Rivals remained, however: other Tyneside towns, North Shields, South Shields and Gateshead; landowners on Tyneside, who had ambitions to bypass Newcastle's control of the coal trade; and other rivers and ports such as the Wear and Sunderland and the river and town of Blyth. The new men, who took over Church lands and were eager to exploit mineral wealth, were, if not themselves Newcastle merchants, just as much a threat to the town's domination of the river and the coal trade; but that domination continued to hold.

The Grand Lease demonstrates the difficulties, which faced even a powerful man who dared to take on the Newcastle oligarchy and break into its coal trade. In 1577 Thomas Sutton, Surveyor of the Ordnance in the North,[8] was granted by Queen Elizabeth the lease of all the coal mines in the Bishop of Durham's manor of Gateshead and Whickham for seventy-nine years. He wished to work the coal mines himself but, as he was not a freeman of Newcastle, he was excluded from the local market. In 1583 he sold the lease, which had by then been extended to ninety-nine years, to two Newcastle merchants, Henry Anderson and William Selby. In fact, it was a consortium that acquired the lease with Anderson and Selby as the front men, but its purchase for about £12,000 put Anderson and Selby and their associates in a lucrative position at a time when the demand for coal was growing apace.

The Grand Lease was only one of the benefits to Newcastle that derived from the diminution of the powers of the bishops of Durham, who had enjoyed enormous secular as well as ecclesiastical powers. The semi-regal status of the prince bishops had been somewhat eroded from the time of the episcopate of

Antony Bek in the early fourteenth century when Edward I had intervened in a dispute between Bek and the cathedral community and temporarily taken over the bishopric's revenues. The Palatinate was ultimately subject to the King and no bishop could hope to defy a determined sovereign but, nevertheless, the inhabitants of the Palatinate continued to pay taxes to the Bishop rather than the King and it developed an administration which was almost akin to that of a small independent state with its own jurisdictional authority. The mid-sixteenth century saw years of crisis for the bishopric, not least the consequences of the switchback of change from the last years of Henry VIII's reign through the imposition of a severe Protestantism during that of Edward VI, the Catholic reaction during that of Queen Mary, and the return to Protestantism under Elizabeth, the potential moderation of which was tempered by fear of foreign Catholic threats to the realm. In 1536 much palatine judicial power was transferred to the Crown. During the brief ascendancy of John Dudley, Duke of Northumberland, during Edward VI's reign it seemed that the bishopric might be abolished altogether. At this time, Newcastle seized the chance to take over Gateshead and an Act was introduced to this purpose in 1553. There was also a proposal to divide the see of Durham and give Newcastle its own bishopric and a bill was read in the House of Lords to this effect. Before this legislation could take effect, Edward died and Queen Mary came to the throne; the Act for the incorporation of Gateshead in Newcastle was repealed in 1554 as part of the restoration of the bishopric, but Newcastle's determination to crush its neighbour was such that it managed to have Gateshead weakened by gaining a 450-year lease of the latter's Saltmeadows, control of the borough's tolls and, eventually, the enforced sale of the lease of the manors of Gateshead and Whickham with their coal mines.

After the Pilgrimage of Grace had been defeated and Henry VIII had reneged on the promises to the Duke of Norfolk, who had persuaded the pilgrim army to disperse, a determined effort was made to assert royal authority over a lawless North. In 1537 the King's Council in the North Parts was created with authority over all England north of the Humber except the Duchy of Lancaster.

Its power, together with the surrender of the franchises of Hexham and Redesdale, and the emasculation of the Palatinate of Durham, meant that in real terms the North East was at last being subject to direct Crown control, a process further advanced by the

destruction of the Percys and the Nevilles following the failure of the 1569 uprising. Shadows were to remain, however, the wardenships [of the Marches] lasted until the Union of the Crowns; vestigial remains of the palatine jurisdiction lingered until the nineteenth century; and Durham was denied MPs until 1673. But by the end of the sixteenth century the distinctive features of government in the North East had substantially disappeared.[9]

The Rising of the Northern Earls in 1569 elicited similarly little support from Newcastle despite the attempt of a former mayor, Lancelot Hodgson, to seize the town in support of the rising. The town had successfully maintained its independence from the great aristocrats of Northumberland for centuries and, as the chief result of the rebellion was to weaken the already diminished influence of the old aristocracy, this independent status was even more firmly underwritten.

For Newcastle, then, the main economic effect of the Henrician Reformation was to provide a stimulus to the coal trade and to place the town ever more firmly in charge of coal mining close to Tyneside and of coal exports. Politically, the town's status and independence were enhanced, while age-old rivals disappeared or were weakened. As with the North East as a whole, the most immediate religious consequence seems to have been negative, an end to a less than vital previous order without any dynamic replacement. Though rich in its assets and with powerful patronage, the Church in the North was by the sixteenth century less assiduous in its religious and social functions than in its protection of its economic position. This was particularly true in more remote areas where priests were thinly spread and rarely well educated. The religious houses had been in steady decline since the fourteenth century. Despite the vast estates they controlled, the total number of monks, friars and nuns in Northumberland and Newcastle was only about 220 at the time of the dissolution.[10] Chantries were the most common religious foundations of the later middle ages and there were thirty-three in Newcastle but by the sixteen century few were still being founded, perhaps because of a growing disbelief among the wealthy that endowments and financial provision for prayers for the dead facilitated remittance from time in purgatory; they were dissolved throughout the kingdom in 1547, ostensibly because they encouraged superstitious practices, though their dissolution increased government revenue.

The transition to a Protestant regime met little overt resistance in Newcastle due in large part to a feeling that the church had become corrupt, the prelates and priors excessively wealthy and the priests too often ignorant and idle. There is some evidence of the previous presence of Lollard preachers and of the attractions of the Bible translated into English by William Tynedale for some Newcastle citizens but Newcastle was far from being a hotbed of Protestantism. The practices, holy days and feasts of the Catholic Church were deeply ingrained in popular mentality and in the annual cycle of civic life and the Church gave an explanation and reassurance for life's troubles and tragedies. Newcastle's population shared in this mentality and that the town gave little support to the Pilgrimage of Grace, while much of the rural North supported it, may be explained by the fact that the economic advantages of the Reformation for Newcastle had to be set against any regret for the religious change. In any case, after the immediate shock of the dissolution of the monasteries, there came a lull as a conservative reaction set in and many Catholic beliefs and practices were reaffirmed.

Historians of the post-Reformation religious dispensation have pointed to the difficulties for a regime, which favoured teaching, preaching and doctrine rather than ritual and holy days but inherited a clergy (for most conformed) and a parochial system that were little suited to it. Many rural clergymen had little education and it was difficult to attract able and well-read preachers to remote parishes, though recent studies have modified the picture of a backward Durham diocese.[11] Towns were clearly better off in terms of the quality of their clergy but educated vicars tended to be more earnest when it came to theological disputes, as were the better educated merchants.

The concept of strong links between Protestantism and men of business, anxious to throw off the old social and religious order, has been highly influential though the ubiquity of such links has perhaps been exaggerated. Catholic merchants could be as hard-headed, as determined for profit and as impatient with a neo-feudal social order that placed restraints upon their trade and limited their social advancement, as their Protestant counterparts. Whereas recusant families in rural areas of the North often saw the Henrician Reformation as a threat to their social, political and economic positions as well as to their religious beliefs, it was quite possible for many merchants in Newcastle to welcome the secular impact

of the changes – dissolution of monasteries, friaries and nunneries; the sale of church property; and the diminution of the power of prelates, especially the Bishop of Durham – while regretting changes in theology and religious practice. It has been recently argued that many members of the ruling merchant elite in Newcastle retained their Catholicism in a discreet manner; they outwardly conformed and were occasional attenders at church, but held household Catholic services and protected priests. This group of what may be termed closet Catholics included the Grand Lessees and leading Merchant Adventurers and Hostmen. They (Andersons, Selbys, Hodgsons, Lawsons, Jennisons and Carrs), it is asserted, retained their positions and beliefs throughout Elizabeth's reign, making sure the clergymen appointed to St Mary Magdelene Hospital and the schoolmasters at the Grammar School were of their persuasion, despite opposition from Protestants in the town, successive bishops of Durham, government officials and the Council of the North.[12] Whether it is correct to term all these families 'Catholics' is debatable and another recent study has referred to the Grand Lessee, Henry Anderson, as a 'deeply committed puritan'.[13] Most of the dominant group of merchants, with the exception of some of the Lawsons and Hodgsons, conformed, at least outwardly, and many of the accusations that they were secret Catholics came from their enemies. What seems certain is that, for the most part, they were not enthusiastic or extreme Protestants, nor much concerned to apprehend Catholic priests smuggled into the Tyne or have neighbours arrested for their religious beliefs.

A zealous form of Protestantism was, however, imported into Newcastle in the middle of the century. The town had laws against the employment of Scots as merchants or apprentices but the expansion of the coal trade attracted many Scots who came to work as colliers or keelmen. Religious turmoil in Scotland meant that the first wave of Scottish immigrants consisted of Catholics seeking asylum in the less oppressive climate of the last years of Henry VIII's reign, but those attracted by the coal trade tended to be Protestants. John Knox, exiled from Scotland and just released from imprisonment on a French galley, came to Newcastle in 1550 in the middle of Edward VI's short reign. In the propitious atmosphere of more extreme Protestantism, he was appointed a lecturer at St Nicholas's and thundered from the pulpit, attracting large congregations in which Scots were in the majority with his attacks on Popery and Popish rituals. This

was too much even for a Protestant like John Dudley, Duke of Northumberland, who had Knox removed to London, where he was offered but declined the bishopric of Rochester. Writing to the Secretary of State, William Cecil, in 1552, Dudley requested Knox's removal to the South on various grounds: he would be 'a whetstone to quicken and sharpen the Archbishop of Canterbury' and a 'confounder of the Anabaptists'; he should not continue his ministry in the North; and too many Scots were attracted by him to Newcastle 'which is not requisite'.[14]

The ruling elite of Newcastle were probably content with the restoration of Catholicism by Queen Mary and even those of a positive Protestant persuasion had little to complain of Mary's reign was not bloody in the North East, for Bishop Tunstall of Durham was a mild and moderate man with a pronounced distaste for inquisitorial activities and his moderation may have been assisted by the general lack of opposition to the restoration in his diocese. During the early years of Elizabeth's reign it seemed that the diocese would likewise be spared the persecution of Catholics. Tunstall was removed from his see for the second time in 1559 for refusing to take the Oath of Supremacy but was treated gently enough. Elizabeth's initial aim was limited to ensuring submission to her position as head of the Church. A number of factors came together to make her government more active against Catholicism: the general recovery of a reformed Roman Catholic Church with the Counter-Reformation saw Europe divided into hostile religious camps with England a major target for reclamation by Catholicism; there was a growing conviction that uniformity of belief between monarchs and subjects was essential to the unity and defence of realms; and the arrival of missionary priests from Douai, antagonistic to any accommodation with the English Church, made Catholicism appear a political threat. The Rising of the Northern Earls in 1569 seemed to prove that such a threat was real and there was the danger that future revolts might be backed up by foreign armies.

The obvious targets were the recusant gentry, even though many of them had not joined the rising, and the seminary priests rather than the burghers of Newcastle who had proved themselves loyal to the Crown even if the religious persuasion of many of them was suspect. Catholic priests from Douai were, however, smuggled into the Tyne and two of them, Joseph Lampton and Edward Waterson, were executed in Newcastle in 1593 and another, John Ingram, at

Gateshead the following year. The Council of the North and successive bishops of Durham appear to have become progressively doubtful of Newcastle's Protestant fidelity towards the end of the century, finding their attempts to have safe men appointed to the town's churches and hospitals thwarted and their attempts to root out Catholics confounded by the lack of co-operation of the leading burgesses.[15] William Jennison, Sheriff of Newcastle in 1593, was accused of having cut off the arm from the quarter of Lampton's body which was hung up after his execution, presumably to preserve it as the relic of a martyr. Bishop Toby Matthew was incensed when he appointed a commission in Newcastle in 1592 to discover and punish priests and recusants only to find that the Sheriff of Northumberland, Ralph Grey, claimed he couldn't find any.

Newcastle was rather more decisive when it came to dealing with Puritans. In 1589 John Udale, a Puritan minister, was introduced to Newcastle by Lord Huntingdon but was then summoned to London where he was tried for being the author of a book, *Demonstrations of Discipline*, which attacked the order of bishops, and sentenced to death. Udale died in prison but it is clear that the Newcastle Puritans blamed the town's rulers for his trial and sixty years later a leading Newcastle Puritan, Lieutenant Colonel John Fenwick, upbraided the town:

> Newcastle famous for thy mocking and misusing of Christ's messengers and ill entertainments of his servants ever since the reformation … witness learned Udale, thy faithful monitor, whose innocent blood cries yet from the ground, whom, for writing against the prelates, though prosecuted as a traitor to bonds, imprisonment, and sentence of death, under which he died before execution.[16]

As we have seen, the problem with asserting that the principal merchants and office holders in Newcastle remained Catholics is that these same people were conformists and made a great demonstration of their loyalty to the Crown, celebrating the Queen's Day, 17 November, sometimes dutifully but sometimes, when their position was attacked, with great fervour. It seems likely that most were conservative in their religious outlook and quite happy to allow those who were Catholics to follow their faith, provided they did so discreetly.

Newcastle presents a complex and somewhat contradictory picture when it comes to trying to determine religious allegiance.[17] On the one hand the Knoxite

tradition was certainly alive in the late sixteenth century and John Mackbray, another Puritan Scot, who was appointed vicar of St Nicholas's in 1568, was only one of a number of extreme Protestant preachers at that church, where the congregation was swelled by large numbers of Scottish immigrants. Yet the Newcastle elite may have had to suffer such preachers because of the influence of bishops and the Council of the North and Scots were not wildly popular in Newcastle. The picture is further complicated by the perennial struggle between the magic circle of power and those on the edge of it or representing the craft trades. This struggle could have had a religious dimension – Protestant outsiders against Catholics or more likely conservative members of the national church – but, for the outsiders, accusations of Catholicism were a useful weapon against their opponents: Lionel Maddison, leader of the opposition faction, who enjoyed a short-lived triumph when he became mayor in 1593, alleged, in almost Stalinist fashion, that his opponents were recusants in thought, if not in deed.

The grip on the economy and government of the town by an elite composed of those who were usually mercers and hostmen had tightened during the sixteenth century and the Grand Lease had played a great part in this. The profits and power consequent on the Lease had been shared among a relatively small group, so to the long-standing attempt to rest power from the merchant oligarchy was added the desire for a more equitable share of the proceeds; religion was an element in the struggle that was renewed in the 1590s. The election of Lionel Maddison as mayor in 1593 was the harbinger of the crisis; it was perhaps no coincidence that the persecution of Catholics increased after his election. The old elite regained control the following year but in 1597 the dispute over the Grand Lease came to a head with an appeal to the Privy Council by the complainants against the leaseholders and a counter appeal alleging that the complaints were unfounded and were got up by Henry Sanderson, the Queen's customs officer and an extreme Protestant. The charges were full of insinuations as to the dubious religious sympathies of the ruling group. The Privy Council overruled the dissidents and confirmed the conduct of the defendants, the main leaseholders: Thomas Riddell, Henry Chapman, Henry Anderson, William Selby and William Jennison. As with so many Newcastle disputes, religious and political rhetoric may have disguised jostling for economic advantage and civic position. Sanderson was certainly influenced by the fact that the Grand Lessees

had injured his interests in the coal trade. He had previously been in alliance with many of those he accused of Catholicism but municipal alliances could change rapidly in Newcastle.

The elite of mercers and hostmen ended the century firmly in control with a new charter from the Queen which confirmed their authority, giving the Company of Hostmen corporate recognition and the exclusive right to trade in coal on Tyneside and authorising electoral arrangements that assisted their monopoly of municipal offices.[18]

During the sixteenth century, the institutions of the town developed considerably. Unsurprisingly, given the central importance of the river to the town's prosperity, a company charged with the assistance to and control of navigation came into being. The growing importance of the Tyne and the large numbers of ships coming in and out of the river posed problems. Entry to the river was not easy and mariners had to navigate past the treacherous rocks of the Black Middens on the north side and the Herd sand on the south side once they had passed Prior's Haven. Passage further upstream to Newcastle became more difficult as ballast dumped by incoming ships silted up parts of the river and narrowed the channel.

It was largely the problems of navigating the river that led to the expanded importance of a body which had begun as a religious foundation, the Guild and Fraternity of the Blessed Trinity, and maintained a chantry at All Saints' church. The original purpose of the Fraternity was to act as a charity directed towards the need of distressed seamen and aged mariners but it became a guild of pilots and seamen, changing its name to the Society of Masters and Mariners in 1492 when it acquired a piece of land known as Dalton Place in Broad Chare. The land was the gift of Ralph Hebborn of Hebborn, who gave his name to Hebburn and, rather than a peppercorn as rent, the brethren were to enjoy the property in exchange for a red rose every Midsummer's Day. Thirteen years later a chapel, hall and lodgings for infirm or aged brethren was built on the land. Henry VIII granted the guild a charter of incorporation in 1536 which allowed them to elect a master and four wardens and erect two lighthouses at Tynemouth for the support of which it was empowered to receive 4*d* from every foreign vessel and 2*d* from every English vessel entering the river. There was some dissension between Trinity House as it came to be known and the Newcastle Corporation

in 1584 over whether the Brethren had the right to exact pilotage charges from foreign ships but in the same year Queen Elizabeth issued a charter confirming the rights of the 'Masters, Pilots and Seamen of the Trinity House of Newcastle upon Tyne'. Further charters followed and that of 1606 further extended the tolls they could charge ships using the Tyne for pilotage, the relief of shipwrecked mariners, the support of poor members and the provision of buoys and beacons in addition to the lighthouses.

Another new institution was the grammar school. This 'hyghe skull' was founded by Thomas Horsley, a mayor of the town, who in 1525 bequeathed his estate to the Corporation for the purpose of endowing a free school. The school began in a building in St Nicholas's churchyard and the positions of master and usher, who were appointed by the mayor and Corporation, were, inevitably, a cause of contention and were bound up with religion and local politics. A zealous Protestant, Francis Borrows, was appointed as schoolmaster to this hitherto conservative institution in 1593 by Lionel Maddison. He had been recommended by Henry Sanderson and approved by the Archbishop of York, the Bishop of Durham and the Earl of Huntingdon. When Henry Anderson regained control in 1594, he sacked Burrows and appointed a Mr Anthony, who has been described as 'a Catholic'. Bishops and the Council of the North might protest at this but Anderson had his way. The Charter of 1600 saw the school refounded and incorporated under the name of 'The Master and Scholars of the Free Grammar School of Queen Elizabeth in Newcastle-upon-Tyne' and transferred to the Virgin Mary Hospital with the offices of headmaster and master of the hospital united. The appointments of master and usher continued to be, in practice, in the hands of the mayor and burgesses though the monarch had a right of presentation; they were 'to appoint an honest learned and discreet man to be master, and another person, of a like description, to be usher in the school'. Unsurprisingly, appointments continued to be contentious.[19]

During the medieval period, the town's religious buildings had far outshone any of the secular buildings in the town save for the castle, which was of course the monarch's. The growing confidence of secular authority in Tudor times was expressed in the building of the Town House or Exchange (for the town's revenues were collected there and were kept in a large box or trunk) around 1509. It was described by the antiquary Leland as a square hall. Immediately to the east

of it stood the Maison Dieu, founded by Roger Thornton,[20] in 1412 and above it was the Merchant Adventurers' Court. The Maison Dieu remained in the hands of the Thornton family until their descendent, Sir Richard Lumley, presented it to the mayor and burgesses. Bordering or leaning against the west side of the Town House or Hall was the Town Court or Guildhall which incorporated a weigh house. Here town courts and the meetings of companies were held and banquets were given. One can imagine the mayor and Corporation feasting on Queen's Day, the anniversary of Elizabeth's succession, while outside, at the Sandhill, lesser folk were entertained by musicians and performing players or animals and enjoying the free beer, wine and food provided for them.

That the Merchant Adventurers' Company was the only company to have its own court adjacent to that of the Town Council was a physical expression of its powerful position in the town. The rise of the coal trade and the system by which Newcastle merchants controlled it led to apparent change in the civic and commercial life of Newcastle but in fact the dominant characteristic was continuity. As we have seen, there had been a challenge from the artisan mysteries or craft guilds to the oligarchic monopoly of the wealthy merchant guilds. This challenge was defeated by the support given to the merchants by central government in the form of the Star Chamber and the Privy Council. The tenacity by which an elite of merchants maintained its control of the levers of power in Newcastle is impressive. The Merchant Adventurers' Company was composed of much the same sort of men who had dominated the Merchant Gild and, when wool gave way to coal as the principal business of the town, the important members of the new Hostmen's Company were Merchant Adventurers.

The merchants who controlled the coal trade had been known as 'hostmen' since the later Middle Ages. As theirs was an export trade, they were invariably Merchant Adventurers and indeed the Company of Hostmen, whose privileges were recognised by the Charter given to the town by Queen Elizabeth in 1600, originated as a sub-group among the Merchant Adventurers. Although the Hostmen became a separate body with special privileges and a monopoly of the coal trade, the Merchant Adventurers never really surrendered control.

The elite which dominated Newcastle was not composed of all hostmen (it was in fact not difficult to become a member of this new company which did not rank among the mysteries) but just those who were also powerful merchants. After an

analysis of office-holding in the town, Roger Howell concluded that it was not the Hostmen alone but those coal traders who were also Merchant Adventurers, and particularly Mercers, who formed the inner ring. [21] The Common Council of the town was very similar in composition to the governing body of the Merchant Adventurers, while those who held the major offices of Mayor, Sheriff or Member of Parliament were nearly always not just Hostmen but Merchant Adventurers and usually Mercers:

> To be a Hostman without at the same time being a member of the Merchant Adventurers was of small avail … The inner ring which dominated the town was largely composed of the men who held membership of both companies, such as Sir George Selby, Sir Henry Anderson and Leonard Carr. [22]

The oligarchy was, however, by no means static. New men came in while established families died out, lost their wealth or transferred it into landed estates. The divide between the Newcastle elite and that of and the surrounding hinterland of Northumberland and Durham has been much exaggerated. It is true that much of Newcastle's history had been a battle to gain and preserve privileges and this had set it against the county of Northumberland and the great aristocratic families. Relations between the gentry and yeomen families of Northumberland and Durham could, however, be close and, with the decline of the northern aristocracy, it was increasingly the gentry who counted. County families needed positions for younger sons and successful merchants looked upon land and country estates as a secure investment for their mercantile wealth. In many ways the Merchant Adventurers' Company can be looked upon as a revolving door which enabled the younger sons of the gentry to become merchants and successful merchants to acquire enough wealth to become gentry. Even this latter group took time and generations before they separated their gentry status from their mercantile origins for ties of gold bound them to Newcastle.

The very nature of the coal trade made for close bonds between land and trade. Coal came from under landed estates whether or not the owners mined it directly or let out their coal seams. Many hostmen were also mine owners and relations between those on whose estates the coal was mined and those who organised its transport to London were strong. Even the Liddells of Ravensworth, who

had already embarked on the course that would lead them from trade to the peerage, were to maintain their contacts and their influence in the coal trade. Nevertheless, really new men with no discernible contact with the merchant life of the town were rare, as is pointed to by the fact that the rapid establishment of the Ellison family in the mercantile and civic life of Newcastle has been accounted a phenomenon.

Welford comments that:

> It is a noticeable circumstance that the Ellisons make their appearance in Newcastle history all of a sudden as it were. The books of the company of Merchant Adventurers of Newcastle contain entries of the apprenticeships of John and Cuthbert Ellison, dated respectively 1523 and 1524; the books of Trinity House show that in the last named year 'Sir' Robert Ellison was chaplain and John Ellison an alderman of the fraternity. Six years later, Robert Ellison occurs in the Merchants' books as entering upon his apprenticeship. Thus in the space of seven years, we have evidence of five Ellisons living in Newcastle, of whom no previous notice occurs – a chaplain, an elder brother of the Trinity House, and three young men just commencing life as merchant adventurers.[23]

Before this the Ellisons had probably been yeomen at Hawkwell near Stamfordham, a village 8 miles north-west of Newcastle, where the Elysons had a share in the fields.[24] Cuthbert's will of February 1556 reveals him to have been a man of wealth and property: houses in the Bigg Market, the Windaes, Middle Street and Gowler Rawe; land at Bamburgh; leases on farmland and mills at Heworth; and a half share in a salt-pan. Certainly by the mid-seventeenth century the family were firmly based in Newcastle.[25]

In the course of his career the first Cuthbert Ellison held the offices of Sheriff and Governor of the Merchant Adventurers and was Mayor in 1549 and 1554. He proved a stern Governor of the Merchant Adventurers as can be seen by the bye-law he issued regulating the dress and conduct of apprentices. The rowdy and bawdy behaviour of apprentices was a perennial problem in most towns and the periodic reactions of authority were sometimes warranted, but often no more than the intrinsic irritation of the middle-aged with the high spirits of the young. A further irritation may have been the airs and comparative affluence of some apprentices to Merchant Adventurers. It would appear from the preamble

to Ellison's bye-law that the behaviour of the Newcastle apprentices had given more than the usual cause for scandal:

[What] dyseng cardeng and mummying! what typling, daunseng, and brasenge of harlots; what garded cotes, jagged hose lyned with silk, and cut shoes! what use of gitternes by night! what wearynge of berds! what daggers ys by them worne crosse overthwarte their backs, that theise theire doings are more cumlye and decent for raging ruffians than seemlie for honest apprentizes.[26]

If these were Cuthbert Ellison's words, he had certainly a turn of phrase and one wonders whether he had heard John Knox preach in Newcastle five years previously. The force of his restrictions upon the dress of apprentices was somewhat modified by further rules which exempted the apprentices of the senior inhabitants, the Mayor and the Governor of the Merchant Adventurers' Company from them.

If the boisterous activities of the apprentices of the Merchant Adventurers had to be curbed what then of the ordinary inhabitants of town? How much fun and pleasure did they enjoy and what restrictions were put upon them? The members of all companies had their high days and holidays when they feasted together. The poor enjoyed civic hospitality on occasions such as the inauguration of a mayor while entertainment was provided by the jugglers, actors and dancing bears at the Sandhill and by the celebrations at Corpus Christi. No doubt, they got drunk and made the best of it when they had the money but such occasions were probably rare enough. In many ways they endured a highly regulated society and, presumably, one with many informers who told the authorities about their neighbours' transgressions, for there are numerous accounts of those presented for fornication and for adultery, for being 'scolds' or drunkards, or even witches and being sentenced to stand in church with sheet and candle, paraded with a scold's bridle, made to walk within a barrel or being 'ducked'. In 1596 the Corporation paid 4*d* 'for carrying a woman through the town for scolding with branks', a local term for a scold's bridle, a sort of iron helmet which left the face exposed but inserted a length of iron into the mouth. You had to watch your language and, for calling Elizabeth Hayning an 'arrant witch, common slut and curtailed knave' among other things, Alice Carr was ordered to purge herself of the offence in All

Saints's church.[27] It seems likely that for the most part the wealthier inhabitants of the town were immune from such accusations or penalties.

The reign of Edward VI saw a determined effort to abolish many of England's festive days and popular customs, which were seen as representing ritualism and superstition as well as conflicting with public propriety and order. Not only religious feast days like Corpus Christi but Midsummer bonfires, mummers, and George and the Dragon came under threat. After Mary came to the throne, she issued injunctions for 'the resumption of all former seasonal processions and all the old "laudable and honest ceremonies"'.[28] The accession of Elizabeth to the throne did not lead to an attack on the old customs and, along with many other towns, Newcastle continued to see performances of the Corpus Christi plays in the 1560s and 1570s with the support of the Corporation and 'the mayor laid on "a ship for dancing" at midsummer, minstrels and fools at Christmas, and troupes of actors and more musicians on other occasions'.[29] In the 1580s, however, these were discontinued and in addition the town withdrew support for Midsummer bonfires. Those who favoured a Godly society seemed determined to do away with the holidays, the sports, customs and fun which had enlivened the hard lives of the poor. Nevertheless, the appetite of Newcastle for pleasure and overindulgence was strong. The medieval Church had been unable to curb it and had allowed carnivals as a necessary release. Its Protestant successor was to find that its attempts to reform the manners and festivals of the population met with strong opposition. In the narrow margins between work, want and early death, even the poor of the town reached out for passing pleasure and in Newcastle not all the elite were in favour of denying the town its high days and holidays.

The tendency for power and wealth in Newcastle to pass into the hands of a small number of related families was assisted by several factors. These included the relative independence of the town from local aristocratic influence and the nature of its constitution, which was complex and cumbersome in its electoral process and designed to ensure continuity and the concentration of power in a few hands. Newcastle had been administratively separate from Northumberland since 1400 and had a social and economic order largely independent of aristocratic influence. As Howell has argued:

> Newcastle was not dominated by a powerful local family or even by a complex of
> local gentry families ... Those members of the local gentry who exercised influence in

Newcastle politics, like the Liddells and the Maddisons, owed their landed position in the county to their trading connections in the town rather than their town power to their local influence.[30]

The last years of Elizabeth's reign saw Newcastle's position consolidated by the granting of the 'Great Charter' of 1600 which confirmed the privileges of the town. At the same time, the Queen gave a charter to the Hostmen which recognised their monopoly over the coal trade in return for a tax of a shilling on each chaldron of coal shipped. The Hostmen were to enjoy the privilege of 'the loading and unloading of stone, coals, grindstones, rubstones, whetstones, and the loading and unloading of any ships, keels, or vessels, pit-coals and stones, within the river and harbour of Tyne, between Newcastle and Sparhawk'.[31]

The Newcastle Hostmen and the London coal merchants had inevitably opposed interests, the one wishing for the price of coal to be as high as possible, the other, at least when it came into their hands, as cheap as possible. The Queen's government skilfully sought to satisfy both parties. London merchants were appeased by a secret clause stating that the price of coal would not be allowed to rise above 10 shillings a chaldron, while the Hostmen's Company was persuaded to accept in a charter, issued two weeks after the original, a tax of one shilling on each chaldron. Thus, clauses in the charter reveal the basis of the deal, some price security for the London merchants and recognition of the privileges of the Hostmen in exchange for a tax of a shilling: this 'Richmond shilling' was to be excised for over two hundred years.

Elizabeth had been a friend to Newcastle and the town had flourished during her reign but there was little fear as to what the accession of James VI of Scotland might bring. Scotland was a Protestant nation but James was said to be tolerant of Catholics; his reign seemed likely to put an end to border conflict, and surely, like his predecessors, he would value and protect a town of such economic importance to his new kingdom.

4

NEWCASTLE 1603–1688

The early seventeenth century saw a further expansion of the coal trade and a time of growing prosperity for Newcastle. The town walls may well have seemed less essential and the fabric of the castle was allowed to fall into disrepair, yet the town's defences were to prove more necessary than ever. Its economic importance, especially to London, and proximity to Scotland were to place it in the eye of the storm as the Civil War approached. A Scottish army occupied the town in 1640 and when armed conflict between Charles I and Parliament broke out, Newcastle, which was loyal to the King, was besieged by Parliament's Scottish ally and surrendered after holding out for three months. Despite some internal dissension, Newcastle continued to prosper during the Interregnum and the Restoration found it with its trade intact and its control over the Tyne secure.

THE EYE OF THE NORTH

On the death of Elizabeth, James VI of Scotland crossed the border to claim his inheritance as King of England. The Corporation and citizens of Newcastle gave him a warm reception:

> When his Majestie drew neare to Newcastle, the Mayor, Aldermen, Counsell, and the best Commoners of the same, beside numbers of other people met him: the Mayor presenting him with the sword and keyes, with humble dutie and submission, which his Highness graciously accepting, he returned them again; giving also to his Majestie a purse full of gold.[1]

Suitably gratified by his reception in Newcastle, where he spent three days basking in adulation, James is said to have declared, 'By ma saul, they are enough to spoil a gude king!'

As was customary at the start of a reign, James gave the town a new charter. This largely underwrote the Great Charter of Queen Elizabeth but it also fine-tuned the method of electing the governing body of the town along the lines of the traditional Byzantine procedure. The result was to strengthen the position of the governing clique, which was, no doubt, intentional for James was assured of its loyalty and, like his predecessors on the throne, found it easier to work with established oligarchies, rather than with whole communities of burgesses.

It was as the centre of the coal trade that the town was increasingly known to the world and it was upon that trade that its wealth and prosperity had come to be based. Its first historian, William Gray, described at mid-century the extent of the employment it created:

> Many thousand people are employed in this trade of coales – many live by working them in the pits – many by conveying them in wagons and waines to the river Tine; many men are employed in conveying the coales in keeles from the stathes aboard the ships … this great trade hath made this towne to flourish in all trade.[2]

The rise of the coal trade, rather than diminishing other trades, enriched and expanded them. Its overwhelming importance was a relatively recent development with the shipment of coal out of the Tyne accelerating sharply from the late years of Elizabeth's reign, and its dominance overlaid a previous economic order. Coal exerted a firm but informal grip on the economy and civic life of the town. As Roger Howell, the leading authority on Newcastle during the period of the Civil War, has shown,[3] the trade affiliations of those admitted as freemen in the first sixty years of the seventeenth century seem to show a town without any dominant trade or industry with scarcely a mention of the coal trade. The clothing trades had the greater share of admissions of members in the early decades, giving way to the maritime trades towards mid-century, yet no trade gained more than 30 per cent of admissions. But, as Howell has demonstrated, this is misleading in that the dominant trade, the coal trade, is not overtly represented in these lists but is there, nevertheless, because the hostmen, who dealt with the export of coal,

were generally also members of another company, the most important hostmen usually being members of the Mercers' Company. The coal trade was both ubiquitous and yet inseparable from other trades because, as a newcomer, it had to fit in with and work within an existing economic and political order, while, as it was a risky trade, it was unwise to be solely dependent upon it. Real power in Newcastle continued to lie with those hostmen who belonged to one of the three companies or mysteries who made up the Merchant Adventurers' Company.

One man's monopoly is, no doubt, another's co-operative enterprise and both terms could be used to describe the merchant guilds of Newcastle and, indeed, the town itself. The town's history was, indeed, in large part that of layers of monopolistic influence and power. In the first place there was Newcastle's claim to control all trades into and out of the Tyne; on this all citizens of Newcastle could unite. Then there was the distinction within Newcastle between the rights of the burgesses and freemen, largely synonymous groups, as opposed to other inhabitants; freemen seem to have made up about a third of the male population and, as we have seen, it had become the norm that only members of companies were free burgesses. If all companies had privileges and especially the twelve leading companies or mysteries, which provided the members of the Common Council, then the merchant companies, which fiercely preserved their sole right to trade against the craft guilds and which generally occupied the top positions in civic government, were by far the best situated. As has been noted, however, even the Newcastle Merchant Adventurers had themselves to bend the knee and make payments, not only to kings and central government, but, in the sixteenth and seventeenth centuries, to the London Company of Merchant Adventurers, as did some lesser Newcastle companies, such as the Silversmiths, who had to recognise the superior authority of the London Silversmiths.

An inner circle of power will, however, always face problems and threats to its position: divisions within the inner circle, jealousy from the outer circle and the ambitions of those without. But within Newcastle, opponents of those in power had to be very careful that their opposition was not made use of by those who were enemies to the position of the town itself. Few in Newcastle would have wanted to see the town's control of the river and the coal trade brought to an end.

Under the rule of James I, Newcastle was largely left to mind its business, which was business, provided the royal interest was safeguarded. A great

spendthrift, James was wise enough to accept that Parliament would not countenance increases in taxation. One answer was the sale of honours; peerages, knighthoods and, a new invention, baronetcies, multiplied. Newcastle gained its share of knights (Sir Peter Riddell, Sir George Selby, Sir Robert Dudley and others) whose status was elevated even as their pockets were lightened. As for religion, the King soon established that he was a firm Protestant but, even after the Gunpowder Plot, one who was prepared to accept that Catholics could be loyal subjects if they openly declared their allegiance to him.

The first decades of the seventeenth century were prosperous and peaceful years for Newcastle. Threats from Scotland seemed a thing of the past, border reiving was being suppressed and at nearby Denton the Erringtons were so bold as to build an unfortified manor house, while at Belsay and even Chipchase in the wild North Tyne, gentry families tacked on comfortable mansions to their tower houses. The coal trade flourished. The London market remained the most lucrative trade but coal opened up numerous links along the east coast. The 'sea-cole' fleet was said 'to number about 400 vessels, one half of which supplied London and the remainder the rest of the South and East Coast ports'.[4] The international trade was also considerable with whole fleets of French and Dutch ships descending on the Tyne and loading up with coal despite the high customs duties imposed upon exported coal. Ancillary industries were stimulated by coal: salt produced by salt pans fuelled by small coal, not worth exporting, had been developing since the fifteenth century but an innovation was glass making, introduced by French Huguenots from Lorraine at the mouth of the Ouseburn.

Ships had been built on the Tyne for many centuries but Tyneside was not a major shipbuilding centre. One reason may have been that Newcastle, far up the river, was not the ideal place to build ships but the town's shipwrights were determined to prevent the development of shipbuilding in the other riverside towns. The Newcastle Guild of Shipwrights was one of the town's minor guilds among the twenty-one craft associations and the fact that it had its miracle play, appropriately 'Noah's Ark', demonstrates that it must have been extant in the later medieval period. It was not until 1604, however, that, along with fourteen other by-trades, it was admitted to a share in the government of the town and acquired full guild status. It thus gained the right to all shipbuilding and ship-repairing work on the whole river. Though ten ships big enough to act as naval auxiliaries

in time of war were built at Newcastle in the early seventeenth century the main work of the shipwrights was probably repair work for most of the century. The company not only faced the task of preventing non-members from practising the craft but also the problem of what to do about members who moved to another riverside town like South Shields.

Despite the squalid overcrowding of many of the chares that led from the quayside, the visitor Sir William Brereton could describe Newcastle as in 1635 'the fairest and richest town in England, inferior for wealth and building to no city save London and Bristol'.[5] In a time of peace and prosperity, there was some modest expansion beyond the town walls. Speed's map of 1610 shows some houses outside Newgate and Westgate but none outside the Sandgate, but William Grey at mid-century wrote that, 'Without Sand Gate is many houses and populous all along the waterside; where shipwrights, seamen and keelmen most live, that are imployed about ships and keels.'[6] The plague of 1636 is said to have killed some 5,000 which seems incredible as this would have halved the population. A recent study has, however, estimated that 5,600 died in all and that, in proportionate terms, 'the Newcastle epidemic of 1636 may have been the most devastating culling experienced by any English city in this period'.[7] There were, however, plenty of healthy immigrants attracted from surrounding rural areas and from Scotland, many of the latter settling in Sandgate and working as keelmen, which enabled the town to recover rapidly and increase its population to around 12,500 in 1665.

The life of the town was not radically different from that at the beginning of the sixteenth century. There were fewer holidays as the celebration of many Saints' Days was discontinued after the Henrician Reformation but changes came slowly. Corpus Christi remained the town's great day and, if some secular plays began to replace the religious mystery plays, many of the latter continued to be performed into the early seventeenth century. The town's markets continued to provide noise, bustle and entertainment, while the two annual fairs held at the Flesh Market at Lammastide and St Luke's Day were great occasions in the life of the town. A further fair was held outside the town at Cow Hill and was attended by horse and cattle dealers from all over the north. Musicians and companies of itinerant actors were frequent visitors to the town on its high days and holidays.

The poor of the town, which included most who were not freemen or of freemen's families, would have been very dependent on the largesse of food, ale and entertainment provided for them by the richer burgesses on special occasions such as the inauguration of a mayor. Bread was the staff of life for the majority, as was the case all over Europe, and it was usually rye bread but fish was cheap enough and cheese was also in the reach of the poor. The town's festivals were probably the only time that meat came their way. Ale was a necessity as well as a source of pleasure; it was drunk from breakfast to supper and at work. As the eighteenth-century poet John Cunningham was to put it:

> Your spirits it raises,
> It cures your diseases –
> There's freedom and health in our Newcastle beer.

Fashion in clothing must have changed for it was found necessary to bring in new rules for the apprentices of merchants:

> Their apparel of cloth to be under ten shillings a yard, or of fustian, of under three shillings per yard. They are not to wear any velvat or lace on their apparel, neither any silk garters, silk or velvat girdles, silke points, worsted or jersey stockings, shoe strings of silke, pumpes, pantoffles, or corke shoues, hats lined with velvat, nor double cypress hat-bands, or silke strings, nor clokes and daggers; neither any ruffled bands, but falling bands' plaine without laice, stiche, or any kind of sowen work; neither shall they weare thaire hairs longe, nor locks at their ears, like ruffians.[8]

As they were also forbidden to play dice, dance, mum, or use any music by day or night in the streets, the merchant apprentice would, if he had obeyed the rules, have been destined to be a dull dog. Probably most disobeyed or bent the rules and much would depend on the strictness or Puritanism of the master or, if by chance someone complained, whether penalties were incurred.

That the apparent tranquillity of the town concealed a degree of unrest with its governors, which could boil over into riot when mayor and Corporation ignored traditional and customary rights or appeared to be corrupt, is shown by the events of 1633. The townspeople had three main recreation areas: the Forth, Shieldfield

and the Ballast Hills. The latter had been created over many years by the ballast of earth, sand and stones brought by ships coming to Newcastle with little or no cargo prior to taking on coal. They were used for the drying of washing but also presented pleasant walks much frequented on Sundays and holidays. The erection of a lime kiln was felt to spoil this public amenity and on Shrove Tuesday a group of apprentices pulled it down. These apprentices were arrested but their friends closed the Sandgate in an attempt to prevent their captors bringing them into the town and then, when they had been imprisoned, released them. By this time, a disturbance had grown into a riot and the house of Christopher Reasley, the owner of the lime kiln, was attacked with pikes and halberds. The attempts of the mayor and justices to put down these riotous proceedings were hampered by the fact that many of the burgesses clearly supported the actions of the apprentices.

It is clear that the Shrovetide riot was about more than a lime kiln and that there was widespread dissatisfaction with the town's government. Concurrently with the riots, a petition from the ordinary burgesses was sent to the Secretary of State complaining of, among other things, corruption in terms of misappropriation of money and sale of offices, attenuation of meetings of the common council and lack of representation of ordinary burgesses on the council. Charles I passed through Newcastle two months later on his way to be crowned in Scotland, enjoying the hospitality of the city fathers, but as he left the town four burgesses followed him and presented their petition to him. Little came of this but the whole affair does suggest discontent with a close-knit elite that had become too comfortable in its enjoyment of power.

For the majority of the inhabitants of the town, there was a combination of greater licence and more draconian penalties if one was informed upon than those which threatened apprentices to the elite companies. It is hard to escape the conclusion that Newcastle, like other towns of the period, had plenty of citizens of all ranks who were drunken, violent, adulterous and given to fornication. Probably popular attitudes usually determined the limits of behaviour. At the same time the laws which theoretically governed behaviour were strict and penalties for transgression were severe. This must have made things easy for informers, whether inspired by religious enthusiasm, personal animosity or jealousy. A creeping Puritanism may have led to a greater number being forced to stand in church, clad in white sheets and holding a candle in one hand, as

penance for adultery or fornication, though whether those ducked, made to wear a scold's bridle ('branks') or a drunkard's barrel increased as opposed to earlier times is uncertain. No doubt the crowds enjoyed such public humiliations of their fellows but not so much as they enjoyed a good execution. What was new was the number arraigned and punished for witchcraft. It is a paradox that Puritanism, born of the belief that the literate individual could found his faith on the Bible without the leadership of priests, should have inaugurated the witch-hunts of the seventeenth century. In 1649, a Scottish witch-finder had thirty women he accused of witchcraft brought to the Town Hall and stripped before having pins thrust into their sides; most were found guilty. He was, eventually, exposed as a bounty hunter, who confessed to having been the cause of the death of some 220 women in Scotland and England for the gain of a pound per head.

Religious antagonism bubbled under the surface but was given little encouragement by the King. The Newcastle elite remained, in general, conservative in religious matters though moving gently with a Protestant tide. The increasing Scottish population, drawn to Newcastle by the opportunities of employment as keelmen or colliers in the pits that surrounded Newcastle, brought with it a degree of stern Presbyterianism. Some members of established families moved towards a more extreme Protestant outlook. Robert Jennison, the nephew of the closet Catholic William Jennison, who was successively sheriff, mayor and MP, became a lecturer and then a vicar, desired to create a godly town. On the other hand, a petition read in the House of Lords in 1624 referred to prominent Newcastle citizens who were either open recusants or suspected 'of ill affection to religion'; among them were William Jennison, Sir Thomas Riddell and Sir William Selby, all commissioners of the peace. Riddell had in the previous year been revealed as the proposed recipient of a trunk, intercepted at Dover, containing beads, letters, pictures and prohibited Jesuitical publications.[9] It was not possible for men holding office to openly proclaim their recusancy but it was quite common for the wives and other members of their family to be less discreet; thus Riddell's wife and eldest son were openly Catholic. In 1616, the Archdeacon of Durham reported that 'popery flourishes' in Newcastle and provided the names of nine Catholic ladies married to principal men of Newcastle and Gateshead.[10] Two individuals in the neighbourhood of Newcastle openly flaunted their Catholicism, Sir Robert Hodgson of Hebburn and Mrs Dorothy Lawson of St Anthony's. In

1625, Bishop Neile told the mayor that these two were dangerous neighbours and were in constant touch with each other from their opposite positions on the banks of the Tyne; no action was taken by the mayor, who found nothing more sinister save that they both had boats. The indomitable Dorothy Lawson certainly put the toleration of the authorities to the test, emblazoning the end of her house with 'Jesus' so that it might be seen by mariners, keeping a chapel and having each room in the house dedicated to a saint. Despite many allegations against them for harbouring seminary priests, the civic authorities seem to have protected Sir Robert Hodgson and Mrs Lawson and the latter's funeral was a grand public affair with large crowds, including magistrates and aldermen, respectfully attending at the quayside, where her coffin arrived by barge, and accompanying it to the church door where it was delivered to a Catholic priest. Such toleration would, as S. Middlebrook comments, 'have been impossible in a Puritan stronghold'.[11]

Newcastle was not a Puritan town, though it had a sizeable minority of that persuasion, but nor was it by this time a Catholic town, though several leading citizens retained that faith. The majority of the elite seem to have been dutiful members of the established Church, not disinclined to some ritual and colour in church services, suspicious of Calvinism, happy enough with the moderate approach of James I and content with what became known as Arminianism, the anti-Calvinist theology which stressed free will, episcopal authority, and a more Catholic – but not Roman Catholic – approach to worship and submission to royal authority. Undoubtedly a minority Puritan faction strongly resented Charles I's more purposeful religious policies but what the religious disposition of the majority of inhabitants of Newcastle was we do not know, nor whether religion was very important to them.

The moderate Anglicanism of the Newcastle establishment was unusual in merchant communities on the east coast of England. The combination of the assertion of royal authority, increased taxation, the King's support for Arminian bishops along with his marriage to a Catholic princess were the major factors in the dissension that was to lead to civil war, though it was troubles in the other kingdoms of Scotland and Ireland that were the catalyst. The internecine conflict known as the Civil War or the Great Rebellion was to alter the situation and give an opportunity to wealthy and ambitious men, Merchant Adventurers but outside the inner ring.

NEWCASTLE & THE CIVIL WAR

Historians have, of late, become sceptical as to the accuracy of the term 'English Civil War', arguing that 'English' does scant justice to the Scottish and Irish dimensions of events and that, within England, much account needs to be taken of provincial and county issues.[12] What occurred, it has been argued, was, 'military failure and collapse in the face of a Scots rebellion and invasion'.[13] Such revisionism also rejects explanations which see the war as either about clear-cut constitutional divisions or as a social conflict between specific classes or strata.

Newcastle may well have considered that it could relax and no longer have to fulfil its role as a border fortress after the accession of James I and the Union of the Crowns. There seemed no real need to keep the castle and the town walls in good repair. By the late 1630s, however, relations between Charles I and his Scottish subjects were increasingly strained. The King's attempt to impose the new Anglican prayer book in Scotland antagonised Calvinists and resulted in many thousands signing a National Covenant.

The town's walls had for centuries provided a formidable defence against attack; indeed the town had only been besieged once, by King David in 1342, and that had been a failure. John Leland on a visit to Newcastle in the reign of Henry VIII had stated that 'the strength and magnificence of the walling of this town far surpassed all the walls of the cities of England, and most of the towns of Europe'.[14] By 1640, however, they were in a sad state:

> Since the Flodden campaign of 1513, the town had not been threatened with attack again. The townsfolk ceased to repair the walls, and many sections began to crumble. Houses were built against the wall and the towers were occupied as meeting places by the trade guilds. Newgate was turned into a prison and the other gates went unrepaired despite regular damage from carts entering the town. By 1640 the castle was no longer in a defensible condition.[15]

Newcastle felt the full force of Scotland's involvement in the Civil War, being occupied by General Alexander Leslie's army in 1640–41 and then besieged and taken in 1644. In 1640 King Charles's attempted invasion of Scotland was countered when a Scottish army invaded England and, after his small army was

81

defeated at the Battle of Newburn Ford, Lord Conway, who had been sent to Newcastle to supervise the defences, abandoned the town as General Leslie's forces advanced on it. The town surrendered, leaving its new defences untried. A Puritan, Robert Bewick, became mayor and welcomed the Scots into the city; they stayed for a year.

General Leslie's occupation of the town hardened its traditional antipathy to the Scots and made the majority of the inhabitants look with suspicion upon Scots living in the town. Even the Puritan and Parliamentary faction which had at first welcomed Leslie and his army soon reconsidered its sympathies. Although Leslie forbade looting and made his soldiers pay for goods, his men were allowed to pillage unoccupied houses and the cavalry commandeered fodder for their horses, while he extracted £200 a day from the Corporation for the cost of billeting his troops and, when he and his army eventually left in August 1641, he demanded a loan of £40,000.

Within three years, however, the Scots were to be back with their army again led by General Leslie. If the town had surrendered easily in 1640, 1644 was to be Newcastle's finest hour. As the King made his final split with Parliament, the town declared for the Royalist cause. Well aware of Newcastle's strategic importance, Charles had already garrisoned the town. So long as the Marquis of Newcastle's army was successful in the North, Newcastle was safe but with the defeat of the Royalists at Marston Moor on 2 July, the town was isolated as the Earl of Callander's 10,000-strong Scottish army appeared before it, soon to be reinforced by 20,000 men under Leslie, now Earl of Leven. With only 800 of the town's trained band and 900 volunteers, Newcastle led by the mayor, Sir John Marley, put up a ferocious resistance. Marley had already made haste to have the castle and the town walls repaired and reinforced, while he had two forts constructed outside the walls at Shieldfield and Sandgate and a battery built on the Quayside.

The Scots had been predicting the fall of Newcastle since February 1644 and the town had been surrounded since early August but it did not surrender until 22 October 1645. 'The 1,500 defenders of the town tied up an army of 20,000 men for ten weeks of full siege, and the Scots paid a high price in lives lost and resources expended.'[16] At the Restoration the town was given the motto *Fortiter Defendendo Triumphat* – 'She glories in her brave defence' – though C.J. Bates

complained that this was later modified to *Fortiter Defendit Triumphans*.[17] Most historians of Newcastle have seen the town as predominantly Royalist and acclaimed the doughty resolve in defending it. S. Middlebrook considered that:

> With an Anglican and Romanist preponderance that was unique in the bigger towns of the seventeenth century, the people of Newcastle would in any case have been out of sympathy with the Roundheads. The antipathy to Puritanism, however, was intensified by the border tradition of hostility to the Scots, so unexpectedly revived and envenomed by General Leslie's occupation of the town in August 1640.[18]

A contrary view is taken by Roger Howell, who argues for a strong vein of Puritan and Parliamentary support in the town.[19] But it is difficult to see how the besieged could have maintained their sturdy defence with a powerful, dissident fifth column in their midst. Perhaps it was fortunate that the suburb of Sandgate, where many keelmen were Scots or of Scottish extraction, was without the walls[20] and indeed it was a 'false rebellious Scot', John Osbourn, who employed colliers to undermine the walls at White Fryer Tower and Sandgate and allowed the Scottish army to enter the town in the end.[21] That there were Puritan factions in Newcastle is of course the case, that their hour had come after the Scottish victory is obvious, but that they ever formed a majority seems very unlikely. The majority were forced to adapt to the new circumstances and had to wait until the Restoration to demonstrate their allegiance again. We do, however, have to remember that the siege was by the Scots, who were much disliked in Newcastle, even though, or because, many had moved to the town since the Union of the Crowns. Where Howell is correct is in claiming that if national politics or even religious affiliation were all important to a minority, for the majority they were secondary to the earning of livings and the making of money.

Newcastle remained in the eye of the storm of the Civil War when, after King Charles gave himself up to the Scots at Newark in May 1646, he was brought as a prisoner to Newcastle and lodged at the town's largest mansion built on the site of the old Franciscan friary and called Greyfriars, the Newe House or Anderson Place at different times. His nine months of captivity there were comfortable and he was able to play golf at Shieldfield. He still had limited options: to accede to Parliament's demands, to come to an accommodation

with the Scots, or to escape. He attempted to escape on at least two occasions, turned down Parliament's demands and refused to promise the Scots to accept Presbyterianism as the dominant religion in England. Eventually, the Scots accepted £400,000 from Parliament for the King and delivered him over to the Parliamentary Commissioners once the first instalment of £200,000 had arrived in Newcastle in a train of wagons. Thus, Charles departed from Newcastle; two years later he would be executed.

With the fortunes of war and the twists of national politics, factions in Newcastle had their hour and rose and fell. National political and religious affiliations loosely but sometimes inexactly paralleled struggles for power and position within the town with the victory of Parliament over the King enabling an attempt to usurp the position of the existing elite by those who were just outside it. What did correspond – albeit imperfectly, for there were some Puritans within the old inner circle – to factions in Newcastle was religion, and the new oligarchy, which took over in 1645, was a Puritan one. Those disenfranchised for their Royalism in 1645 – men like Sir John Marley, Sir George Baker, Sir Nicholas Cole, Sir James Liddell and Sir Ralph Bowes – were overwhelmingly hostmen, mercers and, from a Puritan viewpoint, delinquents. The new men who took over were headed by Henry Dawson and included Thomas Bonner and William Johnson; all were merchants, but outside the inner ring, and Puritans, and they co-operated with more established Newcastle figures such as John Blakiston, Henry Warmouth and Sir Lionel Maddison, who were associated with the Parliamentary and Puritan cause.

But, despite war and religion, life goes on. The town recovered surprisingly rapidly from the dark period when, during the first Scottish occupation and then the siege of the town, the coal trade, the key to prosperity, had been sadly interrupted. The attitude to the Civil War among the majority of Newcastle burgesses and the wider body of inhabitants was that it was a terrible disruption to their innocent pursuit of wealth and the making of livings. Yet, it also provided opportunities:

> More often than not … the bulk of the population shifted and turned in their loyalties as the military situation demanded and … used the political troubles of the time to work out local rivalries.[22]

Among those who prospered in these 'interesting times' was the head of the Ellison family, Robert Ellison (1614–1678). He had by 1643 become a supporter of the Parliamentary cause and was forced to leave Newcastle. A Resolution of the Common Council of September 1643 declared that:

> Whereas out of disaffection to his majesty and the present government Robert Ellison merchant [and others] have withdrawn themselves and most part of their estates, out of Newcastle and have refused to hold with our sovereign lord the king against all persons, to live and die according to the oath they took when they were made free burgesses and have been incendiaries and have treated with men of another nation to invade their kingdom and possess themselves of this town – ordered that they be disenfranchised.[23]

He played a prominent role after the town's capture by the Scots when there was a purge of Marley[24] and other Royalists.

In December 1644 the House of Commons passed a series of resolutions affecting Newcastle. The Mayor, Sheriff, Recorder, Collector of Customs, and several aldermen were dismissed; the duties of the Sheriff, the Royalist James Cole, were to be taken over by Robert Ellison. At the same time a committee of fourteen was appointed to sequestrate the estates of 'delinquents' and Robert Ellison was a member. In May 1645 the Commons issued further orders, confirming the dismissal of delinquents from office and castigating the 'malignant and wicked party, ill-affected to the King and Parliament, and the true Protestant religion'. Henry Lawson, Henry Dawson, Thomas Legard, John Cosin and Thomas Bonner were made aldermen and Ellison was made sheriff. By June Ellison was, along with the Town Clerk, issuing decrees concerning the management of the coal mines belonging to delinquents. He was in a powerful position for his brief was a wide one and he was entitled to make decisions in the light of 'the best management of the State'.[25]

Robert Ellison, despite his high standing in the eyes of Parliament, was not a member of the Puritan faction led by Henry Dawson and, unlike most of that clique, he can't be seen as an outsider to the old oligarchy as were the Dawsons, Bonners and Johnsons. Ellison was both a hostman and a mercer while he was related to the Selby family and to the Carrs of Newcastle, who were influential in the inner ring. His position was unusual and in the long run advantageous for he seems to have retained

the confidence of much of the old elite as the best custodian of their interests in unpropitious times and to have been less identified with the Puritan faction than other established figures like Warmouth and Maddison. At the same time, as a Parliamentarian, he was in a position to benefit from the turmoil of the times.

His differences with the Puritan faction can be seen in the Parliamentary election of 1647 when he and Henry Warmouth contested the seat left vacant by the removal of Sir Henry Anderson, a moderate reformer opposed to royal policies when elected in 1640, but who had later rallied to the King's forces. A new member for Newcastle was therefore required to join the remaining sitting member, John Blackiston, soon to gain notoriety as a regicide. Both Warmouth and Ellison were strong Parliamentarians and the fierceness of the election contest points to the rivalry of factions based on internal Newcastle interests and issues being at least as important as national politics. Warmouth was supported by such leading members of the Puritan faction as Henry and George Dawson and Thomas Bonner, while among Ellison's backers were Robert Carr and Robert Anderson who belonged to well-established Newcastle families. Although Warmouth was the son of a mayor and was himself an alderman and former sheriff, Ellison had the closer connections with the old oligarchy and in the election we can perhaps see the hostmen-mercer establishment backing a moderate Parliamentarian as the best bet to keep the temporarily dominant new men of the extreme Puritan faction at bay.

Some 700 freemen turned out to vote and the mayor, Henry Dawson, together with the sheriff and most of the aldermen, considered that Warmouth was the winner. That judgement was fiercely denied by Ellison's supporters and, although Warmouth was temporarily allowed to take his seat, a House of Commons committee eventually decided that his election was illegal. Ellison won the subsequent contest against a new opponent, Thomas Ledgard, a prominent member of the Dawson circle. Despite further objections on the grounds of unfair practices, Robert Ellison's election was allowed to stand.[26]

Essentially a moderate Parliamentarian, who supported reconciliation with the King, Robert Ellison was among those MPs who were forcibly excluded from the Commons by Colonel Pride on 6 December 1648. Unlike his fellow MP for Newcastle, Blakiston, a regicide, he thus bore no responsibility for the king's death and was indeed opposed to it.

The election dispute reveals that there were factions within the ranks of the Parliamentary supporters but this did not rule out co-operation on a number of fronts. There was much to play for. Political power and personal economic advantage have rarely, if ever, been entirely separate and seventeenth-century mores took a realistic view of their connection. Royalists, now dispossessed of their political positions, could expect to pay a price in terms of sequestrations while, conversely, the new men installed in political office could hope to improve their political fortunes.

Local committees were set up to sequestrate the estates of those who had espoused the Royalist cause and were in the terminology of the time 'delinquents'. This was of course a national issue but very important in a region where Royalism was strong and had made its mark with the stout defence of Newcastle in 1644 and where there were perpetual rumours and fears of Royalist plotting. But, as ever, local rivalries and ties complicated the issues. On Newcastle's committee sat men like John Blakiston, all three Dawsons (Henry, George and William), Thomas Bonner and Thomas Ledgard. This was not a body likely to deal lightly with men who were not only Royalists but members of the Newcastle establishment that the sequestrators dearly wished to replace. Yet, although the committee could be harsh enough and one of its victims, Sir Thomas Riddell, was only cleared of his delinquency on payment of £4,000, the control of the chief delinquents, such as Sir Thomas Liddell, Sir Francis Anderson, and even Sir Thomas Riddell and Marley himself, over the key to power and wealth on Tyneside, the coal trade, was left largely intact.

Among the reasons for this was the great difficulty in establishing, amid the complex pattern of ownership and occupation of estates and mines on Tyneside, who exactly owned what. Then there was the fact that many families had members on both sides of the political-cum-religious divide and, when it came to family as opposed to ideological interests, family loyalties often won out and relatives would be protected and estates and assets transferred to other parties. Above all, it was important to protect the coal trade and Newcastle's domination of it; the existing owners had the wealth and experience to run it.

The town was less its own master during the Interregnum than previously, for Parliament, the army and then Cromwell exercised greater centralist authority than Charles at the height of his powers. There were governors of the town,

Robert Lilburn and then Sir Arthur Hazelrigg. The coal trade soon recovered, however, and one sign of this recovered prosperity was the building of a new guildhall in the 1650s.

The *architect* was Robert Trollope, the first northern builder to be known by that dignified term. Little is known about him, save that he was born in York, but the buildings attributed to him, which include grand country houses, Capheaton Hall and Callaly Castle, reveal an accomplished architect who borrowed eclectically from the emergent classicism that was just beginning to find followers in England. Built in a mixture of Gothic and Classical styles, the Town Court, a long hall, had towers at each end and stood over the Exchange and Weigh House which had an open arcade to the north. The building was linked to the existing Maison Dieu with the Merchant Adventurers' Hall above it by an elaborate entrance to the north from which a double flight of stairs led to a common landing.

Despite this evidence of prosperity and civic pride, there were threats to the position of Newcastle and its merchant elite during this period. The Council of Trade, set up in 1650, was perceived by the Merchant Adventurers of York, Hull, Newcastle and Leeds as London-dominated and as challenging the privileges of northern towns. The northern Merchant Adventurers were therefore concerned to petition for the same protection as Londoners for their trades, for the right of non-Londoners to join the Greenland and Muscovy Companies, and for the regulation and enforcement of apprenticeships. Their opinion was that 'Trade bee not left loose but may be regulated by companies'.

The Newcastle Merchant Adventurers and the town as a whole were, as usual, fighting on two fronts in this period: against the engrossing of London and against the challenge from other interests on the Tyne; a report of the Council of 26 September 1651 condemned Newcastle Corporation's assertion of its privileges over navigation in the river so that it could extort dues from shipping and its harassment of craftsmen at North Shields. The Navigation Act of 1651 posed new problems, hindering imports from Holland and making Newcastle merchants pay high prices for colonial and staple goods at London.[27]

Perhaps the most serious threat was to Newcastle's right to control of the entire navigable river and its trade from Sparhawk at the mouth of the river to Hedwin Streams well above Newcastle.[28] This right rested upon the charter given to the

town by King John and confirmed by successive monarchs for over 400 years. The first challenge came from a shipwright in North Shields, Thomas Cliffe. His right to work at his trade was challenged by the Newcastle Company of Shipwrights when he was involved in saving a ship that had run aground on the notorious rocks, the Black Middens, at the mouth of the Tyne. Cliffe and his men got the ship off the rocks and brought her to North Shields, where they beached her and began repairs. A number of carpenters from Newcastle, accompanied by two sergeants of the town, arrested Cliffe and his men and then set about Cliffe's wife when she protested, beating her so badly that she later died from the blows. Imprisoned, fined and forced to promise never to work as a shipwright on the Tyne again, Cliffe nevertheless continued to work and complain about the injustice of Newcastle's monopoly and found support among sea captains, many of whom would have preferred to berth at North or South Shields and have their ships repaired at these ports. This support enabled him to embark upon legal action against Newcastle's monopoly. The case dragged on for several years and through several courts and, though Cliffe had to give up in the end, the cause of North Shields was taken up by Ralph Gardner. He came from Chirton, a village close to Shields, and was a coal shipper and brewer who fought a long legal battle against the monopolies of Newcastle. He was imprisoned in the castle for the sale of his beer against the rights of the burgesses. He escaped in 1653 and took his case to London, where he petitioned Parliament. His case seemed to be reaching the point of acceptance when Cromwell dissolved the Rump Parliament. In 1655 he published *England's Grievance Discovered* which recounted his struggle against Newcastle's control over the Tyne. Ambrose Barnes, a Newcastle alderman and member of the town's Puritan faction, dismissed Gardner as one 'who writ a malicious invective against the government of Newcastle'[29] while the eighteenth-century historian the Reverend Henry Bourne showed himself a true Newcastle patriot when he wrote, 'He was a bitter Enemy to this town, and did all the Mischief to it that lay in his Power, as appears in every Page of his Book. In which there are Numbers of Falsities'.[30]

Those who opposed Newcastle's monopolies could always rely upon ships' masters and London coal merchants to support them but the merchants and burgesses of Newcastle forgot their internecine quarrels and closed ranks when the town's position was in danger. Even the powerful Sir Henry Vane did not get

his way over his ballast shore which was destroyed on the orders of Newcastle. John Blakiston proved a doughty defender of Newcastle's interests at Westminster. In general the Puritan merchants who were dominant in Newcastle during the Commonwealth 'proved as uncompromising in their opposition to genuine reformers and as staunchly defensive of the charter rights and independence of the town as any of the older oligarchs they had for the moment displaced'.[31]

These troubled times were not favourable to allowing the all-important coal trade to fall into inexperienced hands. New men did not therefore take over the trade, though the Dawson clique seem to have attempted to do so, becoming hostmen and making determined efforts to gain control. The records of the Hostmen's Company show, however, that the main trade stayed in established hands. Some new men with political clout did get in but only to the fringes of the trade. Thomas Bonner acquired the ballast shores at St Anthony's and Byker and was able to exploit their leases while Robert Ellison did the same thing at Hebburn. The two acted together in impropriating the tithes of Jarrow church.

Bourne in his *History of Newcastle* relates:

> But after the death of King Charles I, Thomas Bonner and Robert Ellison got in to be magistrates; and these men having gotten wealth and increase by the Rebellion, did purchase Jarrow; and what could not be done before in a lawful time, they did bring to pass in this unlawful juncture, building a shore and casting ballast, to the great detriment of the River. And having the Town at Command, Mr Bonner bought St. Anthony's, and Robert Ellison bought Hebburn, and there they both built shores, and got the allowance of the Common Council when they were beyond resisting: and since that Mr Carr [Ralph Carr of Cocken], a man that deserved well of his present Majesty [Charles II], and the Town hath procured that his brother Ellison (for old Ellison's son married his sister) should have liberty to erect his shore to a great length, and which in time will utterly overthrow our navigation, for they will dam out the indraught which makes rivers far off the Sea to be walled out; it will go by and not come in: and some Ancient and discreet mariners of ships have said they have not left a berth to save our ships in, when any land-flood or storm happens in the River.[32]

Robert Ellison's acquisition of the Hebburn estate together with Hebburn Hall was an important step in the rise of the Ellison family. After four generations as

Newcastle merchants, the Ellisons could now be said to have acquired a sort of gentry status although the bulk of their income came from trade. Hebburn Hall was to be the family seat until the nineteenth century and it still remains in the ownership of the Carr-Ellison family. According to Mackenzie and Ross, 'the old mansion house at Hebburn was strongly built, as if for defence, like the Border towers'.[33] It had previously belonged to the fiercely Catholic Hodgson family, which had in its chief branch terminated in an heiress, who had married Francis Carr of Cocken, who sold the estate to Robert Ellison. Francis Carr was later to sell the Cocken estate to Sir Ralph Carr of the long-established Newcastle merchant family, who was to be MP for Newcastle in the seventies and eighties and whose sister, Jane, married Robert Ellison's son, Cuthbert.

There was probably no more corruption and unscrupulous self-advancement under the Puritan Corporation than under the old oligarchy, though corruption can be more glaring when the men involved make much of their religiosity and high-mindedness. Affairs were on the whole carried out efficiently and conscientiously and the interests of the town protected but the leading Puritans undoubtedly enriched themselves during the Interregnum. William Johnson, mayor of Newcastle in 1653–54, bought an estate and substantial mansion at Kibblesworth and Thomas and William Bonner also acquired land there.

There was, indeed, little alternative to the sort of regime that ruled Newcastle in these years. Whether it was popular is another matter. But if the fortunes of the Puritan faction were at their zenith in the mid-1650s, a reckoning was to come with the Restoration. Newcastle had sent a loyal address to Oliver Cromwell in 1654 and then condolences to Richard Cromwell on news of his father's death in 1658. As late as 1659 petitions to Parliament, which was then considering a bill for the better government of the town, still protested loyalty to the Commonwealth. Royalist feeling was, however, increasingly evident in the autumn of 1659 and the position of the Puritan faction was becoming uncomfortable.

Thomas Bonner had just been elected mayor for the third time. He and the Dawsons had for some years managed mayoral elections so as to keep the office within their circle, but this year the times were changing: Commonwealth generals rushed hither and thither (both Monck and Lambert were to be at Newcastle during the winter) and emissaries were crossing to the king in Holland, while, in Newcastle, Marley was back. That pillar of Puritan rectitude,

Ambrose Barnes, saw the way things were going and resigned his position as alderman in September. Bonner, the 'miracle of the age', as Barnes had called him, had resigned the lucrative position of steward of the manor and lordship of Gateshead and Whickham a few days earlier. A hagiographical biographer of Ambrose Barnes described the sorry scene when Bonner was attacked:

> The worthy Mayor of Newcastle making scruple to surrender the staff to Sir John Marlow [*sic*], who was thought a fit person to succeed him, was so pusht and bruized in the Spittal, that he was caryed out in his chair half dead, such was the violence of the faction.[34]

Robert Ellison was in a more advantageous position. He was able to return to Parliament when, under General Monck's protection, the excluded MPs of 1648 took their seats once more in February 1660. He went on to serve in the Convention Parliament (April–December 1660), which resolved in favour of government by King, Lords and Commons and agreed to the King's unconditional return. As one of those who had assisted in the peaceful restoration of the monarchy, Ellison's position was fairly secure.

With the proclamation of the King in June 1660, the population of Newcastle, which had so roundly cursed Sir John Marley for bringing the Scots upon the town, sought credit for having been continuously, if often discreetly, loyal to the Royalist cause and the stout defence against the Scots became a proud boast. Not surprisingly, back came the old guard of aldermen, Sir James Clavering, Sir Francis Liddell, Henry Maddison and Cuthbert Carr, and out went the new, George Dawson, Christopher Nicholson, Henry Rawling, William Johnson and Peter Sanderson.[35]

All in all, it was a pretty modest reckoning, as indeed the penalties paid by the Royalists previously had been modest enough. John Blackiston, the regicide MP, was dead but his wife forfeited her estate. Otherwise most of the men who had governed Newcastle during the Interregnum lost office but little else, though those who refused to embrace the broad church that was Anglicanism would find their religious practices for the time being outside the law. Perhaps the former moderation begat the latter. Perhaps it was felt the Puritan Corporation had governed Newcastle efficiently, had protected the town's interests and had not been too unpopular.

RESTORATION NEWCASTLE

Newcastle thus emerged from the Interregnum with its trading position intact, its control over the river secure, and the structure of its government much as it had been previously, though with some reshuffling among the dominant elite. It had been sensible for those of Royalist sympathies to keep their heads down and abstain from participation in the town's political life. There had been, however, little to prevent them carrying on with affairs of business. One family which established its fortunes during this period was the Blackett family which was to come to dominate Newcastle's public and civic life after the Restoration.[36]

William Blackett and his brother, Edward, were not untypical of the sort of younger sons who became Merchant Adventurers. Their father was a yeoman of some substance, a landowner who had interests in the lead trade and who was close enough to gentry status for his eldest son to marry the heiress of Thomas Fenwick, who owned land near Wylam. Edward commenced his apprenticeship in 1630 and William in 1636. Edward was not, however, admitted to the Company until after his brother for his apprenticeship was interrupted by the several years he spent in Amsterdam working as a factor for various Newcastle merchants. His Amsterdam contacts were to prove very useful to William who, even before his apprenticeship was over, was trading in his own right with North Sea and Baltic ports.

William Blackett's first fortune was made, so it is said, by an investment in the flax trade with the Baltic that nearly went badly wrong. Coming out of the Baltic through the Sound was ever a risky endeavour, especially in the winter months, and war with the Dutch in 1652 made it riskier still. Having put nearly all his money into the speculation, William heard the bad news that the flax fleet had been dispersed in a storm and most of them had been lost or captured by the Dutch. A probably embroidered account of his good fortune has him walking disconsolately by the Tyne and hearing a ship which turned out to be his own. Making his way to London as quickly as possible, he was able, in the circumstances of a dire shortage of flax, to sell the cargo for a handsome profit.

By the time of the Commonwealth's last years, William Blackett had added to that fortune by advantageous marriage and shrewd investments and, as Merchant Adventurer and Hostman, had been a member of the delegation that Newcastle

sent to London in 1656 to petition Parliament against threats to its privileges. Although known to be a Royalist, he was elected sheriff in 1659. He declined but accepted the following year and soon, as Welford put it, 'tar barrels were burning and Mr Sheriff Blackett was spending £22 for a tun of wine to run through a pant in honour of the coronation of his sacred majesty King Charles II'. Positions and honours now came rapidly. He became an alderman, a captain in the militia, a Commissioner of Assessment, Governor of the Hostmen's Company, mayor in 1666 and MP in 1673. A week after his election to Parliament, he was made a baronet. His economic fortune waxed as he gained his civic honours. He bought or rented lead-rich land around Hexham in the Allen and Wear valleys and smelted his own ore, while he owned coal mines and continued his seaborne trade as a merchant.

In his later years, William Blackett bestrode Newcastle more like a Renaissance prince than a merchant and, not content with his fine house in The Close, purchased the town's most magnificent mansion, the Newe House. No other town in Britain had anything quite like it. London had its great houses surrounded with expansive grounds but these were without the city walls. Robert Anderson had bought the land on which had once stood the Franciscan Friary in Pilgrim Street and the adjacent St Bartholomew's Nunnery forty years after the dissolution of these religious houses. He filled up the dene of the Lort Burn which intersected the grounds and built what Gray in his *Choreographia* called a 'princely mansion'. The house and grounds covered more than twelve acres, an enormous area when we consider the limited acreage within the town's walls; it extended from Pilgrim Street to Newgate Street, came close to the town walls to the north and had Upper Dean Bridge (or High Bridge) as its southern boundary. As we have seen it provided King Charles I with a comfortable place of captivity.

Sir William bought this fine house around 1675 and only enjoyed its grandeur for a few years before his death in 1680 but he left enough money to found not just one but two dynasties. His eldest son, Edward, inherited the baronetcy and considerable land to the west of Hexham but it was his third son, William, who inherited his position as Newcastle's foremost inhabitant and his Newcastle property along with lead-rich estates in Allendale and Weardale and coal mines close to Newcastle. Soon he was an alderman, then mayor, Governor of the Hostmen and MP while

a new baronetcy was created for him. He made extensive alterations to the Newe House, later known as Anderson Place, adding, around 1690, two brick-built wings with sash windows, thus creating a house redolent of the more opulent London houses of the period. His private dwelling was only rivalled by the civic grandeur of the Mansion House, similarly in brick and built around the same time. The Mansion House provided a suitable riverside residence for the mayor and a more magnificent place for civic entertainment than even the recently rebuilt Guildhall.

Newcastle's trade flourished in the late seventeenth century and Newcastle merchants with it. Coal was by far the most important commodity with the bulk of coal cargoes bound for London and, although Newcastle merchants traded in a variety of commodities with ports all over northern Europe, coal usually formed part of outgoing cargoes. The business records of the successful London merchant Charles Marescoe reveal a European-wide trading world in which Newcastle played a part. He corresponded with Robert Ellison and, after Robert's death in 1678, with his son John. The Ellisons arranged shipments for Marescoe, sending two ships to Rotterdam with cargoes of lead in 1667 which yielded him a profit of 14 per cent. Local knowledge was all-important and the Ellisons gave him advice on the state of trade in Newcastle, warning him at one stage not to order iron from Stockholm for the Tyne as there were already three ships at Stockholm loading cargoes for Newcastle. The coal trade across the North Sea was always important and Egidio Ruland of Hamburg, who was an associate of Marescoe, ordered coal shipments via the Ellisons, while Herman Wetkin of Rouen and Jean Freyhoff of La Rochelle traded in Newcastle as well as Scottish coal.[37]

Just how multi-faceted trading ventures could be is shown by a transaction during the Second Dutch War:

> Thus early in 1666 Marescoe was commissioned to handle a complex transaction involving the purchase of salt, brandy and vinegar in La Rochelle and the shipment of Newcastle lead and coal to Rouen. Both cargoes were consigned to Swedish ships, the *Tromslager* and the *Koning David* of Stockholm, and the task of Marescoe and Oursel [his partner in the enterprise] was to settle the consequent bills between them. In 1667 their liaison was reinforced by even larger commissions. Marescoe was called upon to arrange no less than five shipments of lead, coal, butter and vitriol for despatch to La Rochelle from Newcastle and Hull.[38]

Trade with Sweden had become important because of the English demand for iron manufactured there. William Blackett, nephew of the first Sir William Blackett, was based in Sweden, where he was envoy to the court and was also engaged in the iron trade. Unlike other merchants, he didn't buy directly from iron works but bought his iron in Stockholm from other exporters. Much of his business involved transactions with his uncle, Sir William Blackett, to whom he had been indentured as a Merchant Adventurer. Sir William also retained a factor in Stockholm, John Struther, another Newcastle Merchant Adventurer.

As was the nation as a whole, Newcastle was in no mood for further internal strife during the reign of Charles II. The town prospered and the majority of inhabitants were happy enough with the new religious dispensation even if it irked Puritans. Despite Cromwell's desire for a moral reformation and his attempts to suppress alehouses and Sunday sports, the Protectorate had permitted a wide diversity of religious practices. With the Restoration came a triumph for Episcopalianism and England became a confessional state. Both Charles II and his Lord Chancellor, Lord Clarendon, would have preferred a wider degree of toleration but the 'Cavalier Parliament' passed legislation which expelled those clergy who did not accept the Act of Uniformity from their livings and enabled only members of the Church of England to fully engage in civic and political life. Yet, if religious zealotry had not abated, the exactions upon what were to become known as dissenters and even Catholics tended to amount to second-class citizenship rather than involving the executions and burnings of the previous century. Much depended upon the attitudes of local elites as to whether dissent could be tolerated and, even by the late 1660s, 'occasional conformity' allowed many dissenters to engage in civic life. In Newcastle notable dissenters like Ambrose Barnes were harried but continued to have successful careers and those who attended illegal prayer meetings were fined, as were several members of Puritan merchant families after such a meeting at the house of a Richard Gilpyn in the White Friars was broken up in July 1669. A conspiracy by Anabaptists at Muggleswick, a village some 15 miles from Newcastle, intended to force the King to grant religious toleration to all but Catholics, strengthened the hand of those who saw all dissent as a threat. Nevertheless, cautious dissenters were able to survive and even thrive financially despite their disabilities.

The weakness of dissent *a propos* the established church lay in its fear and detestation of Roman Catholicism. Misguided and dangerously close to

Catholicism as Episcopalianism might seem to Puritans, the Anglican Church, nevertheless, provided a defence against the greater evil of Popery. Memories of the reign of Queen Mary were kept alive by preachers and the writers of tracts, while the thought that the Spanish or the French were continuously seeking to re-establish the Catholic faith in Britain was a constant nightmare; better to be discriminated against by the Church of England than to be subjects of Rome. Patriotism as well as religious belief damned Catholicism which was associated with foreign absolutism as well as with priests and masses.

In the latter years of the King's reign, satisfaction with Charles II was diminished by suspicion as to his real religious affiliation, his fondness for a French alliance and by his disregard for the traditional rights of English towns. Parliaments had given Charles every power and prerogative, save the one that made firm executive power possible, an adequate budget. It was this lack of finance that lay behind his desire in the early 1680s to become responsible for the appointment of mayors, sheriffs and other civic office-holders and to make towns surrender their old charters and be granted new ones reinforcing royal power. Such a demand was made of Newcastle in 1684 but reached the town after the King's death. The Corporation seems to have been divided in its attitude to King Charles's new charter with the mayor, Sir Henry Brabant, an ultra-royalist, supporting it and Sir William Blackett resisting it. Despite reverses in foreign policy and the growth of a Whig opposition, Charles's position was strong in the early 1680s. He had triumphed over his adversaries during the Exclusion Crisis, had proved that he could if necessary rule without Parliament, had curbed his expenditure while the collection of revenues had become more efficient and he faced no real opposition. The combination of a monarchy closely aligned with the established church was formidable. If many in Newcastle as elsewhere were disturbed by aspects of royal policies, there were few overt expressions of discontent.

Newcastle & the 'Glorious Revolution'

Charles's brother James inherited a stable regime. The Exclusion Crisis had demonstrated the strong antipathy to the prospect of a Catholic king after James

as Duke of York had openly avowed his Catholicism, but this had been followed by a strong loyalist reaction and the Parliament that met in 1685 was landowning, monarchist and Anglican and prepared to accept the rightful king even if he was a Catholic. The rebellion of the Duke of Monmouth and the supportive revolt of the Duke of Argyll were easily suppressed. Within a few years James II had thrown away all his advantages.

In Newcastle the occasion of James's coronation was greeted with much rejoicing. Sir Henry Brabant was the main proponent of the move to erect a statue to the new monarch but Blackett and his supporters opposed this saying 'it looked like Popery' though they gave way when Brabant threatened to send the King a list of those opposing the erection of the statue. Nevertheless, it was the candidate of the Blackett faction, Nicholas Cole, who won the next mayoral election.

To the modern mind James's policy of religious toleration seems laudable, an even-handed approach to both Protestant dissenters and Catholics. The policy was not a plot to establish a Catholic state against the wishes of the vast majority of the population but was born of James's naïve belief that, once Catholics enjoyed religious freedom, a voluntary reconversion of his subjects would follow in due course. The King grossly underestimated the deep enmity of the nation towards his faith and just as importantly failed to recognise how much his position depended on the Church of England and on the support of the aristocracy, gentry and established merchant oligarchies. The second Sir William Blackett was one who became much dissatisfied. Like his father, he was Tory, an Anglican and a monarchist but the events of 1685–8 were to test his loyalties and turn him into a reluctant Whig. The short reign of James II saw a threat from on high to Newcastle's ancient privileges and autonomy and to the very warp and woof of its governmental and social fabric.

The Declaration of Indulgence of April 1687 suspended all the penal laws against dissent. It was welcomed by some dissenters who took full advantage of its dispensations though others were suspicious. At the same time James sought to ensure that the next parliament would be packed with his supporters; he also sought to appoint new compliant men to the lieutenancies of counties and as Justices of the Peace, and to override the traditional rights of towns by appointing mayors, sheriffs and aldermen who were to his liking and thus bring

about client local government. In so doing he was interfering with the existing fabric of society and the social order. Newcastle provides a good example of how much the traditional elite resented this.

As we have seen, Newcastle, unlike many other commercial towns, had never, save in the unusual circumstances of the Interregnum, been a centre of Puritanism though it had its Puritans and dissenters. Suddenly there was a topsy-turvy world:

> Men were at a loss to see how suddenly the world was changed, the cap, the mace, and
> the sword, one day carried to the church, another day to the mass house, another day to
> the dissenting meeting house…[39]

Many dissenters welcomed James's policy of toleration, which meant that they were able to openly worship in their chapels, however much they disapproved of the same toleration being allowed to Catholics, and some dissenters were appointed aldermen by order of the King. Most burgesses were, however, affronted by King James's disregard for the town's ancient privileges and rights. Those dissenters who took advantage of the new dispensation and became supporters of James's policies lived to regret it when James was overthrown in 1688. Ambrose Barnes was one who stood high in the King's favour. He became an alderman and a principal adviser to the monarch on Newcastle matters.

As C.J. Bates commented, 'The cause of religious liberty brought about strange acquaintances; Barnes had one day two Jesuits and a Capuchin at his table in the Close.' Barnes's ecumenical role was in contrast to his previous beliefs, but his civic life came to an end when William and Mary came to the throne.

Charles II had already issued a charter which gave the King the power to replace the mayor and aldermen at his pleasure and James by mandate in January 1686 removed the common council, ordered new elections and then demanded that the Catholic merchant Sir William Creagh be given the freedom of the Corporation and be made a member of the Merchant Adventurers and Hostmen. Newcastle's response, while polite, demonstrated the distaste of leading merchants to this interference with the traditional rights of the town and its companies. At a meeting of the Merchant Adventurers' Company a letter from the King to the mayor, Sir Henry Brabant, and the Governors of the Merchant Adventurers and Hostmen was read out:

Whereas it hath beene represented unto us that Sir William Creagh of Newcastle upon Tine, Knt', is a merchant of considerable dealeing, wee have thought fitt hereby to require you, that fforthwith upon receipt hereof you make him a freeman, free hoastman and free merchant of our said towne and county of Newcastle, any constitution, custome or order to the contrary in anywise, notwithstanding, with which wee are graciously pleased to dispense in his behalfe.[40]

The mayor, the Hostmen and the Merchant Adventurers reluctantly obeyed but this was not the end of the matter. A month later, a similar demand was made on behalf of the Catholic lead merchants, John and Thomas Errington of Beaufront near Hexham, and again it was acceded to.[41] In July 1687 Creagh was able to produce another letter from the King complaining that, although Creagh had been admitted to the freedoms, this had not been 'in so ample manner as wee intended'; the mayor and governors complied once more.

The Merchant Adventurers did, however, demur when Creagh demanded a list of all the members of the Company and when the King asked for yet another of his nominees, Edward Gray, to be admitted to membership, they suspended a decision and replied to the monarch's demands with a letter pointing out that to admit men who had claim neither by patrimony or apprenticeship to the freedom of the Company would 'leade to the ruine and dissolution of this your majesty's antient society'.[42] In 1687 John Squire was elected mayor but this did not suit the King and he displaced Squire, six aldermen, the sheriff, the deputy recorder and fifteen of the common council, commanding the electors to choose as the new mayor Sir William Creagh, and a sheriff, aldermen, and common councilmen of his choosing. To elect by royal command those who were hitherto outsiders, including an Irish Catholic, was too much for Newcastle merchants and Newcastle refused, but James's placemen were installed. Creagh proved an obedient servant of James, happily surrendering the town's privileges and asking the King to grant a new charter but at the next election the town rebelled and refused to elect James's nominees. Some have seen the election as mayor in 1688 of William Hutchinson, a dissenter, as simply a further defiance of royal wishes but James seems to have acquiesced. Hutchinson's election and that of Matthew Partis as sheriff may well have been a case of the dissenters demonstrating that they could use the new order of things against both Catholics and Anglicans.

Hutchinson was a solid Merchant Adventurer and Hostman and therefore more acceptable to the leading burgesses but it is unlikely that he would have been elected if many Anglicans had not been removed from influential positions.

Attention now focussed on the forthcoming Parliamentary election. The new charter restricted the electorate to those whom the King thought might be amenable to his policy of abolishing the laws against religious dissent but support for the established Church was strong in Newcastle and it became clear that even this group was about to elect Sir William Blackett rather than the King's nominee, Sir Nicholas Cole, at the election due to be held in November 1688. It never took place because of the landing in England of William of Orange and James's subsequent flight.

James, belatedly, recognised the difficulties and dangers of riding roughshod over the established men and customs of towns and removed his nominees from Newcastle and other towns in October. Hutchinson and Partis surrendered their offices and were replaced by Nicholas Ridley and Matthew White, both leading merchants and Anglicans. The King still had everything to play for and this action seems to have secured the loyalty of many towns, including Newcastle. What ensured the revolution's success was not so much the erosion of support in the country but James's vacillation in the face of the invasion force, a vacillation surprising for one who had previously shown himself a decisive military commander.

The fact that, once William of Orange was firmly established, the Newcastle mob – which, as a nineteenth-century historian of the town, R.J. Charleton, recounted, 'had shouted and drank the claret' at James's coronation – tumbled his statue into the Tyne, and shouted for King William,[43] has obscured Newcastle's support for James. Just a few months before the mayor and Corporation declared for the Prince of Orange, the town had sent congratulations to King James for the 'inestimable blessing of a Prince of Wales'. Like much of the nation, Newcastle, despite the King's high-handedness and his Catholicism, was uneasy at the deposition of a lawful king and did not join in the uprising which saw towns like Hull and York seized for William. As late as 6 December, a few days before the flight of the King, Lord Lumley, encouraged by the reception at Durham of the Prince of Orange's declaration, had demanded reception from the magistrates of Newcastle, but had been refused admission.[44]

Newcastle refused to obey William's instruction to hold an election in January 1689 which was called to legitimise the revolution but the sheriff, acting alone, accepted the nominations of Sir Ralph Carr and the sitting member, Sir William Blackett. Two Newcastle clergymen, Ralph Grey and William Richards, were among those who refused to take the oath to William and Mary and lost their livings. The vicar of St Nicholas's, John March, preached a sermon in January before the mayor and aldermen in which he extolled passive obedience and described recent events as 'rebellion'.[45] The Bishop of Durham, the cautious Nathaniel Crewe, who had sat out the months of crisis on a boat off the coast, left England in February, missed the coronation of William and Mary, and returned in July just in time to make his submission. Neither Newcastle nor the adjacent counties gave much of a welcome to the new regime.

5

NEWCASTLE IN THE 'LONG EIGHTEENTH CENTURY'

The concept of the 'Long Eighteenth Century' is an affirmation of the importance of the social, political and economic developments of the later decades of the seventeenth century, which created a viable state and social order, and a rebuke to historians who have been eager to ante-date the changes to British society associated with the 'Industrial Revolution'. In Newcastle, from the late seventeenth century to the third decade of the nineteenth century, there was an institutional and social continuity that begat a dynamic economy, which was far from a mere precursor of the industrial economy established in the mid-nineteenth century. As with England itself, a religious compromise, which saw an Anglican ascendancy retained was buttressed by a general Protestantism, which allowed limited rights to dissenters, while a social order, which was largely hierarchical but flexible enough to allow the majority of the increasing middle orders to increase their influence and wealth and identify with the status quo, endured. Stability can be exaggerated for there were outbreaks of social conflict in hard times as with the invasion and looting of the Guildhall in 1740 and the authorities could never be entirely confident. That it was, on the whole, maintained owed much to the increased wealth of the town which in its turn was a product of national and local stability. Thus, constant parameters, rather than resulting in stagnation, saw Newcastle develop physically with fine new streets and buildings, economically as trade expanded, and socially and culturally as literacy widened and the arts, science and entertainment found a new public space. The history of Newcastle between 1688 and 1835 fits in well with the concept of the 'Long Eighteenth Century' which has become so influential among historians.

That 1688 ushered in a new order that would endure would not have been immediately apparent to the townspeople of Newcastle in the immediate aftermath nor in the next decades. In the first place it was always possible that

James or his son might win back the throne. Then again, leaving aside the change of monarch, it must have seemed to many in the town like a return to the old order. As we have seen, James's short reign had seen kaleidoscopic changes, changes to the town's customs and rights, the intrusion of new men into the ruling circle and Catholics and dissenters in the Guildhall. Now the previous civic regime was back.

Essentially for Newcastle, as for England as a whole, the Revolutionary Settlement was an exercise in pragmatic conservatism. It institutionalised a balance between King and Parliament and ensured that Britain would be Protestant and England Anglican. Despite William of Orange's Calvinism and the passing of the Toleration Act, England after 1688 was to continue until the nineteenth century to be a confessional state. It became easier for dissenters so far as their private worship was concerned but they remained disbarred from public office unless they made a public show of conforming. This seems to have suited Newcastle, a predominantly Anglican town but with a sizeable dissenting minority, well enough. Nicholas Ridley, a member of an up-and-coming Anglican merchant dynasty, became mayor and there were to be no more Catholic nor dissenting mayors or aldermen. There was, nevertheless, a place in public and civic life for those dissenters or Nonconformists who were prepared to be 'occasional conformists' while, so far as business life was concerned, there were few disadvantages.

So far as the threat to the customs and privileges of towns, their methods of governing themselves and the rights of guilds or companies, the revolution provided some reprieve; a governmental drive towards political centralism continued but fitfully, which enabled the ancient methods of corporate towns and many rights and privileges to continue for a century and a half. What was to be more significant in the medium term was the slow erosion of the monopolies and privileges of guilds or companies in the face of new ideas about economic competition and a number of legal cases which found that companies such as the Newcastle Hostmen and Merchant Adventurers were acting in 'restraint of trade'.

Political animosities were strong and often violent in Newcastle in the late seventeenth and early eighteenth centuries. There was something of a Whig ascendancy after 1688, with Tories divided between those reluctantly accepting the

new regime and those passively or actively Jacobite. It is clear, however, that local and personal standing was almost as important as party affiliation. Sir William Blackett was a moderate Whig but his hold on the politics of the town owed much to his generous purse which enabled him to entertain voters at the Newe House:

> Here has Sir William, his lady and his guests, oftentimes paraded on the chequered pavement on the front of the house, or wandered to the brink of the stream which skirted the western boundaries of his gardens, or on his electioneering quests, entertaining a thousand or so of the brethren of the Incorporated Companies, his constituents, or entered his golden coach drawn by horses six.[1]

His opportunities for extensive hospitality were increased when he purchased Wallington Hall and its estate from the over-mortgaged Sir John Fenwick. Wallington was about 12 miles from Newcastle and was a bargain at the price of the settlement of Fenwick's debts of £4,000 and a £2,000 annuity for Fenwick and his lady. In 1696 Fenwick, a rash and incautious Jacobite, was arrested for being part of a conspiracy to assassinate King William and was then attainted and executed; Sir William Blackett MP voted for the Bill of Attainder. It was fitting that the horse King William was riding when he had his fatal fall, White Sorel, had been confiscated from Sir John.

Sir John Fenwick's execution inspired the ballad 'Sir John Fenwick's the Flower Among Them All' and a dispute over the singing of it was the cause of a quarrel between John Fenwick of Rock and one of Northumberland's MPs, Ferdinando Forster of Bamburgh, in 1701. The two met subsequently at the White Cross, renewed their quarrel and drew swords. Forster was killed and Fenwick hung for killing him. This resulted in a further ballad:

> Noble squire Fenwick, he must be put down
> For killing squire Forster of Bamburgh town

Blackett's record in elections was remarkable for he won every one he contested and sat in five of the nine parliaments between 1685 and his death in 1705.

The reigns of William and Mary and then of Anne were noted for politics conducted with considerable animosity between political parties which had

degrees of organisation and unity that would not be seen again until the nineteenth century. That, under the 1694 Triennial Act,[2] elections had to be held at least every three years kept politics constantly on the boil. For most of the period 1688–1710, Whig candidates were successful in Newcastle but 1710 marked a turning of the tide with the defeat of the two sitting Whig MPs, William Carr and Sir Henry Liddell. The two victorious Tories were William Wrightson and the 21-year-old Sir William Blackett who, unlike his father, was not only a Tory but had Jacobite sympathies; a section of electors may well have voted for a Blackett whatever his politics. The triumphant Tories celebrated their victory in song: 'the Church shall stand, the Queen shall reign, / In spite of the Fanatick, / And Whigs shall ne'er vote out again / A Wrightson and a Blackett'.[3] The election did indeed see the beginning of a long period of Tory dominance in Newcastle elections.

JACOBITES OR GEORGE'S MEN: NEWCASTLE AND THE 1715 REBELLION

Newcastle opinion was fiercely divided over the accession of George I. The mayor, Matthew Ridley, refused to announce that it had taken place but Sir Henry Liddell celebrated the event by providing a bonfire and two hogsheads of ale for the populace. The Ridleys gathered a crowd of supporters and tried to put out the fire and a vigorous fight ensued in which the Liddell faction got the better of its opponents, though whether this was because of the popularity of its cause or its beer is unknown. The accession of a German dynasty was generally unpopular in Britain but Catholicism was feared and opposition was fractured. The 'Old Pretender' or 'James III' might be recognised by many as the legitimate heir to the throne but his Catholicism frightened many Church of England Tories.

Whether the 1715 rebellion was just a disruption to the establishment of Hanoverian rule or a serious threat to it has been much debated. Certainly, the taking of Newcastle was essential to any chances of success it had and both those who plotted to put James III on the throne and those who feared a Jacobite rising were aware of the strategic importance of the town and made assessments of its loyalties. Many historians have seen the 1715 rebellion as a wild venture, born in its English dimension of the desperation of those who were on the losing

side in the face of ineluctable economic and social forces. They have pointed to the leading North East participants of the rebellion as being from declining and over-mortgaged, mainly Catholic, families; regarded the loyalists to the Hanoverian regime as representing the emergent, more business-like world; and seen it as significant that Newcastle played no part in the rebellion. The view expressed in a number of recent studies is very different and sees the rebellion as potentially a serious threat to the regime. Studies of Jacobitism have revised the view of the movement as a lost cause and argued that it enjoyed wide popular support both before and after the rising. Its strength lay in distaste for the Hanoverians, a continuing belief in legitimate succession and its ability to be associated with popular causes and discontents; its weakness lay in its reliance upon French support and in the Stuart refusal to consider London worth giving up a mass – that combination of Protestant and anti-French feeling that was to mark British patriotism was already potent. Whatever the potential popular support, the 1715 rebellion failed due to the combination of the failure of the French to mount a landing, a lack of a well-considered strategy and a paucity of experienced military leaders.

A historian of the north of England rising has argued that the original plan, devised by the Earl of Mar, was for

> the creation of a Franco-Anglo-Scottish Jacobite army in Northumberland which would, firstly, seize Newcastle and halt the supply of coal to London, and then sweep all before it in its descent on the capital.

This strategy, so the argument goes, was abandoned by the Duke of Ormonde and Viscount Bolingbroke in favour of a landing in the South West, a plan which failed and left those in the North East who still raised the Stuart standard without French support and without a serious chance of success.[4]

This is perhaps too neat. The main problem was that there was never agreement on a single strategy – Mar's was just one of many – nor a consensus as to whether a rebellion without an invasion could succeed. A recent study has concluded that 'It was essentially the rebellion that should never have happened.'[5] A considerable degree of popular sympathy is never enough for a successful rebellion and only becomes significant when accompanied by rational and coherent planning,

strong leadership and a nucleus of trained troops. French support was never firm, especially after the death of Louis XIV, no trained troops were available, and the tardy arrival of the Pretender on British soil did not help.[6] Success in Scotland was not enough, Irish assistance would have been counter-productive so far as England was concerned, and English Jacobite sympathisers would only have risen in sufficient numbers if success had seemed likely. The North East rising was indeed an act of desperation by an untrained force led by an inept 'general', Thomas Forster, who had no military experience, no great determination and little courage.

There was a strong body of elite opinion and a well of sympathy in popular opinion that favoured a Stuart restoration but many of those who drank to the 'King over the water' were, understandably, cautious when it came to risking their lives and fortunes for the cause. One such was Sir William Blackett, whom the Jacobite conspirators seem to have had great faith in, relying upon him to deliver Newcastle into Jacobite hands, but either his nerve failed him or common sense saved him. He vacillated, went into hiding and, knowing that the Hanoverian authorities suspected him, eventually made his way to court and kissed hands. His fellow MP for Newcastle, Wrightson, seems to have kept a low profile during the rising, giving no indication of where his sympathies lay. How the majority of the Newcastle population or its leading citizens would have reacted had the town been taken by the rebels or the rebellion seemed likely to enjoy success is imponderable. William Cotesworth of Gateshead Park, who acted as a government agent reporting on Jacobite activity, was informed that the Jacobites would try to take Newcastle and expected 'a great many friends at their entrance' but he knew well who the principal conspirators were. Newcastle's loyalties were not put to the test for the Jacobites never collected the military force required to hold the town even if they had managed to take it.

In the end those who participated in the rising were disproportionately members of Catholic gentry families supported by their retainers; most of the High Tories had assessed its chances of success accurately. There is little evidence to support the thesis that those who took part were impelled by a declining economic position – some were heavily mortgaged but so were many Protestant landowners – rather than by their firm belief in Stuart legitimacy. Participating families seem in many cases to have hedged their bets, allowing one member to

join the rebellion while the rest of the family stood aside or put their property into the care of a Protestant neighbour. The great majority of Protestant Tory gentry, however sympathetic to the cause, stayed well clear of involvement. Newcastle merchants, on the whole not a warlike lot, were even less likely to risk their necks once it was clear that there was not to be an invasion force capable of taking on experienced Hanoverian troops.

If Newcastle showed little inclination to support the rebellion, it was less than enthusiastic in its support for the Hanoverian regime, failing to send the loyal address, such as those sent by Carlisle, Chester and Berwick, in the early days of the rising and only doing so when Jacobite defeat seemed certain.[7] Nevertheless, efficient precautions were taken: companies of militia were raised, local Catholics were arrested and Cotesworth's friend and correspondent Henry Liddell, who had no great faith in the town's loyalty, had to admit that 'The zeal of the magistracy, iff unfeign'd, is beyond whatever could have been expected.'[8] The arrival of regular troops may have had something to do with this. Only seven men from Newcastle appear to have joined the rebels, though this may well have been because of the prompt action of the local authorities and the arrival of regular troops.

Towns in general did not provide support for the 1715 rising but this does not mean that there was not widespread urban sympathy for the Jacobite cause. A study of popular disturbances has pointed to frequent Jacobite riots in northern towns between 1714 and 1719 and argues that, 'If riot was an urban phenomenon, rebellion was overwhelmingly rural in origin.'[9] There were disturbances in Newcastle with nine men indicted in February and March 1716 and in June Jacobite supporters wore green boughs on the Pretender's birthday and there were calls for James III and the Duke of Ormonde. Henry Liddell thought that disturbances in Newcastle which involved fighting between Dutch soldiers and keelmen had been encouraged by the Newcastle Tory leaders.[10] When regular troops left Newcastle in 1718 there was singing in the streets and cries of 'James Stuart'.

Jacobite popular disturbances in Newcastle seem to have died out after 1719 but their significance should not be underestimated. The 1745 rebellion failed like that of 1715 because of poor Jacobite planning, the lack of trained troops and poor generalship but it does not appear to have enjoyed the same popular urban sympathy. Greater military success in 1715 would have had the potential to make positive the quiescent support in many towns including Newcastle.

Politics & the Town's Representation & Government 1715–1832

For Newcastle, as indeed for Britain as a whole, the failure of the 1715 rebellion meant a recognition, however reluctantly many acquiesced in it, of the permanence of the Hanoverian monarchy. Whig influence in the town was marginally strengthened but, although Blackett, not very popular with either Jacobite sympathisers or with Whigs, lost the mayoral election of 1717, he won it in 1718 and managed to retain his parliamentary seat until his death in 1728.[11] In 1722, however, William Carr, a Whig, topped the poll and Wrightson was defeated. In 1727 the Tories won both seats with Blackett and Nicholas Fenwick but William Carr, who had come a poor third, petitioned Parliament contesting the result and, after Blackett's death, was allowed to take the seat. Subsequently, the Tory influence again triumphed and Fenwick and Blackett topped the polls in 1734 and 1741.

The view that party politics declined from the 1720s with a Whig oligarchy securely in power and that the main differences in politics came from Whig dissentients or from the divide between court and country parties, finds little support from Newcastle's experience for Tory and Whig loyalties remained strong. Tory success in Newcastle has been attributed 'to the presence and property of powerful local families'[12] but this influence must have been considerable for Newcastle, a freeman borough, had a large electorate. In 1801 it was estimated at 3,000 or 42 per cent of the adult male population and there is no reason not to believe that a similar or larger percentage had the vote a century earlier.[13] Newcastle was not in fact unusual in demonstrating Tory sympathies at elections. For much of the first half of the eighteenth century, constituencies with wider electorates tended to return Tories. It has been suggested that 'the Tories probably secured a majority of the votes cast at every election between 1702 and 1741, with the exception of 1715 (approximately equal) and 1708'.[14]

The degree to which politics in Newcastle reflected national issues and parties or whether it was local issues and personalities that were paramount is indeterminable. The two were clearly closely entwined. The rivalry between the Blackett and Ridley dynasties, which became a permanent feature of the town's corporate government and of its parliamentary representation from the 1730s,

paralleled Tory–Whig rivalry (the Ridleys having become firm Whigs) and may for many voters have been more important than party. It would be condescending to dismiss wider political loyalties as without substance but rash to suppose them more important than local loyalties.

The government of the town remained determined by its old and complex constitution which ensured that it remained the preserve of the wealthier merchants and Newcastle-based mine owners though the body of freemen exerted influence. Sir Walter Calverley Blackett, who inherited the estates of Sir William Blackett, 2nd Bt, was mayor five times between 1734 and 1771, while a succession of Ridleys held the office eight times during the eighteenth century.

There is little reason to believe that, although the system by which the Corporation and its principal officers were chosen favoured the election of a number of prominent families year after year, the majority of the freemen or burgesses were dissatisfied with the outcome. There were occasions when the freemen became disgruntled – as with the row over the Town Moor in 1771 – but, by and large, the prevailing order suited most freemen. They exercised sufficient influence as to ensure that the principal families had to flatter them and refresh them and spend money on civic and philanthropic enterprises, while they could be trusted, whether as mayors or MPs, to look after the interests of the town; at the same time their position as electors distinguished them from those without the polity altogether. For their part, the Ridleys and Blacketts and other important families received the influence that office gave them but had to pay the price of being generous and open-handed, not just at election times but throughout the year, subscribing to charities or civic enterprises. The elite were at once masters and milch cows.

Newcastle dignitaries did themselves well. The Mansion House in The Close provided a fine residence for the mayor's year of office. Its situation was admirable with the river flowing past it and its rooms were spacious and richly decorated with a dining room capable of seating eighty persons where the mayor and his guests ate off silver plate. Even this grand room proved not large enough and in the second part of the century a further building for the purpose of public hospitality was built to the east of it.[15] The mayor enjoyed an allowance of £2,000 but this was never sufficient to cover the expense of the generous hospitality he was expected to dispense; being mayor was glorious but not profitable.

A more profitable civic office was that of Town Clerk, not only for the emoluments, but also because of the knowledge that its holder acquired as to the business of the town and any building schemes that were under way. In many ways the position was analogous to that of the agent or steward of a substantial landowner, many of whom found the path to fortune through knowledge gained in the course of their employment. John Douglas, a Newcastle attorney, became Town Clerk and was followed in this office by his younger son Joshua. John became rich enough to buy up the estates, close to Corbridge, of the over-extended Carnabys which were inherited by his eldest son, Olney Douglas. Nathaniel Clayton purchased the office for £2,100 in 1785. His son John succeeded him and remained Town Clerk until 1867 by which time he owned the fine house and landed estate of Chesters. Modern moralists might not approve of the way they got their offices and benefited from them but the Claytons' achievements for Newcastle were considerable.

There was a fierce contest for the parliamentary seats in 1741 when processions of supporters marched with colours flying and music playing with a background of bells and gunfire. Sir Walter Calverley Blackett, who campaigned as 'the patriot, the opposer of the court', and his Tory running mate, Nicholas Fenwick, came top of the poll after what had been a ruinously expensive campaign for all the candidates. Fenwick was literally bankrupted by it. Blackett's expenses amounted to £6,319. The Newcastle electors had dined well and drunk better.

No doubt the expense of the election was one reason that inclined both Blackett and Matthew Ridley to avoid another such contest but what did the most to bring these two rivals into what was almost a partnership was the experience of the Jacobite Rebellion of 1745. Few even of the Northumberland Catholic gentry became involved in it, while most Tory gentry and merchants were horrified by it. 'Blackett was no Jacobite. Ridley, though a Whig, as mayor of Newcastle during the "Forty-five" engaged in no witch-hunt of Tories but brought the town united through the crisis.'[16] Blackett had a fort, known as Cadger's Fort, built at his own expense on heights commanding the old Salters' Way to protect the approach from Scotland and entertained the Duke of Cumberland and his officers on their return after Culloden.

Blackett thereafter disassociated himself from his previously strong Tory views and reinvented himself as an independent and anti-court MP, though after

the realignment of politics on the accession of George III, he can be considered of the court party himself. The tacit alliance of Ridley and Blackett meant that Newcastle was spared an election in 1747 and to the disappointment of their more zealous supporters and probably the electorate as a whole, the two were returned unopposed. Indeed Newcastle returned them unopposed until 1774, when although they met with opposition, they still topped the poll.

It says much for the hold that Blackett and Ridley had on Newcastle that they won in 1774 against a number of unfavourable factors. Blackett had offended the freemen by taking the unpopular side in a dispute between the freemen and the Corporation over the letting of portions of the Town Moor. The dispute ended in victory for the freemen when the Assizes found for the freemen and their rights were embodied in an Act of Parliament of 1774 which declared that although the Corporation owned the Moor, it could not let more than 100 acres at a time and each resident freeman had the right to graze two cows thereon. The town was also drawn into the national agitation in the wake of the Wilkes affair and candidates all over the country were asked to subscribe to the radical Wilkite manifesto. Blackett and Ridley both refused to subscribe to it and were opposed by Sir Francis Delaval and the Hon. Constantine Phipps. Then there was the matter of the government's policy towards the American colonies which aroused some opposition in the town. This conjunction of national and local issues gave a local radicalism rather more support than it normally enjoyed. One study of Newcastle has argued that during the period 1769–85, 'Radical activity centring on national issues was neither isolated nor short-lived. Instead it persisted throughout this fifteen year period.'[17] A vociferous radical element certainly existed in Newcastle, as in many other towns, during this period but never gained sufficient support to upset the status quo. A recent biographer of the engraver Thomas Bewick has described Newcastle voters as in 1774 'inflamed by the government's high-handed treatment of the American colonies'[18] and depicted a radical town but has forgotten to add that Blackett and Ridley easily topped the poll and refused to sign a petition against the American War the following year.

It is important to distinguish radicalism from the occasional outbreaks of desperate riot and revolt when hard times, whether the result of bad harvests or unemployment, stirred the labouring poor of the town to protest. Keelmen could earn reasonable wages in good times but work was seasonal and, if the coal

trade was slack or there were long hard winters, there were lengthy periods when there was no employment. The winter of 1739/40 was particularly severe and to alleviate distress Alderman Ridley permitted the poor to carry away what they needed from his heaps of small coals. The early summer of 1740 saw continued hardship largely as the result of the disruption to trade caused by the hard winter and when, despite the promise of the Corporation that corn would be sold at a reduced rate, corn dealers kept their shops shut, disturbances followed and granaries were plundered. On 25 June keelmen and pitmen joined with the poor of the town in a riot during which the Guildhall was ransacked and a large part of the town's treasury carried off. Newcastle as the centre for food supplies was always vulnerable in times of hardship to incursions from pitmen from adjacent pits and from Crawley's men from Winlaton; in conjunction with the poorest of the town, whose fate even in good times was close to destitution, they constituted a combination that could overwhelm the town's fairly basic capacity for maintaining order. Three companies of soldiers had to be called on to disperse the mob. The riots of 1740 were by the far worst but 1709, 1710 and 1750 also saw rioting, the traditional manner of protest but one that became more violent in the context of expanding eighteenth-century towns. Such forms of protest were, however, increasingly disapproved of by polite and respectable society, and this included most radicals, who had no longer their traditional toleration of disorder. Radical protest tended to be disciplined and as one study of eighteenth-century society has remarked, 'The Wilkesite disturbances were perhaps the last in which riot was considered legitimate by very large numbers of propertied people.'[19]

Newcastle's radicals included a number of gifted writers and pamphleteers influenced by the scepticism of the Enlightenment and by a secularisation of old Dissent. They included such notable figures as Thomas Bewick, Thomas Spence and the Reverend James Murray. Jean Paul Marat was working in the North as a veterinary surgeon in the 1770s but few of his supposed connections with Newcastle radical circles can be substantiated.[20] One major problem the radicals faced was the large freemen electorate, an electorate which had its place in old regime Newcastle and was not discontented with it. This electorate included many freemen, who, although they belonged to companies and were burgesses, were actually working men, but were opposed to any notion of widening the electorate and were at the same time suspicious of radicals, many of whom were

professionals or businessmen or were in trades which were not recognised within the town's constitution. During the 1774 election, the two parties, that which supported Ridley and Blackett and that which supported Delaval and Phipps, the 'Magistrates' and the 'Burgesses' parties as they became known, actively canvassed the thirty-two incorporated companies. Only the Bricklayers and the Joiners supported the Burgesses' candidates.[21]

The Ridleys continued to maintain their almost effortless hold as Newcastle's Whig representatives. Sir Mathew White Ridley, 2nd Baronet, succeeded his father as MP and held the seat until he handed it over to his son, the third Sir Matthew White Ridley in 1812. That Newcastle society was not censorious or puritanical is suggested by the continued popularity of the second Sir Matthew White Ridley despite some scandal. He has been described as follows:

> ... a most attractive man. He was also a very gay one and was tried for adultery on one occasion and found guilty of 'criminal conversation' with the wife of a Dr Bromel on the staircase of her house in Newcastle and had to pay £400 damages. This little incident did not, however, affect his public career in the least. He was Mayor of Newcastle and Member of Parliament at the time, and he continued to enjoy the confidence and affection of the people in the North, and the reputation of a man of honor and respectability.[22]

The Tories found some difficulty in finding a satisfactory replacement for Blackett, who died in 1777. The seat had it seemed been bequeathed along with Blackett's Wallington estate to the Somerset squire Sir John Trevelyan, but the candidature of Andrew Robinson Stoney, who had just taken the name Bowes, after his marriage to Mary Bowes, the widow of the Earl of Strathmore, introduced an exotic element into Newcastle political life. Stoney Bowes was an unscrupulous, violent and at least half-mad adventurer, who had just married by spectacularly devious means the unfortunate countess who was pregnant by another man, and was busy trying to break an Ante-Nuptial Trust in order to get his hands on her money. He stood, some say, as a Whig, others as a Radical to oppose Trevelyan at the by-election and with the slogan of 'Bowes and Freedom' and the expenditure of a large sum of money, raised on his expectations of his wife's fortune, polled 1,063 votes to Trevelyan's 1,163. His radical appeal of 'Oh, break

the closet-combination of the magistrates and gentry, whose glory it seems to be to treat their inferiors as slaves' was assisted by ingenious bribery as his wife sat in a window letting fall trinkets and jewels and then rewarding the eager voters who returned them with sums of money. He was returned at the subsequent general election in 1780 along with Ridley. One of his tactics was the luring of local Tories on to a pleasure boat in the expectation of hospitality; the boat did not return to shore until the polls had closed. He rarely attended Parliament but voted once to oppose a Bill to reduce election bribery on the grounds that the laws were already too severe.[23]

After Bowes exotic intervention, the Brandlings from 1784 to 1812, father then son, who were major colliery owners, provided the Tory balance to the Ridleys. Although the Newcastle electorate consistently returned a Whig-Tory duumvirate, they did prefer a contest for the same reason that the candidates didn't: greater expenditure upon voters; not that uncontested elections were without expense, for the successful candidates had to spend time and money warding off potential opposition and cosseting voters before and between elections. Newcastle politics in the late eighteenth century reflected local issues and personalities *and* party politics but the two were closely entwined. Parties represented different interests within the town which each had an ethos that loosely paralleled a national notion of Whig or Tory loyalties.

When Cuthbert Ellison of Hebburn Hall became the Tory candidate in 1812 and stood along with Sir Matthew White Ridley, the 2nd Baronet, there had not been a contested election in Newcastle for thirty-five years and there was not to be one then. Ellison had, nevertheless, to work hard and spend money to gain his seat. He inherited an election machine from his Tory predecessors which was controlled by the immensely capable Town Clerk, Nathaniel Clayton. With Clayton's guidance, he prepared for the election as if there was every possibility of opposition. This involved visits to all the mysteries of the town to solicit their support, appointing sub-agents to solicit the votes of freemen non-resident in Newcastle, making sure that the London-based freemen were 'refreshed', attending dinners organised by the numerous Newcastle clubs such as the Free & Easy Johns Society, placing advertisements in newspapers and having handbills printed. None of this was inexpensive.[24] Ellison's manifesto was impressively frank. He was rich because of the coal trade and the town was rich because of

that trade, 'a trade which employs as it does an immense amount of Shipping is the Nurse, in fact the chief support of our Naval power and supremacy'.

In the event, Ellison and Ridley were unopposed and, again in 1818, Ellison and Sir Matthew White Ridley, the 3rd Baronet, won without a contest, even though a number of local Tories, who thought Ellison far too close to a Whig, floated the idea of the candidature of William Scott, son of the High Tory and Newcastle-born Lord Chancellor, Lord Eldon. A handbill from 'A Free Burgess' suggested solid reasons why the voters should not support Scott:

> What would the Freemen derive from such a connexion? If we are to judge from the past, Nothing. Look at your Infirmary, your Hospitals, your different Charities. Have that Family contributed to the Support of any one of them?

The message was clear: the Scotts were not generous benefactors, the Ellisons were. Scott withdrew.

Again in 1820 a combination of ultra-Tories, radicals and thirsty electors backed the candidature of Scott. A handbill entitled *The Bubble will soon Burst* lampooned the Scott candidature as asking the burgesses to support an '*ultra ministerial* candidate, nominated by a *radical* Baker and an *ultra radical catholic* Cobbler'. James Losh commented in his diary that

> Opposition here originated partly in the desire of a third man amongst the lowest of the Freemen and partly in the wishes of the friends of Lord Eldon and Sir William Scott to bring forward one of that family and to resist as much as possible those members of the late Parliament who were supposed to support liberal principles in Church and State. Hence the monstrous coalition which was exhibited between the Radicals and the Tories.[25]

At the nomination Scott failed to turn up and Ellison was convalescing in Italy. Scott was nevertheless proposed and the show of hands went to Ridley and Scott but Ellison's brother demanded a poll. Polling commenced but was called off with the count standing at Ridley 614, Ellison 477 and Scott 217 when Scott withdrew.

In 1826 Ridley and Ellison were again unopposed but, in the closing years of the old electoral system, there was a challenge from John Hodgson, a wealthy

coal owner from Elswick and a moderate Tory, who differed little from Ellison. Welford considered that

> the main purpose of his candidature was 'to break down the influence of the Ridleys'. That, however, was too firmly rooted in Newcastle to be disturbed, but the movement so seriously endangered the seat of Mr Ellison who was a Liberal-Conservative that he declined to go to a poll.[26]

A more recent interpretation is that it was Ridley whose chances were endangered and that Ellison withdrew because of ill health and the desire to withdraw from public life. Ridley, it has been suggested, had become unpopular: he didn't mix easily with the burgesses and, as his agent, Armorer Donkin, told him, didn't treat them to dinners;[27] he hadn't stuck up for the interests of the town; and was in general perceived as remote from its economic and civic life. If Hodgson threatened either of the established MPs, and, even though he was to spend £10,000 on the campaign, both would have been hard to beat, it might well have been Ridley. As it was, there was no contest and Ridley and Hodgson were declared elected. They were unopposed in 1831 at the last election before the Reform Act of 1832.

The success of the Ridleys and their successive Tory running mates in providing the town's MPs, usually without there having to be a poll, is remarkable considering the size of the town's electorate, which in 1831 consisted of 3,000 resident and 2,000 non-resident qualified voters.[28] Tory and Whig support in Newcastle was nearly equal and the tacit electoral understanding made sense considering the expensive nature of elections but what was just as important was the hard-headed realisation by electors that the town was best represented by families which, like the Ridleys, Blacketts, Brandlings and Ellisons, had interests that were entwined with the town's and would spend money year in and year out, not just at election times, on philanthropic causes in Newcastle; there were, after all, no grants coming from central government and who wanted a rise in local taxation?

ECONOMIC DEVELOPMENT

If the long eighteenth century saw little change in the way the town governed itself, it saw major developments in its economic life. One thing was, however, constant: the lives of merchants and keelmen alike, the prosperity of the rich and the wages of the poor, and of all those who lived in the town and, indeed, lower Tyneside, were dependent on the prosperity of the coal trade. As Sir Henry Liddell put it:

> But what signifies all your Balls, Ridottos etc. unless
> Navigation and the coal trade flourish

Newcastle's relationship with coal has often been misunderstood. Charleton, writing in the late nineteenth century, made the perceptive point when considering the Quayside that:

> Newcastle is proverbially famous for coal; it is her principal article of commerce, and yet here upon the Quayside there is not a scrap of coal to be seen.[29]

This was becoming the case in the early eighteenth century. The Quayside was a busy place and was one of the largest wharfs in Britain; on it were unloaded wines from Portugal (after the prohibition on the import of French wines), timber and flax from the Baltic and many luxury goods such as spices and indigo which mainly came via London. The coal trade was the basis of the town's prosperity from the sixteenth century to the nineteenth century, just as wool had previously been, but Newcastle traded in coal rather than produced it though there were coal mines close to the town's walls.

Newcastle's economy depended upon its control of the coal trade and that in turn depended upon its control of the Tyne. Major changes were, however, taking place. The Grand Lease had enabled the town's leading citizens to be both mine owners and coal traders. After the expiry of the lease in 1679, many Newcastle hostmen continued, like Sir William Blackett and Nicholas Ridley, to be owners of coal mines but, in the early eighteenth century, William Cotesworth, an ex-tallow merchant's apprentice from Gateshead, gained control of the mines at

Gateshead and Whickham. The area west of Gateshead became the main centre for new profitable pits, many of them at a distance from the river but viable as wagon-ways enabled the coal to be transported economically to the banks of the Tyne. Later, improved mining technology would enable deeper pits to be sunk downstream from Newcastle. It was not just Newcastle but the Tyne itself that was threatened as the Wear, the Blyth and even the small harbour of Seaton Sluice increased their coal exports. The Tyne continued, however, to be the major coal-exporting river and Newcastle maintained its major influence over the trade.

Coal mining was a dangerous occupation for pitmen and it was a risky and expensive business for mine owners and for everyone connected with it. There were many participants in the journey of a chaldron of coal from a pithead to a London hearth: the coal owners, the fitters, the keelmen, the ship owners, ship masters, and the London coal merchants. All had conflicting interests and these were exacerbated by the problem of excess capacity that existed during the first half of the eighteenth century. The interest of major coal owners in keeping the price of coal high resulted in attempts at 'regulation' by groups of owners, usually the wealthiest. They also sought to limit the independence of the majority of the hostmen who were fitters, the middle men who arranged the loading of cargoes and the shipment of coal. Fitters contracted with the Newcastle keelmen who transported coal from the end of waggon-ways to ships or to jetties further down the river; the fact that ships of any size were unable to proceed further up river than Newcastle with its low bridge protected the keelmen's trade. The London dealers were also rapacious in exacting maximum profits and in playing off one coal owner against another. Cartels did enjoy some temporary success but inevitably broke down in the end, though one authority has argued that 'they were remarkably successful ... in view of the unfavourable climate in which they had to operate'.[30]

Newcastle's control was, however, not broken. The town still jealously guarded its rights over the Tyne, a number of hostmen and prominent townsmen were coal owners, the shipments were still arranged by the fitters and carried by keels, while, moreover, the financial, legal and commercial expertise so necessary to a complex trade was to be found there together with the technical knowledge of mining which was already creating new professions.

The central importance of the coal trade should not overshadow the importance of other trade. Newcastle was a trading town and its merchants would import and export in any goods when they could see a profit. Trade with the Baltic flourished, with timber, flax and corn imported though exports were usually confined to coal and grindstones, while links with Amsterdam, Rotterdam and French ports were constant except when interrupted by war. There was even some trade with the American colonies, though this was largely a triangular trade with Tyneside ships taking Dutch cargoes to the colonies as the Navigation Acts did not permit direct Dutch trade with the colonies.[31]

A great variety of ships were involved in the coal trade. There were the smaller coasters, hoys, billanders, brigantines or ketches, usually less than 80 tons, which put into tiny ports, some at the head of estuaries and undredged rivers such as Blakeney in Norfolk or Melton far up the Deben in Suffolk. Dredging was rare in the eighteenth century so the navigation of many rivers was beset with problems. Colliers also frequently landed their cargoes directly on to open beaches. Only very small ships could take coal to dangerous landing places along the Yorkshire coast where alum was made from alum shale, kelp and urine with coal providing the heat. Large colliers were used for passage to the Thames and for the foreign trade but even then their size was kept down by shallow water at Woolwich and the narrowness at the bar of the Tyne and the average coal cargo delivered to the Thames in the 1730s was about 230 tons or the amount eleven keel boats could carry.[32]

London was increasingly the major destination of coal shipments from the Tyne. Sunderland displaced Newcastle as the main player in the foreign coal trade and the major provider of coal to English provincial ports, while, from the late seventeenth century to 1750, London accounted for 80 per cent of Newcastle's coastal trade. There was a symbiotic relationship between Newcastle and London and one historian has pointed to 'how synchronous growth in demand on the Thames and in output in the North-East were'.[33] Despite competition from Sunderland and from smaller ports like Blyth and Seaton Sluice, the established position of the Tyne and the general expansion of the coal trade meant that Newcastle's trade continued to increase as did that of the North East ports as a whole. Just how this expansion was achieved – a twelvefold increase in coal sent from North East ports between the early eighteenth century and the coming of steam colliers in the 1850s – is contentious but it seems clear that more ships,

larger ships, better loading facilities on the Tyne and Wear, better unloading techniques on the Thames, and more frequent journeys and more winter journeys were responsible.[34]

It might have been expected that the need for colliers would have led to a major shipbuilding industry on the Tyne but the Newcastle yards did not launch a ship of more than 30 keels until the mid-eighteenth century while North and South Shields were held back by the perpetuation of Newcastle's monopoly. Defoe thought that Ipswich was the town where most of the large colliers employed between Newcastle and London were built though he also commented on Tyne shipbuilding that 'They build ships here to perfection.' By mid-century most colliers were owned and built in North East harbours with Whitby, Scarborough and Sunderland providing the greatest number.[35] Tyne shipbuilding was, however, poised for expansion. In 1750 the *Russell*, at 650 tons the largest collier built on the Tyne to date, was launched, the river was winning orders for ships from the Admiralty, and larger yards were created, such as Hurry's at Howden and Rowe's of St Peters. Newcastle's monopoly of shipbuilding on the river was being broken in a new economic climate.

For larger ships the coastal and foreign trade could be combined. Coal and grindstones were the usual cargoes of ships making for Norway or the Baltic and they returned with timber, tar or iron but the Baltic trade was

substantially a carrying trade where the port of destination was not always the port of departure as well. Ships sailing with coal from Shields or Sunderland commonly delivered Baltic timber at Hull, Lynn or the naval dockyards at London or Portsmouth. Moreover, since return voyages to the Baltic could be quite short, usually no more than two months, ships engaged in other trades and arriving at their home ports later in the year could also participate in it. Vessels arriving from longer oceanic voyages during August and September, for example could still undertake a combined coal and Baltic voyage before ice put an end to the sailing season. The opportunity to take these late season voyages was of central importance to shipowners who employed their vessels in the Greenland Whale Fishery.[36]

In its structure of governance and its retention of its rights over the passage of ships up and down the river, the town's position had not changed but other

old monopolies were eroding. Central government and the law could no longer be trusted to uphold the rights and privileges of the Hostmen and Merchant Adventurers. In 1703 six Hostmen were hauled up in front of the society for

> aideing and abetting gentlemen owners of coles not free of this Society who confederate with lightermen and buyers of Coles in the Citty of London to the ruine and prejudice of the hoastmen and Coale trade in Newcastle.

The Attorney-General, Edward Northey, gave an opinion to the effect that the Hostmen's Company was not entitled to the sole loading and disposal of coal on the Tyne and the company took no further action.[37]

Two decades later, the Company of Merchant Adventurers suffered a similar blow when in 1726, after the company's wardens had seized the goods imported by merchants who were not company members, the Court of Exchequer dismissed an application from the company for the upholding of their monopoly over 'foreign bought and foreign sold'. Although the company continued to restrain persons trading in the town who were not free of the company until the 1770s, it is clear that its traditional privileged position was being eroded. The same was true of all the town's guilds and by 1800 it was clear that the rule of membership of a company and the necessary apprenticeship before exercising a trade could no longer be enforced. There was, nevertheless, considerable opposition in Newcastle, as throughout the country, to the repeal of the Elizabethan Statute of Apprenticeship in 1814.

Until the last decades of the eighteenth century, it was still useful for economic purposes to be a Hostman or a Merchant Adventurer and more than useful if one wanted to participate in civic life. The social cachet remained important, with most of the 'great and the good' of the town valuing their membership of the elite companies, though as apprentices became rare, membership was increasingly by patrimony alone. It remained more than convenient to be a company member for those engaged in the artisan trades, while, as we have seen, the companies had to be assiduously courted by candidates at election times.

Newcastle both contributed to and benefited from the financial revolution which from the mid-seventeenth to the mid-eighteenth century transformed the national economy and underpinned the expansion of British power.[38] This financial revolution (perhaps, as with 'industrial revolution', evolution is a better

word) was made up of a number of developments. The foundation of the Bank of England, the beginnings of a National Debt and the emergence of a stock market were central to it and resulted in a state which was not only able to raise money by taxation but borrow large sums from subjects. Just as important was the growth of trade, the accumulation of private capital, the emergence of private banks and a sophisticated credit system. There were many setbacks, including the bursting of the South Sea Bubble and the bankruptcies of merchant houses and banks, but such financial developments were probably more important for long-term economic growth than innovations in manufacturing.

Credit was the lifeblood of merchants. Even within England it was quite difficult either to pay for or be paid for goods traded to and from customers in distant towns. A chronic shortage of coinage didn't help matters. Newcastle merchants, long accustomed to trading overseas as well as with London and other British ports, were experienced in the ways of financing trade. Trust is, of course, the basis of credit. The must trustworthy are, at least theoretically, one's own relations and European merchants had for generations found it convenient to place relatives in the ports with which they dealt, but you can't have relatives in every port and by the eighteenth century merchants in Newcastle as elsewhere had become part of an international network of merchants who trusted each other and would accept without question each others bills of exchange.

The career of Ralph Carr (1711–1806), one of Newcastle's most successful merchants, illustrates the economic and financial changes that were taking place. Ralph's father John Carr, a Merchant Adventurer who also had a multiplicity of interests in the coal trade in lead mining and ship owning, left him a house, estate and a few thousand pounds but by the end of his long life Ralph was a considerable landowner and the sum of all his wealth and possessions must have been around £200,000. John Carr had allowed his membership of the Merchant Adventurers' Company to lapse so Ralph had to serve an apprenticeship. It was still essential to be a member of the company if one was to thrive as a merchant in the Newcastle of the 1720s and 1730s. During his apprenticeship, he took time off to prepare himself for trading ventures by visiting northern France and the Low Countries together with several Baltic cities. The defining characteristic of Carr's business ventures was variety. He, like most merchants of the period, did not confine himself to the buying and selling of merchandise. His activities included

operations that would now be carried on by shipowners, shipbrokers, underwriters, general merchants, commission agents, bankers and, we might almost add marine store-dealers. Nothing seems to have been too large or small for him.[39]

Carr was involved in trade with the Baltic and the American colonies; he had interests in lead mines, an alum works, a whaling enterprise and a glass works, and was a 'proprietor' in the British Linen Company. As a merchant, he extended credit and loans, and by the time of the 1745 rebellion was able to provide £30,000 to pay the troops of the Duke of Cumberland's army in Scotland. It is, thus, unsurprising that he was the main partner in the foundation of Newcastle's first bank, arguably the first proper bank outside London and Edinburgh, in 1755. The role of credit and banking in making possible the increasingly complex and sophisticated eighteenth-century economy has been underestimated; the coming of provincial banks was crucial to the advancement of commerce.

Those who don't know Newcastle often think of it as a manufacturing town but it has always been mainly a commercial and administrative port town but one set in an area which for much of the modern period has been dominated by extractive and manufacturing industries. Tyneside had in the eighteenth century a plethora of manufacturing industries, many of them by-products of or interlocked with coal. The salt pans at the mouth of the river fired by low-quality coal produced around 15 per cent of the national salt production and much of it was shipped to foreign ports.[40] Glass making had become established on Tyneside in the seventeenth century by the end of which there were 15–20 glass works in or near Newcastle;[41] their number had not increased by the 1770s but output and variety had increased with different firms producing bottles, cheap soda glass and the delicate glass that was worked on by skilled engravers of which the most famous were the Beilbys. Glass making needed sand and was therefore usually made close to coasts (as at Seaton Sluice) but by happy chance colliers came to Newcastle with ballast cargoes, usually sand. Other manufactures linked to coal were soap, paper and pottery.

Lead mining was probably more profitable than coal mining though its scale was smaller. The high price of lead in the late seventeenth and early eighteenth centuries made the fortune of William Ramsay, son of a Newcastle goldsmith, and many others. Between 1731 and 1734 Sir Walter Calverley Blackett made

£5,500 each year from his mines in the Allen and Weardale valleys.[42] The export of grindstones has a less spectacular history but grindstones were a steady earner over centuries and in 1731 nearly 6,000 tons were exported from the Tyne.[43]

Most of Tyneside's exports were raw materials extracted from the soil or intimately connected to the main extracted material, coal, though agriculture played its part in the export market with Northumberland becoming for a short time an exporter of corn. Iron making and iron products were in a different class for, although stimulated by demand from the coal industry for iron wheels and rails and the maritime need for anchors and chains, the iron industry represented an industry which for most of the eighteenth century used charcoal rather than coal. Ambrose Crawley's works in the Derwent valley was a wonder of the age with its vast workforce and an annual wage bill of £20,000. It used local supplies of iron and exploited the water of the Derwent River as well as imported Swedish iron.

The bulk of extracted and manufactured products was exported from the Tyne and Newcastle controlled the river. It had the expertise, the shipping offices, the merchant houses, the banks and the Custom's House, which facilitated the export of those products as well as the import of the timber from the Baltic and the iron from Sweden which industries needed. The town clung on to its traditional rights and privileges, stunting so far as it was able the growth of rival riparian towns. It was impossible, however, to maintain the tight control of former times. Newcastle was more than 8 miles from the sea, and North and South Shields provided a convenient harbour without the difficult and sometimes dangerous journey upriver and were able to provide many of the services that shipping required. The town could no longer enforce ancient edicts against the practice of trades without its walls. Shipyards grew up along the lower reaches of the river and soon the greater number of ships built on the Tyne were built in such yards. The channel was narrow and the illegal dumping of ballast by ship masters who avoided paying the fees for depositing it on ballast shores made it narrower. Even the quay at Newcastle was unsuitable for many vessels. In 1774 Constantine Phipps, who contested the election that year, indicted the Tyne as 'a cursed horse-pond'. Yet, as the annual Ascension Day flotilla led by the mayoral barge proclaimed, Newcastle continued to assert its rights over the entire navigable river based on the town's charters. As the charter granted by Queen Elizabeth in 1589 put it:

The town is to extend to such bounds, etc, as from time beyond the memory of man runneth not to the contrary, and in the river Tyne from Sparhawk in the sea to the Hedworth Streams.

Whether it was in the town's long-term interests to continue to assert its ancient hegemony can be questioned. The trade of the river as a whole may well have increased faster and manufacturing growth may have been stimulated by a more laissez faire approach; the town's prosperity might have gained more from simply being the centre and natural capital of the riparian economy than from being its somewhat selfish master. Newcastle's population growth was slower in the late eighteenth century than that of many other major towns and manufacturing in adjacent areas seems to have failed to realise the promise it exhibited earlier in the century. Yet there were benefits from the town's continued position as master of the river. Had other towns such as North and South Shields been allowed to flourish, as they might have done without Newcastle's interference, they might well have become major ports a century earlier than they did and acquired the complementary professional and technical infrastructure.

As it was, by hanging on to its ancient command of the river until the 1850s, Newcastle assured its position as a commercial and administrative capital and this was to continue even as its legal mastery was eroded. The slower growth of the town's population was more apparent than real for the perseverance of the old boundaries meant that adjacent areas were not included. Above all there were many indicators of prosperity: social and cultural life was vibrant; there were fine new buildings; and more and more shops.

Newcastle was governed, as we have seen, by a close elite group; 'the town council and local offices of importance were dominated by members of a number of leading families, Claytons, Bells, Andersons, Cooksons and Brandlings passed municipal office among themselves'.[44] They looked after their own interests well, but, on the whole, they also governed the town well by the standards of the time. The charges against the Corporation that it neglected the maintenance and improvement of the river, have some substance, though there's little evidence that the town's freemen electorate was concerned. The argument that it should have encouraged canal building and in particular a scheme to link Newcastle and Carlisle by a combination of alterations to the river above Newburn and canals is

more dubious. It's not clear that the town or Tyneside was disadvantaged by not developing canals and a waterway between Newcastle and Carlisle would have been a massive engineering challenge which the limited trade such a waterway would have carried could scarcely have justified.[45] On the credit side, the Corporation was responsible for overseeing and encouraging the development of the town as a provincial centre that was more than simply a place for business but became a social and cultural capital for a wide hinterland.

A Town Fit for Polite Society

The general tendency for towns to aim to be centres of culture, social life and entertainment during the eighteenth century has been well documented.[46] Aristocratic and greater gentry families might well see London as their home for part of the year when they visited it for the season, but they also sought diversions in their nearest provincial town as well as at the spas and seaside resorts that became popular during the eighteenth century. In Newcastle, as in other towns, county families had for long maintained town houses and, as new fashionable streets and squares were built, junior members of such families, especially widows and daughters who had not married, found it more enjoyable to live in town than in the countryside. At the same time, the middle ranks of society were expanding and many well-to-do merchants and professionals and their wives had widened horizons and social ambitions and were increasingly better educated. As the numbers of gentry, professionals and merchants reached a critical mass, a polite society was formed. The size of a town and its cultivated and/or aspiring sectors were crucial. You might be a highly cultured and fashionable individual in a small market town but, if you had few similar fellow townsfolk, you couldn't enjoy genteel society, bookshops, milliners or an assembly room. The new polite society of Newcastle had its layers and divisions but none was capable of providing by itself the necessary amenities and public spaces for a fashionable social milieu.

The interaction of county and town was facilitated in Newcastle by common interests in the coal trade and the centuries-old process by which county families had sent younger sons into merchant houses. Gentry and merchants, lawyers, doctors and clergymen all found houses in prestigious areas away from the commercial quarters

of towns. A spirit of emulation sought in housing, dress and entertainment to follow the lifestyles of the aristocracy and gentry of London. A consumer revolution was under way and made the fulfilment of such aspirations feasible as towns acquired shops which were able to provide furniture, clothing and china all in the latest styles.

For such a society to flourish, the right physical environment was crucial. Fashionable shops to cater for growing consumer demand, elegant streets and squares for the genteel to live in, and places for elevated entertainment, at once public and exclusive, were required. Newcastle already had some fashionable areas and streets at the beginning of the eighteenth century but was to acquire many more by its end, along with fine new shopping streets with pavements and glass-windowed shops, and theatres and an assembly room. The town did not to expand far beyond its old walls until well into the nineteenth century, although its internal shape was modified as new development took place. Here and there Newcastle edged cautiously beyond its old defences with a few extra-mural streets but, until 1835, the keelmen's crowded Sandgate remained the only substantial suburb outside the traditional bounds of the town.

Both Corbridge's map of 1723 and the map in Bourne's *History of Newcastle* (1736) show a town little changed in its main layout and essential characteristics from the previous century or, indeed, from the medieval town. Within the walls, large open spaces survived. As well as the extensive grounds which surrounded the Blacketts' mansion, the Newe House, there was Carliol Croft which had a pathway skirting the inner town wall 'much frequented on a Summer's Evening by the Gentry of the Town'.[47] The intrinsic problem of the town's topography, the height of the upper town and the streams in their valleys, meant that both main north to south routes from the bridge involved steep climbs. Traffic could proceed from the Sandhill via an arduous climb up The Side and then to the Bigg Market and Newgate Street. Pilgrim Street was the other main route and took the traveller out of the town towards Jesmond but even after the lower part of the Lort Burn had been filled in the road to it from the Sandhill and up Butcher Bank was difficult; most heavy carts and carriages proceeded from the Sandhill along the Quayside and then went to Pilgrim Street via Broad Chare. Nor was there any convenient east to west route across the town for wheeled traffic.

This was, then, a compact town in which lived a growing population. Estimates of population are unreliable but point to a doubling of the population during the

eighteenth century from about 14,000 to 28,000. This increase had mainly to be squeezed in to the existing space and this was done unevenly with the Sandgate and the chares behind the Quayside becoming ever more crowded and squalid; by 1811, the nine houses in Hornsby Chare had 136 people living in them and there were 53 people in the three houses in Plummer Chare;[48] unsurprisingly, by the later decades of the eighteenth century, population growth was sustained by immigration, the death rate being greater than the birth rate.

As early as the 1730s, Henry Bourne detected a movement of the wealthier inhabitants to the upper part of the town. Upper Pilgrim Street and Westgate were, he considered, the more salubrious areas where merchants lived with Fenkle Street being particularly favoured by clergy and gentry, while he described The Side as 'formerly' inhabited by the wealthier merchants. Such a movement was, indeed, under way but it was a slow process and would not be complete until the early nineteenth century. As later as 1778 it has been estimated that of forty-one members of the urban hierarchy (the mayor, the recorder, town clerk, aldermen and councilmen) twenty-two lived in the lower town, five in streets outside the town walls, one (Sir Matthew White Ridley) outside the town altogether at Heaton Hall and the rest were scattered around the upper town.[49] By 1827 not only were many of the leading citizens of the town living in the new streets outside the town walls but some had moved out further to what was still country, Benwell or Jesmond.

Improvements to the town were discussed by the Corporation before mid-century but development did not really get under way until the 1780s. After the 1745 rebellion the lingering feeling that the town walls might yet be needed for defence disappeared and between 1763 and 1812 stretches of the walls were pulled down, beginning with the portion of the wall along the Quayside. At the same time, the Corporation was considering plans for new streets to improve the route from the Sandhill and the Quayside to the upper town. These were delayed by the disaster of 1771 when, after intense rainstorms, the swollen Tyne carried away Newcastle's bridge along with every bridge over the river except for that at Corbridge.

The bridge at Newcastle had probably weakened over time with increased traffic putting a strain on the arches, while the piers, resting on stilts driven into the riverbed, had been damaged by previous floods, debris and collisions when

keels hit them; in addition ballast had built up on the riverbed between the piers. Terrible scenes accompanied the destruction of the bridge in the early hours of Sunday 17 November for, as arches fell into the river, families were swept away with their houses, while others were marooned on the remaining parts.

Ferry services were set up and within a year a temporary wooden bridge had been built, but the town was faced with the expense of building a new bridge and the question of where to build it. The most imaginative proposal was for a bridge at a higher level, running from near the castle to Pipewellgate in Gateshead, the path later taken by Stephenson's mid-nineteenth-century High Level Bridge. This would have done away with the problem of the steep gradients encountered by through traffic on both sides of the river. Should a replacement be constructed on the traditional site or at a higher level? Newcastle Corporation engaged a consultant, Robert Smeaton, who proposed a low-level bridge from the west end of the Close; though less radical a solution than a high-level bridge, this would have been a wide bridge (30 feet) and new roads would have made gradients less steep than those from the old bridge. The Corporation supported Smeaton's proposal but Gateshead and its leaseholder and protector, the Bishop of Durham, were against any plan for a bridge in a new position, feeling that it would take trade away from Bottle Bank, where most Gateshead tradesmen had their premises, and the Bishop refused to contribute to the building of any bridge unless it was on the old site. Eventually, with Robert Mylne, the designer of London's Blackfriars Bridge, in charge of the Gateshead end and John Wooler in charge of the Newcastle end, a new bridge replaced the old one at a cost of £30,000 and was opened to traffic in 1781.

If a high-level bridge had been built in the 1770s, then the town's development would have been accelerated considerably but, at least, with the completion of the new bridge other plans for urban development were able to go ahead. The filling in of the upper part of the Lort Burn between The Side and the grounds of Anderson Place had long been talked of but in 1784 Nathaniel Clayton, the Town Clerk, and Alderman Mosley, were instrumental in seeing that work was begun on the scheme. Dean Street was built over the steep ravine and burn while Mosley Street made for an east–west connection running across Dean Street and joining Pilgrim Street with the market area to the north of St Nicholas's. Collingwood Street, a logical extension westwards, did not follow until 1810.

131

The new streets were broad and had pavements from which pedestrians could gaze into the windows of enticing new shops as excellent, it was claimed, 'as any out of the Metropolis'.[50] As an important cartographical study of Newcastle's development states:

> [A] fundamental contrast emerged between the streets dominated by the remains of the medieval burgage plots with their long narrow units of landownership, running back from the street frontage approximately at right angles, and the newer streets with much shallower building plots.[51]

The former, many of them formerly the sites of integrated enterprises with the merchant's house and business place in front and workshops and warehouses behind, saw the back quarters taken over by numerous enterprises or crowded housing.

Areas of the town had become increasingly segregated and, if there had always been extremes of poverty and ghastly living conditions, these were by the late eighteenth century set apart from the streets and squares where polite society lived and were located in the older riverside parts of the town. As we have noted, the movement of the wealthier classes away from the river was a slow process and the Sandhill and Close managed to retain their respectability until after the beginning of the nineteenth century. It was from the house in the Sandhill of her father, the substantial businessman Aubone Surtees, that in 1772, Bessie Surtees eloped with the young John Scott, later Lord Eldon. The new residential areas of Hanover Square (1720, but never completed), Clavering Place (1780s) and Charlotte Square (1770) to the west of the upper town were, however, becoming the fashionable places to live. Lower Pilgrim Street was losing its wealthier inhabitants though the upper street continued to have prestigious residences, some of them the town houses of rural gentry and others – like 'Alderman Fenwick's House', a fine brick-built edifice which still survives – homes of influential townsmen.

These physical changes provided the context for social and cultural developments that made for a town that was a more convenient and stimulating place to live in and to visit for the more prosperous members of society. From mid-century the development of Newcastle as a centre of fashion and sociability,

providing entertainment, shops and a cultural life for a polite society became more rapid. Newcastle and its vicinity has been seen as having a lot of catching up to do, having little reputation for sophistication earlier in the century, however much it was noted for its wealth, but as catching up rapidly. Edward Hughes wrote of a 'Caucasian spring' in the North East as a whole, a sudden flowering of a more cultured and genteel way of life reflected in houses built for ease and comfort and a refinement of manners and taste.[52] A study of the household possessions in the North East 1675–1725 has suggested that, at least in terms of clocks, earthenware, china, books and curtains, this portrait of rapid change may have been exaggerated as in this respect the area was not substantially different from other parts of Britain, though with a greater distinction between urban and rural areas.[53] The constant maritime traffic between the Tyne and Wear and London may well have facilitated the acquisition of such goods as they were shipped on returning colliers. The acquisition of goods that had once been rare and confined to the rich paralleled and to an extent fuelled changes in social attitudes. There were bitter complaints throughout the eighteenth century about the way people were emulating their betters, becoming ambitious and generally getting above their station. A new spirit of individualism and self-betterment was abroad. By 1757 Newcastle was certainly no cultural backwater and Paul Langford has ranked Newcastle as by then seventh of the 'polite' provincial towns in England in part due to the number paying duty on silver plate, just one less than Bath.[54]

Cecilia Fiennes had in 1698 thought Newcastle 'a noble town tho' in a bottom, it most resembles London of any place in England' while Daniel Defoe had found it 'a spacious, extended and infinitely populous place' in the 1720s. Neither, and especially Defoe, were in the business of giving towns bad write-ups but the view as one approached the town and the spectacle of its business and commercial prosperity seem to have impressed most visitors. Whether either traveller would have found the town's social and cultural life satisfying if they had stayed longer is questionable. Fiennes mentioned the delights of the Forth with its bowling green, walks, gardens and a 'fine entertaineing house'. Fun, no doubt, but several decades later there was a much more vibrant social life.

Early in the eighteenth century, social pleasures remained somewhat limited. There were coffee houses but otherwise Newcastle had little in the way of places

of public entertainment for respectable society. There were pleasant walks for, as well as the Forth and the path beside the town walls at Carliol Croft laid out around 1730, there were the woods at Pandon Dene. The Town Moor became the setting for horse racing and an elaborate stand was constructed and for males of all classes there were other sporting events such as cockfights, while the hunt still met in the centre of town. Civic occasions accompanied by much junketing still punctuated the cycle of the town's year at the times of the quarterly Assizes, race week in June, Ascension Day and the inauguration of the Lord Mayor and Sheriff, but in general social life for the elite was essentially private: a round of card parties, musical evenings and balls in the drawing rooms of town houses. It wasn't until 1763 that Spring Gardens, modelled on the London pleasure garden of Ranelagh, opened.

In the last half of the century the town became more sophisticated as leisure pastimes and social and cultural events gradually came to occupy public as well as private space. An expanded 'Quality' demanded a commercialised leisure. As has been argued:

> Theatre, music, dancing and sport – these were the cultural pastimes for which the prosperous gentry and the new leisured middle class hungered. But their houses were not large enough for private theatres, for private orchestras and private concerts, nor had they the money to lavish on such conspicuous aristocratic consumption as a string of race-horses.[55]

Newcastle life became richer and more varied. Charles Avison, the organist at St Nicholas's, began his series of public concerts in 1736. Tickets cost half a guinea and the recitals usually took place in the assembly rooms. Such concerts became a feature of Newcastle's cultural life for nearly a century. Assemblies were an important manifestation of the trend for greater sociability among polite society; they were places to display one's taste and one's fashionable dress, to meet friends and perhaps find future husbands or wives, and to listen to music or to dance. No town with aspirations could afford not to have one. Assemblies were first held in Newcastle in 1716 in a house in Westgate Road and in 1736 a new Assembly Room was opened in Ridley Court. Lord Eldon remembered youthful flirtations in Ridley Court and how a couple could dance from the large room across the

landing to a smaller room which was 'very convenient, for the small room was a snug one to flirt in'. Assembly rooms with their concerts and balls were a halfway house between being private and open to the general public as they were usually organised on a subscription basis.

It was an important landmark in the town's cultural and social progress when its first purpose-built Assembly Rooms opened during Race Week in 1776. Designed by William Newton, who also built nearby Charlotte Square, it was said to be second only to the House of Assembly in Bath. The list of those who bought shares at £25 each provides, as Helen Berry has pointed out, 'a means of gauging the social composition of "polite society" in Newcastle at the time'.[56] She estimates that 42 per cent came from the nobility and greater or lesser gentry and some 30 per cent from the wealthier members of Newcastle's civic elite but concludes that: 'Attempting to distinguish between county gentry and urban professional groups is in many respects an artificial exercise, since many individuals had business or family ties with both interests'.[57] As was natural, the Duke of Northumberland and his son, Lord Algernon Percy, were the largest subscribers, contributing £700 between them; the Duchess, who died early in 1776, had also been a keen supporter.[58] When Sir William Lorraine with Mrs Bell and Sir Matthew White Ridley with Miss Allgood stepped onto the floor to open the Assembly Rooms, they opened Newcastle's most important social centre. This new public space was open not only to subscribers but to their friends and this widened even further the society that gathered there for dances, lectures and musical recitals. It provided opportunities for men and women to meet and many courtships began there. Such increased sociability was not without its dangers, especially at the larger, 'land mark' assemblies, for unsuitable marriages could come of it, as with the elopement of Lord Tankerville with a butcher's daughter whom he had met at an assize ball.[59]

Theatre in the shape of groups of travelling players had been common enough in Newcastle since the mid-sixteenth century, waxing as the old plays of the mysteries waned, but had been frowned upon during the Commonwealth with players punished by the town's officers. Even after the Restoration, plays tended to be put on in the Castle Garth to escape the attention of the municipal authorities.[60] By the early eighteenth century, however, race week and Assize week saw a variety of theatrical performances. The *Beggars' Opera* was staged in

Usher's Raff-Yard in Queen Street in 1728. Northumberland's enclave in the town continued to be a main venue for popular theatre. It was only with the opening of a theatre attached to the Turk's Head Inn in Newgate Street in 1747 that play-going attracted fashionable society. When Mosley Street was built, a new theatre, the Theatre Royal, opened facing the top of Dean Street. It opened in 1788 and from 1792 was managed by Stephen Kemble, brother of Charles Kemble and Mrs Siddons, and many of the most prominent actors and actresses of the day appeared there.

Mrs Elizabeth Montagu, the lioness of London literary salons and 'Queen of the Blues' (bluestockings) was, in 1760, somewhat reluctant to accompany her husband to take up their valuable North East inheritance, which included the early seventeenth-century mansion Denton Hall, feeling that she was venturing from light to barbarism. She described Newcastle as 'horrible. Like the ways of thrift, it is narrow, dark and dirty.' She soon entered into the social life of the town, however, and wrote to Lord Lyttleton:

> I am actually an inhabitant of Newcastle and am taking out my freedom, not out of a gold box but by entering into all the diversions of the place. I was at a musical entertainment this morning: I have bespoke a play for tomorrow night, and shall go to a ball, on choosing a mayor on Monday night.[61]

She did, however, complain that conversation was limited as 'it always turns upon money'. This was not just south country condescension, for the Reverend Dr Alexander Carlyle, used to Edinburgh literary circles, found Newcastle male society lacking even if the women were acceptable; the men were 'ill-educated while the ladies, who were bred in the south, by their appearance and manners, seemed to be very unequally yoked'.[62]

Mrs Montagu's Denton Hall was only some two miles out of Newcastle but she felt it necessary to maintain a town house. The journey back to Denton, after a night at the Assembly Rooms, the theatre or a private house party, would not just have been tedious and uncomfortable but probably dangerous. Even in the town, there were few street lights; some had been erected in Dean Street, Mosley Street and in the area around St Nicholas's, but it was only gradually that oil lamps were spaced sparsely around the whole town. After a civilised evening, fashionably

dressed ladies and gentlemen would have to make their way homeward, perhaps in their own sedan chairs or one hired from the rank in Upper Pilgrim Street, guided by servants holding lanterns.

After mid-century, there could be little doubt that Newcastle was in the first rank of provincial towns when it came to the cultural and social opportunities it offered to polite society. Its distance from London meant that the bulk of the more prosperous inhabitants and many of the rural gentry were content to create their own rounds of pleasure and entertainment but, as a major port with a busy trade with the capital, Newcastle was very open to metropolitan influences. London fashions quickly made their way to the town and one significant sign of this was the growing number of shops that catered for the elite and were full of goods imported from the Thames.

Shopping had become much more than a utilitarian activity in England and foreign visitors were amazed at the large glass windows and the elaborate displays designed to make shopping an experience. Such emporiums were at first found in London but soon spread to other towns and in Newcastle graced the new streets of Dean Street and Mosley Street with their flagged pavements. Newcastle benefited from the constant sea traffic between it and London. It was some twenty times cheaper to transport goods by sea than by land and ships bound for the Tyne were usually in want of cargo. London goods and London fashions found their way to Newcastle shops quickly as did the the latest play or the latest dance. The aristocracy, greater gentry and richer merchants were pretty hardy when it came to travel and would make their way down the Great North Road over its manifold potholes in badly sprung carriages and stagecoaches for the season, to visit relatives or be presented at court, while increasingly they sent their offspring to schools in the south or to university.[63] At mid-century such journeys took six days, although by 1784, due to better post-roads, turnpikes and coaching services it was down to three. Mail was carried daily up and down the Great North Road.

To what extent Newcastle and its environs retained a distinctive culture or became part of a national culture has been much discussed. 'We imitate your fashions, good and evil' proclaimed one Newcastle writer and there can be little doubt that Newcastle was much more part of a homogeneous English culture by the early nineteenth century. English or British? one might ask, for Edinburgh

influences played a part as well: in the contacts with the Scottish Enlightenment, in commerce, in religious links with Newcastle Nonconformity and via the many doctors trained in the Scottish capital. But the ties to London were stronger and as in other towns:

> Polite culture used London's resources: provincial theatres employed London players, their concerts relied on professional performers from the London pleasure gardens and theatres, portraits hung in provincial parlours were painted by London artists during their summer tours. The provinces followed metropolitan fashion: the theatre repertory mimicked that of the London houses, local orchestras bought their scores from London sheet music-sellers, and images from London's print shops affected taste in the graphic arts all over Britain.[64]

The view that provincial towns should have produced distinctive art cultures of their own is fanciful. Newcastle and its environs provided talent for the developing national culture and received back that culture.

Along with Thomas Bewick, Charles Avison was the most important figure in Newcastle's cultural milieu.[65] Born in Newcastle, he supplemented his £20-a-year salary by teaching, but also achieved a national reputation as a composer, publishing fifty concertos and a number of sonatas. Subscription concerts had become a popular part of the London season and Avison's were held fortnightly each winter. He also organised benefit concerts and music at Spring Gardens. Music was an important part of eighteenth-century social life. A taste for music was expected of a gentleman and the ability to play was a mark of sensibility while ladies were expected to play as one of their accomplishments and some became expert musicians. There was not, however, the pious attitude to music that developed in the nineteenth century when music came to be regarded as imparting an almost spiritual experience and secular musical performances were largely accompaniments to sociability. We must not therefore picture the audiences at Newcastle concerts as sitting in dead silence while they concentrated solely on the music but as chatting to each other, greeting friends and probably drinking a glass of wine or eating an orange while the music was played. In his *Essay of Musical Expression*, Avison was rather ahead of his time in contrasting sublime and elevating music with simply graceful and elegant music, thus anticipating Romanticism. His influence was considerable: William

Shield, who went on to become Master of the King's Music and the composer of the opera *Rosina*, was a pupil of his; and he can be said to have been central to the town's musical culture and to its social life. His eldest son, Edward, and then his second son, Charles, succeeded him as organists to St Nicholas's church and as teachers of music. The second Charles Avison was a popular figure at the musical evenings of high society whether held at neighbouring manor houses or in the town houses of the urban elite.

Avison was a close friend of the Reverend John Brown, Canon of Carlisle and then Vicar of Newcastle 1761–5. Nicknamed 'Estimate' Brown after his *Estimates of the Manners and Morals of the Times* (1757), which railed against a supposed national decline caused by commerce, Brown shared a love of the landscape, literature and painting with Avison. It's a testimony to the national cultural and intellectual network to which Avison belonged that among those who assisted him with his *Essay on Musical Expression* were, as well as Brown, the Newcastle bookseller Joseph Barker, and Robert Shafto, such national figures as the poets Thomas Gray and William Mason, and the historian John Jortin.

Mark Akenside, physician and poet, became an influential member of London literary society. His *The Pleasures of the Imagination* drew on Addison's essays on the imagination published in the *Spectator* and he wrote fortnightly articles and reviews for the *Museum: or, Literary and Historical Register*. Akenside, a member of the Royal Society and the Royal College of Physicians, who became the Queen's Physician, was a somewhat pompous man[66] who had little time for Newcastle once he had found fame in London. Nevertheless, Newcastle was proud of him and renamed his birthplace of Butchers' Bank 'Akenside Hill'.

One aspect of the developing national culture was, paradoxically, an increased interest in locality, its past and even its demotic culture. John Cunningham, though born in Ireland, lived for most of his life in Newcastle; his poems were a mixture of the pastoral, the patriotic and the demotic, a poet with one foot in high and the other in popular culture. Then there was Edward Chicken, who described the drunken and boisterous aspects of local life with affection and wit; his poems seemed too bawdy and rough for some of polite society but *The Collier's Wedding*, his best-known poem, went through many editions. He was an acute observer who neither elevated nor sentimentalised those he described, as with the wedding guests who arrive at St John's church:

The gates fly open, all rush in,
The church is full with folks and din;
And all the crew, both great and small,
Behave as in a common hall.

In music, William Shield was a great collector of folk tunes from Northumberland which he rearranged and elaborated on in his operas. As ever, there was interchange between high and popular culture.

If there is one period in Newcastle's history when the case can be made for the town as an innovative centre for the arts, it is during the last decades of the long eighteenth century. As Paul Usherwood has argued:

[There] has so far been only one moment when the town (later city) could claim a genuine art of its own and this was at the start of the 19th century, during the age of Bewick.[67]

It is possible to consider Bewick as either an innately local artist wedded to subject matter drawn from the life and scenes of Newcastle and the banks of the Tyne or as an instance of a talent whose work chimed in with metropolitan and even European intellectual preoccupations. What seems certain is that it was the growth of print culture in the town which provided the opportunities for Bewick.

Newcastle had become by the end of the eighteenth century a major centre for printing with twenty printers, twelve booksellers and three engravers. Books could be read at the library of St Nicholas's church (endowed by Sir Walter Blackett) or, if one could afford the charges, be borrowed from the circulating libraries which catered for the growing appetite for reading in Newcastle as in other towns. The town's first newspaper, the *Newcastle Courant*, was printed in 1712. It was to last until 1902 and was followed by the *Newcastle Journal* (1739–88), the *Newcastle Gazette* (1744–55), the *Newcastle Chronicle* (1764–present), the *Newcastle Advertiser* (1788–1814), the *Tyne Mercury* (1802–42) and the new *Newcastle Journal* (1832–present).[68]

Whether we term the culture home-grown or part of a cultural network based upon London, there can be little doubt that its cultural life attained a dynamism

and vitality during the period roughly commensurate with Bewick's lifespan. It benefited from the convergence of a number of trends: a polite society demanded books, glassware, paintings and furniture as well as fashionable clothes and assembles and theatres at which to wear them; new technologies and innovations enhanced old crafts and led to new ones; the spirit of the Enlightenment encouraged enquiry, scepticism, the recording and cataloguing of the natural world, while sociability, discussion, clubs and societies came to be seen as essential to progress.

The brothers William and Ralph Beilby in their workshop at Amen Corner engaged in all sorts of engraving work of which the best known is the enamel graving on glass done by William and his sister Mary, which was among the best in Europe. Ralph was the businessman of the partnership and, after his brother and sister moved away from Newcastle, Thomas Bewick, who had made his way from his father's farm at Cherryburn to be apprenticed to the Beilbys, became a partner in 1776. Bewick worked as woodblock engraver and book illustrator. Wood engraving did not rank high in the hierarchy of art but Bewick was an artist of genius who transformed his craft. His would have been a great talent whatever the milieu of his time and place, but it was the context of the Newcastle of his day and the intellectual attitudes of the late eighteenth century that enabled him to project his work on a national scale. The reading public had increased, interest in the classification of birds and animals was high and prosperous families were concerned that books for children should be entertaining as well as improving, while Newcastle was a publishing centre. Bewick's *General History of Quadrupeds* (1790), his *Land Birds* (1797) and *Water Birds* (1804) and children's books such as *The Fables of Aesop* (1818) found a wide readership. A Deist, 'He claimed to be more than a simple transcriber of nature; he avowed that his greatest aim was to reconstruct, orchestrate and present God's great design'.[69]

The 'Bewick period' saw a cluster of artists working in Newcastle: Thomas Miles Richardson, J.W. Carmichael, Thomas Carrick, Henry Perlee Parker, Thomas Richardson and David Dunbar. Although Newcastle was to be tardy in founding a municipal art gallery, the 1820s saw the foundation of two institutions designed to promote fine art: the Northumberland Institution for the Promotion of the Fine Arts in the North of England and the Northern Academy of Arts, the latter housed in the fine building erected in Blackett Street to Dobson's design. If the

view that, after Bewick's death in 1828, 'art life in Newcastle generally languished' and 'most of the key artists began to leave'[70] is sweeping, it seems essentially true of the fine arts but, if we consider architecture, then Newcastle's great period must be held to have lasted a decade or so longer. Between *c.* 1780 and *c.* 1840 David Stephenson, William Newton, John Green, and John Dobson were only the foremost among the architects who created, along with Richard Grainger as developer, builder, speculator or planner, the Newcastle that Nikolaus Pevsner, writing before much of it was destroyed, termed 'the best designed large city in England'.[71]

The social and cultural world that was open to the educated and prosperous sections of Newcastle society provided exciting new opportunities for women from merchant and gentry families. In general the amount of freedom given to young women increased, more care was taken over their education, and affectionate relations and trust between fathers and daughters grew. Balls, lectures and concerts took place in what may be termed controlled public space. The controls were, however, relatively flimsy in that such events were open to anyone whose dress and manners fitted in and had the money to pay the subscription or entrance fee. For the young woman in search of a husband this had the effect of widening the field of possible partners. There were dangers in this as parents were aware – for sons as well as daughters, as we have seen with Lord Tankerville's alliance with a butcher's daughter – but less so in a town like Newcastle than in watering places like Bath or Scarborough where adventurers might seek to trap an heiress. Daughters were still expected to make suitable marriages approved by their parents but were confronted by a far greater choice of partners than when they had to rely upon introductions in private houses. Assemblies provided exciting company. Rhoda Astley of Seaton Delaval Hall described a visit to an assembly in Newcastle at mid-century in a letter to Lady Delaval, her sister-in-law: 'Yesterday sennight we were all of us at Newcastle assembly. There was a great deal of good company. It was the day of the Mayor's Feast. Ridley is Mayor. My Lady Blackett was there, and made many enquiries after you.'[72]

Later in the century the widened social and cultural opportunities for young women had widened further as is illustrated by the experiences of Annabella Carr, the eldest daughter of the successful merchant and banker Ralph Carr. The Carr family divided its time between the main family home, Dunston Hill, a

few miles from Newcastle on the south bank of the Tyne, and their town house in newly built Charlotte Square, with occasional visits to Hedgely Hall in north Northumberland which Ralph had recently acquired. Annabella and her sister, Harriet, were given a freedom that would have horrified mid-Victorians and there was no nonsense about some intellectual pursuits being unsuitable for women or, indeed, that there was a choice to be made between being serious and enjoying balls and flirtations.

In 1780, Annabella, at the age of sixteen, wrote to her brother John of her success at the Election Ball at the Assembly Rooms:

> I danced with (to use Papa's expression) the Baronet Williamson [of Whitburn Hall] who I also dined with last Sunday … This particular attention to your humble servant was noticed by the whole room … I forgot to tell you that Bowes very politely asked me to dance with him at the last Guild Assembly as did Lord Lindores and Baron Norton [son of Lord Grantley] but I was engaged to Williamson – this is ostentation I know but it is to let you know that I'm in fashion with the beaux at present.

Annabella was a talented musician and she and friends, including the younger Charles Avison, performed for their own pleasure and to small audiences at Dunston Hill and Charlotte Square and she rarely missed a professional concert. A good horsewoman, she would ride into Newcastle to attend lectures on mechanics or 'Hydrostaticks and the doctrine of fluidity'. She corresponded with the poet George Crabbe, and in 1807 published a book, *Conversations on Chemistry*.

The social life of the town was much enlivened when a regiment of militia was encamped in its vicinity. From 1781, there were militia camps at Stella only a few miles upriver and the presence of the militia meant parties and balls and opportunities for young ladies to meet dashing officers who might be prospective spouses. Annabella Carr recorded one hectic day in a letter to her brother. After attending a review of the militia after which there was a breakfast given by Lord Adam Gordon, she returned home with friends for a musical soirée:

> We then came home … and had Monsieur Noser [Noserre, a professional musician], Mr Milner, Wallace, Captain Rudyard, Sir Thomas Clarges, Mr Beilly of the East York

(who plays very decently) to dinner – and in the Afternoon had the band and a little concert. Mr Webbersley was our violincello, and acquitted himself with great éclat.

Then they went on to the assembly.[73]

Like any society, that of Newcastle was, on close observation, made up of a number of what can be termed subcultures but they overlapped and were part of a broad pattern, even when they appeared disparate and antagonistic. Polite society encompassed aristocrats, gentry, merchants and professionals and was bound together by a permeable social life and a loosely Anglican religious identity. Then there was Nonconformist society, the more stalwart members of which held themselves apart from balls and musical evenings. Nonconformists included, however, Quakers, who were in this period inward-looking but had to do business, and Unitarians, whose freethinking ways drew them into association with Deists and radicals, many of whom came from the bookshops, printers and engravers with which the town abounded. The freemen of the town were a disparate bunch, enjoying their ongoing political privilege as the electorate and their declining influence over their exclusive trades, but this category embraced both wealthy merchants and a majority of artisans. Far from the bottom were the keelmen, who enjoyed reasonable wages in good times and while in good health, and below them came the semi-skilled, the unskilled and those who were usually near destitution. It was, nevertheless, a small town and, even as the sections of society lived further apart, people knew each other.

Enlightenment thinkers placed great stress upon the virtue of social and intellectual intercourse and admired sociability, the public man, the club and the society. In the age of the coffee house, assembly rooms, music societies and numerous voluntary societies, friendship and sociability could flourish as never before. Newcastle had always been a sociable place and until the eighteenth century the social life of burgesses and even of those, like the keelmen, who were not burgesses revolved around the common interest of their trade. The town was far from unique in this as in most towns it was guilds which had been central to urban life from medieval times, representing not just economic self-interest but a brotherly feeling expressed in a common social life marked by convivial dinners, rituals of admittance to membership, special ceremonial days and attendance at fellow members' funerals. Even as the economic significance of the companies and

societies formed by particular trades began a slow decline, their social dimension remained important. A recent study has argued that, although the thesis that patterns of socialising were indeed transformed in English towns from the Restoration is correct, an important continuity has been neglected. The conviviality of the trades companies in Newcastle was changed by the diminished importance of communal and civic celebrations but adapted to new patterns of leisure.

Companies not only incorporated rising leisure activities into their social calendars, but also acted as an important exemplar for the development of a new institution of sociability, the club.[74] Although many companies remained vital economic organisations until the end of the eighteenth century and most retained some of their older ceremonies, conventions and rituals, there was a tendency for a clubable side to assert itself and for regular dinners and social evenings in public houses to become popular. As in the City of London, membership of a company was a prerequisite for civic life and the right to vote in elections. As apprenticeships declined, it became usual for gentlemen to join companies as honorary members. Companies in Newcastle resembled by the mid-eighteenth century a halfway house between a trade association and a club.

If the guilds provided one model for clubs, the coffee house provided another. The tendency for like-minded men to form clubs and associations was a general one and Newcastle became a town of many clubs and societies: some were political and others had some worthy purpose, such as discussion of the issues of the day or philosophic enquiry; all involved eating, drinking and conviviality and for many these were their avowed purpose. In the political category there were by the 1780s the Constitutional, the Independent and the Society of Patriots. The French revolutionary and Napoleonic wars saw the formation of rival Pitt and Fox clubs. Freemasonry, 'rejoicing in British constitutionalism and prosperity, and dedicated to virtue and humanity under the Great Architect',[75] was a self-conscious development of the Enlightenment which grew rapidly nationally and was successful in Newcastle with St John's Lodge, founded in 1725, able in 1777 to move into its own hall in Friar Street. Freemasonry provided another version of the serious-minded but sociable club promoting brotherhood, benevolence, conviviality, liberty and civilisation.

There was a hierarchy of clubs. The Recorder's Club (the recorder was an important official in the Corporation) was founded as early as 1747 with a

membership made up of notable Newcastle citizens and the nearby county gentry. It often met in the house of a member, sometimes far from the centre of town, and meetings were fixed for nights when there was a full moon, as was often the case in a period when the lights of carriages provided little vision for the coachman. In 1828 the Northern Counties Club was formed in conscious imitation of the recently formed London gentlemen's clubs; in the 1830s, the club was installed in a fine, spacious and imposing building in Dobson's Eldon Square. Foremost among the purely social clubs and one with a wide variety of members of all classes was the Free and Easy Johns Club which as we have seen was important enough to be canvassed by candidates at election times. This was formed in 1778 and soon had over a thousand members. Like the Masons, members had their initiation ceremonies and secret handshake, but their purpose was simply conviviality. The Oddfellows provided a combination of a good night out, a bit of half-serious dressing up and mutual support; they had several branches based in public houses in the town.

There were clubs for almost every social group and viewpoint. Protestant anti-Catholic feeling found its associations in the early nineteenth century as the Orange Order spread to the North East and two Orange Lodges were founded in Newcastle.[76] Lodge 69, which met at the Cock Inn at the Head of the Side, had more than 700 members.

It was in debating, discussion and philosophical clubs that the Newcastle Literary and Philosophical Society formed in 1793 had its origins, though it also drew on the tradition of the public lecture programmes which had developed in the last decades of the eighteenth century and had models in the Lunar Society of Birmingham and the Manchester Literary and Philosophical Society. Swarley's Club which flourished in the 1770s and 1780s was dedicated to convivial but decorous discussion of literature, philosophy and politics. The Philosophical Society founded by Bewick and a group of friends had similar aims but was not always well behaved. Although its largely radical members aimed at rational discussion, that 'strong whig', Bewick, who was from a farming background, was so inflamed by Thomas Spence's attack on the private ownership of land that he knocked him down. The Literary and Philosophical Society, mindful of the passions that politics and theology could arouse and of the attitude of the authorities in the circumstances of revolution in France, excluded discussion of religion and 'all

Politics of the Day'. The society was much more consciously respectable than the clubs to which it was heir; the beery, inky world of engravers, booksellers and printers merged with the more genteel world of concerts and lectures. James Losh – whose statue by Lough, depicting him in a toga, dominates the staircase of the society – recorded in his diary that on 8 February 1820 it was decided that Byron's *Don Juan* was 'an unfit book for our library'.[77] The guiding light in its foundation was the Reverend William Turner, Unitarian and cautious radical, and its first president was John Widdrington, landowner and businessman (the second was to be Sir John Swinburne) and the membership was made up of radicals, worthies of the Newcastle establishment and Whig gentry. The Society met in a succession of premises, the Dispensary, a house in St Nicholas's churchyard, the Assembly Rooms and in the old assembly rooms in the Groat Market, before moving into its fine new building designed by John Green in Westgate Road. The foundation stone was laid in 1822 by the Duke of Sussex, the most liberal of George III's sons, with much junketing and many members of the gentry present.

Religion

The religious life of the town remained dominated by Anglicanism though there was a substantial minority of dissenters. As might be expected of a town so close to Scotland and with many Scottish immigrants, the Presbyterians formed the largest dissenting body in the first half of the century. An estimate made in 1715 found three of their churches with 1,200 adherents, one Independent or Congregationalist chapel with 100 members and a small community of the Society of Friends or Quakers. The latter had been banned from Newcastle, expelled to beyond the 'blew stone' to Gateshead where they met until 1698 but had then established a meeting house in Pilgrim Street; though numerous in west Northumberland, Quakers were never to establish themselves in great numbers in Newcastle but formed a close fellowship with an aptitude for business. The Baptists had a chapel on the Tuthill Stairs, though as it held less than a hundred persons their following cannot have been large.

A Unitarian Chapel was opened in Hanover Square in 1727. Unitarian congregations grew out of other dissenting sects but were to have an influence

in Newcastle, as elsewhere, out of all proportion to their size. We can discern in Unitarianism a distinctive culture, rational and radical in its approach to politics and society, which eschewed the enthusiasm generally associated with dissent. Technically, Unitarianism was in a different legal position because non-belief in the Trinity amounted to blasphemy but penalties were rare. It made its appeal primarily to an educated alternative elite, largely composed of merchants and professionals, which presented a polite opposition to the established elite; Hanover Square was a select address. Unitarianism's contribution to the town's intellectual life was to be considerable. Its members were serious-minded, but less puritanical than most dissenters and, if intellectual enquiry drew some towards a moderate radicalism, their open-mindedness enabled them to engage and mix with Anglican society to some degree. Their ministers tended to be of intellectual calibre and the Reverend William Turner, minister in the later decades of the eighteenth and the earlier of the nineteenth century was no exception, establishing himself as a leading light of the town's intellectual life and as we have seen, playing the principal part in the formation of the Literary and Philosophical Society.[78]

The profile of dissent, though he would have disclaimed the label, remaining as he did an Anglican, was transformed by John Wesley. He paid several long visits to Newcastle and preached on the waterfront in Sandgate in May 1742 to a large gathering of more than a thousand. He founded the Orphan House in Northumberland Street which opened the following year. Methodism had little in the way of doctrinal differences with the Church of England and in many ways it can be seen as part of the evangelical movement which stressed the centrality of the Bible, conversion and salvation by faith. The societies Wesley set up were intended to be supports for the Church but their emphasis upon lay organisation and preaching was unwelcome to many of the clergy and after Wesley's death Methodism became a separate denomination. What above all characterised Methodism was enthusiasm. Older dissenting sects had grown quietist and, in the case of Unitarianism, rationalist; Methodism emphasised emotion and salvation. It seems to have attracted many members of the old dissenting congregations and there were complaints from Independents in Newcastle that Methodism had 'devoured' some meetings almost whole.[79] Although Wesleyan Methodists were generally more conservative in political outlook than other Nonconformist

denominations, it was a popular movement and breakaway churches, like Primitive Methodism, were to be more radical. In the long run Methodism galvanised dissent in general with the Baptists and Presbyterians reviving after 1760. In Newcastle this was reflected in several new meeting houses and chapels, the Presbyterians building one in High Bridge in 1765 and one at the junction of Hanover Square and Clavering Place in 1821, the Baptists a new chapel on their old site on Tuthill Stairs and the breakaway Methodist New Connection opening Bethel Chapel in Manor Chare.

The town's Catholics were by now a small group, though recusant gentry families were still scattered around the Northumberland countryside. Provided they were discreet, a tacit tolerance was forthcoming and it was well known that they worshipped in a private chapel in the yard of the White Hart in the Flesh Market and later at one in The Close. In gentry circles, landowning Catholics were increasingly accepted as rather odd members of the landowning class and, like other gentry, participated in the social life of the town. In 1798, after the annulment of the penal laws forbidding public Catholic services, a public chapel opened in Pilgrim Street.

Non-juring Anglicanism, closely associated with Jacobitism, persisted longer than in most towns. A number of clergy had been educated at St John's College, Cambridge, a notable centre of Jacobitism and High Churchmanship. William Richards, the Vicar of St Andrew's in the early years of the eighteenth century, was well known to be a non-juror but was protected by Sir William Blackett. As well as those non-jurors who maintained an ambiguous position within the established church, there were distinct non-juring groups. Abraham Yapp was a presenter and minor cannon at Durham until 1716 after which he became minister to non-juring congregations in Newcastle. During the Tory mayoralty of Blackett these congregations flourished and Newcastle was said to have the largest non-juring community in England. A congregation persisted until 1784, meeting in premises in the Iron Market, a continuation of the Groat Market.[80]

Influence and power in Newcastle remained, however, almost entirely with the established Church and its members. The Royal Grammar School was a firmly Anglican institution. Its headmasters would lead their scholars to church on a Sunday. In 1736 the master of the combined institutions of St Mary's Hospital and the Grammar School was the Revd Dr Thomlinson D.D., a considerable

pluralist, who was also prebendary of St Paul's Cathedral, rector of Whickham and master of the Chapel of St Thomas the Martyr (beside the end of the bridge) and St Mary Magdalene Hospital. The school did not flourish under him or his successor and had only a handful of pupils when the Revd Hugh Moises took over in 1759. Moises, a Cambridge graduate and a Fellow of Peterhouse turned the school into a leading northern grammar school; alternatively described as a scholar, 'good and gentle' and a 'disciplinarian', he seems to have been all of these. Above all he was clearly a gifted teacher who took a keen interest in the progress and capabilities of his pupils whether they were intellectually gifted or had more practical leanings. Among his pupils who went on to eminent careers were John Brand, clergyman and antiquarian; the Scott brothers, John and William, the future Lords Eldon and Stowell; William Burdon, coalowner and man of letters; and Cuthbert Collingwood, who became Admiral Lord Collingwood. At a time when the aristocracy and gentry had taken to sending their sons to schools in the south of England, Moises's period as headmaster enabled the sons of the second echelon of Newcastle society to be educated to the point that they could aspire to great careers. When George III wondered, after reading Collingwood's despatch which related the Battle of Trafalgar, 'Where did this sea captain get his admirable English?', he then declared, 'Oh I remember, he was educated by Moises.' An example of literal nepotism saw the great headmaster succeeded by his nephew, Reverend Edward Moises, his sons having been introduced to well-endowed livings via the influence of his erstwhile pupil and friend Lord Eldon. Unfortunately the school did not flourish under Edward Moises and in 1820 had a mere nine pupils. The Corporation set up a commission and following its report a number of changes were made, the most important of which saw a widening of the curriculum though classics remained central. By the time that the school had to leave its old home in the Hospital of St Mary the Virgin in Westgate in 1844, numbers were again desperately low and but for the persuasiveness of Dr James Snape, who convinced the Council to let it continue under his leadership, Newcastle's oldest school might well have closed.

Georgian Newcastle was, by the standards of the time, well provided with schools of one sort or another. As with the Grammar School, most were Church of England schools. The town's four parishes were the fundamental divisions of the town and had their own institutions and charities. All members of the

Corporation and, of course, the town's two MPs, had to be members of the Church of England, while in the administration of its major charities the Church and the Corporation were entwined. Each of the parishes produced charity schools in the early eighteenth century; that of St Andrew's was founded by Sir William Blackett and that of St Nicholas's by Dame Eleanor Allen. Trinity House School provided instruction for the children of the brethren.

There were in addition numerous private schools. Dame schools catering for the poor were of varying degrees of educational efficiency, yet the fact that England was a far more literate society than most continental countries suggests that the utility of these schools has been underestimated. There were also many small private establishments catering to the children of craftsmen and lesser merchants. These were equally varied in the quality of education they provided but some of them had lofty aims and some of them fulfilled them. William Hutton, the eminent mathematician who later became a professor at the Royal Military academy, was the son of a colliery deputy-overman. Educated at Robson's school at Benwell, he opened his own school, first at Stote's Hall in Jesmond and then at the head of the Flesh Market, offering, from the 1750s to the early 1770s, an ambitious syllabus, which included trigonometry, mechanics and astronomy. One contemporary writer estimated there were twenty-one private schools for boys in Newcastle in 1801. The Revd Edward Prowitt's establishment in Pilgrim Street and the Revd William Turner's at Barras Bridge were both boarding schools. Prowitt's was clearly a superior school for it promised that 'each young Gentleman shall have a separate bed'.[81]

A new institution, the Royal Jubilee School, was founded in 1810 in celebration of the fiftieth year of George III's reign. Its purpose was declared to be 'the teaching the children of the poor Reading, Spelling, Writing and Arithmetic, according to the Lancastrian system of education'. Religious education was to be non-denominational, though Anglicans may well have been concerned that it was the methods of the Quaker Joseph Lancaster that were to be adopted rather than those of the Anglican Andrew Bell, though in fact their methods were very similar. Eneas McKenzie describes the teaching in the new school with enthusiasm: 'It is a curious and pleasing spectacle, to see above 400 boys, in one room, actively and cheerfully engaged in acquiring the elements of education, while their movements are conducted with the regularity and celerity

of disciplined troops.' Such a spectacle would, no doubt, horrify twenty-first-century educational theorists, though school teachers might be envious. Only two years after the establishment of the Royal Jubilee School for boys a similar establishment was opened for girls.

As Methodism increased its following and the older dissenting churches revived, Nonconformity increasingly challenged the Anglican hegemony in Newcastle in education as in other spheres. The Carpenters' Tower School for Girls was formed by the Wesleyan Methodists in 1822 and in the same year the Union Day School for Girls was founded by the Baptists and Congregationalists.

The leading position of Anglicanism was expressed physically in its churches, two of which were rebuilt in the second half of the eighteenth century, while the interior of another was extensively altered. St Ann's church to the west of the old town walls had a long history, beginning with a medieval chapel which was restored in 1682 as a chapel of ease to St Nicholas's, but the restored building lasted less than a century for it was pulled down in 1768 and a new church built with stones from the part of the town wall that had run along the Quayside. This was Newcastle's first classical church and was designed by William Newton who was to be the architect of the Assembly Rooms. Newton would have liked to restore the rather dilapidated old Gothic church of All Saints (or All Hallows) but David Stephenson was commissioned to rebuild it. The result was the present Restoration-style church, an elliptical building with a lofty spire on top of its tower and a portico of slender Doric columns. In neither the case of St Anne's nor All Saints did the ecclesiastical authorities show much respect for the past but in both cases the result was a success, though when Newton and Stephenson worked together on the restoration of the interior of St Nicholas's, the result was the eradication of much of the ornate and probably cluttered historic interior with its many monuments in the interests of a rather severe effect. The 1783–7 restoration has been termed 'over enthusiastic'.[82]

The dominant culture of the town was permeated by Anglicanism. St Nicholas's and All Saints were where the most prominent citizens worshipped and were buried and, if the ability to be able to achieve office in civic life was one inducement for dissenters to conform, then the social pressures should not be underestimated. The concept of urban gentry was not to townsmen of the time an obvious oxymoron and the term 'gentry of the town' was frequently

employed. There were close relations between the county gentry and Newcastle; many landowning families had made their fortunes in the town and continued to take an interest in its trade and affairs; junior members of the same families were often merchants or professionals there, while it was conventional for widows and spinsters to live in the more select streets. The Ellison family is a good example, with the senior line being established as landed gentry with sons serving as army officers, while other branches continued in trade and provided mayors and numerous Newcastle clergymen during the course of the century. It was almost inconceivable that a dissenter, however prosperous, would be numbered among the urban gentry, though by 1800 the Cambridge graduate, attorney and coal owner James Losh, who had Unitarian views, could be accepted as such.

Although eighteenth-century dissenters did not, unlike many of their nineteenth-century successors, abjure alcohol, more serious members of dissenting sects stood apart from much of the drinking and feasting culture that was part of the socialisation within guilds and was generously expressed in the hospitality at the Mansion House or at the great receptions held by the Blacketts and Ridleys. Austerity is imposed upon the poor, though it is anathema to them; it can be voluntary to the striving and newly successful, who hope to become yet more successful; but it can become irksome to those who have become prosperous. It was said that the Quaker crossed over to the Church of England on 'his second horse' and many a Newcastle dissenter, tired of forsaking the theatre, the Assembly Room or the concert, never mind a convivial dinner or a race meeting, moved from occasional conformist to a perpetual one as his bank balance increased or he inherited his father's. Certainly, Quaker records point to a ceaseless struggle to prevent Friends succumbing to the lures of the world; women were repeatedly warned against wearing fashionable dresses, men told to refrain from the 'undecent cocking up of hats, undecent wigs, and unnecessary capes'.[83]

POPULAR CULTURE

The social structure of Newcastle was complex and, to a degree, contested, with well-to-do dissenters feeling that their standards and way of life were equal and

even superior to those of the Anglican elite. A major division remained important, that between burgesses, members of companies and freemen on the one hand and those who had no real place in the traditional order of the town on the other. New groups and professions had appeared and found their economic place but the greatest divide at the broad base of the social pyramid was between those with some accepted stake in the order and those without it; an older conception of orders melded with a newer one of the polite, the respectable and the rough. The cultural divide only vaguely reflected the social. There was polite society and low society and there was high and low or popular culture but most men, with the exception of some dissenters, enjoyed the culture of the tavern, the racecourse and the fair and what can be summarised as the three Bs: beer, blood and betting. Although there was a gap between high and low culture, there was also cultural transmission with songs, dances and theatre benefiting from it.

The cultural life of the poor remained, however, crude. At the very bottom, the life of casual workmen in the narrow alleys or chares behind the Quayside or in Sandgate or the lower part of Pilgrim Street was one of frequent unemployment and hunger. Drink, food and sex were not savoured but swallowed and taken greedily and the term 'Cyprian', used by some observers to describe the desperate drabs who serviced sailors in dark alleys, was far from apposite. Even so, there was a frenetic conviviality on occasions, even if it usually ended with recriminations and fighting. Newcastle was, in this respect, no different to any other port town.

The attitudes of polite society towards the lives and customs of the poor could be unforgiving. In their sexual behaviour, in their approach to courtship and marriage, the customs of the labouring poor were an affront to the conventions and morals of the respectable. If the manner in which many of the lower orders entered the world was often unlicensed, the somewhat ribald accompaniment to their leaving it was also a subject for criticism. Henry Bourne, curate of All Saints and historian of Newcastle, complained of the 'Sport, Drinking and Lewdness' of wakes for the dead: 'How unchristian, instead of becoming sorrow and decent Gravity, to put on an unbecoming Joy and undecent Pastime'. John Brand, similarly a Newcastle clergyman but more of a rationalist and a cynic, who took over and extended Bourne's work later in the century, also wrote about such wakes, where the corpse too often ended up as the centrepiece of a drunken party, and wrote of the participants as having an Epicurean licentiousness which made

them think that 'since Life is so uncertain, no opportunity should be neglected of transmitting it; and that the Loss, by the death of one relation, should be made up as soon as possible by the Birth of another'.[84]

It is, however, above the lowest level that we can discern a rich and vital popular culture. The civic calendar with its great days, the election of a mayor, the Assizes and Ascension Day were still holiday occasions on which all classes celebrated and usually enjoyed not just the spectacles of the urban elite enjoying itself but free beer, while parliamentary elections, even if they didn't go to the poll, were similarly times when electors and non-electors participated and benefited. The town's fairs provided entertainment, much of which – the general hubbub, the cries of the vendors and the come-hithers of the hucksters – was free, while the charges for drink, food and entertainment were modest. Then there was sport, much of it accompanied by betting. Cockfights were common and well attended by all classes, as were bouts of bare-fisted boxing and the hunt was followed by large numbers on foot.

Horse racing was becoming more organised and more popular. Revived after the Restoration at the established course at Killingworth, racing gradually moved from being a matter of private betting between landowners, often riding their own horses, to a sport which attracted large crowds. Bets were laid between individuals until the early nineteenth century when the professional bookmaker made his appearance. From 1721, Newcastle races moved to the Town Moor and were held at Whitsuntide until 1751, when they were held in the week nearest Midsummer Day. Race Week was a time for dances, cockfighting, and other sports as well as horse racing.

Race Week demonstrates another aspect of Newcastle, its role as the playground for surrounding areas, particularly for the miners from the growing number of pit villages. Miners not only flocked to Newcastle races but saw the Town Moor during Race Week and at other times as the venue for their own sports and pastimes such as pot-share bowling and pitch and toss. The town catered for more than just its own inhabitants.

If the Theatre Royal was very much a venue for high culture emulating the productions of Drury Lane or Covent Garden, Newcastle was also home to the more vernacular troupes of performing players who made their annual tours of fairs and race meetings. Many of such companies were by the late eighteenth

century embracing a new professionalism and setting up semi-permanent booths on urban sites for lengthy periods. Billy Purvis exemplifies this tendency. After spending most of his days performing in pubs, the drawing rooms of the gentry and at local fairs as he and his troupe moved around the northern counties, he ended his career with his theatre an almost permanent fixture on the Forth. An entrepreneur, clown, acrobat and fiddler, he was, perhaps the first stage 'Geordie'. He can be said to have had one foot in the fairground and the other in what was to become the music hall.

The clubability of the town extended, as we have seen far down the social ladder, and if the pub was the club of the working man, it often took on many of the attributes of the club and, as most clubs did not have rooms of their own, gave them their homes. By 1830 Newcastle has been estimated to have had 28 brewers and 138 publicans, so many that the Beer Act of 1830 did not lead to the spectacular eruption of beer houses that other towns witnessed.[85] Pubs attracted particular types of regulars, sponsored sporting events and provided entertainment. Several had cock-pits, some acquired rat-pits, many had skittle alleys. The Peacock and the Three Indian Kings, both on the Quayside, had a very specialised clientele for they were used by the Press Gang as their rendezvous or 'Rondy'.[86] All other activities were, however, there to encourage the consumption of drink, the lifeblood of the town's popular culture.

William Hogarth's depiction of a society divided between the jovial and prosperous Beer Street and the miseries of Gin Lane may mislead us into thinking that only the poorest and the most desperate drank gin but the drinking of spirits may well have been a sign of prosperity.[87] Newcastle was a prosperous town and one study has concluded that 'the North East was probably a leading sector among the non-metropolitan regions in the taste for spirits'. It was not an area with a considerable distilling industry but colliers returning from London found gin a useful cargo. Newcastle remained primarily a beer-drinking town but by the end of the eighteenth century gin and other spirits had come to be seen as necessary luxuries.[88] Whether beer, wine or spirits, drink was the accompaniment of work and leisure for all strata of society.

PHILANTHROPY

The poor may have been 'always with us' but they were more segregated at the end of the long eighteenth century than at its beginning. Increasingly there was a sharp division between the upper town areas in which the more prosperous lived and the crowded quayside chares, the streets of Sandgate and lower Pilgrim Street. It is a romantic fancy to believe that the conditions of the poor were better when they lived cheek by jowl with the more prosperous or that the consciences of the rich were more easily stirred when the poor were their neighbours.

The provision made for the poor by the Elizabethan Poor Law has been much criticised as either inadequate or, as argued by nineteenth-century utilitarians, wasteful, but as a study of its application in the the North East has concluded, it 'gave adequate if not unstinting relief within strongly defended communities'. It did, however, pose particular problems for large towns which often found themselves with sizeable bodies of paupers who came from elsewhere. To drive back the poor to their original parishes was in the long run a hopeless enterprise. An anonymous parishioner railed against the swelling army of paupers in 1755 but such complaints had been common since the early seventeenth century, especially in times of poor harvests or high unemployment.[89] Although outdoor relief from the parish was the norm so far as the able-bodied adult was concerned, in Newcastle there was a poor house and General Hospital in All Saints, which received its inmates from all the parishes, but by the early nineteenth century each parish had its poor house and there was also the Lock Hospital which appears to have cared most inadequately for the sick paupers.[90] What the Poor Law provided for the orphan, the sick and the old was, however, supplemented by charity.

Charitable feeling was not new to a town which had been dominated by its friaries in the medieval period, while rich merchants like Roger Thornton had long sought to assist the passage of their souls to heaven by good works. The great and the good of the eighteenth century were also, as with successive generations of Blacketts, generous in their educational and charitable foundations. What was new was a more purposeful, corporate and organised approach to philanthropy. Inspired by the Enlightenment's themes of reason, humanist empathy and belief in progress, the number of hospitals, almshouses and schools proliferated.

If the Guildhall and the Mansion House were public buildings expressing the civic pride of the town's Corporation, the Holy Jesus Hospital, endowed by the Corporation in 1681, reflected its charitable feeling towards the outer circles of the burgesses in its provision for 'poor and impotent freemen or their widows and unmarried children'. The Keelmen's Hospital provides an unusual example of self-help on the part of a section of a poorer, if far from the poorest, section of society. It was erected in 1701, at the cost of £20,000, a remarkable sum as it was raised by the keelmen themselves, just outside the Wall Knoll Tower and overlooking the Sandgate. It had originally sixty rooms and the Bishop of Ely is said to have commented that:

> He had heard of and seen many hospitals, the works of rich men; but that it was the first he ever saw or heard of which had been built by the poor.[91]

Whether because they did not wish the keelmen to get too independent or because of more altruistic purposes, the keelmen's employers, the hostmen, insisted on taking over the administration of the hospital, which was much resented by the keelmen, who, with some reason, suspected the former motive.

A highlight of the stays of Cecilia Fiennes and Daniel Defoe had been a visit to the Barber Surgeons Hall. There Fiennes watched surgeons dissecting and anatomising bodies:

> There were two bodies that had been anatomised, one the bones were fastn'd with wires the other had the flesh boyled off and some of the ligaments remained and dryed with it, and so the parts were held together by its own muscles and sinews …[92]

Defoe simply recorded that 'they have two skeletons of human bodies, one a man and the other a woman, and some other rarities'.[93] The Company of Barber-Surgeons had begun in 1442 and had acquired its hall at the Manors in 1648 but by the mid-eighteenth century it was in decline and increasingly the well-to-do expected their doctors to have studied at a university. There was nevertheless some continuity between the company and medical developments after 1750; as with other emergent professions the old melted into the new and 'barber-chirurgeons became surgeon- apothecaries'.[94] Richard Lambert, the Master of

the Barber-Surgeons, was prominent in the moves to set up an Infirmary and a town physician was appointed earlier in the century.

The Infirmary project found support among the elite and was founded in 1751 with the aim of providing hospital treatment for the sick poor of the town. Among its first presidents were the Earl of Northumberland, Sir George Bowes and Sir Walter Blackett. It moved into a new building on the Forth, designed by Daniel Garrett, in 1752. The funds of the institution were provided by subscribers who had the right to nominate patients; thus charity went hand in hand with patronage. In 1760 a Lying-in Hospital for poor married women was opened in Rosemary Lane near St John's church; patients had to have a letter of recommendation and a marriage certificate. The following year a further charity was founded to provide assistance to women giving birth at home. A dispensary followed in 1782 while in 1804 a House of Recovery, a fever hospital, was built on the edge of the town in Bath Lane, as much to protect against epidemics as for the welfare of patients, and a hospital for eye diseases was opened in 1822 by the radical reformer Dr Fife.

To attend to the sick in these hospitals, Newcastle had medical practitioners who were in the process of establishing themselves as a profession, most of whom also had private practices. There was still no statutory registration of medical practitioners but those attached to the hospitals usually had some recognised qualification. Doctors were gaining increased social prestige but still had to compete with patients' own medical lore and the competition of herbalists, 'wise women' and 'quacks'. Other leading doctors involved with the Infirmary were Adam Askew, John Hall and Samuel Hallowell. An asylum for the mentally ill was opened outside the town walls at Gallowgate after a subscription list had been opened in 1763 and it was described as 'secluded, airy and healthy' though its cells had rings for confining violent patients.[95] Access to medical treatment was a mixed blessing in the context of contemporary knowledge and means of treatment. There was a social division between physicians, apothecaries, wise-women or men, and quacks but no legal one; perhaps the poor were often better off with their faith in traditional remedies than when they were admitted to the Infirmary. The gentry placed great faith in their doctors but could be scathing when their treatment failed. Annabella Carr blamed the death of her father in 1805 on William Ingham, the leading Newcastle surgeon. He (Ralph Carr)

had been brought into this considerable danger by the ignorance and presumption of Ingham in daring to triple the dose of calomel [mercurous chloride, much used as purgative] ordered by Dr Trotter ... It is indeed dreadful to think the life of any human creature should be entrusted to such a Blockhead. His extensive practice shows how inadequate the public is to judge of medical skill.[96]

When Thomas Giordani Wright arrived in Newcastle to serve an indenture to the successful Dr James McIntyre in 1825, the medical profession was thriving and there were ten physicians and forty-three surgeons listed in the town. It has to be said, nevertheless, that the young and inexperienced Wright was learning on the job when he was let loose on McIntyre's poorer patients.[97]

An Elegant & Cultivated Town

When was Newcastle's great period? Claims can be made for the bustling entrepreneurship of the Elizabethan and Stuart town and of the concentrated economic power and influence of the expanded Victorian Newcastle but, if we look to architecture and the cultivation of the arts or seek a dynamic social ambience and exciting intellectual climate, then many will choose the period between 1780 and the early years of Queen Victoria's reign.

In 1780, Newcastle had many of the essentials of a great city. It had its churches, its hospitals, its civic buildings, the Guildhall and the Mansion House, its Assembly Rooms, numerous shops and its new streets but only one example of that most modern and fashionable of housing developments the square, Charlotte Square (Hanover Square had not been and was not to be finished). There followed in the early nineteenth century an extraordinary exercise in town planning which transformed the centre of the town.

Before 1800, Newcastle had essentially grown organically following the outlines of the medieval town. Dean Street and Mosley Street had been built with the support of the Corporation, but they had been designed to make up for the shortcomings of the traditional lines of communication rather than to remodel the town. The first decades of the nineteenth century saw a full-scale planned development of the upper town. It has been claimed that, 'The confidence

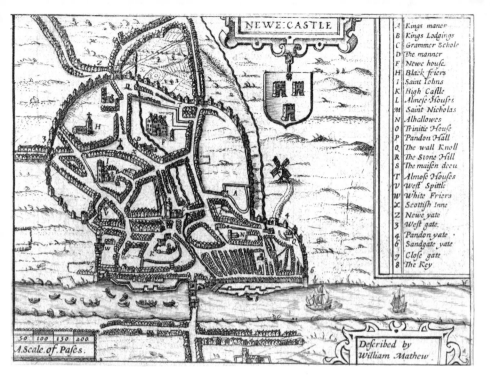

1. John Speed's map of 1611 shows a town little changed in its main outlines from the medieval town. Newcastle Central Library.

2. James Corbridge's map 1723. Although the town still remains within its walls, there is some extra-mural housing beyond West Gate and Gallow Gate. Note the amount of space taken up by orchards and gardens. Newcastle Central Library.

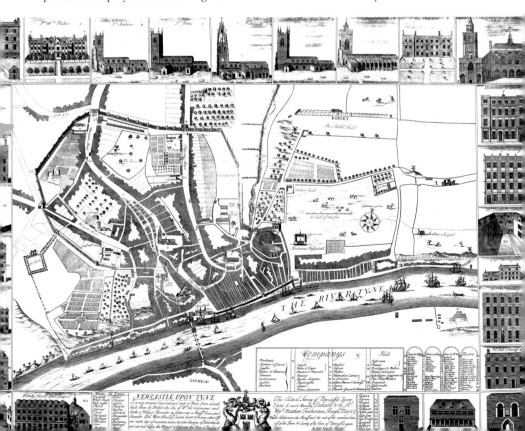

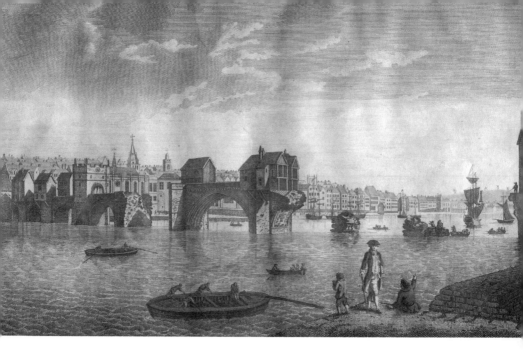

Above: 3. The bridge after the flood of 1771. The swollen river carried away four of the bridge's twelve arches. Newcastle Central Library.
Below: 4. (a). The Medieval Bridge. Built in stone after the destruction by fire of the previous wooden bridge, housing had by the seventeenth century come to occupy both sides along its length. A blue stone marked the boundary between Newcastle and Gateshead, which belonged to the Bishop of Durham. Author's collection.
Opposite: 4. (b). *The Great Bridge of the Tyne, 1700*. Drawn by George Bouchier. Richardson and etched by his uncle, Thomas Miles Richardson, in the early nineteenth century. Richardson probably based his drawing on the work of a previous artist contemporary with the date of 1700. Author's collection.

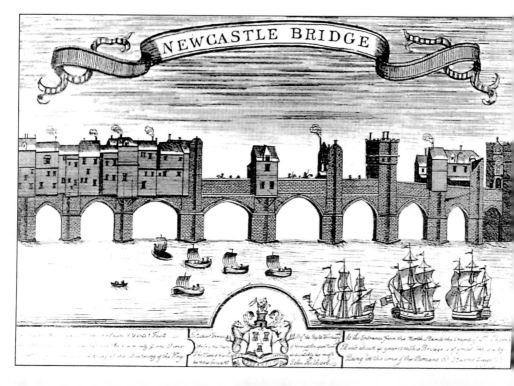

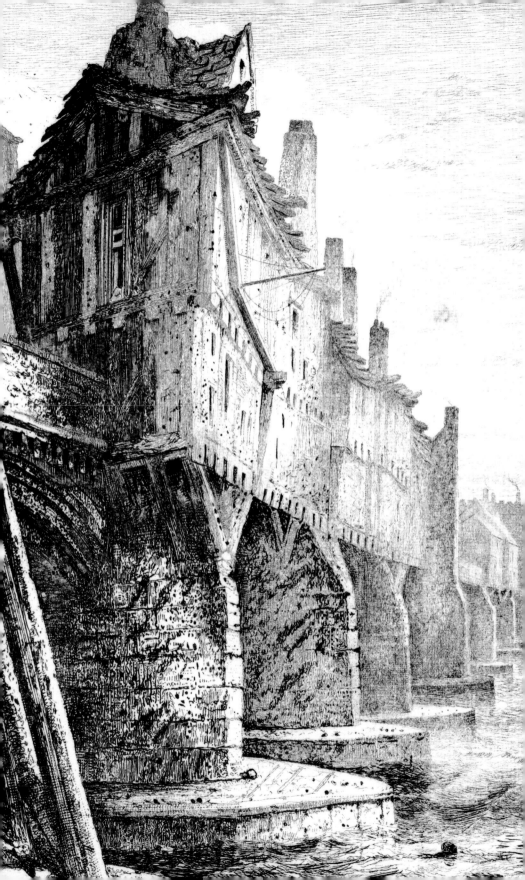

Above: 5. Ascension Day 1827. This print of J. W. Carmichael's oil painting depicts the mayor's barge amongst ships and smaller craft on the important day in the civic calendar when the Mayor and other local dignitaries set off to proclaim Newcastle's control of the Tyne making their way to Sparow Hawk near the river mouth before returning upstream to Hedwin Streams. Author's collection.

Left: 6. The Wesley Orphan House in Northumberland Street was the second Wesleyan chapel to be built in England. Author's collection.

Opposite: 7. The Black Gate of the castle in the early nineteenth century. It had become a run-down area with tenemented slum housing and second-hand clothes and boot shops. Newcastle Central Library.

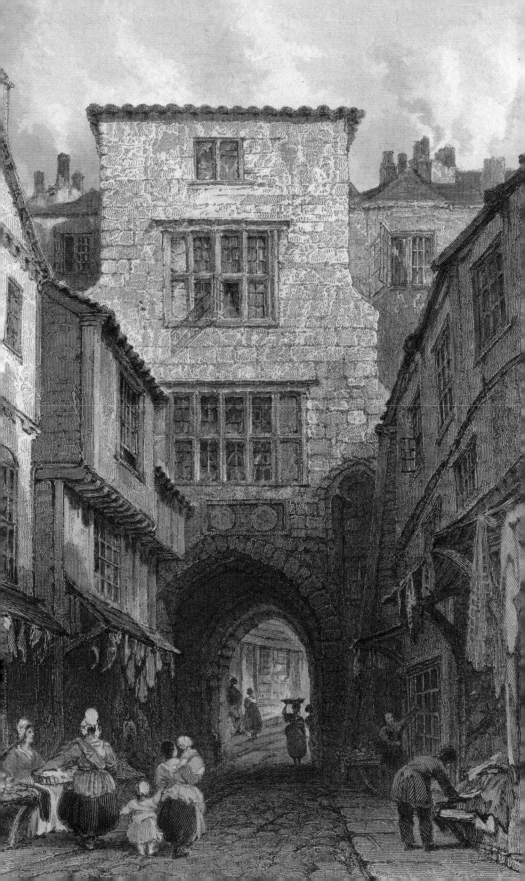

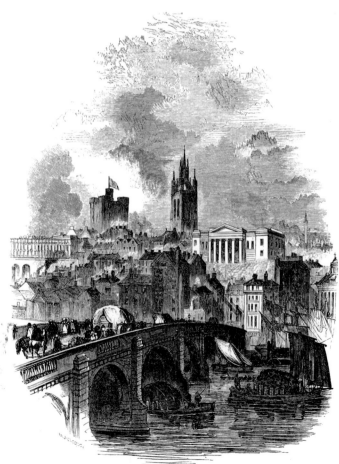

Above: 8. The Royal Arcade, Pilgrim Street in 1834. The arcade at the junction of Pilgrim Street by John Dobson was completed in 1832. It was intended to epitomize the elegance of Richard Grainger's development of Newcastle. It was demolished in the late 1960s. Newcastle Central Library.

Left: 9. After the destruction of the old bridge, ferries were the only way of crossing the river until a new stone bridge with fine balustrades was completed in 1781. Author's collection.

Opposite: 10. The Sandhill. Oddly named in that this triangular area was flat, It was the centre of town life for centuries. Here and along the Close lived wealthy merchants, the major civic building the Guildhall overlooked it, there was a market and it was a place for recreation. Newcastle Central Library.

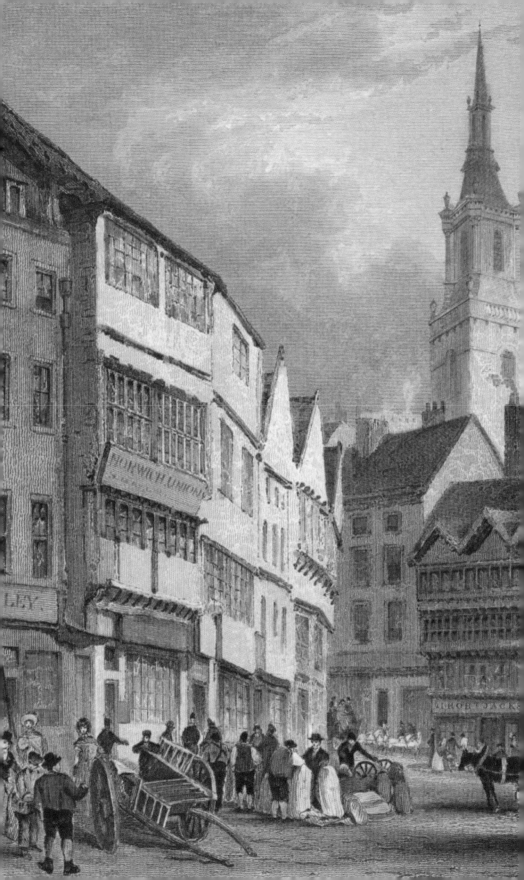

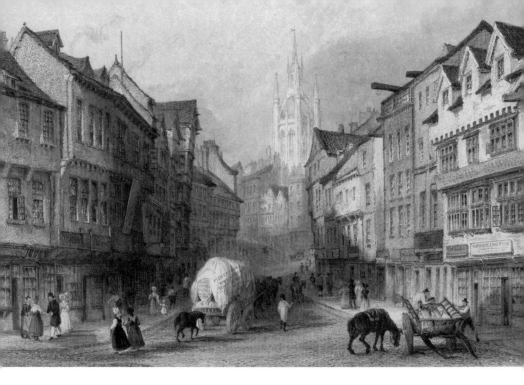

11. The Side. This steep cobbled lane was the main thoroughfare through Newcastle and was part of the Great North Road. If the horse to the right of the picture looks woebegone, it is probably because he realizes he will have to pull the nearby cart up this steep bank. Newcastle Central Library. 12. Map of Newcastle 1808. The town had only tentatively expanded with the odd street beyond the walls. Newcastle Central Library.

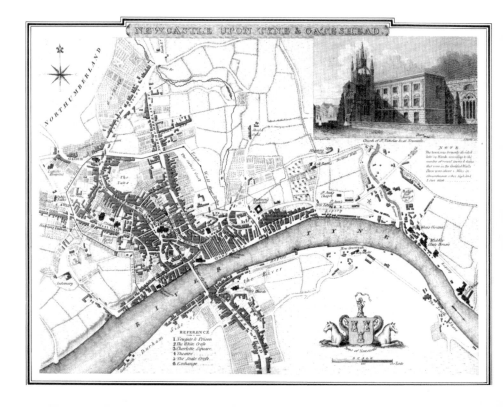

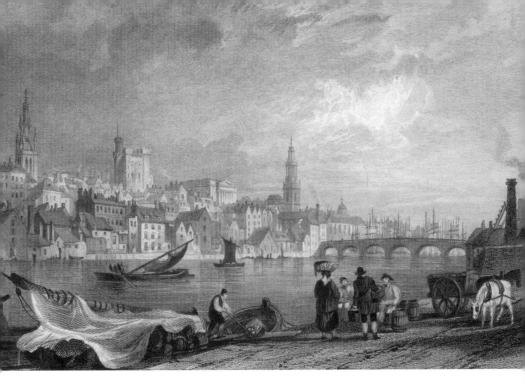

13. A view of Newcastle from Gateshead 1808. Newcastle Central Library.

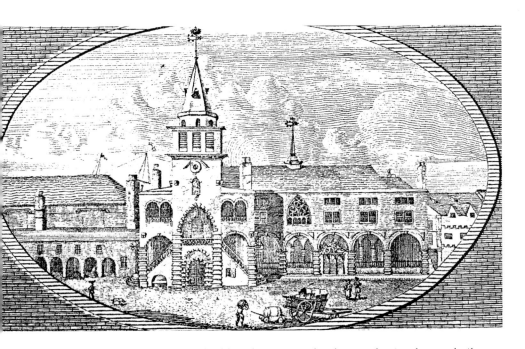

14. The Guildhall in 1786. The building has a complex history having been rebuilt, modified and added to over the centuries. This picture shows Robert Trollope's Guildhall built from 1655 much of which survives but classical north and south fronts were added in 1794-6 and 1809. The colonnaded exchange to the left is where merchants did their shipping deals. Newcastle Central Library.

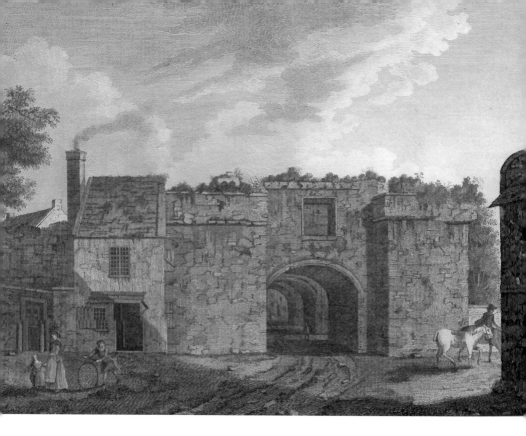

15. The West Gate 1786. The gates of Newcastle were like stretches of the town walls nearing the end of their days in the late eighteenth century. The West Gate was pulled down in 1811. Newcastle Central Library.

16. Grey Street (William Collard), Newcastle's finest street. Courtesy of T. W. Yellowley.

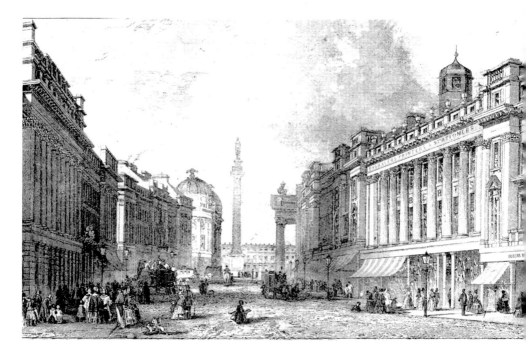

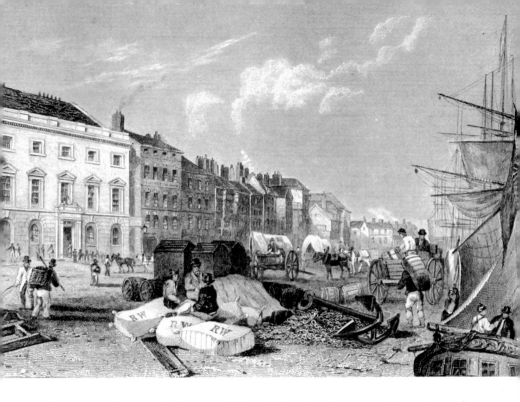

17. The Customs House on the Quayside (William Collard) (1766, refronted 1833). Newcastle's position as a Customs authority was important to the town. Courtesy of T. W. Yellowley. 18. The Assembly Rooms designed by William Newton opened in 1786. A purpose-built Assembly Room was considered to be essential if a town was to be a centre for polite society. The Rooms were built with money raised by the subscriptions of members. Author's collection.

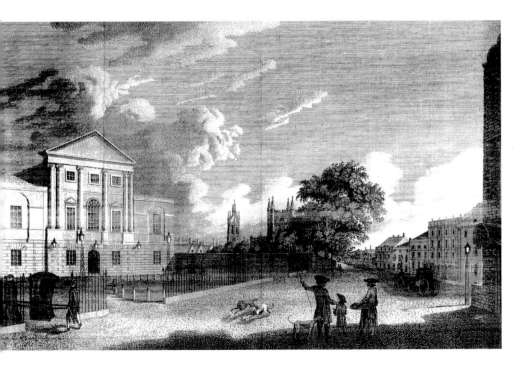

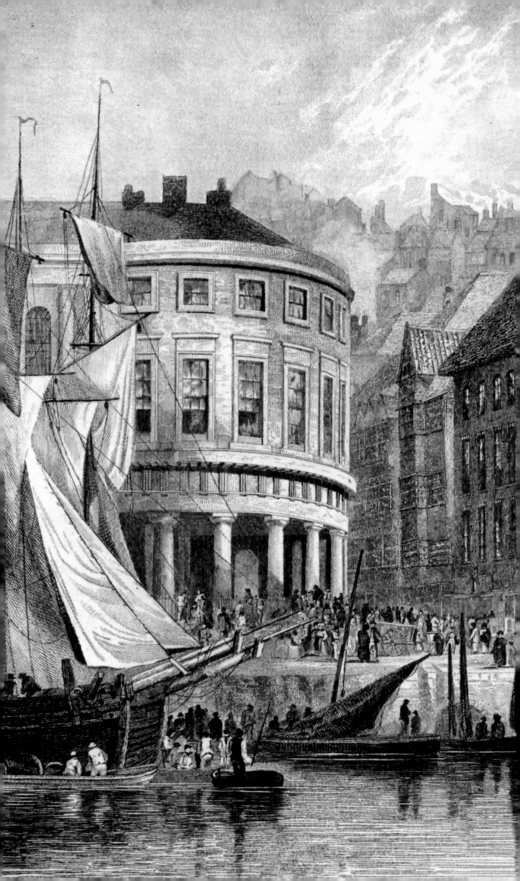

20. Eldon Square (William Collard). One of Grainger's earlier developments, it was built in the 1820s, but all but the east side was demolished in an act of municipal vandalism in the early 1970s. Courtesy of T. W. Yellowley.

21. Grainger Street, looking towards Grey's Monument (William Collard). Courtesy of T. W. Yellowley. *Opposite*: 19. The Fish Market below the Merchants' Court. The proximity of a fish market to the Guildhall does not seem to have worried the town's elite. Courtesy of T. W. Yellowley.

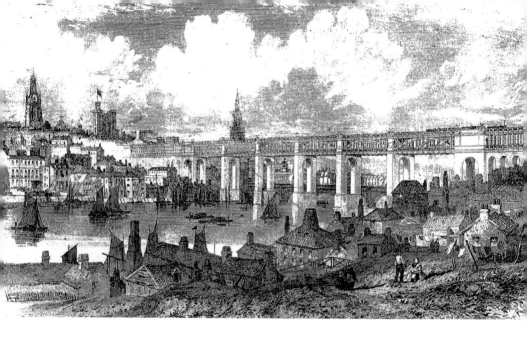

Above: 22. The High Level Bridge. Robert Stephenson's combined railway and road bridge, which was opened in 1849, completed the railway connection between London and Edinburgh. Author's collection. *Left*: 23. The Butcher Market Arcade in the covered Grainger Market, not long after it was built. Courtesy of T. W. Yellowley.

24. The High Level Bridge led to building of the Central Railway Station designed by John Dobson. This sketch was done not long after the station was formally opened by Queen Victoria in 1850. Author's collection.

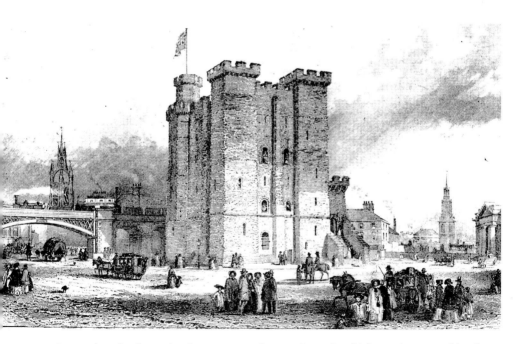

25. A casualty of railway development was the town's castle which was intersected by the railway line. Author's collection.

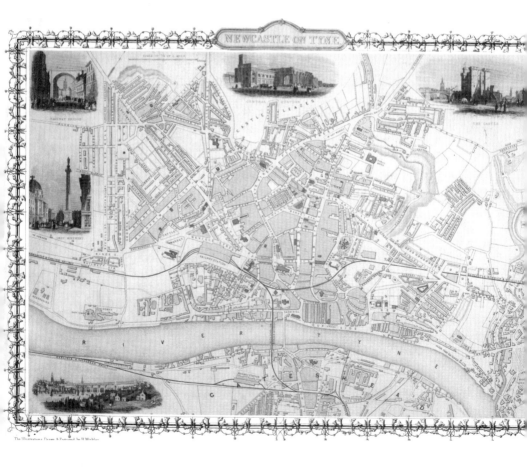

Opposite top: 26. The Ouseburn viaduct, built for the Newcastle to North Shields Railway in the 1830s (William Collard). Courtesy of T. W. Yellowley.
Opposite bottom: 27. John Tallis's map of Newcastle *c.* 1851. John Tallis & Co. produced some of the last decorated atlases. This map shows Newcastle, still a compact town, on the verge of its great period of expansion. Newcastle Central Library.
Above: 28. Jesmond Cemetery: a sombre exercise in Greek classicism, this final resting place for Newcastle's more prosperous citizens dates from 1836 (William Collard). Courtesy of T. W. Yellowley.
Right: 29. St Nicholas Church (it was not as yet a cathedral) as seen from the Bigg Market. Courtesy of T. W. Yellowley.

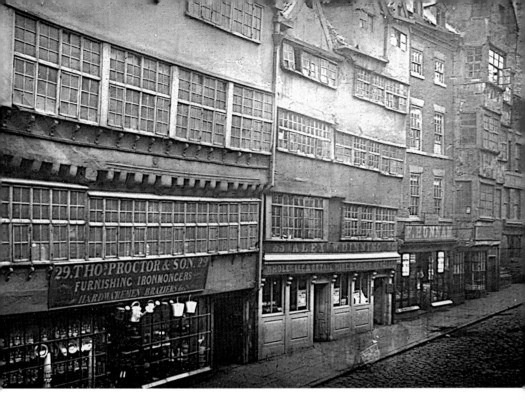

31. Photograph of the Side in 1860. Courtesy of T. W. Yellowley.

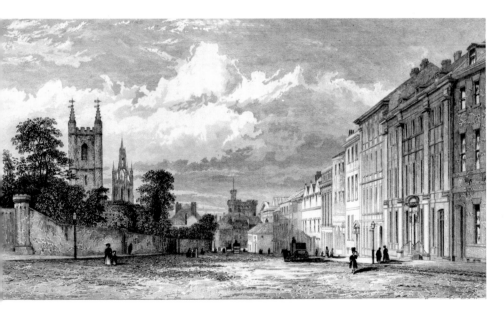

32. Westgate Street. In the early nineteenth century Westgate was becoming one of the most fashionable residential areas in the town. Courtesy of T. W. Yellowley. *Opposite*: 30. The Side was still, at the time this engraving was made, the main road through Newcastle (William Collard). Courtesy of T. W. Yellowley.

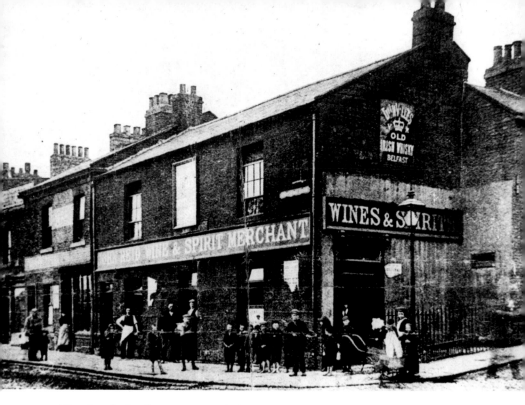

33. 'The Crooked Billet' was one of the many public houses along Scotswood Road. Author's collection.

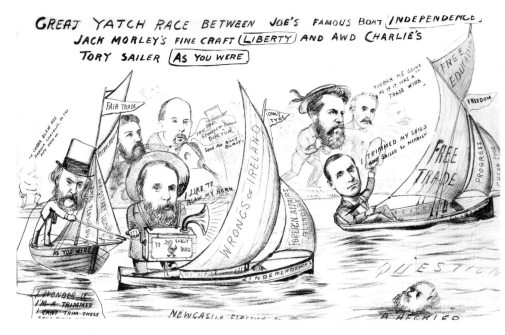

34. The popularity of rowing can be seen from the depiction of the 1880 Newcastle Election as a rowing race in this cartoon with the candidates in this three-cornered contest for the two member seat, Joseph Cowen, John Morely and Charles Hammond, rowing towards a finishing line. Author's collection.

35. Jesmond Dene. Lord Armstrong donated his estate at Jesmond to the people of Newcastle so that they could enjoy something of the rural tranquility he loved. Courtesy of T. W. Yellowley.

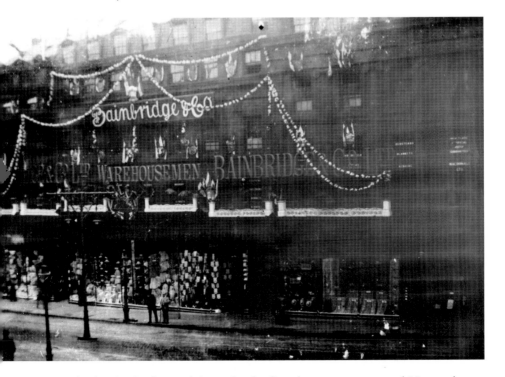

36. Bainbridge & Co. has a claim to be the first department store and Newcastle was developing in the late nineteenth century into a major shopping centre. Author's collection.

Opposite: 37. The Guildhall. A recent photograph of the building which, though rebuilt several times, housed the town's municipal government for centuries. Courtesy of T. W. Yellowley.

Above: 38. Dunston Staithes. Once a familiar sight on the banks of the tyne, coal staithes were where coal was loaded on to colliers. Courtesy of T. W. Yellowley.

Right: 39. The Baltic Art Centre, previously the Baltic Flour Mill. Courtesy of T. W. Yellowley.

40. The Sage Music Centre's great carapace dominates the south bank of the river at Gateshead Quays. Courtesy of T. W. Yellowley

NON·SIBI·SED·PATRIAE
THE·RESPONSE·1914

41. *The Response.* This impressive memorial to the war-dead of the 1914-18 war stands adjacent to St Thomas's Church in the Haymarket. Courtesy of T. W. Yellowley.

42. The Millennium Bridge frames the Newcastle side of the river on which, in contrast with the modern Gateshead bank retains a traditional appearance with new buildings blending with the old. Courtesy of T. W. Yellowley.

43. The Centre for Life. The resolutely modernist Centre for Life preserves in its midst the old weighing house. Courtesy of T. W. Yellowley.

Left: 44. All Saints Church now stands in a renovated area as the city gradually rediscovers its riverside roots. Courtesy of T. W. Yellowley. *Below*: 45. The 'Hoppings', the largest fair in Britain, still attracts the crowds every June. Courtesy of T. W. Yellowley.

46. Dean Street where, until the late eighteenth century, the Lort Burn ran down to the Sandhill and the Tyne. Courtesy of T. W. Yellowley.

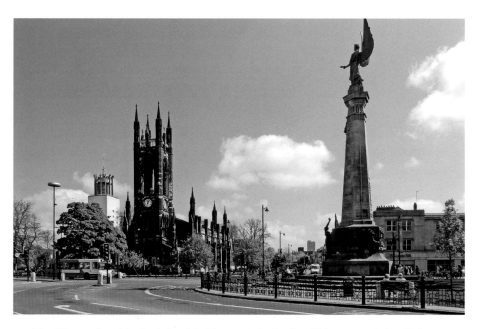

47. The Haymarket. To the left of St Thomas's is the fanciful tower of the Civic centre with its sea-horses and to the right is the memorial to the dead of the South African War, 'Winged Victory' on top of the column. Courtesy of T. W. Yellowley.

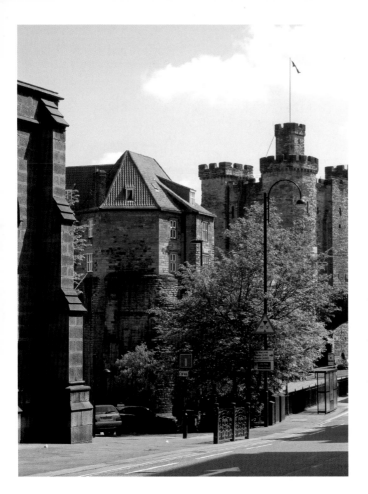

Left: 48. From the south end of St Nicholas Cathedral, a view of the Black Gate divided from the castle keep by the railway line leading to Scotland. Courtesy of T. W. Yellowley.

Below: 49. The lying-in hospital of 1826 is a reminder of early nineteenth century philanthropy. Courtesy of T. W. Yellowley.

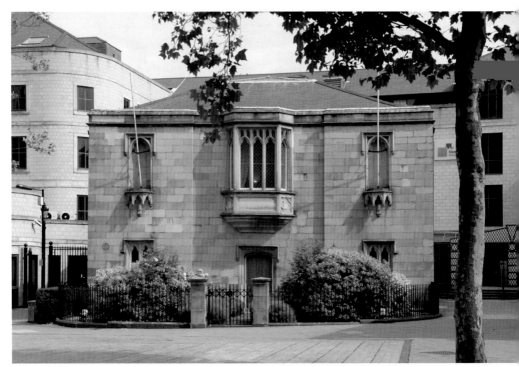

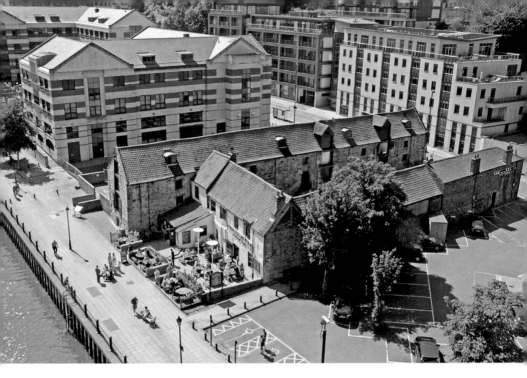

50. The Close was where once the rich merchants and burgesses lived and the Mansion House stood there. It now has a major hotel, office buildings and, at night, becomes part of 'party Newcastle'. Courtesy of T. W. Yellowley.

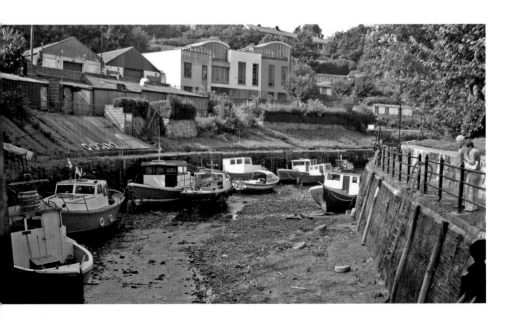

51. The Ouseburn. Though low tide reveals old tyres and other debris in this 2006 photograph, the burn and its surrounds have been transformed into an area with pubs, cafes, artists studios and galleries. Courtesy of T. W. Yellowley.

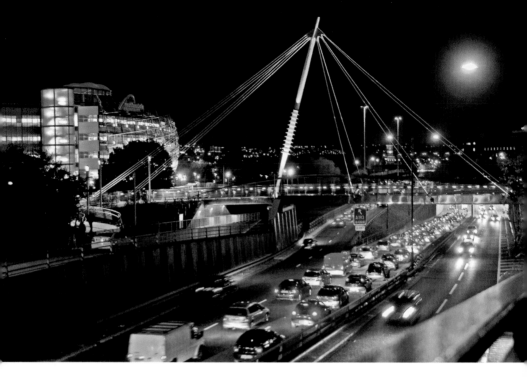

52. A pedestrian bridge over the motorway links two campuses of Northumbria University. Courtesy of T. W. Yellowley.

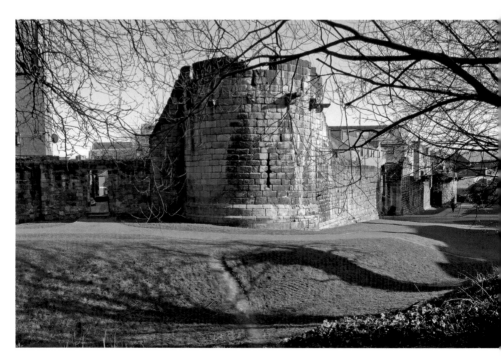

53. After years of neglect, the remains of the Town Walls are now carefully preserved, as with this stretch of the western walls. Courtesy of T. W. Yellowley

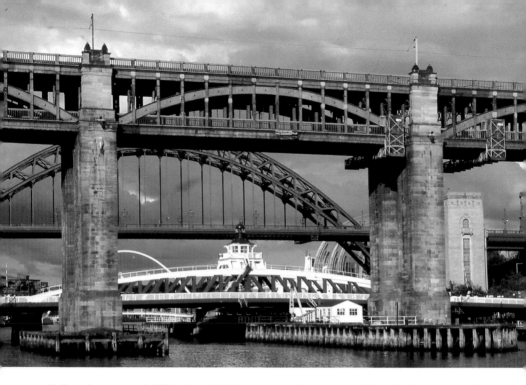

54. Robert Stephenson's High Level Bridge (1845-9) frames the Swing Bridge (1868-70) by W. G. Armstrong & Co. Courtesy of T. W. Yellowley.

55. The Old George, Newcastle's last remaining coaching house. Parts of it date from the seventeenth century. Courtesy of T. W. Yellowley.

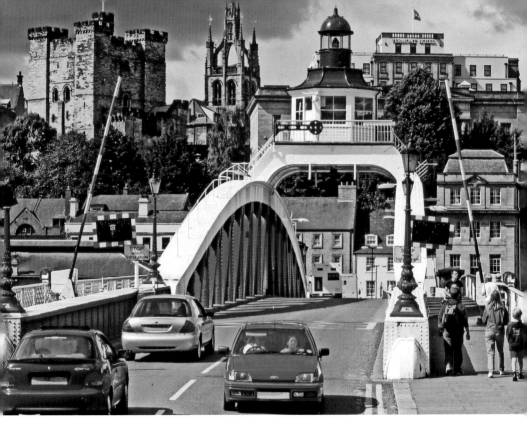

56. The Swing Bridge now rarely swings but has become an essential pathway between the clubs and bars of Gateshead and Newcastle. Courtesy of T. W. Yellowley.

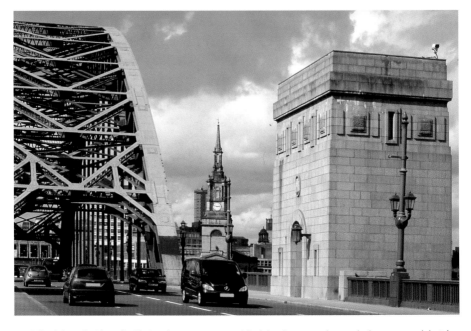

57. The Tyne bridge, built in the 1920s provided both a much needed new road bridge and a boost to the depressed economy. Courtesy of T. W. Yellowley.

and energy of Newcastle's early nineteenth-century developers reshaped a still essentially medieval city in classical terms.'[98]

There were two intellectual influences affecting the views of the educated citizens of the town and indeed of Europe, the Enlightenment and Romanticism, sometimes intermingled but largely contradictory, but it was the rational influence of the Enlightenment with its fondness for symmetry and order which found expression in the new development of central Newcastle. Both modes of thought found their historians: the rationalist progressive influence sought to arrange knowledge of the past as part of its zeal to codify and arrange human knowledge in general but it was Romanticism which inspired affection for the past and its physical remains. The Revd Henry Bourne in his *Antiquates Vulgares* and in his *History of Newcastle* displayed a knowledge informed by primary sources but viewed the town's history as a prelude to the moral and religious improvement of the present. His successor both as vicar and historian, Revd John Brand, drew upon Bourne's work but was less condescending to the town's past, finding its societies and customs more fascinating than barbaric. Nevertheless, Newcastle's historians inspired few to fight to preserve the physical remains of Newcastle's past. For Eneas McKenzie, writing in the early nineteenth century, old buildings should not count against 'the improving spirit of the age'. It was the engraver Bewick who best expressed a sadness at the passing of the old and appreciated the charm of the picturesque, the aged and tumbled-down. Few voices were raised against the partial destruction of the town walls. The Cale Cross at the foot of The Side was rebuilt in 1783 at the expense of Sir Matthew White Ridley but by 1807 it was considered an impediment to traffic and it was removed to Blagdon Hall. The castle keep was advertised as suitable for conversion into a brewery but was saved when the Corporation bought it. This was not a sentimental town and if the general interest in historical buildings resulted in the formation of a Society of Antiquaries in 1813, its voice was neither strong nor confident for many years.

As we have seen, progress had been made in developing the upper town from the 1780s. The town had also by the early nineteenth century redesigned or built new public buildings. Trollope's Guildhall, damaged by riot in 1740 and by fire in 1791, was extensively remodelled in 1794 by Newton and Stephenson and again by John and William Stokoe in 1809 but much of the building that exists today is the work of John Dobson between 1823 and 1826. The old Maison Dieu was

replaced by a semi-circular fish market (walled up in 1880) at ground level with a new Merchants' Court which incorporated the seventeenth-century carved oak panelling and fireplace from Trollope's work above it. The Moot Hall, 'one of the most austere and imposing buildings in Newcastle'[99] was in the area of the Castle Garth which belonged to Northumberland. Designed in 1910 by John and William Stokoe, it was built to house the court and prison of the county; the Duke of Northumberland provided a substantial subsidy for its erection in order to ease the burden on the ratepayers.

Newcastle edged a little more boldly beyond the town walls from the end of the eighteenth century. Saville Row and Saville Place were built in the 1770s and Ellison Place early in the nineteenth century. Beyond Newgate, Strawberry Place led to St James's Street, described by McKenzie as 'one of the most healthy airy and retired situations in the suburbs'.[100] Blackett Street was built along the line of the old town wall in the 1820s, as was the imposing Eldon Square on its north side. To the south of the widened Westgate Road, further high-quality housing was built in the shape of Summerhill Grove and Terrace, Greenfield Place and High Swinburne Place.

The great prize for the planners, architects and speculators was what today would be called a 'greenfield' site. Some thirteen acres of the upper town within the walls were taken up by the house and grounds of Anderson Place, for long the princely town house of the Blacketts. The Corporation had the chance to buy it after the death of Sir Walter Blackett but turned down the opportunity because it was already engaged in the building of Dean Street and Mosley Street. The estate was bought by Major Anderson, 'an opulent builder', and it was not until after his death in 1831 that his son, Thomas Anderson, was persuaded to sell for £50,000 to Richard Grainger.

Grainger's development of central Newcastle has been deservedly praised but there had been other plans for the site of Anderson Place. John Dobson, the North East's greatest architect, drew up a plan that envisaged a more verdant development that would have included fine new municipal buildings. A study of Dobson has described the centrepiece of these plans:

[On] the site of Anderson Place itself should be built a Mansion House with 'four handsome stone fronts, the north, south and west sides to rise from a bold terrace; and

the latter to be ornamented with beautiful pillars. The east front to face Pilgrim Street, and to have a lofty grand portico, capable of admitting carriages.' With the sensitive eye of the landscape gardener, he proposed retaining the avenue of trees leading from Pilgrim Street to Anderson Place as part of the ceremonial approach to this new 'civic palace'.

Dobson, however, lacked the financial and civic backing for his plan and nor did Thomas Oliver, who also had a plan for the site which he incorporated in his grand scheme for Newcastle of 1830. It was Richard Grainger who developed the area. Born in humble circumstances, Grainger became a builder and what would today be called a developer. His success was largely due, however, to his connection with John Clayton, a solicitor and Newcastle's Town Clerk. The Clayton family were a major force in the town: John's father, Nathaniel, had purchased the office in 1785 and John succeeded him in 1822, while other members of the family had held the offices of mayor and sheriff. Grainger, backed by wealthy Methodists, had already built houses in Strawberry Place, Carliol Street, New Bridge Street and Percy Street and a whole new street, Higham Place, when his marriage to the daughter of a wealthy businessman in 1821 brought him a dowry of £5,000. This money enabled him to participate as a builder in the making of Blackett Street and Eldon Square, developed and designed by John Dobson and Thomas Oliver along the line of a demolished stretch of the town wall, and the Northern Academy of Arts. Grainger was by the end of the 1820s becoming more and more ambitious in the schemes he embarked on. The foundation stones of Leazes Terrace and Leazes Crescent, a block of seventy houses designed by Oliver, were laid in 1829 and then came the Royal Arcade, designed by Dobson.

Between 1829 and 1834 Grainger was engaged simultaneously with Eldon Square, the Leazes development and the Royal Exchange. Such works were entirely beyond his means and could only be financed by a complex network of mortgages and remortgages, one step financing the next, and carried forward by optimistic exuberance. The Royal Exchange was an architectural triumph but a business failure. Grainger had acquired the site at the east end of Mosley Street intending it as the site for a new Corn Exchange but the Corporation opted for a Corn Exchange to be built between the Groat and Cloth Markets and Dobson's design had to be modified to create a shopping arcade; this, although magnificent

and said to be superior to London's Burlington and Lowther Arcades, was in the wrong place; superior shops and superior shoppers were put off by the rear entrance to the arcade which led out to Manor Chare, not a very prepossessing area. The Arcade was thus Grainger's first setback and probably convinced him that ambitious ventures needed civic backing; this was where Clayton came in.

John Clayton appreciated both the commercial possibilities and the ambitious nature of Grainger's proposals for the Anderson Place site and it was his support in convincing the Corporation and arranging the necessary financial backing that enabled the proposals to be implemented. Grainger was not, even by the standards of the day when the qualifications for many professions were fluid, an architect *per se* but he was far more than just an experienced builder and developer. His plan for central Newcastle was almost as ambitious as John Nash's vision for the heart of London. The plan was approved by the Corporation in 1834 and by 1840 the scheme had been was largely completed. Grainger and Clayton together created a classical centre for Newcastle, the highlights of which were the sweeping grandeur of Grey Street, the majestic Theatre Royal and Central Exchange and the enormous covered Grainger Market.

If Nash's uncompleted development from St James's Park to Regent's Park is one obvious comparison with classical Newcastle, Edinburgh's New Town, the largest Georgian development in the world, is the other. One thing that links them is that all were built under the old regime, a regime that was reaching the final years of its long eighteenth century when they were completed.

THE END OF THE OLD REGIME

Nothing became Newcastle's 'old regime' better than its final decades. Antique and oligarchic it may have been but it bequeathed to its successors one of the finest town centres in England and a dynamic social and cultural environment. As with the broader old regime of Britain, its end came suddenly and unexpectedly.

Pressures for parliamentary reform and municipal reform and for full citizenship rights for Nonconformists had been there for several decades and there was force in the case that the constitutional arrangements for the nation as a whole and for ancient towns like Newcastle were inappropriate for the

emerging society and economy. Few in the mid-1820s would, however, have expected the changes that were to come in the next ten years. Just as the successive ministries headed by Lord Liverpool had appeared comfortably in charge of a country experiencing population growth and accelerating economic change, so Newcastle's increasingly antiquated constitution seemed far from incompatible with sound government.

The view that the foundations of the old regime were crumbling for half a century before its fall has been the common sense of many generations of historians. The problem is that a general perception of discontent conflates a number of factors and causes which had little in common and are often subsumed under the term 'radical': discontent over wages or food prices, a perception of the loss of ancient rights, manufacturers' dislike of limitations on freedom of trade, Nonconformist impatience with the position of the Church of England, and the demand for parliamentary reform.

Riot was the traditional means of protest particularly when food prices were high and work scarce, while the strike was a newer form of industrial action. Unsurprisingly, given the ready resort to physical force in normal circumstances, the intransigence of employers and the absence of a police force, strikes could be accompanied by much violence, so the new drew much upon the old. Only three groups of Tyneside workers had much in the way of bargaining power – the miners, the keelmen and the seamen – power which would have been much greater if they had ever combined. Keelmen were not only in frequent dispute with fitters over wage rates but felt their livelihood threatened by new means of loading ships as, below Newcastle, coal could be directly loaded onto ships by means of 'spouts' at the end of jetties; there were several keelmen strikes, including those of 1809, 1818 and 1822. 1765 saw an early miners' strike while in 1768 there was mutiny over pay among merchant seamen on the Tyne and elsewhere and there were further seamen's strikes in 1815. During a miners' strike in 1789 colliery machinery was smashed in areas close to Newcastle and in 1819 troops fired on a stone-throwing crowd during a keelmen's strike. That there was not more violence may well have been due to the fact that those responsible for law and order were often not the same sort of people as the employers. Army and naval officers who were called upon to uphold civil power did not always sympathise with employers and nor did all magistrates. Some early trade union leaders undoubtedly had political

views which could be termed radical, reformist or even proto-socialist, but the motive of the vast majority of strikers was economic discontent and most leaders, especially in wartime, realised the imperative of loyal and moderate language.[101]

The relationship between labour unrest, during a period of rapid economic change and wartime and post-war hardships, and the demand for political reform was usually far from close. The leaders of the agitation for reform tended to be professional men or employers with economic views which made for little sympathy with strikers. From the time of Wilkes, support for parliamentary reform built up steadily in the period 1762–85 but subsided after the failure of Pitt's very modest reform proposals. Nevertheless, reform had become 'an issue that would periodically subside but would not disappear'.[102] The French revolutionary and Napoleonic wars saw the growth of militant demands for reform but the counter-effect of distaste for any constitutional change was more significant. Nevertheless, the Whigs were by the post-war period loosely committed to some measure of reform, while throughout the country there were organisations and newspapers which represented those who felt excluded from proper influence within the existing constitution.

Sir Matthew White Ridley had little enthusiasm for parliamentary reform and other Whigs like Armorer Donkin, Ridley's election agent, and Archibald Reed were also lukewarm reformers. There was, nevertheless, a number of Whigs in Newcastle who were more fervent in support of reform and a radical group which was eager for reform with some members even in favour of the secret ballot.

On Tyneside the *Tyneside Mercury* was a radical newspaper and several reformist societies were formed, including branches of the Political Protestants. The local leaders of the reform movement were all either professional or businessmen: James Losh (barrister and coal owner), Dr John Fife, Dr Headlam, Revd William Turner, Eneas McKenzie (author and publisher), Charles Attwood (industrialist) and Thomas Doubleday (soap maker and political economist). Their attitudes to reform varied considerably from Losh's cautious Whigism to Doubleday's enthusiasm for male suffrage and the secret ballot.

Post-war economic depression provided a climate in which popular protest at hardship and the campaign for political reform seemed aligned. It was estimated that at a mass meeting on the Town Moor in October 1819, called to protest

against the Peterloo Massacre, as many as 40,000 attended, indicating mass support from working people. It is significant, however, that, although a keelmen's strike was taking place at the time and there were 300 ships idle, 'the strike was virtually ignored by all radical speeches'. While the *Mercury* devoted fourteen columns in three issues to Peterloo, the death of a bystander, accidentally killed by marines firing above the heads of a riotous crowd that was supporting the keelmen's strike, was given half a column and no editorial attention. 'Clearly the *Mercury* did not choose to connect the keelmen's dispute with the wider agitation for parliamentary reform.'[103]

The economy improved during the 1820s while government seemed competent. Political reform ceased for some years to be a live issue only to come to the fore again with the formation of Lord Grey's Whig government in 1830. That it did so was due to splits in the Tory Party after Lord Liverpool's retirement and subsequent death, splits that widened with the passing of the Repeal of the Test and Corporations Acts and Catholic Emancipation. It has been argued recently[104] that if we look at the 'old regime' or old order of things as a whole, its keystone, which, once taken out, resulted in much of the rest of the edifice tumbling, was its religious arrangements.

The post-1688 constitutional settlement made Britain a confessional state with full rights available only to members of the established Churches, the Anglican Church in England and Wales and the Presbyterian Church in Scotland, though by the late eighteenth century the main disadvantage for dissenters was the Anglican monopoly of civic offices. The long duration of the confessional state can be attributed to a number of factors: the ebbing of old dissent before the mid-eighteenth century, a growing degree of toleration together with the opportunity for formal or occasional conformity, and fear of Catholicism. Religious affiliation, however, changed rapidly in the period 1780–1830: the balance between Anglicanism and Nonconformity in Newcastle was shifting as Methodism and the older dissenting sects attracted increasing adherents, while immigration from Ireland began to lead to greater numbers of Catholics.

The Repeal of the Test and Corporation Acts in 1828, it can be argued, mattered little in itself, as annual indemnities had nullified most of their provisions but it split the Tory Party and paved the way for Catholic Emancipation the following year which further split the party. When the Whig government of Earl Grey came

to office and introduced a bill for parliamentary reform, it was strongly opposed by Wellington and most Tories, the strength of their opposition being dictated more by the Tory leadership's need to reassure supporters that they could stand firm on something, rather than the merits or failings of the relatively moderate proposals. On the other hand, Tory ultras, believing that Catholic Emancipation would not have been passed by a parliament elected on a wider franchise, were by no means all opposed to parliamentary reform.[105]

Newcastle, like other towns, saw the formation of reform societies and numerous public meetings called to press for reform. The Northern Political Union attracted most of Newcastle's radicals such as Fife, Doubleday, Headlam, W.A. Mitchell (the owner of the *Tyneside Mercury*) and the extreme radical Charles Larkin. There was popular support for the cause of reform and large protest meetings were held in Newcastle when the House of Lords threw out the second bill in October 1831 and when, in May 1832, King William refused to make new peers to carry it, while there were celebrations when the bill eventually gained the royal assent.

So far as Newcastle was concerned the Great Reform Act did not increase the electorate. Before 1832 the franchise was restricted to some 3,000 resident freemen and 2,000 non-resident qualified voters and after it there were just short of 5,000 potential voters, about a tenth of the number of inhabitants. After the Act the electorate in several boroughs was actually reduced because of the disenfranchisement of non-resident voters.[106] That Newcastle's electorate did not actually decline in numbers was because of two factors: the expansion of the town in 1835 to include Byker, Heaton, Jesmond, Westgate and Elswick increased the population by about 10,000 and the number of £10 householders from approximately 1,660 to about 2,000; and non-resident freemen living within a 7-mile radius continued to be allowed to vote. If the Whig ministers had had their way, the electorate would have gradually become smaller as their original intention was to do away with all ancient franchises, though allowing those who possessed them to keep them for their lifetime. After the Lords had thrown out the bill in May 1831, certain provisions were recast and when the third version of the bill was introduced it provided for a continuation of the freemen franchise for freemen by inheritance or apprenticeship.[107] This meant that those freemen who did not qualify under the £10 householder franchise were able to remain

electors; otherwise the Newcastle electorate would have been considerably smaller in absolute terms after 1832 as it was in relative terms after 1835.

Nationally, the effect of the Reform Act was to reduce the electoral strength of workmen who had previously formed about half of the aggregate borough electorate. Newcastle was no exception. The majority of the old electorate was composed of artisans, men such as cabinet makers, coopers, carpenters and joiners, who were freemen by virtue of their membership of companies. The Municipal Commissioners' Report of 1835 calculated that freemen occupied only 13 per cent of all houses rated in 1832 at £10 or more.[108] The £10 householder franchise, therefore, represented a weighting of the electorate towards wealthier but hitherto unenfranchised inhabitants and assisted those prominent members of Newcastle society who had felt their place under the previous order had not befitted their abilities or their substance: men such as James Losh, Dr Headlam or William Turner, who, with others, W.L. Burn suggested were the sort of people Lord Lambton meant when he talked of those who

> belonged to that class of society which has not hitherto taken so great a share in the consideration of public affairs as, he was persuaded, it would be highly advantageous to the country that it should – he meant the middle class.[109]

Lambton was, of course only half right. He was talking about only certain sections of those broad and diverse groups of people that were coming to be lumped together as 'the middle class'. Perhaps we need to go back to Newcastle's previous history with its constant rivalries between the inner and the outer circles of power and influence to correctly appraise the situation, with the difference that this time the outer circle was not within the pale of the old constitution; a new world had grown beside the old and the traditional ordering of the town's affairs had no place for the newer professions and many new trades; nor could it encompass the growing strength of Nonconformity, while its ethos was unsympathetic to the nostrums of political economy.

Nevertheless, the short-term impact of reform was negligible: Sir Matthew White Ridley and John Hodgson, the sitting MPs, were re-elected in 1832, although a radical, Charles Attwood, came a respectable third. What needs to be explained is the considerable support from working men for a reform that

could bring them no advantage. Great demonstrations in favour of parliamentary reform certainly took place *in* Newcastle or on the Town Moor but we do not know what proportion of those who attended was *from* Newcastle, rather than from outlying villages and small riverside towns. Either the artisan freemen were extraordinarily altruistic or they didn't participate but there were groups of workers such as the keelmen who had never been represented in the town's civic pyramid of power and others working in trades and industries too new to have been included in it. It seems likely, however, that the main popular support came from pitmen, other workers in industries outside the town, such as iron workers from the Derwent Valley, and from seamen.

There was a temporary conjunction of the wealthy and respectable leaders of reform and workers suffering from hard times, for bread prices were high and a downswing in the trade cycle had brought unemployment and wage cuts. Enthusiasm and exhilaration brought many workers behind reform in the expectation, perhaps, that a measure that would not give them the vote was just a first instalment and, more naively that a reformed Parliament would be more sympathetic to their economic grievances. They were soon to be disillusioned. John Fife resigned from the Northern Political Union within a week of the passing of the bill and the *Tyneside Mercury* declared in its edition of 19 June that there was no longer a need for political unions.[110] The more moderate leaders of the Union considered their aims accomplished, save, as W.L. Burn has commented, in one essential respect: the sphere of local government.[111]

The reformers were assisted in their assault upon the old Corporation by what was to be the last of the long series of disputes between the old elite who governed the town and a wider group of burgesses. This dispute had been going on since 1809 and the group of burgesses in the interests of their demand for greater influence had charged the ruling oligarchy with corruption. They put up a rival candidate for mayor in 1832 but he was defeated. John Fife was able to use his position as steward of the Barber-Surgeons' Company to attack the 'vile and corrupt' Council. This was a useful cry to use against the Council but the Municipal Commissioners who visited Newcastle late in 1833 found no great evidence of corruption and as W.L Burn has said of the unreformed Corporation:

It was highly oligarchical, but, although its accounting system was not such as would satisfy a District Auditor to-day, its members do not seem to have been personally corrupt by the standards of their age, or very seriously at fault by ours.[112]

There had been for many years what has been termed a 'groundswell of resentment among the main body of freemen against the narrow elite which actually ran the town',[113] but just how serious this resentment was or how widely spread is debatable. As we have seen, freeholders had consistently supported the return of Whigs and Tories from the town's elite to Parliament until 1830 and the old governing families still managed until the 1820s to fill the posts of mayor and aldermen. There were, however, problems. Increasingly, it was difficult to find a suitable mayor and the appetite of the town's elite for civic office seemed to be declining. There was dissension between the common council and the stewards of the companies while the meeting of the companies or guilds were 'almost uncontrollably violent, and appeared very like the "bear gardens" of certain large vestries in unincorporated towns'.[114]

If the burgesses' aim of subjecting the common council to their will can be seen as democratic, the 'freemen's party' can not be seen as enlightened; its other aim was to prevent any 'unnecessary expenditure':

> At a time when the Common Council was on its own initiative proceeding with the central area redevelopment ... and maintaining the ecclesiastical establishment of the town by voluntary grants; when it was at least considering the appointment of a full-time Inspector of Nuisances, did actually set up a Peelite police force, and began the task of macadamizing the streets; all the freemen did was to vote down the clerical stipends and police ...[115]

Their victory over the Common Council in the matter of Grainger's corn market scheme, which they rejected, impaired the development of the town.

The man who in many ways epitomises the confusing cross-currents of Newcastle in the 1830s is John Hodgson of Elswick Hall. His political career casts light upon both the parliamentary politics and the corporate politics of the town. As Cuthbert Ellison had been a very moderate Tory and the town's more ultra Tories had tried to replace him with William Scott, it might have

been expected that Hodgson, after whose intervention in 1830 Ellison withdrew, would have been a more unambiguous Tory. He is, however, better described as a populist Tory. He seems to have been the favoured candidate of the discontented freemen, mainly artisans. He was only twenty-three when he challenged the Ridley and Ellison duumvirate, and his grandfather had supported the burgesses in the quarrel over the Town Moor in the 1770s, while he was rich enough to spend about £10,000 upon an election which never went to the polls. He held his seat in 1832, lost in 1835 but regained it at the by-election upon Sir Matthew White Ridley's death in 1836, retained it in 1837 and was, along with the Liberal, W. Ord, unopposed in 1841.[116] Poll books demonstrate that he secured the great majority of the freemen's votes. The internal government of Newcastle seems to have been a far more important issue at the 1830 and 1832 elections than parliamentary reform, though both Ridley and Hodgson voted for the Reform Act, the Whig rather more reluctantly than the Tory.[117]

It would have been ironic if the last of the centuries-old struggles between inner and outer circles, merchant and craft companies and governing elite and burgesses in general had finally brought to an end a system of government from which all burgesses/freemen gained some advantage, but it seems certain that an act along the lines of the Municipal Corporations Act of 1835 was bound to be passed whatever the faults or virtues of the Corporation of Newcastle. The old regime, it has been argued, 'did not disappear by reason of its own corruption, passivity or incompetence'[118] but it probably could not have survived for much longer. Its economic and social basis, the companies, was anachronistic and the old town boundaries were no longer sensible. Above all, the old elite was withdrawing from the town. Sir Matthew White Ridley, the third baronet, had all but joined the Conservatives before his last election in 1835. Although successful, he was brutally attacked by a mob and only narrowly escaped with his life. He had made Blagdon, some 8 miles from Newcastle, his main residence and his son, the 4th Baronet, took no part in civic or economic life in Newcastle, devoting himself to his estates at Blagdon and Blyth and to hunting. The Ridleys withdrawal has been described as an 'abdication' for 'it is hard to believe that [with their enormous influence] the Ridleys could not have returned whom they wished'. They quickly divested themselves of their social and economic interests in the town, except in coal, selling their shares in the 'Old Bank', which crashed

shortly afterwards. Cuthbert Ellison, after his withdrawal from the 1831 election, could easily have continued in politics across the river in the new constituency of Gateshead where he was considered 'the proper person to represent the town' but he and the family preferred to live in the south of England and abroad although they retained their economic interests in Gateshead and Hebburn.

The 'abdication' of the Ridleys and Ellisons was an extreme reaction but in general, in line with a national trend, older families disengaged from urban politics if not from the representation of towns in Parliament. The Brandlings and Hodgsons retained their interest until the 1840s when the former were ruined by railway speculation and the Hodgsons dropped out after R. Hodgson was defeated at the 1848 election. The Cooksons, Bells and other members of the oligarchy, who, having established themselves as county landowners, had for many decades retained their links with Newcastle, were now less eager to take on civic responsibilities, though they maintained their industrial and business interests. Only John Clayton soldiered on into new eras.

6

VICTORIAN NEWCASTLE

Queen Victoria's reign is usually seen as coterminus with Newcastle's apogee. In terms
of its economic importance as the capital of one of the most dynamic centres of mining,
shipbuilding and heavy industry, and in terms of rapid population growth, this is
certainly the case. Its importance was recognised when it became a cathedral city. The
town expanded beyond its traditional boundaries and new suburbs were created and,
if local government was often slow to deal with social and public health problems, the
Town/City Council had by the end of the nineteenth century extended its powers and
increased the number and variety of its employees enormously. Though it gradually
acquired most of the institutions that characterised major Victorian cities, Newcastle
remained exceptional in that the architecture of the city centre continued to reflect the
influence of the classical redevelopment of earlier decades of the century.

EXPANSION OF THE TOWN

The year 1835 saw not only a reorganisation of Newcastle's system of government
but a considerable expansion of its borders and therefore of its population. The
new Town Council was responsible for a widened area as Westgate, Heaton,
Elswick, Jesmond and Byker became part of the town. Although many of these
areas remained semi-rural, they added about 14,000 to the town's population,
which by 1841 numbered 71,844. The new borders were to persist until 1904.

Until the 1850s there was only a modest increase in population. Newcastle had
over the centuries rarely managed to maintain a birth rate higher than the death
rate but during the nineteenth century it consistently achieved this. Population
growth had been slow in the late eighteenth century and the first decade of the

nineteenth century had seen an actual decline though this was succeeded by rapid growth between 1811 and 1831. To some extent, the modest population, 42,760 in 1831, simply reflected the town's somewhat artificial boundaries, which remained largely those of the medieval town until 1835 when the new suburbs enlarged them. A subsequent, much more rapid, increase brought the population up to 89,000 at mid-century. This growth, nevertheless, still owed more to immigration than to natural increase.

Despite this expansion, Newcastle, in comparison with other major towns in Britain, can be seen to have been a laggard in terms of population growth during the years before mid-century; having been the fourth largest town in the early eighteenth century, it had slipped to ninth place. Even after mid-century, though absolute figures show increases of about 20,000 decade by decade between 1851 and 1881, the peak growth period was in the 1880s when the population grew by over 46,000, followed by nearly 37,000 in the last decade of the century. This enormous increase continued to be fuelled largely by immigration.

Contrary to much contemporary perception, the great majority of the population is shown by the census returns to have been born in either Newcastle itself or in Northumberland and Durham (over 76 per cent in 1881). Cumberland and Westmorland provided a smaller but substantial percentage, considering the size of the population of those counties (3.1 per cent in the decades after mid-century and declining to 2.3 per cent in the 1890s), and London added between 1.4 and 1.3 per cent a decade. The percentage born in Ireland decreased from a mid-century high of 8 per cent to 1.8 per cent at the end of the century and was overtaken from 1871 by the proportion born in Scotland (6.9 per cent in 1871 and 5.7 per cent in 1901).

Newcastle's physical development in the Victorian period can be summed up as follows: industrial expansion along the river banks to both east and west; commercial development above the banks but largely within the old bounds of the town; residential development for workers up and above the banks but in a thickening corridor parallel to industrial expansion and, for the better-off, further advances up Westgate Road and around the Leazes followed by a push northwards into Jesmond.

Much of the town remained densely populated. The drift of prosperous citizens away from the lower town was virtually complete by 1850, leaving the Quayside,

Sandgate, Butcher Bank, The Side and Lower Pilgrim street to the poor, though there were pockets of poverty in the upper town around the Bigg Market and Newgate Street. During the eighteenth century, Hanover Square, Clavering Place and Charlotte Square had been where polite society sought to live but they were no longer so fashionable, though nearby Westgate Road and the squares behind it continued to be favoured by professionals and businessmen; to the north, the streets around the Leazes and those to the east of Northumberland Street, like Saville Row, were also inhabited by the well-to-do.

It is clear that the commercial centre of the upper town retained quite a large population until after mid-century but thereafter it became more exclusively commercial. A similar process seems to have been under way in the northern part of Pilgrim Street and Northumberland Street with shops and offices replacing housing. The effects of the destruction by the fire of 1854 were evident in the reduction of the number of people living close to the west end of the Quayside below All Saints church and the replacement of housing there by new office buildings.

The spread of housing beyond the town's old boundaries and into its incorporated suburbs was gradual. Workers needed to live close to their place of work, where they started at an early hour, and, as there were no trams until the 1880s, office and shop workers preferred not to move out to the suburbs. The sacrosanct Town Moor stood in the way of direct northward expansion.

Today it is hard to think of Westgate as a suburb and, indeed, it was the first of the areas incorporated into Newcastle in 1835 to become physically part of the town. By 1851, housing extended up both sides of Westgate Road as far as Arthur's Hill and by the late 1880s streets had reached the workhouse and were poised for a further advances into Fenham and Wingrove. In 1821 the parish of Westgate had around 1,000 inhabitants but by 1861 it had 21,000.

Elswick had been the object of Grainger's rash speculation in the 1830s. He was ahead of his time and the enterprise nearly ruined him but, after his death, it proved very profitable. The greater part of the area remained until mid-century largely rural with country houses, such as Elswick Hall, Benwell Hall and Benwell House, still surrounded by their estates, providing rural residences for gentlemen who bridged the status of businessmen and county landowners. Then there was a rapid change as the riverside became the site of heavy industry,

and working-class housing in phalanxes of Tyneside flats marched with parade-ground precision up the banks and from the main east–west artery, Scotswood Road, with its fine line of thirty-four public houses. Increasingly from the 1850s, Elswick and Benwell (the latter still not incorporated into Newcastle) became less desirable for those who had been responsible for its emerging profile of industry and terraced housing. The Newcastle to Carlisle Railway provided an exit to and an easy return from the upper Tyne valley for industrialists and businessmen and Wylam, Corbridge and Hexham soon replaced Elswick and Benwell as the desirable places of residence for a gentrified industrial elite. In 1851 less than 4,000 people lived in Elswick but by 1891 there were over 50,000. As Charleton put it in 1885, 'Standing on Scotswood Suspension Bridge ... we can see the houses on the northern bank stretching away in almost unbroken line towards Elswick and Newcastle'.[1]

Byker began to grow from a village to a suburb in the 1870s. Although surrounded by fields, it had for long had a manufacturing dimension as it was close to the Ouseburn with its glass works and other industries, but its growth was stimulated by the building of Byker Bridge, originally a toll bridge, in 1878. This attached the village firmly to Newcastle via Shields Road and by 1911 the population had grown to nearly 49,000 while there was no gap between it and Heaton and Walker.

Heaton was almost entirely rural before 1880 and was graced by Heaton Hall. By 1887, housing was advancing across its fields northwards from Shields Road. From having only 1,000 inhabitants in 1801 it had 16,000 in 1901. Heaton Hall survived until 1923 when it was demolished but much of the parkland around it became a public recreation ground, Heaton Park, thus retaining green space for what became a pleasant Victorian suburb where the more expensive northern end merged into streets inhabited by skilled workers and clerks to the south.

Jesmond at mid-century still consisted of three separate villages, Jesmond, Jesmond Vale and Brandling Village. It had become an area favoured by the town's elite, carriage-folk, who could conveniently live further out. Here were houses in the country if not country houses, houses like Jesmond Grove, home of James Losh, West Jesmond House where Sir Thomas Burdon lived, Armorer Donkin's Jesmond Villa,[2] and T.E. Headlam's and later Sir Andrew Noble's Jesmond Dene House. Although some fine terraces had been built at Brandling

Village, more intensive development was gradual though a rash of villas appeared after 1850. The making of Osborne Road was followed by rows of terraced houses in the 1890s and the population expanded rapidly from 8,442 in 1891 to 21,367 in 1911. Many of the wealthiest residents moved further into the countryside, the grounds of their large houses were sold to builders and Jesmond moved from being an upper-class to a mixed but largely middle-class suburb. It acquired the churches that mark its expansion: John Dobson's Jesmond parish church in 1861, followed by three Nonconformist churches and a further Anglican St George's church in the 1880s.

Transport was the key to the expansion of a town which continued until late in the century to have a concentrated population. Railways did not at first attract many work-bound travellers. As early as the 1850s rail connections had been developed, connecting Blyth, Morpeth, and Tynemouth to the town, and by 1874 there was an almost complete loop from Newcastle to the coast. This enabled some businessmen and professionals to live in Tynemouth or Whitley Bay and commute to work and the riverside branch, which opened in 1871, was specifically intended for workmen. The cost of fares and the need to be at work at an early hour, nevertheless, limited commuting by rail.

The tramcar had a far greater impact on the physical expansion of Newcastle. The first horse-drawn trams appeared in 1879 and by 1893 there were '44 trams and 272 horses operating on 17 miles of track from depots in Percy Street and Gosforth High Street'.[3] Slow and with limited passenger capacity as they were, they enabled people to commute from areas like Byker and Jesmond and even from beyond the city boundaries. Most unusually for a council reluctant to embark on municipal endeavours, the Corporation, at the very end of the century, decided to run its own tramways and work began on an electrified system in 1899.

By 1900 the town, now a city, exhibited a much clearer separation between the areas where people worked and those where they lived. There was also a more distinctive correlation between socio-economic status and area of residence as office workers moved to suburbs from which tramways enabled them to travel to work. Areas like Byker, Heaton and the expanding suburbs along Westgate Road were attracting a population distinguished by a wage and salary band, rather than any class definition, and comprised in large part by skilled workers, clerks and salesmen.

Place of origin came into the picture as well. Immigrants from different counties or countries settled in different proportions in different districts of the town. The Irish were at mid-century to be found in great numbers in All Saints and especially in Sandgate, the most crowded areas of Newcastle, while Scots were more widely distributed but with concentrations in Westgate. By 1891, though both Irish and Scottish immigrants were more dispersed around Newcastle, the Scots still showed a strong tendency to settle in the west of the town. The pattern of Irish and Scottish settlement reflected occupations as much as place of origin. There were well-to-do businessmen of Scottish extraction but many more clerks and skilled workers. One historian has remarked that the Scots were, in 1891, 'still mainly living in the western sector of the city, in the newer "respectable" working-class housing developed from the 1870s onwards', reflecting their modes of occupation as skilled artisans or clerks and retailers.[4]

The new suburbs acquired their own shopping centres, churches, clubs and social hierarchies but the enlarged Newcastle remained a relatively compact town. No satellite competed with the old town which remained the centre of administration and commerce, the place where everyone shopped for more than everyday goods and where there was bustle amid the theatres and pubs. Until late in the century, this was an intimate town where a music hall song like 'Blaydon Races' could bring in the names of local characters and know that the audience would recognise them.

By the 1890s new housing was being built, largely for professional and clerical workers, outside the city boundaries in Fenham and Gosforth (or Bulman Village as it was known), while there was little to separate physically Elswick from Benwell or Byker from Walker. Asa Briggs, identifying late Victorian Tyneside as a 'great new urban complex', commented that, 'No stranger could tell … where Newcastle ended and Wallsend began,'[5] though a recent study has added, 'He chose his words carefully, well aware that locals saw boundaries and divisions where strangers did not.'[6]

The New Municipal Order

After the Municipal Corporations Act, council elections were conducted in a way which formed a curious halfway house between a modern system and the traditional system that continued for parliamentary elections. There were no

hustings but rather ballot papers with the names of selected candidates that were provided to all rate-payers and had to be signed by the elector. The Council consisted of a mayor, aldermen and councillors. Councillors were elected for three years but a third had to retire every year; aldermen were elected by the councillors every three years and sat for six; and the mayor, chosen by the Council served for one year. The number of councillors was, at forty-two, almost double that of the old common council and there were to be fourteen aldermen. During the course of the nineteenth century these numbers were modestly enlarged as the growth of Elswick led to a further six councillors and two aldermen.

Continuity was provided in the shape of the Town Clerk, John Clayton, who retained his position until his retirement in 1867. He had told the Municipal Commissioners that 'with elections absolutely popular it would be impossible to govern the town' but, nevertheless, took on the task with the representative principle, albeit limited to rate-paying householders, that was inaugurated. That a man so associated with the old Corporation, who had been attacked by disaffected freemen and reformers alike, maintained his influential position can only be explained by his seeming indispensable by virtue of his vast knowledge of the town's affairs, while his network of associations and financial links, which involved almost everyone of influence in the town, must have led to his knowing 'where all the bodies were buried'. Although he owned the great country house of Chesters, built for his father, his Newcastle residence was in Fenkle Street, where he lived simply with his brother and legal partner, Matthew. The story goes that, when the caretaker of his office in the Guildhall asked if he wanted more coal on the fire, he replied 'a little' – truly a cautious man. It was said, in 1855, that he 'has increased in money and influence and his power is greater in the new corporation than in the old'.[7] There can be little doubt that the Claytons, and John in particular, enriched themselves in the course of the management of the town's affairs, but they did so discreetly and Newcastle benefited enormously from John Clayton's sound judgement and his pivotal role in the development of the town's centre. His loyalty and assistance to Grainger, when the latter ran into severe financial difficulties due to his purchase of Elswick Hall and its estate, demonstrate that he was a man of integrity.

Was the new council an improvement? The old regime was replaced by a council elected by rate-payers and the rates became a central concern for councils. Parishes had since 1601 raised rates for the relief of the poor and sick

but Newcastle Corporation had, hitherto, raised most of its income from the management of town property, market tolls, river dues and tolls on traffic and goods entering the town. S. Middlebrook was, no doubt, correct in arguing that 'these sources were inadequate by the early nineteenth century for the provision of resources that had become urgently necessary' but the new council does not seem to have given much thought to their provision.

If the old Corporation can be criticised for concentrating on the upper town, the development of its shopping and business and genteel residential streets, at the expense of the quayside chares and Sandgate, then it cannot be said that the new Corporation was any more eager to tackle the manifold problems, especially those of poor sanitation and overcrowding, of these areas of the town. It is, of course, easy to criticise ratepayers for their reluctance to countenance greater expenditure in a town desperately in need of solutions to the problems of public health, sanitation and housing evident in its poorer quarters. Many rate-payers had only modest incomes and even small increases in the rates could threaten their solvency, while contemporary society was, with some reason, unconvinced of the beneficent qualities and efficiency of local government.

There was more than a whiff of philistinism about the new council with its narrow emphasis upon economy mixed with a mean desire to destroy the town's traditions, as demonstrated by its sale of the venerable Mansion House and its silver and furnishings at knock-down prices.[8] In general in this 'age of improvement' there was, despite the formation of the Society of Antiquaries in 1813, no strong conservation lobby in the Newcastle of the time. The old Corporation had at least bought the castle keep to stop it being sold for conversion into a brewery, but had destroyed the bailey gate and the old Moot Hall, formerly the Great Hall, to make way for the fine new Moot Hall. In the last decades of the old Corporation, much of the town wall had gone and in the early nineteenth century gates went one by one as with Pilgrim Street Gate in 1802 and New Gate in 1823. The Cale Cross and the White or Market Cross went in 1807 and the medieval chapel of St Thomas the Martyr beside the bridge was pulled down in 1827 in the interests of traffic flow; the Maison Dieu and Merchants' Court were replaced by Dobson's Fishmarket and new Merchants' Court in 1823. By the late Victorian period, the conservation voice had grown loud enough to make a fuss but was not powerful enough to prevent the demolition of the Carliol Tower in 1880.

One innovation, forced upon the Council by the Municipal Corporations Act, was the establishment of a police force. The old Corporation had tried to introduce a constabulary upon Peelite lines in 1832 but opposition had forced it to be disbanded. In May 1836, with some reluctance and despite rate-payer hostility, it was re-established.

The Poor Law Amendment Act was as, if not more, important than the new council in reshaping an important dimension of local government and in providing a national system for poor relief with elected Poor Law Unions and paid officials. Hitherto, poor relief had been the responsibility of the four parishes in Newcastle but the new Union was an amalgam of the parishes. As each parish retained responsibility for its own paupers, however, there was no sharing of the load between a parish like All Saints with many paupers and St Nicholas's which had far fewer. The election of guardians was by a complex system in which voters could have a number of votes dependent upon the value of their property and voted via ballot papers bearing the printed names of the candidates, putting initials against the favoured candidates and adding their signature and details of their property qualifications. To a degree Poor Law Unions were a parallel form of local government to councils, though the leading lights in both were often the same people. The introduction of the new Poor Law system which aroused widespread opposition nationally does not seem to have been so controversial in Newcastle or the North East generally as the area was not experiencing high unemployment in the mid and late thirties and the new legislation was introduced with caution and sensitivity.[9]

Chartism in Newcastle

If the history of Victorian Newcastle can be written largely in terms of a developing economy, an expanding town and a very gradual improvement in the facilities provided by local government, then the first years of Queen Victoria's reign provide a very different picture, that of a town faced with the problem of preserving law and order in the face of political discontent.

The period 1832–7 had seen a decline in radical protest and agitation with few demonstrations or mass meetings. There was, however, considerable chagrin

among the more radical elements and those working men who had supported reform at the lack of further progress towards male suffrage and the secret ballot. The leaders of the reform agitation had been for the most part prosperous and respectable citizens who were content enough with the limited suffrage that had been achieved in 1832 and, after 1835, such men, who could loosely be described as Liberals, though they ranged from Whigs to moderate Radicals, were happily running the new council. If more impatient Radicals were disappointed with the Whig government, they could until 1837 take comfort in Lord Durham's continued if ambiguous support for reform but from that year he was abroad, first in Russia and then in Canada, and in the same year Russell's 'Finality Jack' speech put an end to hopes that a Whig government would introduce further parliamentary reform. Radical dissatisfaction gave birth to the Chartist movement with the six-point Charter being drawn up in May 1838.

The old concept of Chartism as a 'knife and fork' movement that rose and fell as the economy waned and waxed never fitted Tyneside Chartism. The years 1837–42 were a fairly prosperous time for Tyneside unlike most of the country. How potent the appeal of the first phase of Chartism in and around Newcastle was has been hotly contested by historians with W.H. Maehl arguing that it was strident and vehement[10] and D.J. Rowe that the response was modest.[11] It would appear that the echelons of Tyneside Chartism consisted of an unusually high number of businessmen among the leadership. In many respects it resembles Birmingham's Chartism where the movement was allied with middle-class reformers. They were supported by artisans and shopkeepers and a sizeable section of the pitmen who, perhaps because of the position of their leader, Thomas Hepburn, unusually for a working man among the local Chartist leaders, could be relied upon to turn out for mass demonstrations.

Political radicalism had revived on Tyneside in 1837 before Chartism began, with the formation of working men's associations dedicated to reform. The Newcastle Working Men's Association had Thomas Hepburn as its president. The *Northern Liberator*, which had hitherto directed its attacks upon the new Poor Law, now began to concentrate on demanding political reform. The view that all of the middle-class leadership which had headed the agitation of 1831 and 1832 were not interested in pushing for further reforms is confounded, at least partially, by the fact that Thomas Doubleday was co-proprietor of the *Liberator*

along with the prosperous furrier Robert Blakey, and that John Fife chaired a meeting in December 1837 called to protest at Russell's declaration that no new political reforms would be introduced.

The years 1838 and 1839 saw both the beginning and the apogee of Tyneside Chartism. In June 1838 there was a major demonstration on the Town Moor in support of the Chartists' National Petition and on Christmas Day 1838 a meeting on the Forth to elect delegates to the Chartist Convention and addressed by Julian Harney was attended by many thousands. It was at this meeting, it has been suggested, that the violent language of physical force Chartism began to imbue North East Chartism. Whit Monday 1839 saw a meeting in Newcastle attended by a huge crowd, whether or not the figures of 140,000 or, more modestly, 80,000, suggested by Chartist newspapers, are to be believed. As with the crowds who had attended the demonstrations before the passing of the Reform Act, it may be questioned how many came from Newcastle itself rather than outlying villages. Newcastle, it has been claimed 'was a psychological centre rather than an actual centre of Chartist strength'.[12] 1839 saw alarming reports of Chartist preparations around Newcastle at Bedlington and at Winlaton, where the ironworkers were said to be making weapons and practising military drill.

After the rejection of the Chartist Petition by Parliament and the call for a 'National Holiday' from 12 August, tensions heightened. When permission for a meeting to be held on the Forth on 30 July was refused, a number of Chartists went ahead with it and afterwards marched through the town coming face to face with the mayor, John Fife, some magistrates and a body of police. The 'Battle of the Forth' has been seen as Newcastle's Peterloo with A.R. Schoyen writing of 'almost regular warfare' and a 'potentially revolutionary' situation[13] but D.J. Rowe has responded that, 'It is a long time since anything approaching regular warfare did not lead to a single serious injury.'[14]

As with all 'potentially revolutionary' situations, we can never really know how dangerous either the skirmish on the Forth or physical force Chartism in and around Newcastle really was. That which comes to nothing or very little may never have had the potential to amount to much and nervous authorities and property owners may have exaggerated the danger, just as Chartist newspapers almost certainly exaggerated numbers involved. Alternatively, the numbers involved in demonstrations were certainly large, the language was fierce and

there were arms to hand. The population of Newcastle was about 43,000 in 1831 and that of the expanded town in 1841 some 72,000, so, even if we halve the more extravagant estimates of those present at demonstrations, one can understand the fears that were held by much of citizenry. The evidence suggests that government was resolute and the armed forces quite capable of dealing with revolt, so that any revolution had little chance of success, but mistakes by the authorities on Tyneside in the form of either heavy-handedness or vacillation could have led to major disturbances and many deaths.

The ambitions of local Chartists for a 'sacred month' having diminished, the more limited aim of a 'sacred day' on 12 August was only partially realised with very few staying off work. Workmen and especially pitmen were quite prepared to suffer financial loss and hardship in the pursuit of economic grievances but 'were not ready to sacrifice prosperity for political principle'.[15] Nevertheless, further disorder followed with riots on The Side on 20 and 30 August and the Riot Act had to be read on the latter occasion before cavalry dispersed the rioters. On the whole, however, the authorities, even after the Newport Rising of 3 November, seem to have responded calmly to the Chartist threat with the Home Office advising a restrained reaction.[16] Chartism on Tyneside continued to have support after 1839 but was unable to enlist the same enthusiasm or mount similar mass demonstrations in the 1840s.

Much of the attention that has been given to Tyneside Chartism has focused on the role of John Fife, from 1840 Sir John Fife, knighted for his role as mayor in 1839. He has been seen as an exemplar of those middle-class radicals who headed the reform movement in 1830–32 and then turned their backs on demands for further political reforms which would have benefited working men. The contrast between the Fife of 1831 and the Fife of 1839 is indeed stark: Fife only just stopped short of calling for physical force in the cause of the Reform Act, while, in 1839, he was, cutlass in hand, leading magistrates and police against Chartist demonstrators. Supporters of Fife can, however, argue that he never wavered in his support for further reforms but was consistent, despite some fiery language in 1831–2, in his opposition to violence and revolt.[17] The differences between Fife and most Chartists went deeper than disagreements over tactics or a love of order as opposed to being prepared to countenance violence and were psychological and cultural. We can distinguish perhaps between the ostensible

aims of Chartism and its ethos. Recent analyses of the movement have pointed to the significance of its language, imagery, ritual and the choreography of its torch-lit mass processions, all with their roots in traditions and lore, which spoke of ancient rights and moral economies, none of which made any appeal to a man like Fife with his belief in political economy and support for the New Poor Law and who had resigned from the Northern Political Union in 1832 on the grounds that it was becoming the tool of William Cobbett.

THE ECONOMY

Newcastle at mid-century was facing major problems. To many it seemed that its economic fortunes were faltering and, as we have seen, its population growth had been, relative to other major towns, modest.

> [About] the middle of the century there was anxiety and ground for anxiety about the future of the town. It was fast losing its iron trade to Tees-side and, concurrently, the old sea-borne coal trade was threatened by the development of railways.[18]

The coal trade continued to expand but, to add to the concern that railways might make the London market accessible to inland coalfields, there were worries that other ports and rivers in the region were increasingly expanding their trade at Tyneside's expense. As well as the decline of the iron industry, much of which was eventually lost to Teesside, the glass industries were in decline, lead mining in the northern Pennines was faced with foreign competition and salt manufacture was largely a memory. The railways had provided a stimulus for the beginnings of heavy engineering but, at the very time that Stevenson's High Level Bridge was making it possible for the passenger from London to alight in Newcastle, the boom, which had seen railway shares go higher and higher, burst and even the best companies lost 50 per cent of their net worth. Such anxiety on the eve of the major expansion of Tyneside manufacturing was, with hindsight, misplaced, but it was apparent that there were threats to the basis of the existing economy. Closer analysis might have discerned that there was already an increase in the proportion of coal shipments destined for foreign ports and that new heavy

industries and shipbuilding, which would transform the Tyneside economy, were emerging. That transformation owed much to a number of remarkable men who were part of 'a highly successful local entrepreneurial elite … Although external factors of supply and demand were crucial in determining the region's progress, so were the actions of this group.'[19]

The development of railways had already led to the foundations of Tyneside's heavy industry. The Newcastle works of Robert Stephenson & Co., started in 1823, were one of the first locomotive-building plants to be established. Son of George Stephenson, Robert had by mid-century amassed a considerable fortune and employed a workforce of about 1,500. Another successful endeavour was the works of Robert and William Hawthorn; started by Robert with a workforce of four in 1817 to engage in the manufacture of steam engines along with general engineering work, it employed nearly a thousand men in 1850. Nevertheless, the expansion of heavy engineering was still modest in comparison to what was to come and that further expansion owed much to two men.

One of them was Charles Mark Palmer, the founder not only of a shipyard but of the town of Jarrow. The launch of the first steam-powered boat on the Tyne on Ascension Day 1814 may have been a harbinger of the later shipbuilding industry manufacturing steam-powered ships but it was another thirty years until that industry got under way. Tyneside had always had a shipbuilding industry but had never been among the major shipbuilding ports and rivers. The late eighteenth century had, however, seen an expansion of shipbuilding and a number of large yards, like Hurry's at Howden and Rowe's of St Peters, had been set up. For the first time in 1804–5 Tyneside's new tonnage exceeded London's and the river had seven large yards under five owners employing between 60 and 180 men each. A crash followed, however, and of the 'big seven' only the smallest, William Rowe's yard at St Peter's, survived (Hurry's and Simon Temple's closed in 1806 and 1813 respectively). Smith's took over Rowe and managed to break into the market for the large ships required for the East India trade, while down river J. & J. Hair and Glady & Lamb were by mid-century producing medium-sized ships.[20] During the first half of the nineteenth century, the Wear was, nevertheless, a more significant shipbuilding river and was producing about one third of the wooden ships built in Britain.

It was with the introduction of iron ships that the Tyne became the most important shipbuilding river in England. In 1852 Palmer's shipyard in Jarrow

launched the *John Bowes*, an iron-built and screw-propelled cargo ship, the first successful modern cargo ship. The subsequent expansion of shipbuilding was astonishingly rapid; by 1862, there were more than ten shipyards on the Tyne building iron ships and they employed more than 4,000 workers. In 1906 the major yards on the Tyne launched together ships with a total tonnage of 411,716.[21] The introduction of iron colliers did much to retain Tyneside's share in the London coal trade in the face of competition from coalfields nearer to London who could now transport their coal by rail. The new colliers could transport more coal more quickly; the eleven steam vessels launched by Palmer's in 1853–5 could make thirty journeys between the Tyne and London in a year, carry twice the load of sailing vessels and could load coal faster because they used water for ballast rather than solid materials. Most shipyards and coal mines and staithes were outside the boundaries of Newcastle but, as the centre of commerce, banking and insurance, the town benefited from all economic expansion on the Tyne.

In 1847 William Armstrong, a solicitor who became an engineer and then a major industrialist, started a small factory at Elswick to manufacture the hydraulic crane he had invented. During the Crimean War, another invention of his, a breech-loading field gun, was ordered in large quantities by the government and the Elswick Works expanded into a major armaments manufacturing centre. In 1868 Armstrong began co-operating with Charles Mitchell on warship production with the ships being built at Mitchell's shipyard at Walker and armed with Armstrong's guns. The opening of the Swing Bridge, powered by Armstrong's hydraulic machinery, enabled ships to sail up to Elswick to be armed and in 1882 he bought up Mitchell's, built his own yard at Elswick, and, thereafter, built merchant ships at Walker and warships at Elswick. By the end of the century Armstrong's had bought out the Manchester firm of Whitworth's and the Scotswood Shipbuilding Company and was employing 10,000 people on Tyneside.

Armstrong's was an example of heavy industry within the town's boundaries as were the firms of Robert Stephenson & Co. and R. & W. Hawthorn, both on Forth Banks. Newcastle had, therefore, an industrial dimension and, with further expansion of its boundaries in 1905, was to acquire more industry, but it is important to emphasise that it has never been the predominantly industrial or manufacturing town that is the image many outside the North East have

of it. Lower Tyneside acquired after 1850 an economy largely dependent upon industry but Newcastle's economy was different, being dominated by commerce, administration and retailing and other service or consumer trades. Clearly the economy of the town and the surrounding area were interdependent to a great degree, with the professional expertise to be found in the town providing an essential service to Tyneside's industries and the prosperity of Newcastle's shops dependent on the wages of the industrial workers from outside the town, but the economies of Newcastle and the rest of Tyneside were different.

The town's neighbour Gateshead was still a small town with a population around 15,000 in the 1830s but was expanding rapidly with a number of industrial enterprises. The heavy engineering firm of Hawks, Crawshay & Sons produced a bewildering array of products ranging from anchors and spades to paddle steamers and dredgers. By mid-century John Abbot & Co. and Black, Hawthorn & Co. were building railway engines. In 1832 the town became a parliamentary constituency and in 1835 its antique constitution ended and it became a municipal borough. The area close to the bridge was, like its counterpart on the north bank, already overcrowded and poverty-stricken but early in the nineteenth century much of Gateshead still consisted of large landed estates and, as these were sold off, many semi-rural areas saw the building of substantial villas which proved popular as the residences of wealthy citizens of Newcastle. By the end of the century Gateshead was to have a population of around 110,000 but was still, as the daily movement across the bridges demonstrated, something of a suburb of Newcastle, a city with which it had an uneasy but close relationship.

The economic development of Newcastle and of Tyneside owed little to government, whether national or local, and a great deal to the entrepreneurial elite. To a marked degree this was an integrated elite not simply because industrialists, merchants and financiers had common interests but because many major figures were involved in a number of enterprises: 'Indeed, it was also common to find a combination of entrepreneurs with experiences in manufacturing and finance among the directors of a single company, in order that their different skills could be combined to aid a firm's success.'[22] Another sort of integration was achieved by the amount of intermarriage between the families.

The history of economic development has too often highlighted the great manufacturers and engineers, important as they were, at the expense of financiers

and bankers. The success of a manufacturing enterprise is dependent on a number of factors: the ability to supply as against a shrewd estimation of demand, and the provision of capital to back the supplier. Since the 1750s Newcastle had been a banking centre, though its history, like that of banking as a whole, is punctuated by crises and failures.[23] Whereas in south Durham, banking was dominated by Quaker families, notably the Backhouses,[24] Newcastle tended to be run by an amalgam of established merchants, gentry and aristocrats. As a banking centre with a regional branch of the Bank of England from 1828, Newcastle was robust enough to furnish the finance for regional entrepreneurs. Nevertheless, in 1847 the Bank of England had to step in to ameliorate the effects of the failure of the North of England Bank and to shore up the District Bank[25] (not the last time the Bank of England had to step in to rescue a Newcastle bank) and when, ten years later, that bank finally went under, to assist its unfortunate business customers with loans.[26]

Marine insurance, an essential for a prosperous shipping industry, had long existed in Newcastle. A form of insurance was covering your risk by owning fractions (usually 64ths) of several ships rather than one ship and this system endured into the early twentieth century. A further and more professional method had come with mutual insurance clubs[27] and with the practice of merchant houses engaging in marine insurance as one of their many activities.[28] The insurance of iron and screw-propelled ships involved large sums of money but groups of Tyneside shipowners, like the Newcastle Protection and Indemnity Association (1886), were prepared to take the risk at rates below those of Lloyds.

For a trading town, good communications were a priority. The railways grew out of the mining industry with its wagon-ways enabling coal to be taken down to the banks of rivers and with the expertise in steam engines that came from their use in draining water from mines. The North East saw their introduction and their expansion in the 1830s and 1840s. Again, the Newcastle Chamber of Commerce supported a number of railway projects, and local entrepreneurs William Losh, the iron and alkali manufacturer, and William Woods, the Newcastle banker, were promoters and directors of the Newcastle & Carlisle Railway, while the Corporation also invested in it. By 1838 the Newcastle–Carlisle railway was largely complete, though it wasn't until 1846 that the trains actually entered Newcastle. A line to North Shields opened the following year.

Sea links had always made Newcastle feel close to London. 'It was considered wonderful that letters could be taken from Newcastle to London by steamer for eight pence in 1835; three years later, thanks to the railways, the mail came round by Carlisle in twenty-six hours and the London morning papers were delivered at one o'clock on the day after publication instead of on the morning of the second day'.[29]

The complexities of travel in a period when railways were just beginning are illustrated by the journey to Ireland made by the country gentleman Ralph Carr in 1837. He left Newcastle by road and was able, by changing coaches at Leeds, to reach Manchester in a day and then took the train from Manchester to Liverpool before embarking on a steam ship for Dublin. The return journey from Liverpool was made largely by rail via Carlisle.[30]

The importance of rail links to the south and to London in particular was obvious but presented a considerable engineering challenge. Gateshead was connected to London by 1844 but it was not until 1849 that the High Level Bridge enabled the line to be extended across the Tyne. Railway stations are perhaps the most impressive examples of Victorian architecture and Newcastle Central Station, designed by Dobson and opened in August 1850 by Queen Victoria and Prince Albert, is no exception. The pity is that it could have been even better, for Dobson's original design was for a more ambitious building with a much longer arcade and two porticos, but, at a time when railway shares were falling in value, the railway companies insisted they be modified and the final front of the station was much more modest with a single covered gateway approached by seven arched bays.

One important effect of the High Level Bridge and the Central Station was a shift in the town's centre of commercial gravity from the riverside to the west of the upper town, a shift embodied in the fine new banks and offices in Collingwood, Neville, St Nicholas and Mosley streets. Railways made principal stations the hub of Victorian towns and Newcastle was no exception with travellers and goods decanted into the town centre. The opening of Redheugh Bridge in 1871 assisted this commercial movement. A toll bridge, it also joined Gateshead and Newcastle from the top of the banks enabling workers, shoppers and carts to cross easily between the west ends of both towns.

There was a price to pay, however, in the destruction of ancient buildings. The brutal insertion of the railway between the Keep and the Black Gate is the most

obvious example of this – Cadwallader Bates described it as done 'as if for the express purpose of vaunting modern progress at the expense of the historic past'.[31] The Stank and Spital Towers, the Forth House, where the Grammar School was based, and Westmorland Place were also pulled down, while the combination of railway development and industries meant the end of the pleasant meadows of the Forth, for centuries a place of recreation for the townspeople. To the east, the building of Manors station and its goods yards and sidings involved the destruction of King's Manor and the Surgeons' Hall.[32]

If the Corporation was supportive of railway links to the town the same cannot be said of its care of the river which had always been the source of Newcastle's wealth. A major failing of the old Corporation had been its lack of concern for the condition of the Tyne, which had for generations been the cause of vocal complaints by ships' masters and shipowners. The increased draught of ships meant that navigation problems due to the silting up of stretches of the river were getting worse. It was possible at low tide to wade across the river at places below Newcastle. Although the Corporation in 1813 commissioned a report by the civil engineer John Rennie, who drew up a plan which he estimated would cost £519,320 to implement, for narrowing the river to improve scouring and therefore depth, nothing came of this.[33]

The Reform Act by creating the borough constituencies of Tynemouth, South Shields and Gateshead strengthened considerably the hands of those who had long opposed Newcastle's control of the Tyne. An enquiry in 1849 heard evidence that Newcastle had received £957,973 in the last forty years in river dues and spent only £397,719 on improvements, the balance having been used to pay for the amenities of the town. In the same year a bill creating a Tyne Improvement Commission on which all four towns and the Admiralty would be represented was introduced.

The reaction of the new Newcastle Council was close to that of Newcastle's reaction to Ralph Gardener's opposition to the town's control of the river in the seventeenth century and the bill was fought with 'an obstinacy, an intransigence and a lavishness of expenditure'[34] worthy of the old Corporation and with temporary success but a second Tyne Conservancy Bill did become law the following year. It was to take another decade before the Tyne Improvement Commissioners made serious efforts to make the river on which all lower Tyneside towns depended

more navigable. When J.P. Ure became Engineer in 1859, dredging began and plans were made for piers at the river mouth to enable ships to enter more safely.[35] An important role in the work of the Improvement Commission was played by the Newcastle Chamber of Commerce, founded in 1815, which was much involved in the election of commissioners. The Commission was chaired by Joseph Cowen Senior from 1853 to 1873. Cowen's role was significant as he was a representative of above-bridge business and, therefore, supportive of Ure's work.

Ure employed powerful dredgers to improve the depth of the river below Newcastle but it still wasn't possible before 1872 for ships of any size to get beyond Newcastle due to the low height of the arches of the eighteenth-century bridge, while above the bridge were islands at Blaydon and at King's Meadows beside Elswick, which had for long been the site of regattas and fairs. If the pressure for improvements to the lower reaches of the river came from North and South Shields, economic interests upstream, including Crowley's works at Winlaton, had long resented paying tolls when the river above Newcastle was only navigable by small craft. The replacement of the Tyne Bridge by the Swing Bridge, completed in 1876, together with subsequent dredging, excavation and the removal of islands, increased the river's depth and width above Newcastle and up to Newburn.

The Swing Bridge, designed by Sir William Armstrong, thus facilitated the development of industry upriver, with a major beneficiary being Armstrong's own works at Elswick. Armstrong had not selected his site with an eye to shipbuilding and, even after the bridge was opened, Elswick was an odd place to launch big ships. Soon, however, great warships were being built there and were able to pass by the new bridge on their way to the sea. Progress for some can, however, mean disaster for others and the Swing Bridge marked the end of the keelmen as the ability of colliers to proceed up river and take on coal at staithes made them redundant.

With Elswick incorporated into the town, the riverside from Forth Banks to Armstrong's became the town's most important industrial area. Industry and housing didn't of course halt at the town's boundary and there was a gradual expansion of industrial and urban growth into, not only Elswick, but Benwell, Fenham and Lemington. Previously, the area to the west of Newcastle had contained a number of coal mines and scattered small industries, largely off-

shoots of coal and lead mining, such as a glass works and lead refining, and, mirroring the south bank and the Derwent, some metal manufacturing and a steel works at Newburn.

To the east of the town centre there was a cluster of industries and workshops on the banks of the Ouseburn. Glass making there dated back to the seventeenth century and there were potteries, brickyards, a copperas works, a foundry, small boatyards and a ropery. A somewhat larger enterprise was Morrison's engineering works started at mid-century to make marine engines, steam hammers and cranes. It failed in 1866 but was succeeded by a unique experiment when, under the aegis of Dr Rutherford, a Nonconformist minister and philanthropist, a co-operative was set up to take over the works; it too went bankrupt. More typical of the Ouseburn were manufacturers which polluted the stream and spread noxious fumes, such as tanneries, dye works, the processing of bones into manure, and chemical works, for the valley was far enough from the town centre and genteel areas for these to be tolerated. Newcastle was too far upstream to be suitable for shipyards building large ships (Armstrong's was unusual and had not started off as a shipyard) and the first shipyards below Newcastle were at Walker, not yet part of the town, though increasingly physically and economically integrated with it.

Newcastle's manufacturers, shipowners and bankers not only invested in each other's companies and were the main investors in utilities but the families intermarried to a marked degree. It may well have been an integrated elite but it encompassed men of very different origins. Some came from families that had made money in the eighteenth century for, if several prominent families had withdrawn from Newcastle and its business and commerce, others continued to be closely involved, while even those who concentrated on county life were prepared to make investments in new enterprises. Many, as ever, were established coal owners, diversifying into industries dependent upon coal; while others were of comparatively humble origins, making their way from being colliery viewers or engineers to co-owners of large enterprises. It was by no means a closed elite for new wealth from within Tyneside was represented by men like the Joiceys, John Buddle or Armstrong. There were also men from outside the region like the bankers Thomas Hodgkin, William Barnett and William Woods from London and Andrew Noble, a director of Armstrong's, from Edinburgh. There were men

of foreign origin, such as John Theodore Merz, who played a major role in the development of the electrical industry, and Christian Allhusen, an important figure in the chemical industry, who also had commercial interests in coal, corn and iron. They were linked by a matrix of connections: school, church, chapel, the reserve forces, and the membership of clubs and societies, such as the Northern Counties or the Union Clubs and the Literary and Philosophical Society.

This mixed but cohesive group of entrepreneurs has been viewed in different ways. The study of the major employers of west Newcastle by the Benwell Community Project detailed the inter-relationships of a 'capitalist ruling class' but, concentrating on social inequalities past and present, made little assessment of their ability or positive achievements.[36] A recent study of the integrated Newcastle elite has, however, concluded that 'the activities of the entrepreneurial elite in all areas of the Newcastle economy contributed to the town's high levels of prosperity and innovation'.[37]

To a considerable extent these men were not just entrepreneurs who chanced across business opportunities but businessmen who were abreast of the science and technology of their time. They were founders and members of societies specialising in branches of applied science and patrons and contributors to learned journals. The Newcastle Chemical Society published its *Transactions* from 1868 to 1882 and the North East Coast Institute of Engineers began publishing its *Transactions* from 1884, while the Institute of Mining and Mechanical Engineers had been founded in 1852. Nicholas Wood and E.F. Boyd were prominent among the founding fathers of the society which in 1870 moved into the newly built Neville Hall next to the Literary and Philosophical Society. While they were learned bodies, it has been written of them that 'they were largely composed of practical men working in industry and the chief subject matter of their discussions was the problems and practice of the major industries on which the local economy was based'.[38] Indeed, without this practical elite the very fabric of the town would have suffered, for much the same men were responsible for the new utilities that enabled Newcastle to expand and have, eventually, clean water, gas and electricity.

Industrial expansion in the last half of the nineteenth century on Tyneside and its environs was largely based on coal mining, engineering and shipbuilding. Shipments of coal from the Tyne rose from about 3.6m tons in 1848 to 12.2m

in 1894. Armstrong's amalgamation with Charles Mitchell's shipyard at Walker produced a firm employing 10,000 in the early twentieth century. There were industries which declined or were lost to Tyneside. The chemical industry was a major force until late in the century with Tyneside producing more tons of alkali than any rival in the 1860s, but from the 1880s it followed the iron industry in relocating on Teesside. D.J. Rowe has commented that:

> It may be that both the financial and entrepreneurial capacities of the area were so stretched in the second half of the century by the enormous expansion of the coal-mining, engineering and shipbuilding industries that other industries failed to attract capital and talent.[39]

Innovation continued and not only did both merchant and warships grow bigger and faster but the latter became better armoured and better armed with ever bigger guns. Charles Parsons, although the son of an earl, served an apprenticeship at Armstrong's and after becoming a junior partner at Clarke Chapman where he developed his turbine engine,[40] formed his own company at Heaton and another at Wallsend, the Marine Steam Turbine Co., where the *Turbinia*, the first craft to be powered by turbine engines, was developed. The turbine proved not just applicable to ships but was later to be employed in power stations to produce electricity, a further innovation in which Newcastle played a great part, for in 1880 Joseph Wilson Swan demonstrated a light bulb to a meeting of the Literary and Philosophical Society and then set up the first electric light bulb factory in Benwell.[41] Nor was the industrial elite complacent for, acutely aware of the importance of the coal industry, there was constant agonising over the prospect that one day the coal seams might be exhausted and, as early as 1863, Armstrong devoted his speech to the meeting of the British Association for the Advancement of Science in Newcastle to the subject.[42]

Manufacturing accounted in 1851 for a comparatively small percentage of the employed population of Newcastle, though whether situated in the town or within a 20-mile radius, it was along with coal, the basis of its prosperity. Newcastle was the capital, the head office, the cultural centre, the playground and shopping mall for Tyneside. Though manufacturing within the town's boundaries increased in absolute and relative terms, it continued to be a far smaller sector than the service

sector in general for the town provided services, food, drink and clothing as well as administrative and professional expertise for a vast surrounding area. There was a much larger percentage of professionals than in any other town in the North East except for Durham. As early as 1829 there were 61 solicitors and 53 doctors in Newcastle and Gateshead combined. By 1891 the professions and white collar workers made up more than 5 per cent of the working population. Retailing, excluding shoemakers, milliners and tailors, employed some 3,500 people in 1851, 5,000 in 1881 and around 10,000 in 1911. As in other towns the biggest single employed group was in domestic service, nearly 10,000 in 1891.

The history of modern shopping is one of a gradual shift from markets to shops, a move away from a concentration of specialisms in particular streets and quarters, the development of the department store and the arrival of chain stores. The shift from markets to shops was, especially in food, a gradual one and one partly arrested by the development of indoor markets: Grainger's development of central Newcastle made special provision for the sale of meat, vegetables and fish in indoor markets. The Butchers' Market contained 187 separate shops.[43] Open-air markets continued with the long-established food market in the Bigg Market on Thursdays and Saturdays, only yards from the covered Grainger Market. The number of shops in fixed premises expanded rapidly, however, and butchers and grocers sprang up in new residential areas. Co-operative stores were established after mid-century making a particular appeal to the more prosperous members of the working classes. In the poorer areas pawnshops, second-hand clothes and shoe shops abounded to the degree that their relative density has been used has been used by historians as a social indicator.[44] Although Newcastle had acquired grand and fashionable shops in the eighteenth century, these had tended to cater for a relatively small polite society and to be mainly dedicated to the sale of clothing, china and furnishings. Newcastle was, however, a pioneer of the department store. Bainbridge's of Newcastle vies with Bon Marche of Paris and Kendal Milne of Manchester for the honour of being the first department store; starting out as a draper's in 1837, it gradually opened other departments selling different goods. Drapers had previously relied upon a select wealthy clientele, had given credit and charged a commensurately high mark-up. Bainbridge's had clearly marked prices, goods of high quality and operated on a cash-only basis. The number of clerks, administrators and junior managers in Newcastle

together with the fact that working men's wages were high by national standards were important factors in its success. This was the beginning, as the major authority on the department store's history, Bill Lancaster, has demonstrated, of a 'democratised shopping', the goods available to all who could afford them, while the co-existence of luxury goods and less expensive items meant that most potential customers could afford something and everybody could browse. Fenwicks with its origins in fashion rather than drapery followed in the 1880s. At first it operated several shops in Northumberland Street but in the 1890s became a department store which emulated Paris's Bon Marche and offered its customers an experience as well as simply goods, with its carefully designed window displays and various departments providing fantasy, adventure and cornucopia.[45]

In the last decades of the century, Newcastle benefited from the retail revolution that transformed British shopping and improved both the price and the quality of food and clothing for ordinary people. The same shops, Thomas Lipton's, the Maypole Dairy, the Meadow Dairy, Boots and the Twenty Shilling Tailors appeared there as elsewhere but there were also local chains operating throughout Tyneside like Law's, Duncan's and Brough's.[46] This development did not do away with the small self-owned shops which, if they rarely thrived, survived and even expanded in numbers, and new suburbs soon found houses converted into shops, especially on corners.

MUNICIPAL POLITICS & GOVERNMENT

The constitution and politics of early Victorian Newcastle had changed fundamentally within a few years and the new Council had been faced immediately with major problems. Elected by an electorate rather smaller than the parliamentary electorate, it contained a majority of Liberals of various hues, but, it has been argued: 'Soon after the first couple of bitterly contested elections for the reformed council, party politics virtually disappeared from Newcastle local government'[47] and contested elections were rare. Politics in a formal sense may have disappeared but groups and factions jostled for influence and there were bitter rivalries, while the parliamentary representation of the town remained an overtly political business. The 1830s and 1840s saw the rise of power brokers, men

who had a hand in every corner of the life of their towns and who controlled municipal and parliamentary elections alike by influence and manipulation. Across the river in Gateshead, William Brockett is a well-known example[48] and, in Newcastle, little happened without the approval of Dr Headlam. Prominent as a supporter of parliamentary reform, physician to Lord Durham's family, and from a minor gentry family, Headlam was one of those 'evolving a new style of politics, which combined the old techniques of interest-building through office and place with the articulation of opinion, in this case of the upper middle class, who dominated the towns for the generation after 1832'.[49] He secured the return of his nephew, Thomas, as one of the town's MPs in 1847.

The composition of the Council registered a change consequent on the withdrawal of many of the old elite like the Ridleys, from urban life and became dominated by new groups of businessmen, industrialists and professionals. They tended to be more urban in their interests than many of their predecessors, who had had one foot in Newcastle and the other in county life, though in time several would acquire country houses. Continuity with the old Corporation was, however, represented, not just by John Clayton, but by the coal owner John Brandling and the lawyer Armorer Donkin. Clayton was succeeded by the lawyer Ralph Park Phillipson as Town Clerk and, like his predecessor, he was effectively in control of affairs. The Council operated a committee system with decisions tending to be taken by the major committees:

> … especially the Finance and Town Improvement committees. Both normally had powerful and long-serving chairmen. For example, James Hodgson, until 1850 proprietor and editor of the *Newcastle Chronicle*, was chairman of the Finance committee for 22 years from 1844. He was succeeded by Isaac Lothian Bell, one of the region's most prominent industrialists, who was followed by Thomas Hedley, soap manufacturer and director and chairman of the Newcastle and Gateshead Gas Company. Finally … one of the most prominent of Tyneside's industrial elite with widespread financial interests, William Haswell Stephenson, was Finance Committee chairman for 28 years from 1890 to 1918.[50]

Local government was of far greater importance in Victorian towns than it is in the early twenty-first century when the main decisions are made by central

government and most of the money is provided by it. Although certain functions such as the institution of police forces, provision of schools after 1870, a basic system of care for the indigent and the sick, and responsibility for highways and bridges were laid down by central government, many other activities *could* be carried out and Local Acts of Parliament were important. Many public health measures were allowed by permissive legislation but were, for long, not compulsory. Similarly libraries, bath houses, public parks and museums could be provided and some towns got such amenities decades before others. Councillors could decide that the municipality would be responsible for water and gas or they could leave these services to the private sector.

Municipal government was not monolithic and nor was the rating system which supported it. In 1862 rate-payers in Newcastle were liable to seven separate rates for different purposes and the number was to grow in ensuing years. As well as councils, there were, as the century progressed, School Boards as well as Boards of Guardians, separately elected bodies with different franchises and elective systems. Poor Law Unions acquired a number of functions as well as the relief of poverty, becoming responsible for the registration of births, deaths and marriages and having important functions as hospitals. By 1880 the Newcastle Union was employing a headquarters staff of fifty-seven.

If in many towns much the same group of people were prominent in all these bodies, differences often emerged. School Boards, provided for by the 1870 Education Act, had the widest electorates and could easily become a battleground for religious pressure groups and this happened in Newcastle, though not to the degree found in many towns. Both Anglicans and Catholics objected to the Cowper-Temple Clause that forbade the teaching of any denominational doctrine in Board Schools and fought for seats on School Boards. In the Roman Catholic parish of St Dominic, Catholic candidates, often priests, stood for the Board and the Catholic congregation was told to vote for them. The alternative was to increase the number of Church of England and Roman Catholic schools which both churches did with some success though they found difficulty in providing the level of accommodation that was required to qualify for state aid.

In contradiction of the myth that education for the mass of the population only began with the Education Act of 1870, Newcastle had, as we have seen, a multiplicity of schools in the late eighteenth century and educational provision

in the town had subsequently widened considerably. This provision was, nevertheless, patchy and the remit of School Boards to build schools where the voluntary sector was not providing sufficient places led to the opening of board schools in Westmorland Road, Arthur's Hill and St Peter's in the 1870s.[51] As well as Anglican and Roman Catholic schools other voluntary schools were founded by Dr Rutherford in Bath Lane and by Armstrong, who opened Newcastle's largest school at Elswick for the children of his employees. Although some voluntary schools, mainly Anglican and Roman Catholic schools, received government grants, the Board Schools were, nevertheless, providing elementary education for the majority of Newcastle's children by the end of the century.

Secondary education had made greater strides. The Royal Grammar School had since its foundation been supported by the Corporation but in 1888 control of the school passed to a private governing body though the Corporation continued to have representatives on it. It was by this time much larger than the struggling school which had been based in a single house in Charlotte Square at mid-century and the curriculum had been extended. It had moved to new premises in Rye Hill in 1870 and in 1897 a branch was opened in Jesmond. The old charity school of St Nicholas's, founded by Dame Eleanor Allan in the early eighteenth century, was transformed into Dame Allan's Endowed Schools, grammar schools for both boys and girls with fee-paying pupils, in 1887, and moved into new premises in Northumberland Road. The Roman Catholic Church was busy and St Cuthbert's Grammar School opened in 1883.

The growing provision for the education of girls is one of the most significant features of the period. By 1900 several secondary schools for girls had been established: Central Newcastle High School which was part of the national Girls' Public Day School Trust, the Newcastle upon Tyne Church High School and two Catholic schools, the Convent of the Sacred Heart in Fenham and the Convent de la Sagesse in Jesmond. What was their purpose? Only a few of the founding mothers of these schools or indeed parents looked forward to pupils having careers, moving into the professions or setting up businesses, though schoolteaching was increasingly offering an opportunity for the educated woman. The idea that a woman should be well educated had, as we have seen, been a concern of upper-class families on Tyneside as elsewhere since at least the late eighteenth century and was transmitted in the late nineteenth century

to a broader upper and middle class. The result was not as yet, and indeed not for another hundred years, to make large numbers of women determined on careers. It did, however, make it possible for an increasing number of women from middle-class households to work before marriage in the burgeoning number of jobs that were becoming available, particularly elementary school teaching and secretarial work. Just as importantly, wives and mothers became more equal partners, often to the discomfort of men, and secondary education for women would, in the next generation, transform aspects of social life and even the agenda of politics.

The creation of secondary schools available at modest fees did much to bring new opportunities to the widening sector of Newcastle's society that, with a very broad brush, has been labelled the middle classes, but did little for the comparatively small section of even the skilled working class who were in search of upward mobility. Here there was the double problem of supply and demand, lack of institutions to provide the means and a culture wedded to the hereditary principle. Skilled artisans were proud of their position and trade, which on Tyneside provided good wages, at least in good times, and had no desire to see sons join the middle classes by becoming 'namby pamby' clerks. Apprenticeships were subject to a considerable degree of control by the trade and increasingly the unions and ensured that the next generation inherited not only a family's work but its culture. The attractions of secondary education were, at first, rather greater for parents who were clerks or had junior positions in local government than for skilled artisans. The main instigator of free secondary and technical education in Newcastle was Dr Rutherford. This remarkably influential Congregational minister founded numerous educational establishments in Bath Lane: his elementary school acquired a 'higher class', which then became a separate School of Science and Art, and in 1892, two years after his death, his planned Rutherford Memorial College was opened and his aim of opening a pathway from elementary school to higher education was on the way to being realised. Rutherford College's aims and ethos were in sympathy with the aspirations of white collar workers and managed in time to tune in, via its part-time courses and co-operation with trades, with those of skilled artisans and with employers.

The police force grew from 85 men at its inception to around 400 in the early twentieth century. The police were not popular and with some justice for they were for decades not very well paid and received little training. It was not until the

end of the century that the Newcastle force could be described as a professional body. One reason for distrust of the police was that Chief Constables seem to have had a propensity to recruit men from outside the town, often countrymen because they had good physiques; this had advantages because they were more likely than locals to enforce the law impartially but it did not endear the force to townsmen. No wonder, the *Newcastle Daily Chronicle* thundered, that a man

> who up to yesterday had consorted principally with horses, kine and pigs, and who today
> is the representative of law and authority in the busy haunts of city life, occasionally
> misconstrues the true nature of his new function.[52]

In usual circumstances few would help the police but when in 1851 the town's police came under attack from a large Irish crowd in a poor area, 'the equally rough native inhabitants sallied forth into the streets to aid the police against the Irish, and this unusual alliance drove the Irish from the scene of conflict'.[53] It was an alliance that was to occur again at a riot on the Town Moor on the day of the Northumberland Plate in 1866.[54] The police force continued to have problems and the major engineering strike of 1871 found it in disarray because of the combination of low pay, poor conditions and an overbearing Chief Constable.[55]

Stability, some might claim inertia, characterised the Council until well into the twentieth century. Contested elections were the exception, while the system by which a third of members were elected every year tended to rule out sudden change. It cannot be claimed that the Council evinced a great appetite for intervention in the town's many problems and there was none of the gas and water municipal socialism that characterised some towns and cities. Significantly Joseph Cowen, a councillor before he became the town's radical MP, was 'much opposed to the Corporation engaging in any commercial undertaking or attempting to compete with private individuals'.[56] Whether, as has been alleged, 'the limited and reluctantly agreed range of municipal activity ... has to be seen as resulting in large part, from clear evidence of incompetence, mismanagement, nepotism, pilfering and absenteeism in major departments over a very long period'[57] is questionable. Certainly such sins were to be found in Newcastle but they were widespread in Victorian local government and corruption was far from incompatible with greater municipal activity which could indeed increase it. What

was more important was the lack of pressure from the electorate: electors were content that the private sector should shoulder responsibility for many amenities, were suspicious of officialdom and suspected that municipal innovations would put up the rates. Whether their suspicion was justified is another matter, for in some boroughs proponents of municipal services argued that providing gas and water was profitable and helped keep down the rates. Whether Newcastle gained or suffered by leaving such services in private hands is again debatable but by the end of the century it had effective supplies of gas and water and was in the vanguard when it came to electricity.

The Council was rich in comparison to most town councils. It had inherited a secure financial position from the old Corporation, which had in its last years had an average annual income of £43,000, and the combination of income from property, harbour dues[58] and tolls enabled rates to be kept low throughout the century. As property values increased, rate income grew without increasing rating levels. Population growth and the rise in rateable values increased income and, even though expenditure increased, rates remained low in comparison to those of other towns.

Even without the Council willing it, local government in Newcastle expanded rapidly as the town grew and central government demanded more services. New categories of employees emerged such as engineers, accountants, inspectors of weights and measures, and public health officers. As we have seen, the police force, under the tripartite control of the Chief Constable, the Watch Committee and, via the Inspector of Constabulary, the Home Office, grew in size and it gradually acquired a professional ethos. The Poor Law Union and the School Board, created by the 1870 Education Act, both employed increasing numbers although the former did not come under the direct control of the Council until 1929 and the latter until 1902. In 1833, the old Corporation had employed 62 officials; by 1911 the cleansing department alone employed well over 300 men.[59]

The Council remained apolitical with any hasty ideas for extravagant expenditure kept in check by a Ratepayers Association, though by the end of the century a few working men had been elected to the Council and made common cause with some Liberals in support of the municipalisation of public services. A rare and late example of municipalisation was the decision to create and manage an electrified tram system at the very end of the century. In the case of trams

the need for major work on so many streets made the need for intervention by the Council with its statutory powers imperative but such was the opposition led by Cowen and the *Newcastle Chronicle* that a compromise was reached in 1878 by which the Council owned the tramway and leased it to the Newcastle & Gateshead Tramways Company which operated the horse-drawn tramcars. When electrification became possible, municipal control finally triumphed, though its dawn was tarnished by the confusion which marked the introduction of the new system with no trams at all being available for several weeks in 1901.[60]

A CATHEDRAL CITY

Until 1882 Newcastle remained a 'town' but in that year it became a 'city'. From the medieval period, Newcastle had been one of the most important towns in England but city status was, until recently, not usually granted to towns, whatever their importance or self-importance, unless they possessed bishops and cathedrals.[61] The ancient ties to the Bishopric of Durham were broken in 1882: the diocese of Newcastle was formed, St Nicholas's church became St Nicholas's cathedral, a bishop (Ernest Roland Wilberforce) was appointed and a palace was found for him in the Dobson-designed mansion Benwell Tower.[62] The house, surprisingly the gift of a leading Quaker, J.W. Pease, underlined the Bishop's elevated position, while placing him close to many of his parishioners living in the terraced houses adjacent to its grounds.

The new diocese, proposed as early as 1854 by Sir Jon Fife, was met with strenuous opposition from Nonconformists with Joseph Cowen a prominent opponent. There was also competition from Berwick and Hexham, where there was strong feeling that the new diocese should be termed Northumberland; Hexham pressed for the cathedral to be based there as the see of Northumberland had been established at Hexham in AD 678. On the side of the proposal was the growing population of Newcastle and Tyneside together with the feeling of many Anglicans that the Church would only fulfil its mission if it reformed its organisation in keeping with demographic change. Against it was the fact that Newcastle and indeed Northumberland had ceased to be a predominantly Anglican area. The 1851 census had shown that although the Church of England

had the greatest number of attendances of any denomination; 57 per cent of those who had gone to church on census day had gone to other places of worship.

The early twenty-first century townscape retains the many churches built by all denominations in a competitive and self-conscious reaction to the census of 1851. To many in the Church of England it seemed that the towns must be reclaimed and converted: new parishes were formed and clergy imbued with an almost missionary zeal. The Nonconformists responded by increasing their efforts to expand their flocks. Between 1851 and 1881, though the Church of England in Newcastle increased the number of sittings by 14,500 (46 per cent), the Nonconformists had increased theirs by 14, 500 (76 per cent).[63] Religious competition was fanned by the determination of the Anglicans to start more Church schools and by the issue of support for them via the rates.

Despite furious argument and the peppering of each expanding suburb with numerous and, as it proved, supernumerary new churches, the proposal for the new diocese eventually came about though, embarrassingly, it appeared from the 1881 census that not just the Church of England itself but churchgoing in general had declined to the degree that 4.3 per cent of the population of the town attended Anglican churches and only 15 per cent attended any church at all.[64]

City status conferred by royal charter followed promptly upon the institution of the diocese. This made little difference in practice to the government of the erstwhile town, though there was some satisfaction in the new status which recognised Newcastle's place in the kingdom. To most inhabitants and neighbours it remained 'the town'.

PARLIAMENTARY REPRESENTATION

Parliamentary elections were by contrast with municipal elections both party political and fiercely fought. Newcastle was in the mid-nineteenth century to become a Liberal stronghold but, although W. Ord and Ridley won in 1835, Ridley was virtually a Conservative by then, and it was not until 1847 that Whigs or Liberals took both seats. This may have been because £10 householders came to greatly outnumber the freemen voters as the electorate expanded and the number of freemen declined. So far as what eventually became the Liberal Party

is concerned, we are faced with the problem of discerning distinctions between Whigs, Liberals and Radicals for which historians have tended to use a number of different definitions. It does seem apparent, however, that in Newcastle the choice of 'Liberal' candidates was made until well after mid-century by an urban elite and that the candidates chosen were not in their own image, but usually selected from men of gentry or professional backgrounds.

The 1832 Reform Act, thus, made little difference in the type of men who became MPs. Even urban constituencies continued to be largely represented by country landowners. Attendance at Parliament was expensive and relatively time-consuming and manufacturers and businessmen were too busy expanding their fortunes. The candidates for Newcastle, whether Liberal or Conservative, tended therefore to come from county families as with Charles Bigge, John Blenkinsop Coulson, William Ord and John and Ralph Hodgson. Another was Christopher Blackett, of the Wylam branch of that established family. He was the Liberal candidate chosen to fight Hodgson in the by-election consequent upon Sir Matthew White Ridley's death. He had fought in the Peninsula with the 18th Hussars and had been for a year the member for Beer Alston, elected along with Lord Lovaine, in 1831. Beer Alston was a pocket borough in the gift of the Duke of Northumberland. His political background made radicals reluctant supporters but he only lost to Hodgson by forty-eight votes and went on to become MP for South Northumberland in 1837. William Ord of Whitfield Hall and Fenham Hall was the senior Liberal MP between 1835 and 1852, though he was pushed into second place in a straight fight with Hodgson Hinde in 1841. The pattern was therefore one of Liberal or Whig preponderance albeit with a strong Conservative challenge that faded in the last years before mid-century.

The Blacketts seem to have had an attraction for Newcastle's Liberals for they adopted Christopher's son, John Fenwick Burgoyne Blackett, Fellow of Merton College, Oxford, a barrister and a contributor to leading Liberal journals, and he was elected with a huge majority in 1852. He seemed destined for a great political career but ill health forced him to retire after a single term in 1856 and he died shortly afterwards. As a lawyer as well as a landowner, Blackett embraced another category of MPs for, alone among the professions, a parliamentary career offered opportunities to lawyers. Dr Headlam's nephew, who was returned along with Ord in 1847, went on to become Judge Advocate General in 1859. Landed families

could, of course, produce radicals and George Ridley was such and was considered something of a family traitor by his brother Sir Matthew White Ridley: he stood, unsuccessfully, in 1852 for South Northumberland, 'very improperly in the Radical interest without consulting me' as his brother complained. Probably this 'radicalism' was much exaggerated for, when returned for Newcastle in 1856, he was considered a Whig, though 'he was reputed to have been a "thorough Tory" in every other way'.[65]

Newcastle became solidly Liberal in the mid-Victorian period and the Conservatives tended to put up only one candidate or none at all, the constituency being contested by three Liberals or species of Liberals in 1859 and 1865. The electorate went up from 5,200 in 1852 to 6,000 in 1859, while the 1867 Reform Act was to bring it up to 7,000 in 1868. That Newcastle seems to have become not just more Liberal but more radical was, it has been suggested, because the high proportion of retailers formed a radical 'shopocracy'.[66] Nevertheless a by-election in 1860 saw a decisive victory for the Whiggish S.A. Beaumont in a straight fight with a radical, though Beaumont may have been assisted by Conservative votes.

An expanded electorate needed to be enthused and informed in new ways and it was by a combination of personal charisma and the articulation of his views via his newspaper the *Newcastle Chronicle* that Newcastle's most idiosyncratic politician, Joseph Cowen, came to become an MP. Cowen flashed across the political sky of Newcastle like a comet. He has been seen as epitomising the new breed of provincial radical MPs, generally local industrialists, who seemed to be the spirit of their towns rather than just their representatives. The obvious comparison is with Joseph Chamberlain with whom for a time he was in close alliance. Both came from similar backgrounds, wealthy and Unitarian, both flirted with republicanism and were considered the radical wing of the Liberal Party and both enjoyed the enormous loyalty of their electorates. In the end, both fell out with Gladstone and the Liberal Party. Cowen's achievements were, however, modest as compared to Chamberlain's, no solid municipal progress to compare with the gas and water socialism and urban development of Birmingham and no great political career after the break with Gladstonian Liberalism. Probably Cowen's aims were so lofty and manifold that he could not compromise. Another way to see him is as a romantic in politics, a man with generous sympathies in search of causes.

Cowen's father, Sir Joseph Cowen of Stella Hall, was a Liberal, sometimes referred to as a Whig, and a wealthy brick manufacturer, whose work as chairman of the Tyne Improvement Commission had earned him a knighthood and who in 1865 became one of the town's two Liberal MPs. His son was educated at Edinburgh, though he left without taking a degree, and became the epitome of the rich young radical, using his wealth to back revolutionary movements in the disturbed Europe of the late 1840s, embracing republicanism and secularism, and involving himself in dangerous enterprises including a plot to blow up Napoleon III. Calming down a bit, he turned his attention to mechanics' institutes, the co-operative movement, parliamentary reform in the shape of the Northern Reform Union and, controversially, support for Irish nationalism. With his purchase of the *Newcastle Chronicle* in 1859, he found his metier, transforming it into a popular newspaper which mixed radical politics with sport, special features and local news and gossip. At a time when the provincial press was becoming increasingly influential, the paper far outsold its Newcastle rivals the *Newcastle Journal*, *Newcastle Guardian*, *Newcastle Daily Leader* and *Newcastle Daily Telegraph*. After his father's death in 1873, Cowen inherited his seat when he won the ensuing by-election. It has been suggested that it was the younger Cowen's success which 'contributed to Gladstone's hasty decision to ask for dissolution on the false assumption that the north-east was typical of the country as a whole'.[67] He was re-elected in 1874 along with a Conservative, Charles Hamond, the first Conservative success since 1841. The defeat of the Whiggish T.E. Headlam, who had been a Member for Newcastle, was blamed on Cowen's supporters who had plumped for their hero and thus let in Hamond and, as one historian has remarked, 'This needs to be borne in mind when the troubles between Cowen and the local Liberal organisation at subsequent elections are examined.'[68]

Cowen quickly established himself as a prominent member of the Chamberlain group of radicals. He cut an unusual figure in the House, dressing 'like a workman, with a black comforter around his neck, and the only wide-awake hat at that time known in the House of Commons'.[69] His 'Doric' accent, for he spoke with a strong Tyneside inflection, is said to have persuaded some MPs that he was speaking in Latin. He may well have exaggerated his accent, aligning it with his dress to fit a romantic self-image.

If his dress was unconventional, so were his political sympathies and he was out of line with his party by the late 1870s. The implications of the mass electorate ushered in to boroughs by the 1867 Reform Act had contradictory implications for a charismatic politician like Cowen. He had the rhetorical skills and the control of a popular newspaper which made engagement with a wider electorate (Newcastle had over 20,000 voters by 1874) possible and he was able, as his ties to the Liberal Party loosened, to appeal over the heads of his party to a wider public; in this sense, he was like Gladstone and Chamberlain, but, as both Cowen and Chamberlain found out, there was only room for one Gladstone in the party. On the other hand, more electors meant for political parties more organisation and discipline in order to control them. 'By the early 1880s, the introduction of more sophisticated party machinery imposed more constraints on members of both parties ... Cowen's frosty relationship with Gladstone made it difficult for the Newcastle Liberal Association to promote Liberal policies'.[70]

By 1880, Cowen and the Newcastle Liberal Association were at loggerheads. On the Eastern Question he had taken the opposite line to his party's, his support for Irish nationalism[71] seemed increasingly close to sedition, and he had become attracted by imperialism; this collection of views made it difficult for him to align with any political party.

Cowen's break with the Newcastle Liberals was not just about policies. He saw himself as Newcastle's voice and, though he would have been happy enough with some local nonentity as running mate, resented the idea of some coming man from outside filling that role. When the association invited Ashton Dilke[72] to be the second Liberal candidate, it seemed to Cowen that they were importing a rival and he rebelled, stood as an Independent and came first in the poll in 1880 with Dilke in second place. His support was volatile and mixed: Conservatives could empathise with his foreign policy views; radical working men with his expressed sympathy with labour representation and with trades unions and the Co-operative movement; the considerable Irish Catholic population of the town saw him as a staunch friend; and he was emphatically a Newcastle man. Any hope of reconciliation with the Liberals was dashed when, after Dilke's death, John Morley was imported as Liberal candidate for the by-election. Morley's victory, that of a stranger to the town, astonished and outraged Cowen. Although he won again in 1885 with the help of Conservative voters, he resigned in the

following year. His statue stands near the bottom of Westgate Road, often adorned with a traffic cone[73] placed on his head by revellers who probably know little of Newcastle's famous radical.

In the Cowen era, Newcastle had been a Cowenite rather than a Liberal stronghold; now it seemed it was to be a normal Liberal-controlled constituency with a well-organised Liberal association linked via the Northern Liberal Federation to the National Liberal Federation. Several factors militated against this: the split in the Liberal Party over Home Rule for Ireland, the revival of urban Conservatism, the beginning of the demand for independent labour representation and the stirrings of socialism.

Morley turned out not to be the MP Newcastle Liberals had hoped for. He appears to have rather neglected the constituency and become a liability. Morley's running mate from 1886 was James Craig, a merchant and shipbroker whose main asset was as a 'golden source' for he had for long been the main fundraiser for the party; basically, he was a political nonentity and a poor speaker. It was apparent that Conservatism was now mounting a serious challenge and, with leading local worthies Sir William Armstrong and Sir Matthew White Ridley[74] as Liberal Unionist and Conservative candidates, Liberal majorities for Morley and Craig were modest.

Socialism and Independent Labour were wild cards in the politics of the 1890s, not sufficiently powerful forces to gain electoral success themselves but sometimes able to influence the balance as between Liberals and Conservatives. The accepted history of the Labour Party has it as growing out of the trade union movement and of the radical Liberal tradition with even the Independent Labour Party close to radical Liberalism. In the 1890s this was not always immediately apparent and Newcastle witnessed labour and socialist interventions directed rather more at Liberalism than Conservatism. In 1892 Morley and Craig were opposed by a single Conservative, Charles Hamond, who had shared the representation of the town with Cowen between 1874 and 1880. An ebullient chap, almost a music-hall swell or 'champagne Charlie' with his white waistcoat and penchant for kissing female supporters while canvassing, he topped the poll and ousted Craig. His victory was, however, assisted by the support of the Newcastle Labour Party, an organisation set up under the aegis of J.H. Mahon and Harry Champion, ex-Social Democratic Federation members who were determined to cut loose from

Liberalism and appeal to working-class Conservatives. Morley was opposed to the campaign for an 'eight hour day' and even Keir Hardie supported the call to vote for Hamond. At the by-election consequent upon Morley's appointment as a minister, Champion and the Newcastle Labour Party again opposed him but Morley survived.

In 1895 the choice of running mate for Morley was crucial. Hamond was popular and would take a lot of beating and there was another formidable Unionist candidate, W.D. Cruddas, a director of Armstrong's. There was also a threat from the left in the candidature of F.P. Hammill, an Independent Labour Party candidate. One option open to the Liberals was to choose Arthur Henderson, a Liberal, a trade unionist and one of the three union-backed councillors in Newcastle. Despite his being proposed by Dr Spence Watson, the doyen of Newcastle Liberalism, and supported by the Liberal Association Executive, Henderson was rejected in favour of Craig by the majority of the Liberal caucus.[75] A major factor in Henderson's defeat was Craig's money and his ability to contribute towards the campaign but perhaps as important was the reluctance of the artisans and workmen,[76] who made up a majority of the 'One Thousand', to have a working man as their candidate.

The election was not a straight fight between Liberal and Conservative as F.P. Hammill entered the fray as an ILP candidate. He secured 2,302 votes but more votes were split between him and Hamond than between Hammill and any other candidate.[77] The Conservatives won both seats and did so again in the 'Khaki election' of 1900 when Sir W.R. Plummer and G. Renwick were elected.

By the end of the nineteenth century, Newcastle was no longer the Liberal stronghold that it had been fifty years earlier. For a town in which Nonconformity was so strong, Newcastle was kind to the Conservatives (or Unionists) in 1892, 1895 and 1900. The substantial middle class was no longer predominantly Liberal, many of the workers in the armaments industry were Conservative[78] and varieties of socialism or independent labourism had introduced a new factor into the town's political life.

Interwoven with these political developments was the growing importance of the trade union movement. Tyneside as a whole saw the emergence of well-organised trade unions during the second half of the nineteenth century. The mining unions achieved a position where the overwhelming majority of workers

in the industry were members by the end of the century. Other unions made slower progress, though the fact that during the important Tyneside engineering strike of 1871 only a tenth of striking workers were members of the Amalgamated Union of Engineering Workers did not prevent the strike from being successful. From the 1870s onwards, however, shipbuilding workers, engineers and to a lesser extent railway workers were increasingly members of unions, though not always of the same ones. That single unions for particular industries did not develop was due to rivalries and distinctions between crafts and the different interests of skilled, semi-skilled and unskilled workers.

Newcastle had a rather less unionised workforce than other riverside towns due to the diversity of its employment. Mining was peripheral to the town while only a minority of the population was engaged in manufacturing and white-collar workers and retailers tended not to belong to unions. The 'new unionism' of the general labour unions like the Tyneside Amalgamated Union of Labour or the National Union of Gas-workers and General Labourers attracted a proportion of the hitherto un-unionised and towards the end of the century clerical and teaching unions were founded but in the main it was among shipyard workers and engineers that the greatest number of trade unionists were to be found. In general industrial relations in the town's main manufacturing firms were good in the last decades of the century with a high number of disputes being settled by arbitration. Although socialist movements had, as we have seen, established a presence in Newcastle, the combination of high wages for the skilled workforce and the relative placidity of industrial relations largely explain the relatively slow progress of any demand for independent labour representation that went beyond Liberal-Labourism.

Social Problems

The increase in population was not until the 1870s accompanied by a commensurate increase in the housing stock. This was due to the need for workers to be close to their workplace and to the fact that the Town Moor prevented expansion to the north. Like Tyneside as a whole, Newcastle was to demonstrate a combination of relatively high wages and poor housing conditions. A Council report of 1865

listed 9,639 families living in single rooms and nearly 14,000 people without 'water closet or privy accommodation of any sort'.[79] Karl Marx in 1867 pointed to Newcastle as a town with particularly bad housing.[80]

The death rate remained not only high by more recent standards but marked by peaks in the years of cholera epidemics, 1832, 1848–9 and 1853. Cholera was a horrifying and spectacular visitor, killing 1,500 in five weeks in 1853 but more everyday diseases, such as typhus, scarlet fever, smallpox and diphtheria, were greater killers. The psychological impact of the cholera epidemics did, however, lead to a degree of panic which resulted in enquiries as to public health. Gradually there came a realisation that cholera, typhoid and other diseases were waterborne rather than carried by miasmas and that, although overcrowding, poor sanitation and lack of refuse collection correlated with high death rates, the wealthy were not immune if their water was contaminated.

If the old Corporation had neglected the overcrowded lower town in its support for the development of the upper town and left public health and medical care to charitable institutions like the Dispensary, which did at least institute a programme of inoculation against smallpox, the new Corporation was no better. Conditions in Lower Pilgrim Street, the Quayside chairs and Sandgate were appalling with, in some streets, families living five to a room. Two enquiries were held nearly half a century apart, that by the Dispensary in 1802 and that by the Health of Towns Commission in 1845, the latter suggesting that no improvement had taken place in the meantime. Again in 1853 the Cholera Commission lambasted the Corporation's neglect of the poorer parts of the town.

Having been visited by cholera in 1853, Newcastle experienced fire in 1854. It started on the Gateshead waterfront, spread to a warehouse full of inflammable substances and the subsequent explosion hurled stones and burning timbers across the river. Fifty people were killed and the west end of the Quayside and the chairs behind it were set alight. The fire destroyed some of the worst fever districts of the town and by 1866, rather belatedly, the area was rebuilt giving us Lombard Street, Queen Street and King Street, the rather splendid and aptly named Phoenix House by William Parnell facing the Guildhall, and next to it round the corner on the Quayside, the Exchange Buildings by the same architect.

One result of the fire was that it left the eastern end of the Quayside and Sandgate as the worst area of the town in terms of overcrowding and may even

have worsened conditions there as no provision was made for re-housing the poor left homeless by the fire. The Sandgate area had for long had a bad reputation not only for its unsanitary and densely populated nature but as a disorderly and dangerous place and the slow decline of the keelmen's trade, relatively well paid in good times, increased its poverty. It was held to be a centre of vice and prostitution.

It is notoriously difficult to assess the amount of prostitution in Victorian towns and Newcastle and the particular Sandgate area are no exceptions. It was clearly a numerous profession but the numbers may well have been exaggerated. For an occupation that was supposed to be unmentionable, it was mentioned a lot, especially by social 'explorers' but then as now sex sold newspapers and a cloak of outrage enabled quite explicit articles to be published. In 1850 a series of articles in the *Newcastle Chronicle* regaled readers with an anonymous investigator's visits to the area. Noting the many prostitutes, he asked one of the policemen, 'Is this the worst part of town?' 'Decidedly the worst. We call Sandgate the city of sin, sir'.[81]

The Sandgate appears to have had a larger number of women than men[82] and the lot of the single, mature working-class woman was not a desirable one in Newcastle. There were few desirable occupations for such single women in mid-Victorian Newcastle, a town where both the social ethos and the economic structure dictated that married women did not work outside the home. Other than domestic service and retailing, both of which usually required a degree of respectability, there was rope-making, the notoriously unhealthy white-lead industry and street-vending. Earlier in the century women were employed as hod-carriers and roofers in the building industry and the demise of such employment for women was considered a measure of the town's social advance. A proportion of poorer women also engaged in scavenging work of one sort or another. The prevailing attitude among workers as well as the middle classes that the husband should provide for his wife and children was not borne out in every marriage and widowhood could bring disaster but the absence of large-scale industries employing a substantial number of women made the position of the unmarried woman in the lower strata of society particularly undesirable.

On the whole, rates-conscious Victorian towns didn't respond with alacrity to the permission given by the Public Health Act of 1848 to set up Boards of Health

and appoint Medical Officers of Health. Newcastle's death rate was so bad that it was above the level of a death rate of 23 per 1,000, which meant that central government could insist on the creation of a Local Board of Health to take steps to improve matters. By 1865 the town's death rate was 36.7, the worst in the country and a Medical Officer of Health was not appointed until 1872. This made a difference and the rate fell from 30.1 to 19.1 between then and 1900 though there remained considerable variations between different parts of the town.[83]

A major health factor was the quality of water. Dr John Snow had made the case for cholera being carried by waterborne contagion in his book *On the Mode of Communication of Cholera* in 1849 but it was many years before this was universally accepted by the medical profession. Newcastle's experience would have made a useful case study for him. Supplies to the growing town were increasingly inadequate at mid-century and at various times of shortage the resort had been made to pumping water from the Tyne. Although the water was taken upstream from the town, the Tyne is tidal up to above Newburn, and it is significant that cholera followed the times when river water was extracted for public use. A new company, the Whittle Dene Water Company, named after the eponymous reservoir completed in 1848, became responsible for the water provided directly into a limited number of homes and to the public pants at which the great majority got their water. Its provisional committee, listed in the its prospectus of 1845, was almost a roll-call of the local establishment and included Addison Potter, Sir John Fife, William Henry Brockett and Robert Hawthorn. Among the benefits it was claimed would come from a copious supply of water was that it 'would be conducive, in the highest degree, to habits of sobriety and cleanliness in the working-classes'.[84] Although the company, after 1863 the Newcastle & Gateshead Water Company, failed in the 1850s to keep water supply abreast of expanding demand, it invested heavily in reservoirs, filter beds, pipelines and pumping stations far to the west of Newcastle. In the mid-nineteenth century, the company was hard-pressed to supply 1.5 million gallons of safe water daily; by 1914 it was able to supply more than 20 million gallons.[85] This success was another example of the successful co-operation of members of the local elite bringing together doctors, industrialists and county gentry. The solicitors to the company were Donkin, Stable and Armstrong and the involvement of William Armstrong, solicitor and engineer, was important as the experience of work on Whittle Dene

assisted his development of the hydraulic machinery which powered his cranes and the Swing Bridge.

The provision of gas may not have had the same impact upon public health as did an improved supply of water but it did enable houses to have a more convenient means of illumination, while streets, hitherto lit by a paucity of oil lamps, evil-smelling when whale oil was used earlier in the century, became better lit at night. The first use of gas in the town was as early as 1815 and Mosley Street was the first thoroughfare to be gas-lit but it was from the 1850s that its use became more general. The Newcastle & Gateshead Union Gas Light Co. was empowered by an 1846 Act to purchase land for gasworks and opened the Elswick Gas Works in 1859. In 1876 the Newcastle upon Tyne & Gateshead Gas Co. opened the Redheugh Gas Works on a site on the south bank of the river. By the end of the century, the gas fire and the repayment slot meter had been invented and demand had soared.[86] The supply of gas was in the hands of men drawn from the business elite with some overlap of personnel with the water company; A.L. Potter, Armorer Donkin and Robert Hawthorn were subscribers to both companies while there was much overlap between the gas company, the water company and Armstrong's.

Electricity became available to consumers in Newcastle in 1890, far earlier than in most towns, when the Newcastle & District Electric Lighting Company (DISCO) and the Newcastle upon Tyne Electric Company (NESCO) began generating power. DISCO, founded by C.A. Parsons, provided electricity from a power station at Forth Banks to the west of Newcastle and beyond and NESCO, founded by Theodore Merz and expanded by his son Charles, provided power to the eastern part of the town and to north Tyneside below the town from generators at Pandon Dene.

The provision of public utilities in Newcastle was thus exclusively the work of private companies. The same was true when it came to the provision of housing. Housing was an area for which the town had, as we have seen, a poor record for a number of reasons: the necessity for most workers to live close to their place of work; the exodus from the houses in the lower town and parts of the upper town by the wealthy, enabling their dwellings to be turned into tenements; and the inclination of even relatively well-paid workers to put a low priority on housing. It was not until the 1870s that owners of land in the new suburbs began

selling their land largely, for parts of Elswick are an exception, to small builders. Speaking at the end of the century to the Northern Architectural Association, its president, William Glover, made the following claim:

> In my opinion the speculative builder has been the most important agent in providing suitable houses for the poor ... [Since 1875] within three miles radius of Newcastle, 2,492 acres have been laid out for building purposes, on about two thirds of which the following houses have been erected: 109 detached villas, 209 semi-detached villas, 1,906 superior self-contained houses, 1,184 superior flats, 3,547 workmen's self-contained houses, 12,788 workmen's flats ...[87]

Most of these workmen's flats were what had become known as the 'Tyneside flat', described by one authority as 'a unique response to the town Improvement Acts of 1850 to 1871, whereby the worst excesses of "back to back" housing elsewhere were avoided by stringent regulations'.[88] The standard model and most common style consisted of an upstairs and a downstairs flat in a terraced row with two front doors side by side, the downstairs flat consisting of three rooms and the upstairs four rooms both with sculleries and kitchens ranges and narrow backyards containing coal-houses and lavatories.

Only a small proportion of houses were owned by those who lived in them. Home ownership did give security but was not a particularly attractive investment as house prices tended to be static so that even rich Victorians often rented. Building societies throve in Newcastle. The initial purpose of several was to increase the number of voters because of the link between property and the vote and their institution tended to be encouraged by radicals like Richard Cobden and the temperance lobby but when societies like the Northern Counties Permanent Benefit Building Society, the Rock Permanent Benefit and the Newcastle & Gateshead Permanent Benefit became firmly established most of the mortgages they granted were to builders or those who bought as a nest egg and who then rented out the houses.[89] Even with all this building, housing didn't keep pace with the expansion of the population. There was an improvement in the quality of houses but in 1914 the average number of persons per house was just over eight, the same as in 1851.[90]

It seems likely that better housing for many, cheaper and better food and the provision of decent water did more to improve public health in Newcastle than

either the efforts of the Council or improved, if still very limited, access to medical care. The death rate in Byker, where most people lived in newly built houses, was, for instance, far lower than in the parishes of St Nicholas and All Saints. General progress was, nevertheless, made. The death rate in 1872 was 30.1 per 1,000 and had by the turn of the century fallen to 19.1 in large part due to a fall in infant mortality. The Council's performance did gradually improve, in part because the rise in rateable values provided increased income and partly because prodding from central government and new national legislation impelled greater activity. The Sanitary Committee became a main standing committee and presided over eight sub-committees which supervised different aspects of its work. Nuisances of various kinds continued, however, to exist. One such was the existence of dairy herds and cow sheds within the town itself. There were still 73 cow houses containing 628 cows in 1895 and two thirds of the cow houses were considered to be overcrowded and a risk to public health.

Advances in medical treatment played a part in improved life expectancy but a modest one in comparison to preventative measures, especially improved sanitation while better and cheaper food was also important. The town was fortunate in its first Medical Officer of Health, Dr Henry Armstrong, an able and dedicated man who considered that more than a quarter of deaths were preventable. At the time of his appointment in 1873 he had a staff of six and by 1900 it had grown to ten.[91] Newcastle had from the eighteenth century never lacked numerous doctors and had by the mid-nineteenth century the Infirmary, the Dispensary and some specialist hospitals including the Lying-in Hospital, a rather inadequate fever isolation building and a lunatic asylum. One of Dr Armstrong's achievements was the taking over of the Fever Hospital by the Corporation and its transfer to new premises at Walker Gate as the City Hospital for Infectious Diseases. The Board of Guardians had a duty to house the sick and infirm and the Union Infirmary grew out of the Workhouse on the West Road. During the later decades of the century further specialist hospitals were founded: the Eye Hospital, hospitals for diseases of the chest, the skin, the throat, a hospital for women and one for children, a dental hospital and a home for incurables. The rather grim lunatic asylum gave way to the Mental Hospital at Coxlodge.

Private benefactors played a large part in the provision of hospitals. The long-established voluntary hospital at Forth Banks benefited from large donations

from Lord Armstrong and Robert Stephenson. In the year of Queen Victoria's Diamond Jubilee, two donors, Mr and Mrs Watson Armstrong and John Hall, each contributed £100,000 for the new building beyond the Haymarket. John Fleming, a Newcastle solicitor, provided the new children's hospital in 1888. Small regular subscriptions from workers also became increasingly important to philanthropic institutions such as hospitals and resulted in the appointment of worker governors representing these subscribers. By 1898 £2,503 in such subscriptions was collected for what was to become the Royal Victoria Infirmary and there were nine worker governors on the 32-strong house committee.

Social Life & Leisure

In 1829, Dr Fife, surgeon and radical reformer, gave several lectures on anatomy in the Surgeons' Hall using for instruction the body of 'a most disgusting and abandoned female'. It was the unfortunate woman's third public appearance for, having been brought before the Assizes and been sentenced to death for the murder of her mother, whom she had stabbed while drunk, she had then been taken by cart, sitting on her coffin, to the gallows on the Town Moor. Her execution was said to have been attended by 20,000 spectators and was accompanied by much ceremony.

Public executions were popular events and continued to be so into the mid-Victorian period. People took children along and vendors of food and drink made good profits. We are often told how in an 'age of progress' the railways enabled church groups and temperance societies to go on excursions, perhaps to hear the Messiah at a musical festival, and Thomas Cook to found his travel business. Less often mentioned is that railways enabled large numbers to witness executions in towns other than their own. The abolition of public executions was one of the most unpopular acts of Lord Russell's second administration; one of the last such executions in Newcastle in 1863, which took place outside the jail in Carliol Square, was attended by a crowd so dense that many people fainted.

Much of popular culture in the early nineteenth century was brutal by later standards with its cockfighting, dogfighting and bare-fisted boxing. Almost every sport from running races or 'pedestrianism' to cricket was also accompanied

by heavy betting. Indeed the three Bs, blood, betting and beer, characterised the most popular recreations. Since the eighteenth century, there had been attempts by a variety of societies to reform the morals and manners of the people, to suppress vice and do away with pastimes and customs that were likely to lead to violence and disorder. How much success they met with is debatable and changes in social habits and recreation may have owed more to an increased respectability emergent among the populace itself or, indeed, to commercial forces, which found less violent entertainments more remunerative, but it is clear that, in the course of the nineteenth century, popular culture was, to a degree, tamed. By 1900 there were no public executions for the people of Newcastle to witness and cockfighting had been forced underground.

A major development was the fragmentation of social life. It is perhaps romantic to see the previous leisure world of Newcastle as civic and inclusive but its high days and holidays were enjoyed by many sections of society and there was often a common focus as with Ascension Day, the coming of the judge to the Assizes, the inauguration of a mayor or the celebration of a coronation. The sociability of the town had always been stratified, the upper orders within the Guildhall or Mansion House and the lower orders outside, though enjoying free beer and food; wealth and position dictated precedence but the event included most people. Now social worlds became separate rather than stratified.

The decline in the importance of great civic days is significant. In the early nineteenth century, as a historian of the town's sociability has commentated, 'The Corporation began to give up its civic platforms and retreat to the more formal civic ceremonies.' The argument is that the crowd had become radical, divorced from the elite and too rowdy as exemplified by the riot that took place at the time of the celebrations for George IV's coronation. A reaction to the Corporation's withdrawal of support for civic festivity was a revival by the populace of the old carnival of St Crispin's Day and a fondness for parades by friendly societies[92] but, by and large, great communal occasions declined.

Victorians were ambivalent in their attitude to old festivals and customs. On the one hand there were attempts to revive, improve, even invent, traditions. Especially in rural areas paternalistic landlords encouraged annual pageants and the crowning of May Queens, while organisations such as the Primrose League and working-class friendly societies revelled in mock-ancient titles and ranks.

On the other hand, many old festivals were curtailed and yet others, like the Lord Mayor of London's inaugural procession, were mounted with greater panache. Workaday and business-like Victorian Newcastle seems to have little affection for its old ceremonies. The custom of escorting the Assize Judges from Sheriff Hill, near Gateshead with elaborate ceremony was one of the first to go. Ralph Carr (later Carr-Ellison) was the last High Sheriff to set off, accompanied by bailiffs, trumpeters, gentlemen and yeomen, to meet the judges. The next year, 1846, the judges came by train and were met at the Newcastle & Carlisle Railway Station. The Ascension Day procession of the mayoral barge, accompanied by a flotilla of other craft, down and up the river lingered longer but in an attenuated from. After 1850, it took place only every five years and was held for the last time in 1901; the mayor's barge was laid up and left to rot.

Civic celebrations had over the centuries been always likely to get out of hand, riots had reflected the animosities of the day and tensions between the populace and the wealthy and powerful were nothing new. What was different was a disinclination by the authorities to see disorder as a necessary release for tensions and a growing gulf between the sensibilities of different social groups. This was not a difference between the urban establishment and radicals or even between rich and poor, though such distinctions were part of it, but it was more a matter of the divide between the respectable and serious on the one hand and the volatile crowd on the other. That robust and hard-drinking world of eighteenth-century radicalism was passing and the Victorian radical was more likely to be found at the orderly meeting of a learned society than in a tavern. The great magnates of the town had buttressed their position by ostentatious generosity, treating and obligatory attendance at popular clubs; the new elite had less appetite for slumming.

Following the example of London, a number of gentlemen's clubs were formed. The Northern Counties Club announced its intention of being on the lines of the clubs of St James's and was founded in 1829. It moved into its fine premises in Eldon Square in 1835. Its membership encompassed both gentry and businessmen and there up-and-coming Joiceys mixed with firmly established Lambtons and Ridleys and there was also a strong link with the army especially the local yeomanry, the Northumberland Hussars. The Union Club, similarly a gentlemen's club but with a weighting towards the business community rather than the

gentry, moved into its imposing building at the bottom of Westgate Road in 1877; among its prominent members was Lord Armstrong. The Recorder's Club with a membership largely of the established mercantile families and county gentry had been founded in the eighteenth century and took its name from that important officer of the old Corporation; it was peripatetic, holding its boisterous dinners in different venues before eventually becoming almost a club within a club at the Northern Counties. The Liberal Club was established in the fine brick house in Pilgrim Street, which had formerly belonged to Alderman Fenwick, and for Conservatives there was the Constitutional Club in Clayton Street.

A varied social and cultural life remained available to the upper and upper-middle classes of the town but, by contrast with its eighteenth-century equivalent, it was privatised, taking place in formal clubs with their own premises. The public lectures and scientific demonstrations of the late eighteenth and early nineteenth centuries had been open to all who dressed respectably and could pay a modest fee but now such events usually took place in learned societies. The Assembly Rooms and the concerts and balls that had made them the centre for society became less fashionable around mid-century.

Historians have often depicted early and mid-Victorian England as a period when the upper and middle classes withdrew into domesticity. Although home, hearth and garden did become seen as almost sacrosanct, men had social lives in clubs and societies, but social life for women does seem to have become more circumscribed. The late eighteenth century had been a time of increasing social freedom for the wives of merchants and gentry, who were able to enter the new culture of leisure and go to balls, concerts, exhibitions, card parties and assemblies. The mid-nineteenth century saw a step backwards for women of merchant and gentry families; too bold an expression of intelligence or of artistic ability and too great a delight in the social whirl were frowned upon by 1850 and many features of eighteenth-century polite social life were no longer regarded as respectable. Women of good family were no longer allowed the freedom enjoyed by Harriet and Annabella Carr or Rhoda Astley Delaval.

The social divides of Victorian Newcastle were more complex than the broad brush of class terminology increasingly used by contemporaries would suggest. The distinctions between skilled, semi-skilled and unskilled workers in the same workplace were sharp and were reflected in social life while differences among the

middle classes were even greater. Then there were the vertical divisions running through the social spectrum, the most important of which was religion.

The rise of evangelicalism and the expansion of Nonconformity played major parts in the fragmentation of social life. Newcastle was no longer by 1850 the predominantly Anglican town it had been in the eighteenth century and evangelicalism had made many Anglicans more earnest. Evangelicals and Nonconformists alike in their concern with salvation, redemption and atonement had little empathy with a fashionable high society and less for an unredeemed popular culture. The radical and historian Eneas McKenzie had to put on rose-tinted spectacles when he summed up the morals and characteristics of the townsfolk: the men were calm and dignified in public and 'scarcely ever express their resentment in acts of riotous violence' for even when roused, 'their conduct is temperate firm and imposing', while the women retain 'those cleanly, neat domestic habits, which conduce so much to the production of virtue and happiness'.[93] So he may have wished.

The decorous society imagined by McKenzie was the dream of many in the nineteenth century who hoped to bring about the improvement in the manners and morals of the people envisaged since the late seventeenth century by those numerous societies for the reformation of morals and the suppression of vice. A major target was a bawdy, hard-drinking, boisterous and sometimes riotous popular culture and an attempt to replace it by a culture of rational recreation. Although members of the middle and upper classes were prominent in this crusade, it would be a mistake to see it as the province of any one social group and it had a strong appeal for working-class radicals who wished for an improved culture of the people, a serious and sober culture and one associated with mechanics' institutes and self-education rather than drinking and betting. When improved behaviour could not be gained by persuasion it could perhaps be enforced and the high days of popular celebration be controlled or abolished. Fairs and town contests, such as annual 'football matches' or 'bull runnings', were a common target as they were seen as times when law and order broke down. Newcastle seems not to have witnessed attempts to close down fairs and it had no tradition of Shrove Tuesday football matches or other events which turned towns into battlefields but there were constant demands for restrictions on popular festivity, holidays were reduced in number and Sabbatarianism limited entertainment on Sundays, restricting it, ironically, to the pub.

Newcastle continued to be a sociable and not very sober town. There were 425 public houses and 76 beer shops in the early 1850s and, by 1899, 691 licensed premises, one for every 307 of the population[94] but save for a few hotels where dinners and other social functions were held they were rarely frequented by the self-consciously respectable citizens of the town.

Between pubs and even within them there were social and cultural demarcations. Some pubs were just for the rough, most of those by the Quayside were for seamen and dockers, while others catered for the 'fancy', enthusiasts for prize-fighting or racing. Some were specifically for workers in different trades or industries for, if the pub has been called the 'working-man's front parlour', it could often be an adjunct to the workplace. It was the canteen where the early-morning glass of whisky or rum was downed before work started, the place where the day's work and labour problems were discussed in the evening, and a stratified area where the hierarchy of the shop floor was maintained, with foremen, skilled and unskilled workers drinking in different rooms.

There were many varied places in which to drink, ranging from the bare amenities of a beer house to a public house like The Douglas, close to the Central Station, with its Long Bar across from the Central Station and its glittering buffet, a lost masterpiece of Victoriana adorned with scenes from Shakespeare, which had its entrance in lower Grainger Street. The pub was always more than just a place to drink. It was a centre for a largely male social life. Sporting activities were based at the pub, friendly societies and trade societies met there and the music hall developed from its 'free and easies'.

Newcastle appears to have always had a great thirst for beer and, as the population has never had a propensity for moderation, temperance advocates were able to brandish plenty of evidence of drunkenness. Statistics of crime are usually dubious and arrests for drunkenness an unsure guide to the amount of drunkenness as they often merely reflect the degree of toleration of different police forces but Newcastle was usually top, or near the top, for such arrests among any list of comparable port towns. As ever, we must remember that Newcastle was the Mecca for those from surrounding towns who wanted a night out and much of its beer was consumed by non-residents.

Clubs and societies often began in public houses or hotels before, if successful, finding their own premises. There was, as we have seen, a long history of clubs

and societies in the town and the nineteenth century saw further developments. There were political clubs, religious clubs, sporting clubs, clubs for the gentry and urban elite and, increasingly from mid-century, working men's clubs.

The first working men's club in the town, the Newcastle Working Men's Club & Institute, was set up in 1863 in St James Street. Sir William Armstrong and Sir Joseph Cowen were among its first patrons and it was dedicated to recreation free from alcohol as were all the clubs in the CIU (Working Men's Club & Institute Union) founded under the aegis of the Revd Henry Solly. These clubs were the site of a three-way ideological and cultural struggle between those who wished to combat radicalism and the pub, those who wished to combat the pub in the interests of radical discussion and those who wanted a sense of ownership of a convivial environment where they could drink and enjoy themselves. The latter won and from 1873 drinking became central to club life.

It has been estimated that, by 1914, there were almost sixty clubs in Newcastle. In addition to CIU clubs, there were clubs for particular groups of workers like the Elswick Collieries Workingmen's Social Clubs and the Tramways & Vehicle Workers' Social Club.[95] There were also working men's Conservative clubs (the antipathy of many Liberal Associations to drink tended to preclude Liberal equivalents). Under clubs we must include the lodges of the Masons, the Orange Order, the Oddfellows and the Free Gardeners, all of which thrived in Newcastle, and later in the century sports clubs, many of which became licensed.

Working men's clubs continued something of the social side of the medieval guilds or mysteries. They provided beer cheaper than that which was available from pubs, eventually establishing their own brewery, the Federation Brewery, and entertainment in their lounges and singing rooms. Self-help was part of their ethos and they instituted saving clubs for Christmas fare and day trips for members, old folk and children.

The music hall has been seen as the epitome of nineteenth-century popular culture. Like most popular entertainments it emerged from the public house which had always been a centre for music and singing. Enterprising publicans added special entertainment rooms for 'free and easies' which featured not just musicians and singers but comedians. The Music Hall in Nelson Street was one of the earliest, a venue for emotive recitals from his novels by Charles Dickens as well as more populist entertainment. The best known, because of its mention

in 'Blaydon Races', and most enduring, Balmbra's, was opened by the publican of the Wheatsheaf Inn. At mid-century the Royal Hotel in Grainger Street was offering 'Harmonic Evenings'. There was also the tradition of the travelling showman of whom Billy Purvis was the most famous; with his entrepreneurial flair and skill as a comic, he was a seminal influence on the Newcastle music halls. Thornton's Music Hall began in 1885 with a seating capacity of 1,000 and with enlarged premises became the Empire Palace of Varieties in 1889. The transition from public house to elaborate theatre of variety took some of the spontaneity and populist spirit out of music hall just as it removed drink from the auditorium. It may be purist to distinguish music hall from variety theatre but, if the distinction be not only drinking in the auditorium but a local flavour to the entertainment, music hall in Newcastle lasted longer than in most towns.

The new theatres cannot, however, have provided too decorous a form of entertainment for a correspondent to the *Newcastle Weekly Chronicle* in 1892 considered the music hall 'responsible for half the immorality of the age'. They were probably less expressive of local culture, for the mid-century world of songs by George Ridley, Ned Corvan and Joe Wilson had given way to entertainers with national reputations who made their way around country-wide circuits. By the end of the century the town had numerous variety theatres including The Gaiety, The Olympia, The Grand at Byker and The Palace in Percy Street.

Although historians have pointed to the great variety of women's work in early nineteenth-century Newcastle, to the place of women like the famous hard-drinking Cushy Butterfield in popular songs, and to the considerable number of women's benefit societies, the public sphere of the popular culture that had emerged by mid-century was very much a man's world. A central criterion for respectability in the eyes of most working people was that wives should not have to go out to work. Most pubs were male preserves and the clubs were entirely so except on high days and holidays and working women did not participate in sport. Single women did, of course, work but some types of work were more respectable than others. Those who worked on building sites, in the rope works or as fishwives may have been colourful but they were looked down upon by the respectable working classes. Parents closely supervised the leisure of their daughters for the fate of the 'dirty stay-out-all-night' was well known. The home may well have been where women held sway but homes were private places and

the street and corner shop were the venues for female sociability. Some workers took their wives with them to the music hall and to fairs or even to race meetings, while from the 1870s as public parks were created – partly as a counter attraction to pubs – husband, wife and children might walk in Leazes, Elswick or Heaton parks. In general the later decades of the century saw a modest increase in the opportunities for leisure and entertainment for the respectable working-class woman with days out and visits to the seaside becoming part of working-class leisure.

Sport

A major feature of social life was the ever-increasing popularity of sport. Feats of athleticism and of strength and endurance and contests between champions had always attracted crowds and heavy betting, as had horse races and fights between cocks or dogs. Most sports had their roots in rural life and it is perhaps paradoxical that they were to flourish with urbanisation. The changes that came with the nineteenth century were not so much in the essential nature of sports but in the degree of organisation, including their regulation by accepted rules and the growth in the number of spectators. Sport did not become commercialised for it had long been so, but it became commercial on a grander scale. It then ran into the ethos of amateurism and we can distinguish the emergence of a division largely parallel to social divisions between professional and amateur sport.

The essence of popular culture on Tyneside is usually seen as embodied in what has become the local anthem 'Blaydon Races' by Geordie Ridley but Tyneside's most famous sporting event was not a success. It rained heavily on the day described by the song and the Blaydon Races were only held for four years. Nevertheless, the song 'conjured up the special place of sport in the festive life of the city whether it was racing or rowing, running or football'.[96]

Horse racing had a long history in the area and, as elsewhere, had been usually a matter of a contest between the favourite horses of the aristocracy and gentry, often ridden by their owners. Race meetings had moved from Killingworth to the Town Moor and a Race Week had been held since 1751. Racing was becoming better organised with stands and better laid-out courses. In 1838 the

Northumberland Plate was held for the first time. Gentry and workers both enjoyed racing though, like the theatre, courses became marked by different enclosures at different prices. Although many a grocer or bank clerk has lost his shirt at a race meeting, the respectable middle of society, especially if Nonconformist, was less evident. Around the Town Moor Races was a carnival of sideshows, cockfights and beer tents but the main attraction was the race itself, an experience heightened by the atmosphere with the gesticulating bookies, the roar of the crowd as the race got under way and the adrenalin that came with risking one's money. Successful local horses, such as Dr Syntax, after which a pub in the nearby town of Prudhoe was named, and his offspring Beeswing, became legends. In 1880 Newcastle's races moved to Gosforth Park when the old mansion and estate became vacant, leaving the Town Moor's part in Race Week to the annual fairground, the Hoppings, originally a temperance festival. In 1899 another, more working-class venue for horse racing was established at Byker where hare coursing, pigeon shooting and a variety of other sports also took place.

Until the second half of the century, rowing vied with horse racing as Newcastle's most popular spectator sport and it was certainly the sport that produced the town's popular heroes. A river with many boatmen almost inevitably led to competition as to who was the strongest, fastest and most skilful oarsman; such contests were watched by great crowds who backed their favourites with hard cash. The close but ambivalent relationship between the Tyne and the Thames, a river with its own tradition of races between watermen, resulted in contests between the champions of Newcastle and those of London. Harry Clasper, the premier Tyne oarsman of his day, is the most celebrated and after leading his crew to victory on the Thames in 1855 he came home to a hero's welcome. He enjoyed the traditional retirement of the professional sportsman as the owner of several public houses. Clasper was followed by his protégé, Bob Chambers, who won a skiff championship race over a 3-mile course between Scotswood Bridge and the High Level Bridge against the London rower Tom White in 1859 and went on to be Thames champion six times. The last of the great Tyneside rowers was James Renworth, who in a short career won the world sculling championship in 1868, took a team to Canada in 1870 where they won a £1,000 prize on the St Lawrence and then the following year collapsed at his oar while rowing against

another Canadian crew in New Brunswick and died on the riverbank at the age of twenty-nine. Performance-enhancing drugs are not a recent element in sport and it appears Renworth had taken too much of one.

At the height of rowing's popularity thousands of spectators thronged the banks of the Tyne to watch well-publicised rowing competitions for high stakes. The adulation in which the great rowers were held was demonstrated by the more than 200,000 mourners at the funerals of Bob Chambers and Harry Clasper. Of the three champions only Clasper was a waterman by trade but Tyneside's success at rowing was intimately linked to the life of the river and, when the river was improved and ships could come alongside quays and there was less need for boatmen, the age of the professional rower was over. Rowing became an amateur sport and the new clubs like the Newcastle Amateur and the Tynemouth Rowing Clubs had a largely middle-class membership.

As rowing showed, you can bet on people as well as animals. Pedestrianism (competitive walking or running) followed much the same path as rowing, popular so long as it was a part-time professional sport and less so when it became amateur athletics. The sport was popular all around Newcastle and particularly in the mining villages of south-east Northumberland. Races were run on public roads and links and commons but by far the most popular place for such contests was, in the early nineteenth century, the Town Moor. By and large working men liked prize money for their athletic efforts and their supporters liked to bet on their champions. In this they were not unlike the aristocracy and gentry. George Wilson the celebrated pedestrian performed his first famous feat while confined for debt in Newcastle's Newgate Gaol: in return for £3 1s he walked 50 miles in 12 hours within the prison walls. His walk of 90 miles in 24 hours on a half-mile stretch of the Town Moor in 1822 bears a strong resemblance to Squire Obaldeston's achievement of riding 200 miles in 8 hours at Newmarket; one was 52, the other 45 and both promoted their challenge and won large sums of money. Mrs Morrison, the mother of another famous pedestrian, Peter Morrison, was a rare example of a female athlete and, when 64, she walked 92 miles in 24 hours.

Later in the century commercial running grounds were opened, usually by publicans. The Victoria Grounds and The Grapes were able to provide handsome money prizes that attracted competitors from far and wide. Pedestrianism can't be said to have been a particularly clean sport. The large sums of money involved

led to all sorts of cheating with fancied runners sometimes deliberately losing because they'd been bribed to do so or in order to gain a better handicap position in the next race. As one sports writer put it:

> [The] pedestrian circle is too much surrounded by a halo of beer and skittles and amenable to the low art of the bookmaker to make it either a healthy or improving place of resort, or a reliable gauge of a man's physical powers.[97]

Sport in Newcastle was not simply a matter for its inhabitants, for the town was the playground for people from miles around it. Miners especially saw the Town Moor as a sports field. Much of their leisure was highly physical, traditional and essentially rural. They engaged with pedestrianism, boxing, quoits, fives and potshare bowling, cockfighting and hare coursing. Potshare bowling was basically a simple game but a great test of strength. Two men would, alternatively, throw their bowls over a predetermined course, usually a mile, and he who got to the end of the course was the winner. All matches were played for money. Time and again the Council tried to remove bowlers from the Moor but interestingly faced opposition not just from the miners but from business interests who complained of loss of trade because the miners' wives were no longer shopping in town. In 1880 the miners took the Council to court on the basis that they were being denied access to public land and the Queen's Bench in London found in their favour. The Town Moor continued to be a place of recreation and sport for both townsmen and miners but there was a gradual tendency for most sports to remove to specialist grounds or premises. Boxing's transition from bare-fisted combat to gloves and Queensberry Rules was accompanied by a move from commons to arenas such as the Amphitheatre in Northumberland Road.

The development of sport was a complex process marked by the perseverance of tradition, the gradual transformation of traditional sports and the emergence of new ones. It was the second development that produced what became almost a religion for many on Tyneside, Association Football, and made Newcastle United one of the best-supported clubs in the country by 1900. Almost everywhere in Britain a rough form of literally unruly football has always been played by youths; such 'matches' on the Scottish border had, in Elizabethan times, often led to a renewal of warfare. As elsewhere, the new game with rules and referees was

introduced by ex-public schoolboys and spread quickly. Newcastle United was born of an amalgamation of the East End and West End clubs in 1892. By the turn of the century the club had a stadium at St James's Park and was playing the top sides from all over England.

Cricket, often seen as the sport which exemplifies social harmony,[98] followed a very different path to football. It never became as popular as football in Newcastle but never became as socially exclusive as tennis or golf. Matches were played by two clubs on the Town Moor in the 1820s and by mid-century the Northumberland Cricket Club played near Ellison Place and there was another club, Newcastle Clayton. Richard Holt tells us that both these clubs had their own bands which played during matches. By the end of the century there were around a dozen clubs in Newcastle and a Northumberland county side was playing other minor county sides at County Ground in Jesmond.

Did sport bring the diverse sections of society together or drive them apart? The wealthier suburbs developed a distinct social life highlighted by leisure activities and particularly sport. A very important division in sport was that between the professional and the amateur and from the 1870s this division became more formal. The new athletics and rowing clubs were usually prefixed by 'amateur', distancing themselves from their sports' recent pasts. It was not just that football acquired a largely working-class following that made young graduates turn to rugby but the increasing ubiquity of the professional in the former game. Rugby was based at Gosforth, where both Gosforth and Northern Rugby clubs were founded in the 1870s, and most players came from independent schools.

Golf and tennis were sports largely played by the upper and upper-middle classes. It is not surprising that Jesmond, Gosforth and Fenham, the latter two still beyond the formal boundaries of Newcastle, were where tennis clubs sprang up. Tennis had always been an elite game and a Racket Court had been built by a number of local gentry next to the Assembly Rooms in 1822. Real tennis, as the game came to be known, later removed to Jesmond, where F.W. Rich designed a magnificent Tudor-Jacobean-style court for Sir Andrew Noble at Jesmond Dene House. As lawn tennis was developed, the Portland Park Tennis Club with five courts and a croquet lawn was established in 1878; others followed, not only in Jesmond but in Fenham, Forest Hall and Gosforth. Nevertheless, there were public courts at Leazes Park by the end of the century. If we exclude Charles I's

games at Shieldfield, golf began in Newcastle on the Town Moor, but by the end of the century a more exclusive club had been established at Gosforth Park.

Sport represents, along with theatre, the holiday resort and the fair, the public face of leisure while the hobby is more private. Stamp collecting ran across the social spectrum, the Duke of York sticking stamps in his album, when he was not shooting down unconscionable numbers of pheasants, but also the father in Jack Common's *Kidda's Luck* doing the same thing in his house in Heaton, when he was not driving a train. The pigeon fancier inhabits a halfway house between the sportsman and the hobbyist, quietly tending his pigeons, but intensely competitive as they zoom home from the Belgian town to which he has sent them by rail and sea in the hope of winning a sizeable money prize. Coarse or sea angling is another sport-hobby which can be very competitive and attracts huge numbers, but few headlines. The innocent arcadian pleasure of the garden or the allotment can be inspired by aesthetic, consumerist or competitive impulses. Gardens were unusual when it came to Tyneside working-class housing but allotments enabled workers not only to assist the household economy but to go in for flower shows and vegetable shows, especially Tyneside leek shows, often with valuable prizes.

As arrangements for sport and entertainment became more elaborate so the price went up but wages were increasing. Nevertheless, there was still cheap and even free entertainment to be had in the life of the streets and at bustling markets. Shopping at the Grainger Market was not just about buying but was a social occasion involving meeting friends, making a circuit of all the stalls, having a sandwich or savaloy dip and a drink at one of the pubs with which the market was thoughtfully surrounded. Then there were the naptha-lit stalls in the Bigg Market:

> The auctioneers, old book dealers, quack doctors, and corn doctors; the purveyors of matches, leather laces, and all the other open air tradesmen, enter with spirit upon their evening campaign.[99]

As the town slowly expanded, the countryside retreated and the 5½-day week became the norm, the attractions of the countryside and the seaside beckoned. Wealthier Newcastle residents had, since the eighteenth century, for health and pleasure made their way in the summer months to Tynemouth, South Shields or

Cullercoats but the railways made it possible for the 'day tripper' to make brief forays and towards the end of the century better-paid workers could even manage a week's holiday at a seaside resort perhaps nearby but often quite distant. Lads who couldn't afford the fare to the coast walked the 8 miles or so and, after a day at the beach, made their weary way back.

The bicycle provided new mobility for clerks and skilled workers and even a growing number of women, opening up the countryside to the urban dweller and becoming a popular open-air pursuit. It was a decidedly respectable activity and the Heaton area, 'with its abundance of churches and dearth of public houses was the type of place where the activity flourished. The local cycling club was among the most popular in the district, while residents of Heaton also figured prominently among the elected officers of other cycling clubs in Newcastle'.[100]

Popular leisure was not synonymous with working-class leisure. Clerks and shop assistants and even some managers or professionals attended Newcastle's music halls or watched Newcastle United. Social stratification was, however, marked. There were respectable music halls and those that were rough and at all there were seats at different prices as there were sections at different prices at most entertainment and sporting events.

It is always dangerous to fall into the trap of believing, like many cultural theorists, that the culture of the mature industrial society of which Newcastle was a part was provided for the people rather than emanating from them and even most Marxists accept that people make their choices within contextual limits. There is much that is admirable about the leisure life of late nineteenth-century Newcastle and indeed of Britain as a whole. Opportunities were widening, holidays were no longer just time off work, sport was more purposeful and organised as well as less brutal, and among most sections of society there was a self-conscious appreciation of the countryside as a welcome escape from the urban environment. There was also, however, a certain defensiveness and conformity which was not just confined to the private tennis and golf clubs of Gosforth and Jesmond. The vitality and 'from the people' nature of the music hall has been much admired by historians of working-class leisure but, at least by the 1880s and 1890s, its bawdiness had to be expressed in the theatres of variety by codes and double entendres and its erstwhile realism by often mawkish sentiment. Like the street bookmaker, it had to be ready to run at the appearance

of the constables of propriety. Even the new popular sport of football imposed a kind of uniformity as crowds were corralled into sections and the pressures to support Newcastle United or not be considered a real member of the community were considerable. In contrast to the boisterous and uninhibited world of leisure in eighteenth- and early nineteenth-century Newcastle this was a tamed leisure culture.

Urban Culture

'Newcastle's golden age was over by the last years of Victoria's reign, when the city grew faster, from less than 100,000 in 1851 to 215,000 at the beginning of the new century,' wrote Asa Briggs. Newcastle was conspicuously absent from the cities he devoted chapters to in *Victorian Cities*, though it was a city he knew well and admired. The paradox is that the best of Newcastle in terms of its architecture until the 1880s is either not Victorian or is atypically Victorian, though the last half of the nineteenth century was the great period in terms of its growth and prosperity.

The period of imaginative urban development and graceful architecture came to a spectacular finale with Dobson's Central Station, an exercise in monumental classicism, but Newcastle's Victorian architects sensibly continued the classical tradition in most secular public buildings. A new spirit is to be found particularly in the architecture of commercial buildings in the last years of the century and, as Tom Faulkner has commented, 'The eclecticism and opulence of late Victorian and Edwardian architecture was perhaps never better displayed than in its commercial buildings.' The free-wheeling historicism of the banks and insurance buildings of Collingwod, Dene and Mosley streets exemplify this statement. The bank built for Hodgkin, Barnett, Spence, Pease & Co. and the former Prudential Assurance building, respectively in Renaissance and Gothic Revival styles, are fine examples.

Victorians were ambivalent about large towns and cities as they were about industrialisation. For every hymn of praise to progress, the achievements of industry or the sterling worth of Leeds or Manchester we can find a denunciation of urban life, not just because of the problems of overcrowding and squalor, but

235

because large towns were less natural and less moral than the market or cathedral town or the countryside. If illegitimacy rates are taken as indices of sexual morality, such pundits were spectacularly wrong as rural areas had far higher rates than towns. The village of Corbridge had, for example, a much higher rate of illegitimate births than did Newcastle. Fields and hedgerows and service in big houses provided rather more opportunity for clandestine sexual romps than did the streets and back lanes of towns. Certainly, however, the balance in literature and painting is predominantly anti-urban and anti-industrial.

Many cities, however, did take pride not only in their productivity and their commerce but in their civic culture and were eager to link their ethos with urban civilisations of the past, especially the classical past, and trumpet their support for the arts as well as science and technology. It cannot be said that Newcastle Council exhibited much in the way of the civic pride that the councils of several Victorian towns displayed. Having begun with the shabby business of selling off the Mansion House and its contents, it approved a new Town Hall. Built in the mid-1850s, this building in Italian Renaissance style soon proved too small for its purpose; Cadwallader Bates described it 'as in an awkward situation, and shaped like a grand piano'. The expression in architecture of the ethos of town government and a desire by city fathers to make a statement of their time and place in history that we find in Leeds and Manchester was not for the councillors of Newcastle. The town was indeed slow to acquire the municipal amenities that many other cities and towns instituted. An Act of 1850 allowed the creation of public libraries but it was not until 1880 that a town library was built.

Victorian Newcastle had a vibrant intellectual and cultural life but it was expressed largely in private societies and subscription-funded institutions rather than in municipal museums and galleries. By the late nineteenth century, private initiatives had provided the town with a number of libraries, learned societies and with the Hancock Museum of Natural History and the museum of the Society of Antiquaries in the Black Gate of the castle. If most of these institutions can be seen as catering for the well-to-do, the Mechanics' Institute provided for artisans and clerks, while the Tyneside Naturalists' Field Club had members from most sections of society.

The late development of civic cultural amenities in Newcastle in comparison to towns like Leeds or Manchester, where the urge for public education in the

arts and history was strong, and the belief that museums, concert halls and galleries would bring what Matthew Arnold called 'sweetness and light' into the lives of ordinary citizens and give their lives a spiritual dimension, needs some explanation. Possibly, it was the late development of Tyneside as a manufacturing centre and the consequent late development of Newcastle as a populous town, only really expanding its medieval boundaries after mid-century, that is the key. Industrialists like William Armstrong and Charles Mitchell were building their fortunes in the 1860s and 1870s and, though men with wide cultural interests, only turned their attention to the arts in their later days, both building galleries in their houses in the 1880s. The Council was largely composed of men who were concerned with economy and were answerable to rate-payers with the same priority; the number of small businessmen and shopkeepers may have made the local government electorate more opposed to municipal grandeur than the electorates of towns with a greater manufacturing workforce. In any case, despite the distinction it gave to the town, the Grainger development of central Newcastle had been viewed with suspicion in some quarters because of the way private and public money had been entwined in its financing and this may have led to a prejudice against ambitious public architectural schemes. At the same time private institutions were filling the gap, so why put culture on the rates?

In the late eighteenth and early nineteenth centuries Newcastle had seemed an important provincial centre for painting and sculpture as well as for architecture and the applied arts. This, it has been argued, cannot be said of the later nineteenth century. The synergy that had seemed to characterise the arts and culture evaporated. With the departure from Newcastle and the death of T.M. Richardson, the Northern Academy of Arts soon closed. The Northern Institute for the Promotion of the Fine Arts moved into the Central Exchange and William Bell Scott reluctantly accepted the post of master of the new School of Design set up by the government, but the fine arts did not on the whole flourish in Newcastle during the second half of the century and had little encouragement from the Town Council.[101]

It is probably unfair and redundant to single out Newcastle as noteworthy for failing to nurture a strong local artistic culture. The influence of London as the centre for the creative arts grew stronger after mid-century and, if other provincial towns did more for the public access to great art via museums and galleries, none

were notable for nurturing communities of local artists. Historians have tended to be rather dismissive of the Central Exchange Gallery, though a recent study has seen it as playing 'a major but underrated role in Newcastle's nineteenth century art story' and has argued that it 'successfully combined art exhibitions with other more populist forms of entertainment and therefore reduced the need for a civic gallery by providing a popular cultural service'.[102]

Certainly music fared no better. The rich musical life of the town during the eighteenth century seems to have petered out. While Manchester had its Halle Orchestra and one of the purposes of Leeds Town Hall (1858) was to provide a suitable centre for musical performances, Newcastle had neither orchestra nor concert hall. Both as a cultural and a social centre the great days of the Assembly Room were in the past. The theatres did provide some light musical performances and chamber concerts were held in the later decades of the nineteenth century, while the Victorian enthusiasm for choirs found expression in the Newcastle and Gateshead Choral Union, but there was no support from the Council and, indeed, little demand from the rate-paying electorate.

Joseph Cowen's brand of democratic radicalism was a powerful force in Newcastle particularly during the 1860s and 1870s. Its nature may well have influenced the town's approach to the lack of the sort of 'municipal socialism' that was found in many large cities and towns. He was enthusiastic about working-class organisations of the self-help variety, seeing friendly societies, trades unions, mechanics' institutes and co-operatives as progressive forces which made for self-improvement and were a means of bringing workers into an expanding democracy. He did not, however, believe in councils taking on tasks that were properly the business of the private sector. He appreciated the importance of cultural activities in creating full citizenship and via his newspapers and the Tyne Theatre and Opera House, which he opened in 1867, helped to encourage intellectual activity and the enjoyment of the performing arts. Essentially, however, he thought such activities should grow upwards via popular subscriptions and enlightened patronage rather than be designed by local government. Recognising, however, the necessity of an educated democracy and the inadequacy of what even the Mechanics' Institute could supply in the way of access to books for those with little surplus spending power, he flung his weight behind the campaign for a public library.

There was plenty of encouragement for reading in Newcastle before the start of the Newcastle Public Library Service in 1880, thirty years after the Public Libraries Act of 1850. The Literary and Philosophical Society catered for the more cerebral members of the upper and middle classes and in its centenary year of 1893 it had 1,230 members; the Newcastle Mechanics' Institute having nearly foundered in the early 1860s recovered and had a membership of 1,510 in 1874; the working men's clubs had their libraries; and there were a number of circulating libraries. It was, nevertheless, the case that all existing library provision required subscriptions of some sort.

The campaign for a public library was initiated by Councillor Dr William Newton, medical officer for East All Saints Ward, as early as 1854 and was supported by Robert Spence Watson, Joseph Cowen, Dr Rutherford and other local worthies. Cowen's newspapers also provided support with W.E. Adams, the editor of the *Weekly Chronicle*, putting that paper's influence behind it. Opposition on the Council and in the town was, nevertheless, considerable and it was not until May 1879 that work began on the site of the Carliol Tower.[103]

That there was an unsatisfied demand for books is demonstrated by the fact that about 4,000 readers enrolled when the Public Library, temporarily housed on the ground floor of the Mechanics' Institute, opened. The library inherited the books of the Institute (7,450 volumes in 1860) and those of the old library at St Nicholas's church. It began with a stock of 20,000. By the end of the century two branch libraries at Elswick and Heaton had been opened.

After the opening of the Library, the town had to wait nearly another quarter of a century for a municipal art gallery and in the meantime it failed to acquire the impressive collection of Pre-Raphaelite paintings built up by the industrialist James Leathart. The Laing Art Gallery, built adjacent to the Library, was opened in 1904, but owed more to the generosity of a local wine merchant, Andrew Laing, than to municipal support, while it was another wine merchant, Albert Higginbottom, who provided it with an important collection of Japanese artefacts.[104]

The beginning of higher education in Newcastle owed little to the Council. The College of Medicine was at first a voluntary body organised by the medical profession. In 1852 it became the third college of Durham University. A campaign for a college teaching science and engineering was led by the leading lights in the

town's learned societies, Nicholas Wood and E.F. Boyd of the Institute of Mining and Mechanical Engineers, Thomas Hodgkin and Robert Spence Watson of the Literary and Philosophical Society, and Albany and John Hancock of the Natural History Society. In 1871 the College of Physical Science, later known as Armstrong College, was established and it became part of the University of Durham in 1874 and shared rooms behind the Literary and Philosophical Society with the College of Medicine before moving to Barras Bridge in 1888 while the College of Medicine moved to premises in Northumberland Road the following year.

Late nineteenth-century Newcastle did, as we have seen, have a lively intellectual life orchestrated by private societies which became semi-civic institutions. A cross-section of the town's elite shows they were not only successful entrepreneurs, shrewd bankers or eminent in the professions but men of wide interests. Few of them were in the standard sense 'self-made men'; they had, for the most part, turned modest fortunes into bigger ones and the majority had been well educated. If much of the intellectual drive of the industrialists was devoted to the furtherance of science and technology that would further the development of local industries, they were also fascinated by history and natural history and several became patrons of the fine arts. They were joined in their intellectual and cultural activities by members of the county gentry and by the well-educated and bookish clergy with which Victorian Northumberland and Durham abounded. New members elected to the Society of Antiquaries in 1883 were the Bishop of Newcastle, James Joicey, Edward Pease, Lt-Col. Sheppey and Henry Morton of Biddick Hall, and among its officers in 1885 were the Duke of Northumberland (patron), the Earl of Ravensworth (president), Sir Charles Trevelyan (vice-president) and John Clayton (vice-president). The twelve honorary members of the Natural History Society in 1887 included two lieutenant colonels, two clergymen, two professors and a knight. The centre of intellectual activity was the Literary and Philosophical Society, from the beginning an institution which united, sometimes uneasily, urban and county elites.

The ethos of the town's intellectual elite was a contrary mixture of satisfaction in the town's and Tyneside's economic progress, pride in the town's and the counties' (particularly Northumberland's) histories, and delight in the variety of the topography and the flora and fauna of the adjacent countryside and seashore.

The contradictions are obvious enough and indeed there was no consensus: economic development was diminishing the environment and polluting the Tyne, political and social development was eroding ancient customs, ways of life and even the physical remains of the much valued past were being destroyed. These 'New Northumbrians', as Robert Colls has termed them,[105] were faced with the same problems as the early twenty-first century, particularly how to reconcile economic development and conservation. It is to their credit that, if they failed to solve these problems, they raised them and by supporting measures such as the Sea Birds Preservation Act (1863) and the Alkali Act (1874), and pioneering the conservation of historic monuments and the excavation of ancient sites, attempted to ameliorate the consequences of industrial and population growth.

Lord Armstrong, Newcastle's greatest industrialist, demonstrated many of these contradictions. Inventor, entrepreneur and employer of thousands, he had transformed the north bank of the Tyne above Newcastle and was a major philanthropist in his devotion to the town's welfare and yet his great love was for rural Northumberland. His house and estate of Cragside at Rothbury were at once modern, baronial and homely. It had its own electricity supply and every domestic convenience of the age, yet its inglenooks adorned with sentimental messages suggested a shepherd's dream of a giant cottage, while the gallery for his art collection emulated the houses of aristocrats. Robert Spence Watson, a successful solicitor, epitomised the secularisation of the Quakers' erstwhile religiosity, finding its outlets in radicalism and social reform, but he too was entranced by the countryside of Northumberland and its history. As we have seen, the Newcastle elite tended to intermarry and successful newcomers followed this trend. Spence Watson married Elizabeth Richardson, daughter of the industrialist Edward Richardson, while John Theodore Merz, son of a German immigrant, married her sister. Merz and his son Charles played a major part in making Tyneside a pioneer in electrical power but Theodore Merz had also wide cultural interests. He lectured to the Literary and Philosophical society on such subjects as 'European thought in the nineteenth century', Coleridge, von Schlegal, Descartes and Leibniz.

This elite had a great interest in history, especially the history of the Roman period in its major local manifestation, Hadrian's Wall, and increasingly, if we go by the publications of the Society of Antiquaries, in the history of medieval

Newcastle and Northumberland, and, as we have seen, in natural history. The Literary and Philosophical Society maintained a splendid and comprehensive library and continued to be the main forum for intellectual discussion. It was there that Joseph Swan demonstrated his electric light bulb but the members were also treated to lectures by Ford Madox Brown and Oscar Wilde.

A passion for discussion, debate and argument had characterised Newcastle life since the time of Bewick and it is not surprising that when, towards the end of the century, there was national fashion for debating the issues of the day in a formal, often parliamentary manner, this became popular in the town. The Lithosian Society started off with a number of friends forming a mock parliament and debating political and moral motions sometimes earnestly but often simply to exercise the art of public speaking and it was followed by other debating societies such as the Wranglers and the Junior Lithosians.

Yet, despite this varied intellectual life, it is still difficult to understand the town's failings when it came to the public expression of urban culture and civic pride or the patronage of art and music in comparison to Manchester, Leeds or Birmingham. By comparison there was little of 'sweetness and light' about municipal provision in late Victorian Newcastle.

In Joseph Cowen, Newcastle had a spokesman for the new urban world but although he was a supporter of the campaign for the library his brand of liberalism had little truck with notions of interventionist urban government. Economic progress and individual freedom were what was important and, the first to take out a book from the new library, he chose J.S. Mill's *On Liberty*. In 1870 he wrote:

> The ancient boroughs were the arks and shrines of freedom. Today, behind the dull roar of our machinery, the bellowing of our blast furnaces, the panting of the locomotives and the gentle ticking of the electric telegraph, we can hear the songs of the children who are fed and clad, and the acclaim of a world made free by these agencies. When people declaim in doleful numbers against the noise and the dirt of the busy centres of population, they should remember the liberty we enjoy as a consequence of the mental activity and enterprise which have been generated by the contact of mind with mind brought together in great towns.[106]

He had a point. Victorian Newcastle left many problems to the future but it had managed by its industry and ingenuity to permit a vastly increased population to thrive and the majority to be better fed and housed, to have increased life expectancy and some opportunity for personal advancement. The Town Moor had proved sacrosanct, parks had been provided and Jesmond Dene bequeathed so there were still green spaces and the trams and the railways provided escape to seaside or open fields. It might be a dirty and blackened town with an increasingly polluted river, but its skilled workers were well paid and it could take pride in its position as a control centre for Tyneside's industry and a worldwide reputation for ships, ingenuity and enterprise.

7

NEWCASTLE 1901–1945

Whether, like Edwardian England as a whole, Newcastle in the period 1901–14 has an identity of its own or should be seen as essentially the last years of the Victorian city and perhaps its Indian Summer, is debatable. There was no slackening of economic growth and the major manufacturing industries developed in previous decades seemed more prosperous than ever. To many contemporaries, however, changes in attitudes, ideas and leisure seemed to demarcate the period from the previous century. The First World War provides a more definite and significant watershed and the post-war world saw the decline of the industries with which the city had become associated. Newcastle, however, was less affected by the economic tribulations of the 1920s and 1930s than was most of Tyneside. The city continued to expand, new housing estates were built and shopping and entertainment became more important than ever. The Second World War had the effect of revitalising older industries and of retarding the developing consumer economy apparent in the 1930s.

Three years before the death of Queen Victoria, the eminent local historian Richard Welford exulted in the changes wrought in Newcastle during the nineteenth century: 'Truly a marvellous change – almost a magic transformation! Miles upon miles of streets where grass grew, and flowers bloomed, and fruit ripened a hundred years ago'.[1] Such sanguine belief in progress had not diminished by 1913 when F. Harrison of Rutherford College wrote that Newcastle 'has now attained in position and dignity all that a town can desire ... the city of a Lord Mayor, the seat of a bishopric, the chief port of a great river, the past home of many famous men and the possessor of a long history'.[2]

Economy

The town and the Tyne were at their economic zenith. The very names Newcastle and Tyneside were stamped around the world, imprinted on so many ships, bridges and engineering works in far away places. Britannia ruled the waves, not just because of the Royal Navy, but because over half the world's shipping was British-made and much of that British-owned. A considerable proportion, from the magnificent ocean liners to the dirty coastal steamers, were British-manned, while Lascars, West Indians, Europeans and Americans also sailed under the British flag. One in five of the world's ships were built in the North East. Other than 'British', the names which resonated were those of London, the centre of government, banking and commerce, Glasgow and Clydeside, Liverpool and Merseyside, and Newcastle and Tyneside. Newcastle was a well-known name in Spain, where Armstrong had a thriving business, in Italy, where the Pozzuoli Works belonged to Armstrong, and in Japan, where, not only were many of the ships of the Imperial Navy Armstrong-built, but the firm had recently established a steelworks in Hokkaido. Hawthorne-Leslie was building warships in Russia, where it had interests in shipyards. In South America navies ordered ships from Tyneside and the bridges and railway engines often came from Newcastle or the banks of the Tyne.

It is often said that the writing was on the wall even at this zenith, that the North East of England and its northern capital were dangerously dependent on coal and the heavy industry which had developed because of access to coal, but it did not seem like that in the early years of the century. The old staple, coal, was not just there but more important than ever. Despite the earnest and far-sighted debates at the Mining Institute as to the dangers of the coal seams being exhausted,[3] the latest estimates were that they would last for centuries. By 1911 the North East coalfield was producing more coal than any other coalfield, some 21 per cent of Britain's coal production. The northern coalfield's share of the London coal trade might be declining relative to other coalfields closer to London but the sea-coal market for export was expanding and steelworks and household hearths in many parts of Europe were fired by coal shipped from Tyneside. If there was hubris, it was understandable.

Newcastle was the centre of one of the most thriving economies in Britain and, indeed, the world. It would probably be a mistake, however, to think of a North

East economy with Newcastle as its capital for there are many definitions of the 'North East' and the Teesside economy was in many ways separate from that of north Durham, Tyneside and Northumberland. The Great Northern Coalfield did, of course, embrace much of the area from Teesside to the Wansbeck, and the North Eastern Railway, the result of decades of amalgamations and takeovers, dominated transport from the Tweed to the Humber and largely controlled the industrial and coal-carrying network, but the pull of the different rivers was strong and Newcastle was essentially the administrative and commercial centre of the riparian economy of the Tyne. Newcastle and Tyneside industrialists and their Sunderland and Wearside counterparts had often interests in both rivers, notwithstanding the considerable rivalry between Tyne and Wear and Newcastle and Sunderland, but, even today, it is hard to find a sign pointing to Newcastle in the centre of Sunderland. This 'dogged particularism', as a recent, incisive study of the North East has called the divisions and local loyalties within the area,[4] has irritated generations of economists, administrators and planners to whom it has seemed self-evident that there was a region with a common economy which should have the grace to recognise that it needed a common political and administrative structure.

The strength and dynamism of Edwardian Tyneside was symbolised by the launch in 1906 of the *Mauritania*, a Cunard liner which from 1909 held the record for the fastest trans-Atlantic voyage for twenty years, by Swan Hunter and Wigham Richardson and by the building of the King Edward Bridge, the last great railway bridge to be built in Britain. The Russo-Japanese War demonstrated the leading position of the Tyne when it came to building warships in that the Battle of Tsushima saw the victory of a Japanese fleet, many of whose warships were built by Armstrong's,[5] over a Russian fleet with many of its ships built by Hawthorne-Leslie. As an area in the vanguard of the new electricity industry, it could not be said of Tyneside that it was merely continuing to build on its past success in coal, ships and heavy engineering. Merz and McLellan put Tyneside in the avant-garde of the electricity industry. The Corporation's electric trams began to run in 1901 and the NER opened the first electric railway outside London when the circular route between Newcastle and the coast was opened in 1904.

There was little evidence on Tyneside or in Newcastle for the supposed decline of the industrial spirit which some historians have detected among

British industrialists and manufacturers.[6] The notion that entrepreneurs and businessmen should have developed a 'bourgeois' culture – urban and separate and distinct from that of the aristocracy and landed gentry – was always fanciful. Money made on the banks of the Tyne continued, as it had done for centuries, to be invested in country houses and land and a new symbiosis between landowners, merchants and industrialists into a layered elite took place, but as the founders of great firms withdrew they were replaced by capable managers. Lord Armstrong died in 1900 but a recent study has seen Armstrong Whitworth (the result of an amalgamation in 1897) as in 1914 'a financially sound, technologically innovative and well managed armaments company'.[7] Charles Mertz, son of John Mertz, proved that the second generation of entrepreneurs was not always inferior to the first and Mertz and McLellan designed the Neptune Bank power station at Wallsend which was at the time the most powerful in the world.

The charge that Newcastle's and Tyneside's industrialists neglected the future by not diversifying into new light industries and the production of consumer goods is unfounded for attempts were made. Armstrong Whitworth moved into the motor industry in a small way, producing models to the design of the London car-maker Wilson Pitcher & Co. from 1904, but in 1910 and 1911 more of the firm's investment capital went into motor car production than into commercial shipbuilding.[8] Mertz and McLellan pioneered the provision of electrical supply via the heavy electrical industry but they and other Newcastle businessmen were well aware that electricity offered a market for electrical appliances of which light bulbs would only be the first wave. Joseph Swan's light bulb factory at Benwell closed after five years in 1886, not because business failed, but because, after the merger with Edison to form the Edison & Swan United Electric Light Company, the south of England seemed a better centre for production. There was in the end no compelling reason for diversification away from heavy industry when orders were rolling in for ships, armaments and bridges and there were expanding markets for turbines and power stations.

Trade and shipping remained central to the city's prosperity and the Quayside was still the place where most business was done. As we have seen, there had never been much coal on the Quayside and, increasingly, far more cargoes were loaded and unloaded elsewhere on the river, though some 1,400 workers were still employed on the Quay in the 1890s, but the Newcastle Commercial Exchange

was the place where deals were done. This was a coal and shipping exchange, the 'Change', lodged in the rather cramped quarters of the ground floor of the Guildhall, and frequented by

> the core actors – colliery agents, shipbrokers, coal exporters and shipowners – and by insurance brokers, oil merchants, ships' store dealers and dry dock owners ... even traders who were not part of this coal and ship complex gravitated towards the exchange building as the centre point of Tyneside mercantile activity.[9]

Shipping was a business notoriously subject to alternating periods of prosperity and slump. Shipowner Sir Arthur Munro Sutherland recalled the period:

> The prosperous days with which the twentieth century opened did not last long in shipping. Prices came tumbling down as freight charges dropped. On Tyneside empty shipyard berths hastened unemployment. In the seven years after 1900 the decline in values brought shipbuilding prices down by almost half. The ship which in 1900 cost £61,000 could have been built in 1907 for £36,000![10]

But the early twentieth century was overall a period of expansion for Tyneside shipping firms. The great owners like Sir James Knott and Lord Runciman increased their fortunes and Sutherland made his. The Tyne exported 9 million tons of coal per annum at the beginning of century and by 1911 the river's total had exceeded 20 million of which over 15 million went overseas.

Along with other major cities and regional economic centres, Newcastle was increasingly part of a more sophisticated and interlocking economy in which financial direction came from London. The old integrated elite was still important and the representatives of its families still sat in the boardrooms of the largest firms but, just as manufacturing firms amalgamated or were taken over, so the local banks became part of national banking companies: Woods & Company and their eighteen branches were taken over by Barclays (1897) and Hodgkin, Barnett, Pease & Spence by Lloyds (1893), which then went on to take over Lambton (1908). The move towards joint stock companies in shipping attracted London investors, while, after the opening of the Manchester Ship Canal in 1894, investment came from the North West and Tyneside as ship

owners took advantage of the opportunities offered by the new port created by the canal. Outside investment and reliance upon London-based banks may not always have been to the disadvantage of the local economy for this could in good times make more capital available, but it did undermine its autonomy and meant that the decisions as to the provision of capital were increasingly made outside Newcastle and Tyneside.

The search for harbingers of future decline can, however, be taken too far. The Tyneside economy of which Newcastle was the administrative and commercial centre was doing well and, even if it had been possible to foresee a future decline, it is far from certain that steps could have been taken to avoid it. The striking imagery of heavy industry, shipping and the coal trade can, in any case, obscure the important dimension of Newcastle's importance as the area's centre for leisure and shopping and the fact that the expanding city was moving away from the riverbanks.

Even at the height of Tyneside's industrial reputation, Newcastle remained distinctive. Its economy was, as we have seen, different to that of the settlements elsewhere on the river, even if there was a mutual dependency. As Newcastle expanded its boundaries up and down the river, so the number of industrial firms within its boundaries increased and there were coal mines on the fringes, such as the Montagu Pit at Scotswood. In 1901 only around 15 per cent of workers were employed in shipbuilding and engineering and less than 25 per cent in any form of manufacturing, but, after the inclusion of Benwell and Walker, 29 per cent were employed in heavy manufacturing. Nevertheless, the city continued to be dominated by commerce, administration and services and by 1911 there were 1,194 employed in government service. Newcastle had the sixth highest number of white-collar workers among British cities, giving it a much larger middle class than elsewhere on Tyneside or in the North East. Bill Lancaster has put it well:

> Newcastle is not an industrial city. Tyneside is, of course, a conurbation that in the recent past was dominated by heavy industry. Nineteenth-century Newcastle did have some working coalmines, but, as these became exhausted, the relentless rise of the region's 'carboniferous capitalism' took place outside the city walls. Newcastle's primary functions over the last two centuries have been commerce and consumption.[11]

Historians have until recently greatly underestimated the economic and social significance of the revolutions in patterns of consumption and of retailing. It was not just higher wages but the availability of better and cheaper food and clothing which lay behind the improved standard of living which benefited most, if far from all, people in the late nineteenth and early twentieth century. An increasingly sophisticated retail industry also created new demands and aspirations. Newcastle as the regional shopping centre with its well-managed department stores, specialist shops and covered market developed a retail industry that was employing some 10,000 in 1911 and was a major economic force in the city.

The Expansion of Newcastle

Population increase reflected the fact that it was the late nineteenth century and the Edwardian period that saw Tyneside's height of economic prosperity. From 215,328 in 1901 the population of Newcastle grew to 266,671 in 1911. Though this growth was partly because of the expansion of the city's boundaries, it was still an astonishing rise. This physical expansion came in 1904 when Walker, Benwell, Fenham and part of Kenton were added to Newcastle, adding some 3,000 acres to its area. As F.W. Dendy pointed out in a lecture to the Literary and Philosophical Society in 1909, the town's new boundaries were still marked by streams, no longer the Pandon and Skinner, but the Stotts Pow Burn to the east and the Denton Burn to the west while the Cragg Hall Burn continued to separate Newcastle and Gosforth.[12]

Whatever the local government boundaries, housing development marched on. To the east of the Town Moor, Jesmond and Gosforth were merging into each other. As late as 1890, Jesmond was an upper-middle-class suburb with villas and gracious terraces, but, around the end of the century, the Tyneside flat arrived in this elegant area. Speculative builders with the assistance of building society loans built street after street, fanning out from Osborne Road; streets reached out westwards towards the Moor, to the east towards Jesmond Dene and met up with Gosforth as High West Jesmond came into contact with Bulman Village, as Gosforth continued to be called until 1914. There were still green fields in Fenham

and the spacious grounds of several large houses, but by 1914 Wingrove House had given way to Wingrove Gardens, Avenue, Terrace and Road while both sides of Fenham Hall Drive had been built up. A further advance towards Denton was not in doubt. Heaton extended to the north as far as Heaton House and Park while Byker merged into Walker as Elswick did into Benwell.

Physically Tyneside was on the way to becoming a conurbation as gradually the towns and villages along its banks expanded into each other, a process assisted by the developing transport system but, in its local governmental structure and in the minds of its inhabitants, it remained a collection of distinctive boroughs and communities among which Newcastle was *primus inter pares*. The river marked more than a physical divide for loyalties to Northumberland and Durham were strong. It might have made sense for Newcastle and Gateshead to have merged but Gateshead had a strong sense of identity and feared being swallowed up by its larger neighbour. Gateshead had grown rapidly and had a population of nearly 110,000 in 1901 but Newcastle had no wish to take over a town with low rateable values. Newcastle no longer exerted a legal hegemony but its position as the centre of the web of industrial power, the conduit of national government and headquarters of most industries maintained its predominance as riparian capital. As late as 1907, it gave up its age-old right to tax goods leaving or entering the town, half of which were collected on the bridges, perhaps recognising that that such taxes had become counter-productive.

Historians may have modified the image of Edwardian Britain as a serenely confident nation and society and pointed to worries about Britain's economic and Great Power position, to the shock caused by the difficulty in winning the Boer War, and to internal problems such as industrial militancy and the Irish Question, but the overwhelming impression of Edwardian Newcastle is one of confidence, energy and exuberance.

Such qualities are reflected in the commercial buildings of the period which demonstrate a free-wheeling historicism. Collingwood Buildings was erected in Baroque style during the last years of Victoria's reign and in 1903 the magnificent banking hall of Barclays was adapted from it. Like many of Newcastle's banks and insurance offices, it is now a rather grand bar. Emerson Chambers in Blackett Street, now a book shop, is a wonderfully exuberant building, described by Faulkner as 'Baroque-cum-Art Nouveau', with at roof-level a busy landscape

of turrets, domes, chimneys and a clock. Milburn House in Dean Street and Half Moon Chambers in the Bigg Market demonstrate the eclecticism of Edwardian architecture, the one classical with Dutch influence and the other a further mixture of Baroque and Art Nouveau. The Central Arcade, built within the Central Exchange after the previous interior had been destroyed by fire, provided the city with a new and magnificent shopping arcade.

The number of civic and institutional buildings of the town was expanding. By 1901 there were numerous elementary schools, the Central Library had been built and branch libraries had begun to be opened. Most ventures in the fields of the arts, secondary education or medicine remained, however, the product of private initiatives or of an interlocking of local government and private endowment. The Laing Art Gallery, as we have seen, was established round the corner from the Central Library with the help of a generous donor. Opened in 1904, its secluded position rather diminished the effect of what is an impressive neo-baroque building. The Fleming Memorial Hospital for Sick Children, paid for by a local solicitor, John Fleming, was built in the late 1880s in Brandling Park. Newcastle turned down a further generous offer when J.A.D. Shipley, who died in 1909, left his large art collection and £30,000 to provide a gallery and mansion house. The suggestion that a site next to the Laing could be provided was rejected and Newcastle's loss was Gateshead's gain when Shipley's executors turned to his home town.[13]

Civic and institutional Newcastle was heading north and, increasingly, new public buildings were erected on greenfield sites in the north-east of the town. St Thomas's church had been built in what was then largely a rural area in the late 1820s and was an early symbol of the northward march of the town as it replaced the chapel of St Thomas at the end of the old bridge. By 1901 a number of educational establishments had been built close to it in Northumberland Road beside the fine Georgian terraces of Saville Street and Ellison Place: the independent Dame Allan's School and the Sutherland Building, which started life as the Durham College of Medicine, were built in the 1880s and were joined by the offices of the new Education Committee set up after the Education Act of 1902. Another educational quarter was formed in Jesmond, where the Church High School and Central High School formed a private educational quarter with the Royal Grammar School when it transferred to Eslington Terrace in 1907.

On the other side of St Thomas's, across the Haymarket, the College of Science, which became Armstrong College in 1904, was gradually taking shape and behind it was the Royal Jubilee Infirmary on which work began in 1900. As befitted a college of Durham University it was built in Tudor-Jacobean style. The complex of buildings began with the laying of the foundation stone by Lord Armstrong of the eponymous building with its Jubilee Tower and ended, for the moment, with completion of the School of Architecture in 1913. The arches by which its quadrangle is approached from Barras Bridge allowed the college to impress its presence upon and yet be withdrawn from the busy Haymarket. Victoria's Jubilees lingered; the Jubilee Tower was not completed until 1894 and the Royal Jubilee Infirmary, built to commemorate the Diamond Jubilee, was opened by Edward VII as the Royal Victoria Infirmary in 1906. The Infirmary, removed from its site on the Forth where it had been for a century and a half, both complemented the college buildings and represented another step northwards for Newcastle.

Over the road was a reminder that Britain was a martial nation with an empire to defend. The Durham Light Infantry, Northumberland Fusiliers and the yeomanry from both counties all fought in the Boer War, while Armstrong's Elswick Works even raised a special unit of gunners. The magnificent South African War Memorial stands in testimony to their patriotism and sacrifice. Winged Victory surmounts a tall column while a figure with an unfurled flag clasps it below. Erected in 1907, it is one of the finest of the many war memorials that would be erected as the century wore on, two of them close by in the grounds of St Thomas's.

The Haymarket was becoming one of the most important areas of the town,[14] but the Town Moor blocked the way to any further development to the north. The land for the Royal Victoria Infirmary had been taken from the Moor and gifted by the freemen. To the east of it was Exhibition Park, also part of the Moor until it became a park to mark Victoria's Golden Jubilee, and to the west was Leazes Park. Otherwise the Moor remained intact and undomesticated. Further northward development had to be along its flanks up the Great North Road where the Fleming Hospital for Sick Children removed or past the football ground at St James's and up Barrack Road.[15]

A further congruence of public buildings was to the west of the town, where the institutional offspring of Dr Rutherford were based, the Technical College

and Boys' Grammar School in Bath Lane and the Girls' High School in Rye Hill and where the Union Infirmary was already becoming the most important part of the Workhouse.

The town had taken a shape that, although modified, would be recognisable until the 1970s.

SOCIAL LIFE

Today, Newcastle has a reputation as an immensely sociable 'party city' but its robust social life has a history and the Edwardian period saw social life for all classes become more openly hedonistic. Even the Nonconformist churches had to abandon much of their view that worldly pleasures were a snare and only a small minority stuck to the view that sport, entertainment and secular music were roads to damnation, though most Nonconformists continued to advocate temperance and thought dancing dangerous. Though, for many, religion remained important, nothing testifies more to the decline of religion than the steps the churches took to arrest it. Each new suburban development saw an obligatory founding of new churches and chapels to cater for the spiritual needs of the inhabitants, though attendances rarely fulfilled hopes, but efforts to maintain or increase congregations increasingly relied upon what previous generations would have seen as ancillary activities. St George's in East Jesmond formed a social club for young men in 1892, a junior rugby club in the same year, a swimming club in 1894, a cricket club in 1896 and an association football club in 1898.

Although tramways and, later, motor-buses and cars together with the bicycle made access from suburb to city centre easier, Jesmond, Benwell and Fenham developed their own mini-centres for entertainment and shopping. Byker had perhaps the most facilities in this respect with its own department store (a branch of Parishes), numerous public houses, a variety theatre (The Grand), and several cinemas opened both before and after the Great War.

The YMCA and its partner the Young Women's Christian Association were important in providing new opportunities for sociability and sport in a Christian environment for the young of the lower-middle and skilled working classes and the denominations and individual churches made enormous efforts in their provision

for younger members of their congregations. The churches effectively took over the Boy Scouts and Guides at a local level, while in the North East with its strong Presbyterian congregations the Boys' Brigade was a popular institution. All catered for the needs of youth, a new category, seen as, alternatively, a golden period in life or as a problem, but, much as they did in providing opportunities for adolescents and breaking down class barriers, they seem to have done little to ward off the decline in religious observance. This was reflected in the percentage of those attending churches but not in absolute numbers for, like the rest of Britain, Newcastle saw the peak of religious observance in the early twentieth century even as the percentage of the population who went to church or chapel declined. Sunday Schools for younger children remained popular, though, popular gossip had it, more because it provided an opportunity for parents in crowded housing to have sex on Sunday afternoons, than because their offspring were experiencing religious education. As Jack Common puts it in *Kiddar's Luck* (1951), 'In working-class circles, Sunday afternoon is traditionally sacred to the worship of Venus and a nice lie-down.'

Although national consumption of beer and spirits reached a peak in the 1870s and declined slightly thereafter up until the Great War, drink remained inseparable from much of social life and, indeed, working life in Edwardian Newcastle. Contemporary attention was directed to how much working men drank but there is little reason to believe that, although there are many examples of prominent citizens who were conspicuous abstainers, the elite of the town did not do its bit to keep the wine and spirit trade going. Looking back on business life on the Quayside from later in the century, Sir Arthur Munro Sutherland recalled:

> The morning coffee habit had not ousted the practice of morning sherry or port. Drinking in those days was part of the social and business round. Numberless cargoes of coal and scores of ships were bought and sold over a glass of wine in the public houses in and about the Quayside.

Working men's clubs had, as we have seen, found it necessary to abandon their early dedication to temperance, few temperance hotels were a success, and it seems likely that Newcastle's gentlemen's clubs would have soon folded if they had been so unwise as to cease serving wine and spirits.

The drink trade had, nevertheless, found itself hounded by temperance reformers throughout the late nineteenth century and the latter had won a number of victories, making it necessary to have a licence to sell any form of alcohol and gradually expelling children from public houses. Nevertheless, there was no shortage of pubs and in 1899 there was licensed premise for every 307 of the population. The early twentieth century saw some reduction in the number of licensed houses when a 1904 Act gave the magistrates powers to close houses they regarded as redundant. Brewers and publicans responded by insisting on the respectability of their houses and stricter licensing tended to favour the licensed houses of the breweries, who already in 1902 owned 39 per cent of Newcastle's public houses, rather than the independent publican. 'By the first decade of the twentieth century ... Newcastle's licensed trade had shed a deal of its vulgarity and achieved a measure of respectability'.[16]

If plenty of beer was drunk by the residents of Newcastle, it must be remembered that not all the beer sold there was drunk by residents. Newcastle was the leisure centre for a wide area and people came from all over Tyneside and from the pit villages of Northumberland and Durham to watch football, go to the theatres of variety or just to slake their thirsts in the myriad pubs of the town, as it continued to be called.

The pub remained at the centre of popular recreation but it faced greater competition. It had often been a sporting centre and the meeting place for clubs and friendly societies of various sorts but now there was not just the direct competition from working men's clubs, works' clubs and Conservative clubs, such as those in Byker and Heaton, but there were sports clubs and the YMCA. The pub had nurtured the music hall but now the theatres of variety were competitors and these in turn were nurturing what would eventually lead to their demise, the cinema, as they devoted parts of their programmes to showing short, flickering films.

As a historian of the cinema in Newcastle, Frank Manders, has documented, the first showing of motion pictures in the town was at the Palace Theatre of Varieties on 26 March 1896, though the films shown, *Cats Dancing* and *Acrobats Turning Somersaults*, originally made for peep-show machines, do not sound as if they threatened to put music hall stars out of business. Later in the year audiences at the Empire were treated to *Newcastle United Football Team at Play* and *Call*

Out of the Newcastle Fire Brigade. The Olympia in Northumberland Street was putting on extended bioscope shows in the mid-1900s before it was destroyed by fire in 1907. It took a decade or so to establish cinema, but:

> Between 1908 and the outbreak of the First World War thirty cinemas opened in Newcastle and a further six in areas later incorporated into the city. From a lowly position on a variety bill, moving pictures had advanced to the extent that buildings were now being devoted to them.[17]

Some were very basic, converted churches, a shop or any old empty building, but others like the Newcastle Picture House, the Queen's Hall or the Westgate offered opulence, marble halls, page boys and orchestras.

Cinema was not only to be the most powerful art form of the twentieth century: it was to revolutionise the social lives of millions, not just their real social lives – for going to the 'flicks' was to become a weekly or twice-a-week habit, a first step in courtship and a boisterous part of childhood at Saturday morning matinees – but their virtual social lives as dreams and aspirations were fleetingly fulfilled on screen. In early twentieth-century Newcastle, whether in some local shack with a mellifluous name and a noisy audience or at the Queen's, where one dressed up for the occasion, there were only intimations of its potency, but an important part of modernity had arrived. Contemporary pundits found a dark side to the cinema; viewing took place in the dark. As the Revd Stanley Parker pointed out in his piece on 'Newcastle morals' in 1910, 'impurity occurred under cover of darkness in places of amusement'.[18]

More virtuous and perhaps more Godly recreations took place in the light or at any rate in the open air, though it was not always clear whether sport, the countryside and the healthy, fit body brought the individual closer to God or were an alternative trinity. For the nearby radical gentry family the Trevelyans, walking and the countryside became almost a substitute religion and for hundreds of the young of Newcastle the discovery of the countryside of Northumberland on foot or by bicycle was liberation as well as exercise, and villages soon learned to provide cream teas for these visitors. The cult of the sun and the body-beautiful was just beginning, slightly thwarted by ugly, gravity-ridden, woollen bathing costumes or what the prurient still saw as the shocking déshabillé of the female cyclist, but

it would become a persistent urge of youth in the new century. For the majority it was experienced in the minor key of day trips to Tynemouth or Whitley Bay where one sat on the beach but kept on one's normal clothes, perhaps loosening a collar or the top button of a blouse or, daringly, rolled up one's trousers or hitched up a skirt and paddled.

An expansion in leisure time had characterised the later decades of the nineteenth century, but this and new ways of enjoying it had become established by the early years of the twentieth century. A little extra leisure time was the key as the Saturday afternoon off became the norm (Wednesday afternoon for shop assistants) and trades unions campaigned for the 8-hour day. A week's holiday with pay made possible a holiday at Redcar, more adventurously Blackpool, or perhaps quieter Seahouses for the clerks or public servants, but for most it was wise to leave half a crown on the mantelpiece in case the holiday left the family spent-up. The upper-middle classes went to Alnmouth or the Lake District. Only the seriously rich went abroad.

Football and Newcastle United had become the great passion of Tyneside and thousands came to watch the team in one of its most successful periods. In the years 1904–11 it won the First Division League Championship three times, reached the Cup Final five times and won it in 1910. Boxing too became popular, especially after Jack Palmer from Benwell became British heavyweight champion and, close to St James's Park, a boxing stadium, St James's Hall, was opened in 1909.

The popularity of spectator sports seemed ominous to many commentators, who thought a passive mass society was emerging. In fact, rather more people than ever before were actually playing sports whether in numerous football clubs, some attached to churches and others works' clubs, or in the dozen or so cricket clubs, such as those at Walker, Heaton, Newcastle Victoria, Gosforth Percy, Newcastle St Phillip's, Westgate, Jesmond, Rutherford College and the lofty South Northumberland, which played in the Northumberland League in 1900.

For the working classes the public world of leisure had largely been a male preserve and for most men work continued to permeate social life in that status at work, a man's trade and his place in the hierarchy of skills determined who were his drinking companions and friends and what pubs or clubs, even which rooms within them, he resorted to. The provision of social and sporting amenities

by some larger firms reinforced this. As housing improved for many, however, the home, women's sphere, became a more attractive place for a man to spend his evening in, while family excursions to Newcastle's public parks and husband and wife outings to theatres of variety became more common.

The cultural opposition to married women going out to work remained strong but employment opportunities for single women were improving. A few local industries had previously provided jobs for women: rope-making (which was not considered respectable), work in potteries (which was), and the unhealthy jobs in the white lead works, while sweet factories (College Sweets) and tinned-food manufacturing (Angus Watson), which employed large numbers of women, had emerged by the turn of the century. But for single working-class females, domestic service remained the main form of employment.

Women from the more prosperous social strata were in this period experiencing greater freedom and choice in their social lives. Married women were having fewer children, there were tea rooms (that in Fenwick's was particularly popular) and cafés where they could meet friends, while sports clubs and charitable organisations increasingly had social events attached to them. The Edwardian period saw a 'revolt of the daughters' of the wealthier classes, a revolt seen most obviously in the involvement of a minority in the campaign for votes for women (see pp. 264-5), but for many more there was a desire for self-assertion within the home, in cultural tastes, and for greater freedom in their leisure pursuits For unmarried women the tennis courts of Jesmond and Fenham and the bicycle provided pathways to sociability and courtship as well as exercise. Sport, bicycling and sea bathing led cautiously to a new freedom in dress; Fenwick's advertised its 'famous walking skirt', which exposed the ankles but, to avoid risqué implications, it was advertised as the 'Anti-Microbe Skirt'.[19] A rather basic limitation on the range of the respectable woman had been the lack of provision of women's lavatories and one of the benefits of the new inner city world of stores and cafés was that they provided such conveniences.

Consumerism and consumption came together in developing new types of employment for women. Stores like Fenwick's, Bainbridge and Binns were designed to cater for most strata of society but, at the same time, they wanted assistants who were smartly turned out, knowledgeable about the goods they sold, and well spoken. Such assistants were found from among the daughters

of the skilled working class, junior white-collar workers and even professionals. The work appealed to young women who saw themselves as modern, fashionable and self-possessed. Lancaster has argued that the stores also 'opened the door of middle and high management to women, thereby creating perhaps the first career structure with genuine prospects of promotion for women in the modern period'.[20]

Like retailing in which women far outnumbered male employees, elementary school teaching became increasingly a female profession and nursing was overtly so. In the long run the typewriter was to make the female secretary the norm but in Newcastle this seems to have been a slow process before 1914. Wigham Richardson employed a few women office workers from as early as 1886[21] but in general heavy industry was reluctant to do so. Nevertheless, as some city offices began to employ women, fee-paying secretarial and commercial colleges attracted women students and, as the demand for stenographers and typists grew, provided avenues to respectable employment. Telephonists were a female occupation from the beginning.

Two literary depictions of Newcastle in the early twentieth century give portraits of social life in Jesmond and Heaton, adjacent suburbs divided by Heaton Park and Jesmond Dene. Jesmond, as we have seen, was no longer as exclusive as it had been for Tyneside flats had spread along its northern and western fringes, but it still possessed large houses with spacious grounds and many fine terraces. Heaton was a suburb with streets, many of semi-detached houses inhabited by clerks and junior managers to the north, and terraces lived in by skilled artisans to the south.

It has for long been almost obligatory for the middle-class suburb to be seen as conformist by the creative writer and the depiction in *The Islanders* of what is generally accepted to be Jesmond by the Russian engineer and author Yevgeni Zamyatin, who spent two years there while supervising the making of two ice-breaking craft at Armstrong Whitworth, is no exception:

By Sunday, the stone doorsteps of the Jesmond Houses had been scrubbed to a blinding whiteness. The houses were of a certain age and smoke-begrimed, but the steps were gleaming rows of white, like the Sunday gentlemen's false teeth. The Sunday gentlemen were produced at one of the Jesmond factories and on Sunday mornings thousands

of them appeared on the streets with the Sunday edition of the St Enoch's Parish newspaper. Sporting identical canes, and identical top-hats, the Sunday gentlemen strolled in dignified fashion along the street and greeted their doubles.[22]

Zamyatin's picture of Jesmond does little justice to the variety of lifestyles concealed beneath the exterior he describes so vividly, but Jack Common's description of Heaton in the years before the First World War reveals a complex world in which middle-class and skilled working-class respectability were subtly different, if equally conformist, even as both disguised myriad distinctions. Just as Jesmond doorsteps were scrubbed, so the fight against dirt was a major feature of life in Common's Heaton and valour in the fight only equalled by a clean rent book as a signifier of respectability:

> Everybody's washing hung across the lane, so that the appearance of a tradesman's cart meant a rush to tuck sheets and things round the rope and to raise the diminished bunting high over the horses head with a prop. The coal man was the main menace, since a mere brush against his tarry sacks meant a second washing day.[23]

From the child's point of view the main difference between the workers' streets and the 'relatively posh area north of the Avenues' was that in the former children spent most of their time out of doors and made their own society and in the latter parents were ubiquitous. As Common's Bill Kiddar puts it, describing the home of a school friend whose father was a policeman, 'there was a sort of ambience of parenthood in his neighbourhood. You could not strike away from it out into the open street, or be driven out of its way'.

Differences between the skilled working class and the lower-middle class were cultural rather than economic. The clerk might be paid a salary as opposed to a wage but an engine driver, like Bill Kiddar's father, probably earned more than many white-collar workers and he clearly considers it a step down in the world when his son becomes a solicitor's clerk.

The real economic and social gulf was between the respectable working class living in the Tyneside flats of the new suburbs and the often casually employed workers on the Quayside who lived in overcrowded and often in squalid conditions. Model industrial dwellings made only a minor difference, while,

when areas were developed, as with the railway yards which replaced much of the housing in the Manors area, new housing was rarely provided, resulting in even greater overcrowding in adjacent areas. As they had been throughout the nineteenth century, areas of central Newcastle would be noted for their slums well into the twentieth century. It may well have been that the higher wages commanded by skilled workers contributed to the problem as private builders catered to their needs with new housing and had little incentive to build cheaper accommodation for waterfront workers earning a third of a skilled wage.[24]

POLITICS

Newcastle began the twentieth century with two Conservative (or Unionist) MPs, Sir W.R. Plummer and G. Renwick. In the circumstances of the 'Khaki' election they enjoyed a good majority but Newcastle Liberalism enjoyed solid support and the town was in normal times a fairly marginal seat. Disillusionment with the government's handling of the latter stages of the South African War and the peace settlement combined with that 'last hurrah' for politicised Nonconformity, opposition to the 1902 Education Act, should probably have ensured that in that high tide of Liberalism, the 1906 general election, two Liberals would once again have been returned for Newcastle.

A new factor had appeared on the national political scene with the formation of the Labour Representation Committee, which held its annual conference in Newcastle in 1903, but there seemed little reason to believe that one of its candidates would be successful in a constituency where Liberalism was well organised. The Liberal Party in the North East was, however, divided in its approach to the LRC. Few could have predicted the forthcoming rout of the Unionist government and a majority of the Newcastle Liberal Executive took the view, expressed nationally by the secret electoral pact agreed between Herbert Gladstone and Ramsay Macdonald, that a Liberal victory would be consolidated by running only one Liberal and allowing a LRC candidate to run in tacit harness with him.

Walter Runciman, Chairman of the Northern Liberal Federation, was entirely opposed to this policy and tried his best to persuade the ex-Liberal Member John

Morley, to give up his safe seat at Montrose Burghs and return to Newcastle. That recent recruit to the Liberal Party, Winston Spencer Churchill, also tried to persuade Morley to do so. Morley, who seems to have made something of a habit of nearly contesting seats, vacillated but eventually decided to stick to Montrose Burghs and Newcastle Liberals adopted only one candidate, the previous Liberal MP and rather colourless ship owner T. Cairns, and left the way open for an LRC candidate, Walter Hudson, a senior official of the Amalgamated Society of Railway Servants and a prominent member of the Independent Labour Party. Cairns and Hudson were elected in 1906.

Cairns died in 1908 and the Newcastle LRC, rather overestimating its strength and unmindful of the Liberal–Labour alliance, favoured opposing the Liberal candidate, E. Shortt, but the national leadership of the Labour Party insisted that there should be no Labour candidate. Local socialists insisted, however, on fielding a candidate in the by-election and E. R. Hartley stood backed by the Newcastle Socialist Institute, the Social Democratic Federation and many ILP members. Hartley's 2,971 votes gives us a measure of the strength of hardcore socialism in Newcastle, which appeared much the same as when Hammil had stood thirteen years earlier. Shortt was defeated by 2,143 votes by the Unionist G. Renwick. Hartley's candidature may not have been the only factor in the Unionist victory for the government had banned a Catholic religious procession in London and this may have alienated some of the Irish vote.

In the two general elections of 1910 Newcastle saw, as in 1906, the return of Liberal and Labour candidates in tacit alliance, though with majorities reduced as compared to 1906, and in doing so followed the trend in northern cities. There was not to be another parliamentary election until 1918. The Liberal–Labour alliance makes it difficult to assess the strength of the Labour Party in Newcastle before the Great War but it is clear that it was a marginal constituency in which the Liberals held the edge. Unionism or Conservatism was stronger than in most northern towns, though not as strong as in Sunderland, which may point not only to its relatively large middle class, but also to the tendency of the rank and file of shipyard and armament workers to vote Conservative.

The subsequent success of the Labour Party in Newcastle, a party born essentially of the trades union movement and ILP socialism and the eventual inheritor of much of the ethos of the Nonconformist and radical strands

of liberalism, can lead to the underestimation of the importance in the late nineteenth and early twentieth centuries of other, more visionary forms of socialism. The Social Democratic Federation and the many Clarion organisations, which emerged under the influence of Robert Blatchford and his *Clarion* newspaper, offered a more utopian form of socialism but were in some ways more in touch with both popular and high culture and thus were more attractive to the beer-drinking and betting working man and to some dissentient or bohemian members of the middle classes than was the emergent Labour Party. As we have seen, early socialists in Newcastle were prepared to ally for expediency with the Conservatives rather than the Liberals and they could be as patriotic or nationalist as the Conservatives. In some ways their cultural legacy is more important than their modest political achievements: the People's Theatre emerged under the cloak of the Newcastle Socialist Institute and the Clarion Dramatic Society, though theatre, rather than socialism, gradually became its purpose, and the Clarion Cycling Club and Clarion Field Club were in tune with the growing interest in the countryside.

Like most major cities, Newcastle saw its share of suffragist and suffragette activity. With a male electorate the demand for the enfranchisement of women was not a vote-winner, especially in constituencies with a large proportion of working-class voters, as George Lansbury found out when he stood as a socialist candidate for Middlesbrough in 1906 and made his support for the cause clear.[25] Although there were working-class women in the movement, most prominent members of both the suffragists and suffragettes came from the upper and middle classes and, as a city with a large middle class, Newcastle had a group of dedicated supporters. The founder of the Newcastle and District Women's Suffrage Society was Mona Taylor, a member of a wealthy gentry family and one of the first female county councillors in Northumberland, but the group included women in the professions, Ethel Williams and Ethel Bentham, who were both doctors, and Florence Bell, a schoolteacher; Lisbeth Simm was also a schoolteacher and the wife of an ILP organiser but had a working-class background. Group meetings were held in the Drawing Room Café in Fenwicks. The National Union of Women's Suffrage Societies (the suffragists) was much stronger in Newcastle than the direct action Women's Social and Political Union (suffragettes) but, as Martin Pugh has pointed out, the two organisations often co-operated. There

was no social divide between the two and the WSPU included Lady Parsons and Lady Blake among its activists, which did not restrain members from the violent and incendiary activities which turned many against the case for women's suffrage. In the end, the female franchise was to be won, neither at the ballot box nor by violence, but by the winning over of educated opinion. The 1909 by-election in Newcastle saw the Women's Labour League declaring that none of the candidates were worthy of support and, when Mrs Pankhurst attempted to hold a meeting, 'the crowds were so hostile that she was unable to get a hearing and had to resort to a police escort to protect her' and there was 'marked antagonism from working men'.[26] Ethel Bentham, later a Labour MP, was defeated when she stood in a municipal election in Newcastle. Popular opinion in Edwardian Newcastle had still to be won over to the cause of female suffrage.

The issue of Home Rule for Ireland made a considerable impact on Tyneside, where there was not only a large Irish Catholic population but a sizeable Irish Protestant population as well. Lord Londonderry and Lord Ridley were strong supporters of Sir Edward Carson and Andrew Bonar Law in their opposition to Home Rule and there were mass demonstrations against the bill, including a huge rally under arc lights at Wallsend and much signing of the Covenant by Orangemen.[27]

All of the elements of the supposed 'Strange Death of Liberal England'[28] were present on Tyneside for, in addition to the suffragette agitation and the demonstrations against Home Rule, an increasingly unionised workforce reflected the national industrial unrest of the immediate pre-war years with strikes by seamen, dockers, miners, and railwaymen. The degree to which they disturbed the equilibrium of Newcastle politics or indeed of society can, however, be exaggerated. The suffragettes caused consternation, Home Rule aroused strong feelings and strikes caused inconvenience and dislocation, but Newcastle on the eve of the First World War remained a confident and prosperous city.

THE GREAT WAR

Among the many war memorials in Newcastle is that to the Northumberland Fusiliers in the grounds of St Thomas's church. Its theme is 'The Response' and it

depicts marching soldiers with their families alongside.[29] The response from the North East was indeed generously patriotic and thousands volunteered in the first stages of the war and when the Derby scheme was instituted. Some 5,000 of the staff of the North Eastern Railway Company volunteered. In the course of the war the Royal Northumberland Fusiliers provided thirty-eight battalions and the Durham Light Infantry thirty. Many enlisted in Pals' Battalions from the same industry or company, one example of this being the Newcastle Commercials, raised from the Quayside as an RNF battalion. A lingering sense of dual loyalties resulted in there being four battalions of Tyneside Scottish and four of Tyneside Irish within the RNF. Many joined regiments with no connection with Tyneside or the North East because of family connections or demand for their particular skills. As a seafaring area the contribution of Tyneside to the war at sea, whether by service in the Royal Navy or the merchant navy, was considerable.

The case has been made for war and in particular the First World War as, despite the horrendous loss of life, a positive force for economic, political and social change.[30] So far as Newcastle and Tyneside were concerned it is difficult to distinguish such silver lining. It is true that the region prospered as the war effort resulted in orders for ships and armaments and coal remained essential to the economy, but Tyneside industry became dangerously dependent on government orders. Shipbuilders and heavy engineering firms increased their production and the numbers they employed, though the latter involved the 'dilution' of the skilled workforce by unskilled or semi-skilled workers and the almost unimaginable employment of women in hitherto masculine preserves. The shipyards employed women for the first time in 1916 and, by 1918, 150 women or 7 per cent of the workforce at St Peter's Engine Works, a branch of Hawthorne Leslie, were women and the Low Walker yard of Swan Hunter & Wigham Richardson had a shell shop employing hundreds of women.

Armstrong Whitworth, Newcastle's biggest firm and employer, exemplified the fortunes of Tyneside during the war. Much of Lord Armstrong's success had been due to his resisting the lure of dependency upon British government orders. He had learned after the Crimean War not to be too dependent on the whims of governments, only too keen to economise on the nation's armed forces and wont to favour their own ordinance works, and his efficient sales force had taken orders from a wide variety of foreign governments. During the war Armstrong

Whitworth became one of a number of reliable armaments firms specially favoured by government orders. This was to prove a poisoned chalice although in the short term it led to expansion and secure profits. The firm continued to build ships for neutral or Allied nations but, as the Chilean government found out when their warship *Almirante Latorre* was commandeered to become HMS *Canada*, delivery could not be guaranteed, while a promising market in ice-breakers for Russia came to an end with the 1917 Revolution.

Despite losing a thousand workers who volunteered to join the forces on the outbreak of war before workers in armaments industries were prohibited from enlisting without their employers' consent, the numbers employed by the firm on Tyneside rose from over 20,000 in 1913 to 78,000 of which 21,000 were women. The firm's production of artillery was crucial to a war in which the number of guns became a determining factor. By 1918 the company had produced 13,000 guns, 12,000 gun carriages, 47 warships, 230 armed merchant ships, 14.5 million shells, 18.5 million fuses and 21 million cartridge cases. Nor was the new machinery of war neglected for Armstrong Whitworth produced 100 Mark IV tanks, 1,075 aeroplanes and 3 airships.[31]

A major stumbling block to war production was the question of the dilution of labour. The employment of women was not uncontentious but trades unions extracted promises that it was a temporary measure. It was realised, however, that erosion of the demarcation lines between skilled and less-skilled work might be more difficult to phase out when peace came. The issue made for divisions between trades union leaders, susceptible to the appeals of Labour Party ministers drawn into the coalition government and pleased to be offered a wartime partnership by government, and employers and shop stewards, hypersensitive to any erosion of differentials. On the whole, as James Hinton has argued, Tyneside seems to have avoided the bitter disputes that arose on other rivers, notoriously on the Clyde.[32]

November 1918 found Tyneside shipyards and armaments firms working flat out. Peace was likely to bring a great reduction in the demand for warships and guns but Armstrong Whitworth's financial position was strong and there seemed little reason why it should not be able to diversify its production. So many merchant ships had been sunk during the war that a post-war demand for new ships could be expected. Europe would need coal shipments and international trade would resume. Among the extended mourning of the dead and the celebration of their

sacrifice, the future for the Tyne's traditional industries and trade seemed bright enough. Things seemed to be getting back to normal and in 1919 the local Derby between Newcastle United and Sunderland attracted a crowd of 18,000. The gate was given to the Comrades of the Great War and Newcastle won 4–0.

The Inter-War Years

At this point, for the author, as for many of his generation, books and documents become supplemented by memories at second hand and by family history which reflects aspects of life in the Newcastle of the period. My maternal grandfather and grandmother had made their way from Edinburgh to Newcastle in the early twentieth century where they settled in Fenham. He became employed as a clerk by Armstrong Whitworth's motor division. Joining a Scottish Border regiment in the Great War, he was taken prisoner of war during the Battle of Passchendaele and spent the rest of the war in a POW camp. My mother remembered being taken home from school in Wingrove on the news that he was missing and that his pay stopped coming until it was known that he was a prisoner. His only trip abroad ended with him coming down the Rhine on a river boat, the memory of which he treasured. When the car production side of Armstrong's was transferred to Coventry, he had the chance to go with it, but grandmother decided that Newcastle was 'far enough away from Edinburgh' and he became a 'School Board man' for Newcastle Education Department.

My paternal grandfather, brought up in rural Northumberland, became a policeman in Newcastle and also settled in Fenham. As an inspector in the 1930s he patrolled the town centre and, among other duties, looked into the cinemas to ensure that all was orderly; he thus acquired an encyclopaedic, if fragmentary, knowledge of the films of the era, each one of which he had seen for about ten minutes.

My father, educated at Rutherford Grammar, acquired a job as junior reporter on the Evening World. *When the paper closed, after a period of expensive rivalry with the* Evening Chronicle, *staff were paid off in white five-pound notes and went out for a night on the town during which one of their number, Ted Castle (later the husband of Barbara), whose reporting had offended the police, was locked up for the night on flimsy grounds. This was the end of Dad's career as a journalist and, looking for a more secure position, he joined Tynemouth Police Force. My mother*

and her sister were two of those inter-war young women who, modestly upwardly-mobile, moved into the lower rungs of the professions, as respectively a librarian and schoolteacher, enjoying something of the new freedoms available, shopping at Fenwick's and Bainbridge's, holidays at Warkworth, and going to the cinema and to dances. On marrying my father, mother had, as was compulsory, to give up her job at the Central Library.

Economy

Economic historians have now revised the depiction of Britain during the 1920s and 1930s as years of depression, poverty and gloom and seen instead a period of economic growth and rising living standards. This revisionism is a very necessary correction to an image of inter-war Britain which owed as much to wartime and post-war efforts to discredit the governments of the period as to a serious consideration of the facts. It must not, however, let us ignore the very grim experience that the 1920s and 1930s were for a great many people on Tyneside. Those who suffered the most were those who had known good times, the skilled workers in shipyards, proud men with confidence in their skills, who were used to high wages and whose self-respect and manhood was diminished by long-term unemployment. The experience of different areas of the country was very varied and, as the centre of gravity of the economy moved towards the Midlands and the South, those areas which had been the heartlands of the old industrial economy suffered high unemployment and social dislocation. Tyneside was one such area but even its experience demonstrated considerable variations and we are confronted with a complex picture in which poverty and prosperity, dole queues and semi-detached houses, and road houses and demonstrations by the unemployed, existed side by side.

The pre-1914 British economy had been highly dependent on three factors: London's position as the centre of world trade and finance; the domination of world shipping by Britain; and the nation's capacity to export coal and manufactured goods. The burden of financing the war together with the disruption of exports severely undermined the position of the City of London and the strength of sterling, while the major result of the war was the ending of

269

the world's free trade economy in which Britain had thrived. The North East economy was to a great degree export-orientated and even before the end of the war, the reduced ability of wartime Britain to supply exports had caused several countries to develop their own industries to make up for the ships and engineering products which had previously come from the North East. It suffered greatly as the pre-war free-trade world failed to return with peace. Even without the Great War, it seems probable that the major industries of Tyneside would have had to adapt and shrink as the pre-war global economy was not necessarily immutable but the effects of the war were to enforce a sudden change compressed into a few years rather than decades.

The 'too many eggs in one basket' thesis is largely born of hindsight and is probably unrealistic. Perfectly balanced national economies are rare, while such regional or local economies are rarer still. Entrepreneurs and investors before 1914 made their decisions in the light of their expectations of the immediate future and order books on the eve of war were healthy enough. Two factors did, however, make Tyneside and its coal-producing hinterland vulnerable. For an advanced industrial economy, the area was dangerously dependent on the export of a raw material, coal, and on massive and expensive products. As we have seen, there had been some diversification into new consumer-orientated manufacturing before the war, but the demands of the wartime economy had not encouraged their growth. It was ironic that one innovative area of heavy manufacturing in which Tyneside was a leader, the construction of electric power stations, was to prove in some ways a negative factor. A. Reyrolle & Co. at Hebburn and C.A. Parsons at Heaton thrived and created new employment, but the construction of the National Grid in the 1920s enabled manufacturers to move closer to the markets for consumer durables which tended to be in the Midlands and the South.

All seemed well enough in the immediate post-war years. Tyneside's shipyards enjoyed a brief period of prosperity, which encouraged a new firm, the Newcastle Shipbuilding Company (its yard was actually at Hebburn), to set up 1919. It only lasted until 1921 by which time orders for ships which had slackened in 1920 had almost dried up. Shipbuilding was to be depressed with a brief recovery in 1927–8 until the eve of the Second World War and unemployment among shipyard workers exceeded 40 per cent for much of the period. Government orders for warships dwindled almost a soon as the war was over due to the belief

that another major war was unlikely and to the Washington Naval Treaty which limited the size of the British fleet.

The 'Ten Year Rule' which ordained that a war should not be expected within ten years meant a fall in orders not only for warships but for all armaments, which hit Armstrong Whitworth hard. Marine engineering inevitably declined with the slump in shipbuilding and from 1929 there was a decline in engineering generally with output and employment falling nationally and Tyneside experiencing falls far worse than the national average.

Coal mining and the coal trade did not experience such an abrupt decline. There was some slackening in home demand and in export orders in the early 1920s but the French occupation of the Ruhr coalfield in 1923 saw a boom in coal exports with the Tyne shipping 21.5 million tons, of which 18 million were exported. It was only after the long strike of 1926 that the numbers of unemployed miners increased markedly but wages had already fallen by almost 50 per cent between 1921 and 1925. The growing production of coal mines in Germany and Poland affected the export market which went into a sharper decline with the curtailing of foreign orders after 1929, while, at the same time, the local market for coal diminished consequent on the lack of demand from heavy engineering and iron and steel making. Only the traditional coastal coal trade and the London market escaped. Older pits found it almost impossible to make profits and the few remaining mines within Newcastle closed as the decline in the demand for coal accelerated between the mid-1920s and mid-1930s.

The problems of the coal industry were serious. With the loss of markets, any solution, even one involving nationalisation, which the Miner's Federation had pressed for in 1919, would have had to involve the closure of mines and probably reductions in wages. In 1925 the miners secured the promise of support from the TUC and all had seemed set for a strike in July of that year. The setting up of the Samuel Commission by the government secured a respite but when it reported in March 1926 its proposal of cuts in wages followed by reorganisation of the industry satisfied neither workers nor owners. The General Strike began on 3 May, three days after the miners had come out. The strike was, as the unions claimed, an industrial dispute and not a challenge to the constitution but in Newcastle, as elsewhere, it certainly polarised society with the unions displaying solidarity while thousands of volunteers and special constables enrolled to

maintain essential services and law and order. As throughout much of Britain, restraint largely characterised the conduct of both sides in Newcastle but the account of police and strikers playing football has to be set against the police making baton charges against a large crowd. The General Strike ended on 12 May, though the miners stayed out for another seven months, which gave rise to some bitterness between the miners and other workers but Newcastle was not a mining town.

Newcastle's major manufacturer, Armstrong Whitworth, cannot be accused of failing to attempt to diversify its products. It hoped to build upon its experience in motor and aircraft manufacturing and bought up the designer John Siddley's company, forming a new holding company, Armstrong Whitworth Development Company Ltd. with Armstrong Siddley Motors Ltd. as a subsidiary in 1919. Whether because John Siddley and the Armstrong Whitworth board were incompatible partners or whether Newcastle was too far from the main markets for cars and aircraft, the new company was not a success and in 1926 the joint enterprise was sold to Siddley for £1.5 million and continued its career in Coventry. This was a tragedy for Newcastle, depriving the town of a share in one of the burgeoning consumer industries of the period. It might never have happened had Armstrong Whitworth not been seriously weakened financially by another venture, the bold plan to use its expertise to found a new industrial area in Newfoundland: forests were to be exploited and paper mills set up, a hydro-electric system was to be erected and a new port built. This inspired but risky venture proved to be beyond the firm's financial resources and its managerial ability and by the middle of 1925 Armstrong Whitworth owed the Bank of England £2.6 million and in 1927 was forced to merge with Vickers, who became the superior partner.[33]

One far-sighted proposal came from the ex-MP and shipowner Sir George Renwick. In 1926, he submitted to Newcastle & Gateshead Chamber of Commerce a scheme for the development of the Team Valley. His proposal would, he estimated, have cost £2.5 million and unsurprisingly in the depressed climate it was pigeonholed.[34] Team Valley was in the late 1930s to become the site of the Team Valley Trading Estate.

That Tyneside and the North East as a whole suffered unemployment far in excess of the national average during the inter-war periods is well known. At

the peak of unemployment in 1932 22 per cent of the British insured labour force was unemployed but the figure for the North East was 37.4 per cent. Even in the most depressed Tyneside towns, however, the picture was mixed. D.J. Rowe suggests that, thanks to Reyrolle, 'at Hebburn, next door to Ellen Wilkinson's depressed Jarrow, the existence of typical estates of owner-occupied, semi-detached houses, built in the mid-1930s points to the prosperity which came to some even on depressed Tyneside'.[35] The number of new houses built in the most prosperous parts of Tynemouth and Whitley Bay also attest to the patchy nature of depression even in an area with such high overall levels of unemployment. Most workers remained employed and jobs in public service remained secure and expanded during the inter-war period while, even where unemployment was high, there was a market for the new consumer goods and for an increasing number of cinemas. For anyone employed, the deflation of the 1930s meant a rising standard of living. Tyneside may not have seen as much of J.B. Priestley's new Americanised England 'of arterial and by-pass roads, of filling stations and factories that look like exhibition buildings, of giant cinemas and dance halls and cafes, bungalows with tiny garages, cocktail bars, Woolworth's, motor coaches, wireless, hiking, factory girls looking like actresses, greyhound racing and dirt tracks, swimming pools, and everything given away for cigarette cards', as the South and the Midlands, but it had more than a bit of it. Newcastle, along with Tynemouth, Whitley Bay, Cleadon, Gosforth and Ponteland, had the lion's share on Tyneside.

Newcastle was, of course, badly affected by the decline of the shipbuilding and arms-manufacturing firms within its boundaries, though Parsons was the bright spot among its heavy engineering businesses; in 1926 Charles Parsons came up with his third invention, the first high-pressure, turbine-driven steam ship. Given that Newcastle was the capital of Tyneside, the impact of depression in the other riverside towns and in the coalfield was bound to be reflected in the profits of its shops, pubs and cafés and in less work for its offices. The slowdown in trade was to affect the Quayside as, in the early 1920s, the shipping offices found thin business, shipping lines went bankrupt, the 'Change' was half-empty and gloomy, and ship values slumped from about £24 a ton to £4.[36]

Like every area of Tyneside, Newcastle experienced rising unemployment, the east and west ends of the town being particularly badly affected, but it was to

some extent protected by its position as the shopping and entertainment centre of the area and by the numbers employed by central and local government. Newcastle properties had a high rateable value and the Council's income from the rates held up fairly well, enabling it to continue and even expand the number of local government employees and, assisted by central government, to implement new housing estates and other municipal improvement schemes. The expansion of light industry, both within and just outside the city's boundaries, was also significant. Hedley & Sons, the soap manufacturers, faced a severe financial crisis in the 1920s but, after becoming part of the Cincinnati-based Procter & Gamble group in 1930, found new markets with products like Oxydol and Sylvan Flakes,[37] while College Sweets continued to prosper with their packages of sweets despatched to buyers with 'Messages of Goodness from Tyneside'.[38] Although sales of drink in public houses declined, the number of clubs rose. Brewers like Newcastle Breweries and Deuchar's continued to be profitable but the expansion of the clubs resulted in the founding of the Northern Clubs Federation Brewery, which sold cheaper beer.

Not all industries were in the doldrums during the depression. As Natasha Vall has written, 'Many of Newcastle's *less familiar* manufacturing companies ... in what could loosely be defined as the 'lighter manufacturing' sector, flourished during the 1930s to provide new employment opportunities for women'. The greater number of women in the workforce was one of the major features of the inter-war years and is one which in the North East has, until recently, been obscured by an emphasis by contemporaries and historians upon heavy industry and male employment. The wartime involvement of women in work in shipyards and armaments works and in public transport did, indeed, come to an end with peace and demobilisation, but was followed by a considerable expansion of female employment in light industry, offices, public service and shops. In the manufacture of food, drink and cigarettes, the number of female employees expanded by over 100 per cent in the 1920s with over 2,000 employed in this production in 1931, while 700 were making sugar products.[39] The number of women employed in nursing, teaching and local government was also increasing rapidly. This was not just an important economic development for it was to have a significant social effect.

POLITICS

The Representation of the People Act of 1918 not only enlarged the electorate by abolishing the property qualification for voting and enfranchising women aged thirty or over, but it redistributed seats. Newcastle, hitherto a two-member constituency, was divided into four single-member seats, West, Central, East and North. The future pattern of the representation of the city was not discernable from the outcome of the 'Coupon' election of 1918 for all those returned as MPs for Newcastle were holders of the famous coupon[40] and it was not until 1922 that the political complexion of the new constituencies could be seen. In that year three of the seats, East, West and Central, were gained by Labour candidates among whom, elected for Central, was the erstwhile Liberal Charles Trevelyan, heir to a baronetcy and to Wallington Hall, while Newcastle North returned a Conservative. That the Liberal Party in Newcastle could not be written off was shown at the next general election in 1923 when Liberal candidates won East and West Newcastle with the senior Labour figure Arthur Henderson losing the East Newcastle seat he had won at a by-election earlier in the year to Sir R.W. Aske, Bt, and the glamorous C.B. Ramage, barrister and actor, beating the incumbent, D. Adams, in Newcastle West. As the 1924 and 1929 elections confirmed, Newcastle North was the safest Conservative seat in the North, but all the other three constituencies were marginals. Trevelyan held Central for four elections, though his majorities were sometimes narrow, but in Newcastle East (Labour in 1924 and National Liberal in 1929) Labour and the Liberals were neck and neck and Labour only won when there was a Conservative candidate who would take more votes away from the Liberal than from Labour, while in Newcastle West (Labour in both 1924 and 1929) a Labour victory again depended upon a three-cornered contest. Except for Newcastle North all the constituencies were socially mixed although they could be described as preponderantly working-class but Newcastle's industrial workers, though highly unionised, were far from being reliable Labour voters. Armaments workers by no means sympathised with Labour policies on foreign affairs and disarmament and many shipyard workers, as was demonstrated in other Tyneside towns and in Sunderland, voted Liberal or Conservative, which, together with the middle-class vote, made electoral outcomes in Newcastle far from predictable.

The 1931 general election, held after the fall of the second Labour Government and its succession by a National Government headed by Labour's erstwhile leader Ramsay McDonald, decisively changed the political map of Newcastle for the next fourteen years with Conservative candidates winning three seats and the National Liberal Sir R.W. Aske, retaining the fourth, Newcastle East, and the 1935 election saw a similar result. The depths of the Depression saw Newcastle swing sharply to the right.

In municipal politics Labour made considerable gains in the 1920s, achieving seventeen councillors in 1923, but opposition was formidable as unlike national politics, where Conservatives and Liberals divided the anti-Labour vote, the main political group on Newcastle City Council was the Progressives, essentially a Conservative–Liberal alliance, which, although it was by no means parsimonious in expenditure, proffered lower local government rates than Labour.

THE CHANGING TOWNSCAPE

There were several Newcastles during the inter-war years. There was unemployed Newcastle in which many skilled men, hitherto members of a labour aristocracy, found themselves, as in other parts of Tyneside, robbed of their inheritance and forced to kick their heels or loiter in the reading rooms of public libraries, where the racing pages of the papers were carefully blacked out, as they awaited the time when the 'normal economy' would return. Things were very different in Jesmond or in Fenham, a fast-expanding suburb where, as J.R. Blackett Ord sold off his extensive estate in the 1930s, new rows of mainly semi-detached houses were being built; here employment held up far better and J.B. Priestley's 'New England' was emerging. There was a further Newcastle where the poor, who had always, or as long as anyone could remember, been with us, still lived in the atrocious conditions for which the town was notorious, and contributed disproportionately to its high rate of tuberculosis which was 40 per cent above the national average. An investigation in 1933 into child health and nutrition in Newcastle showed that about 36 per cent of working-class children were physically unfit and malnourished and that 33 per cent of families surveyed could not afford fresh milk.

Newcastle had, as we have seen, relied upon private builders to solve the town's housing problems and they had indeed done reasonably well by skilled workers, who could afford, in good times, the rather high rents that were the norm in the city which had the fourth highest rents of all the largest towns in England.[41] Little had been done, however, to provide better housing for the unskilled and casual workers and their families and in 1921 more than 10 per cent of families were living in one room. The Council had shown little inclination to build houses and of the £4 million borrowed from central government by local authorities between 1891 and 1904 under the 1890 Housing of the Working Classes Act, Newcastle borrowed only £5,761. By contrast the 1919 Housing and Town Planning Act was exploited to the full. The Council already owned land at Walker and a housing scheme there was begun in 1919 and land was purchased in Fenham, North Elswick and Pendower. During the 1920s, 4,500 houses and 750 flats were built by the Council and during the inter-war years as a whole the Council built over 12,000 flats and houses. This new council housing, designed under the aegis of R.G. Roberts, City Housing Architect, was, like most of its kind throughout England, of far better quality than those built later in the century and estates consisted of low-density and low-rise housing influenced by the garden suburb ideal and usually had open spaces, grass verges and trees.

The great majority of houses built for rent after 1919 were council houses for at the same time as the local authority's building programme got underway, the private rented sector was in decline. The 1915 Rent Act had been introduced as a temporary wartime measure but post-war governments found it impossible to repeal it and the difficulty in raising rents diminished for the private landlord the attractions of investing in new houses. Far from this meaning that the majority of new houses were built by the local authority, the inter-war period saw an explosion of private house building but these were not built to be rented out but were for occupation by home owners.

Before the First World War, owning one's own house had not been seen as a particularly sensible investment. The concept appealed to some of the lower-middle classes as providing security and a degree of status but many well-to-do Victorians and Edwardians saw little point in it as house prices were stable. After the war, there was a sea-change in attitudes as the cost of building and therefore of buying houses fell, the semi-detached house in a new suburb became an

assertion of status and promised a new lifestyle, and the building societies began to advance 80 per cent or more of loans at a time when interest rates fell. Builders like William Leech began to aggressively market their new estates on the fringes of Newcastle and societies like the Northern Counties and the Rock enabled people on quite modest incomes to buy them.[42] By 1939 new private housing was covering over the fields within the city boundaries set in 1904. The advantages of a 'home-owning democracy' began to occur to the Conservative Party.

The most spectacular change to the townscape came with the building of the Tyne Bridge, opened by King George V in 1928. It is a comment on the city's diverse inter-war history that two reasons were given for its erection: the provision of work for the unemployed and the need for a new bridge because of the congestion caused by motor traffic. A joint venture between Newcastle and Gateshead councils which gained support from central government, it took three years to build. The contractors, Dorman, Long & Co. of Middlesbrough, had already begun work upon Sydney Harbour Bridge and the Tyne Bridge is a reduced version of it. The spectacular visual impact of the supporting arch is reinforced by the great towers at each end though these are largely decorative. The image of ancient Egypt was very popular in the years after the opening of Tutankhamun's tomb in 1922 with architects and designers and the towers or pylons draw upon Egyptian temple entrances for their inspiration.

The impact of the bridge upon the town, its traffic and its businesses was considerable. Upper Pilgrim Street now became the main entrance to Newcastle and through traffic continued up Northumberland Street, the position of which as the city's main shopping centre was reinforced with a consequent diminution of the importance of Grey Street and Grainger Street, and a final blow was dealt to lower Pilgrim Street, which had for long been in decline. Above all, it marked a further stage in the movement of Newcastle away from the river.

It was fitting, therefore, that Pilgrim Street was to be the site of three fine buildings erected either when the work on the bridge was under way or immediately afterwards: Carliol House, the Odeon Cinema and the Central Police Station. Carliol House was built, not just to provide a headquarters for the North East Electricity Company as NESCO had become, but to act as an expression of the majesty of electric power. It is a magnificent example of inter-war architecture; clad in Portland stone and supported by a steel frame, it combines

a little-adorned classicism with elements of Art Deco. The interior combines the most up-to-date technology of the period – the fastest of lifts and a vacuum-cleaning system by which dirt was removed through ducts in the walls – with a rich mixture of marble, mahogany and brass with touches of the fashionable Egyptian motifs. Considering that cinemas were palaces of fantasy and dreams, the exterior of the Odeon built nearby is plain, but the cinema more than made up for this inside where a lavishly decorated foyer led to an auditorium which seated 2,600 and had a ceiling 'fancifully resembling a night sky upon which gilded designs are seen on a dark ground, and in its centre a modern light fitting of opal glass'.[43] The Central Police Station, a splendid monumental building, which like Carliol House stood on a corner on which its imposing entrance was placed, was designed by local architect Robert Burns Dick, who had been responsible for the supporting towers of the Tyne Bridge.

These and other splendid buildings, erected in Newcastle during the 1920s and 1930s, point to the fact that despite the decline of many heavy industries and Tyneside's high level of unemployment, this was not an unqualified bleak period for the city. The Newcastle Co-operative Society felt confident enough to commission its impressive department store in Newgate Street (1929–32), which has been described as Newcastle's 'most glamorous Art Deco department store'.[44] The General Electric Company's building in Gallowgate (1933–6) is another building in the dominant architectural fashion of the time. Northumberland County Council's headquarters (1929–34) in Northumberland's territorial outpost in the midst of Newcastle was an extension of the previous Edwardian offices which complemented the nearby Moot Hall and was a major engineering achievement with its base in The Side and its eleven stories rising to the main entrance within the bailey of the castle. Such buildings exemplify the main reasons for the continued vitality of the city's economy: utilities, public administration, entertainment, and shopping.

CULTURE & ENTERTAINMENT

Just as Newcastle had in the second half of the nineteenth century developed a way of life and a popular culture broadly similar to that of all major cities but with

its own peculiarities, so, in the inter-war period, it moved in step with national developments. Recreation and entertainment became ever more national and even, with the trans-Atlantic influence of films and popular music, international. The wireless brought the same programmes and the same popular music into every home, while the latest hit could be bought as a gramophone record at Windows in the Central Arcade. The stars of music hall had moved around the country as those of variety still did, and, as before, the latest success on the London stage would make its way to Newcastle but the cinema enabled films to be seen in every town soon after their release. National newspapers became ever more popular though, in reaction, regional and local newspapers gave greater coverage to the news and gossip of their areas and Newcastle was for a time able to support two evening papers as the *Evening Chronicle* and *Evening World* competed for circulation.

Cinema had firmly established itself as part of popular entertainment by 1914 but the 1920s saw only a handful of new cinemas open in Newcastle. It was the coming of the 'talkies' which ushered in the great age of cinema and of cinema-going. Frank Manders quotes the manager of the Queen's who, in January 1930, reported 'four capacity packed houses each day, compared to two and a half for silent films'.[45] The cinema became by far the most popular form of public entertainment with many people going several times a week. One result was the building of fifteen new cinemas between 1930 and 1939, super-cinemas like the Paramount, the Haymarket and the Essoldo (the unusual name is said to have been taken from a mix of the first syllables of the names of the owner, Sol Shekman, his wife Esther, and daughter Dora) in the city centre and more modest, but still imposing, buildings in the suburbs, while older cinemas, provided they had been able to afford the expensive new equipment, were able to compete with their cheaper prices. The most imposing cinema outside the city centre was Black's Regal in Byker (1934); a fine art deco building, it was part of a chain of Tyneside cinemas owned by Stanley Black.

Cinema was the first form of public entertainment which attracted more women than men. A housewife could go to an afternoon matinee by herself or with friends or, in the evening, go with her husband or a woman friend, while unmarried women could go with girlfriends or a boyfriend in the evening. Going to the cinema was, after all, respectable. Film-makers naturally responded by making films that would appeal to women.

One effect of the cinema was to reduce the appeal of the theatres. The Tyne Theatre, for long the only rival to the Theatre Royal for serious commercial theatre, carried on as a hybrid for a number of years, sometimes with drama or opera but sometimes with runs of a major film, but in 1919 it closed as a theatre and reopened as the Stoll Cinema, part of the chain owned by the show-business entrepreneur Sir Oswald Stoll. Along with the a grand and imposing décor, a winter garden café, a ladies' orchestra and gentlemen's smoking lounges, it dressed its female attendants in an unusual manner:

> A novelty in the matter of attendants is that at the dress-circle entrance are two young
> women attired in highwaymen's dress, this style of costume having been adopted at all
> Sir Oswald Stoll's picture houses. The rest of the female attendants wear dresses of wine
> gabardine which harmonises with the tone of the whole place.[46]

The variety theatres too found the cinema dangerous competition. The old music hall in Nelson Street, which had become the Gaiety Theatre of Varieties, became a cinema as did the Pavilion, but the Palace, the Empire and the Grand at Byker survived as variety theatres until the 1950s, though the Grand had periods as a cinema.

The city's facilities for drama, music and art remained modest. The Theatre Royal continued to stage a mixture of contemporary and classical plays and opera and an important contribution to the city's intellectual life was made by the People's Theatre. In 1929 it moved from the Royal Arcade to what had been previously a church in Rye Hill. Now very much an amateur theatre company, it had thrown off its early incarnation as a cultural branch of socialism, and, while retaining its enthusiasm for Bernard Shaw's brand of didactic drama and for adventurous plays that would not otherwise have been staged in Newcastle, mixed these with productions of Shakespeare and with the popular plays of the day. It acquired a reputation for being daring, which was not perhaps too difficult among Newcastle theatre goers of the time; when during a play, *The Adding Machine*, a quite adequately dressed performer got into bed with her stage husband, it occasioned 'the vocal indignation of a shocked female in the audience who loudly exclaimed: "they stick at nothing in this theatre"'.[47]

The City Council had reluctantly and tardily given its support to a municipal art gallery but the Laing was now firmly established with a growing permanent

collection and imaginative exhibitions of both contemporary and past artists. In 1928 it arranged an exhaustive collection of Bewick's work to mark the centenary of the great engraver's death. The University's Hatton Gallery provided another venue for art exhibitions. A further rare venture by the Council into the field of culture came in 1928 when the City Hall and the adjoining Northumberland Baths were opened. The Hall in Northumberland Road provided the city with an auditorium that could be used for classical concerts and popular music, for political meetings in the days when politicians still drew large crowds and, as many will remember, for school speech days.

Only the wireless can really be said to have exceeded the cinema as a popular form of entertainment. From its early crackly days when the handyman showed off his skill by coaxing transmissions from crystal-sets, wireless had become a constant presence in most homes and increasingly in factories and motor-repair garages. Between 1934 and 1935 the Newcastle postal area saw an increase of 1,500 in the number of wireless licences issued. Again it was women, who spent more time at home, who listened most to the wireless. Both the cinema and radio contributed to the erosion of regional and local distinctiveness – you didn't hear many regional accents on the BBC and you certainly heard a lot of American ones at the cinema – but also to widened social and cultural horizons.

Sports, particularly football and cricket, had already become national passions before 1914 and, on Tyneside, football in particular dominated the conversations at work and in the pub of many men. Sport and betting had always been combined but the Football Pools enabled their conjunction to be legally enjoyed. The 1920s were a good period for Newcastle United during which Willie Gallagher was its star and the team won the First Division League in 1926/27. The misfortune of relegation to the Second Division in 1934 followed but did not diminish the town's and Tyneside's obsession with the fortunes of the club. Enthusiasm for horse racing was not confined to attendance at meetings, particularly the Northumberland Plate, at Gosforth Park for the passion for betting was strong and even the unemployed would spend long hours weighing up the chances of a horse from a distant stable at a far away race-meeting before placing a complicated and illegal bet for a few pence with a bookie's runner. There were new sports as well for greyhound racing at Gosforth and speedway at Brough Park in Byker became popular, while, for the motorcycle enthusiast, the TT Races made the Isle of Man a holiday destination.

New forms of transport had a major effect on social life. While the railways had linked towns and drawn lines across the countryside and tramways had linked the suburbs to the centres of towns, the horse had still been the main means of transport for those who had no adjacent station or tram stop in the first decades of the century. The motor bus was more flexible and cheaper than the railway and made it possible for working people in Newcastle to venture further out of town for excursions or holidays and added to the numbers of people from pit villages or rural Northumberland and Durham who could journey to Newcastle to shop or watch Newcastle United. For the better off, the growing minority who could afford a motor car, an exciting new world beckoned: commuting into the centre of Newcastle from Ponteland or Tynemouth became more convenient – for a while at least – which increased the popularity of new housing outside the city boundaries; evening trips to old country pubs or a new roadhouse like the Wheatsheaf at Woolsington became common; while the annual holiday or weekends at Bamburgh or the Lake District became easier when you just had to put your bags into the Austin and drive there. Newcastle even acquired a modest airport outside the city boundaries at Woolsington from where intrepid passengers could take off from a grass runway for Croydon or Perth.

The greatest change was in the lives of women. The cinema, the wireless and magazines dealing with women's concerns and fashion transformed the lives of many. Young unmarried women enjoyed a new freedom which extended the progress of the pioneers of the previous generation and widened it as it was embraced further down the social ladder. While older accounts of women's history concentrated upon the campaign for the vote and participation in local government and worthy causes, many recent studies by both female and male historians have put the emphasis upon social freedoms as the un-chaperoned young woman was able to go dancing or to the 'pictures', swim in an ever less-cumbersome swim suit, and have a purse that was her own.

As we have, seen female employment was less affected by the Depression than was male employment. New light industries often employed more women than men, women secretaries became the norm rather than a rarity, the number of jobs in teaching and in various branches of local government including libraries increased, and there was a growing demand for fashionable clothes, factories that could make them and shops that could sell them to carefully identified sections

of customers. Women were in general paid less than men but young women still had some money left over when they had handed over a sum to the family housekeeping, a fact which was quickly recognised by the film, fashion and retail industries. There was a virtuous circle: more female spending power meant more work for the businesses which catered to it and they employed mainly women.

The fashion industry became a major element in the economy of Newcastle as in other towns. There had always been a fashion trade but it had largely involved small shops and workshops making made-to-measure clothes for the wealthier classes but what the department stores and multiples had only tapped previously was a widening market for copies of the latest fashions. Now the main shopping streets of Newcastle were transformed by a fashion explosion. Fenwick's and Bainbridge's continued to be the largest and most opulent of the city's stores and they were vital to Newcastle's reputation as the shopping capital of the North. They were joined in the 1920s and 1930s by such chain stores as C&A Modes, Marks & Spencer, Woolworths and Montagu Burton. Fenwick's French Salon sold *haute couture* and expensive copies to the wealthy but it also sold cheaper copies in other departments. C&A specialised in cheap, off-the-peg clothes, but was careful to make the experience of shopping far from downmarket; its store in Northumberland Street, which opened in 1931, enabled the girl with a limited budget to choose a dress in the latest *mode* within a building in the latest Art Deco and stripped classic design. Marks & Spencer's store, built the following year, had the policy of selling nothing which cost more than five shillings and managed to maintain this price level by dealing directly with its suppliers.

Nothing is so indicative of the ethos of a society as fashion and consumer expenditure. Parts of Newcastle suffered terribly during the Depression but the fourteen chain stores which came to Newcastle in the inter-war period would not have invested in an entirely unprosperous town. It is also clear that most of the spending was done by women. The wives and daughters of the well-to-do could spend a leisurely day in Newcastle, having coffee or lunch in Fenwick's Tea Rooms while listening to an orchestra or go to Tilley's, the most fashionable of restaurants, and find time to have their hair attended to, either within department stores or at the growing number of individual hairdresser's, but aspirations towards modernity and chic also affected a new generation of working women who wished to express themselves as modern, desirable and independent. For

most of them the long-term aim was marriage but that left a few years to enjoy a new world which offered a range of diversions and was dominated by fashion. More than that:

> [Fashion] linked women to modern life and contemporary culture. It drew them into the cultural arena in a very public way, as they aspired to styles which referred to Hollywood films and lifestyles in which women acted out alternative roles to the ones for which these young women working in the North East were destined ... The glamour of Hollywood and the cosmopolitanism of fashions which had originated in Paris, London or New York, but were available in cheaper versions in the North East, represented the internalisation of modernity as opposed to the parochialism of the region.[48]

Not everyone welcomed the new woman. Working men were often displeased by their daughters' economic and social independence, while marriage for many young women meant a return to a more traditional culture. It remained the accepted norm that employment should end with marriage and it was compulsory in the public sector for women to retire on getting married, a rule with which most women concurred. For most of the middle classes, however, marriage became a more equal relationship with household appliances and fewer children providing the opportunity for a fuller social life.

The North East Coast Exhibition was opened on 9 May 1929 by the Prince of Wales in Exhibition Park, the same site on which the Royal Jubilee Exhibition had been held in 1887. Its main purpose was to stimulate local industries and most of the main Tyneside firms participated, showing their latest products in the steel-framed, asbestos-clad pavilions, but both high and popular culture were catered for. The Palace of Arts contained a large number of 'paintings by great masters of the past' and a fine display of Newcastle silver from the private collections of the area, including those of the Duke of Northumberland, the Earl of Durham, Lord Armstrong and Sir Charles Trevelyan.[49] There was also a stadium, Festival Hall, and an amusement park and for the rest of the year the people of Newcastle and Tyneside were treated a variety of spectacles including military bands, two productions by the People's Theatre Company, and fireworks displays. In a complex golfing metaphor the Lord Mayor of Newcastle, Sir Arthur Lambert, summed up the economic situation: 'Our industries were badly

bunkered, but the Exhibition niblick has placed them safely on the green and each one must help to hole the put'.[50]

Probably all these delights did something to encourage industry and stimulate local morale but the Exhibition was staged shortly before the recession became 'the Depresssion' in 1931. Tyneside was, Sir Arthur might well have said, back in a deeper bunker. Yet, by the mid-1930s, though much of Tyneside was experiencing its darkest times, other parts, including Newcastle, were beginning to recover, as was witnessed by that barometer of the prosperity of those still employed in a period of deflation, the housing industry:

> When the Housing and Building Exhibition was held in Newcastle at Newcastle in 1936 its catalogue could state thankfully that 'it is under much happier and prosperous industrial conditions on Tyneside that the second annual Building Exhibition makes its appearance'.[51]

If economic recovery was at first patchy throughout Tyneside and in Newcastle itself, a combination of the rearmament programme of the later 1930s and the government's Special Areas (Amendment) Act, which permitted the Treasury to make loans to firms prepared to move into depressed areas, made it more general. Newcastle benefited directly from rearmament with new orders being placed at Armstrong Whitworth for guns, tanks and warships, and modestly and indirectly, for the city was excluded from the Special Areas legislation because its unemployment level was not high enough, from the establishment of the Team Valley Trading Estate across the river beyond Gateshead.

Newcastle demonstrated many contrasts on the eve of the Second World War. It was a rather grimy town with its fine classical buildings blackened over by decades of smoke from its industries, shipping and coal fires, while the river which had once contained so many salmon was heavily polluted by industrial waste and sewage. Ship owners still met at the 'Change' to make contracts and the old social order still seemed intact with chauffeurs waiting beside Rolls Royces and Bentleys in Eldon Square, ready to whisk their employers back to Jesmond, Gosforth or country estates from the Northern Counties Club. There were fine new office buildings, department stores and cinemas, while private and council estates spread out from the old town centre, but the city was still

recognisably that of 1900, acres of Tyneside flats still covered the banks of the river to the east and west, while parts of St John's and All Saints remained overcrowded and unsanitary. The tattoo of high heels announced the progress of fashionably dressed secretaries and shop assistants through the streets of the town, while stylish ladies took coffee or lunch at Fenwick's Tea Rooms or Tilley's. There was an oyster bar at the Royal Station Hotel, the tennis courts and the golf courses were crowded, motorists drove to Whitely Bay for evening drinks or found themselves static in traffic jams where the Jesmond and North roads met, and suntanned walkers returned from the hills, beaches and byways of Northumberland, but unemployment still lingered.

Two futures confronted each other: a return to the 'normality' of industrial Tyneside as the needs of the approaching war stimulated heavy industry and that future of the consumer society whose neon lights had flashed as the old industries had been silenced. For the moment, however, the future lay in the past.

THE SECOND WORLD WAR

In 1944 Gilbert Gunn's film *Tyneside Story* was released for showing by mobile film units. Essentially a propaganda film, it dealt, like many of the genre, with a question, 'What are we fighting for?' The image of the 1930s had been blackened and stereotyped after the fall of Chamberlain's government in 1940 and it was felt that a 'People's War' must hold out a different future. The film depicts the rebirth of a Tyneside shipyard: the cranes and a skilled workforce had stood idle and grass had grown on the slipways but as war came the nation again needed ships and hammers rung and riveters riveted once more. Complacency is dispelled with the interjection of an angry voice (that of an actor from the People's Theatre): 'Aye, but wait a minute. Tyneside is busy enough today ... but just remember what the yards looked like five years ago ... Will it be the same again five years from now?'

The film epitomises not only wartime attitudes to the immediate past and the proposed future but the problems with those attitudes. The new planned economy and society were in many respects based upon a vision of a fairer past. Just as the Great War had reinforced the existing heavy industries and made

them dependent on government orders, so the Second World War did the same, thus inevitably retarding the half-developed consumer economy of Newcastle.

The shipyards of the North East fulfilled the nation's need, replacing over half of the 4 million tons of shipping lost during the course of the war and Tyneside, which concentrated upon building warships and producing armaments, became an arsenal. Vickers-Armstrongs produced tanks, particularly the Valentine and the Centurion tanks, and anti-aircraft guns at Elswick, while Walker Naval Yard was from 1937 building battleships, aircraft carriers, cruisers, destroyers and submarines. Overall, however, the impact of war was to revive what Tyneside had done before: some shipyards were modernised but the pressures of war did not in general result in new methods of construction, while a key area of war production was denied to the area. Newcastle might well have appeared, with its experience of producing the machinery of war and its skilled engineering workforce, a suitable centre for manufacture of military aircraft and just before the war Swan Hunters had proposed in conjunction with Anthony Fokker and D.W. Douglas of the United States the creation of a modern aircraft factory to be called British Fokker Douglas Aircraft Ltd. This plan was rejected by the Secretary of State for Air on the grounds that Tyneside was vulnerable to attack from the air. In the event, Coventry and other areas in the Midlands and South, where much of wartime aircraft production was based, were, after the fall of France, much closer to Luftwaffe bases than was Newcastle and were to suffer much heavier bombing than Tyneside. Newcastle thus lost the opportunity to become a centre of aircraft manufacture with important implications for the future.[52]

Considering the importance of Tyneside to the war effort, it is surprising that the area was not bombed more intensively, but it did suffer substantial raids especially in late 1940 and throughout 1941; it was the sixteenth worst affected area in Britain. Extended periods during which there was little enemy action were punctuated by heavy raids which did considerable damage and in 1941 a sequence of raids was spread over several days. The area suffered some 719 civilian fatalities because of the raids. One raid on Newcastle in September 1941 killed over 50 people but the city was not hit nearly as badly as towns further down the river with North Shields experiencing the worst of it.

The precautions and arrangements made in anticipation of war and air attacks provided for an Air Raid Precautions organisation throughout Britain with

wardens under the control of local authorities and the police. The position of ARP Controller was to be held either by the Mayor or Chief Constable. In Newcastle the Chief Constable was given this position and a network of Wardens' Posts was organised and large public shelters were set up at Ouseburn Culvert, the Victoria Tunnel and Benwell Tunnel, thus making use of existing structures that were or could be made bombproof. In the suburbs, private Anderson shelters dug into back gardens were slowly becoming available in 1939.

In most ways, Newcastle's experience of the war was the same as other cities in Britain. Children were evacuated with their schools, mostly to rural Northumberland, Cumberland and North Yorkshire. As in many towns in both the North and the South, the process revealed degrees of deprivation among the poorest of which most of society had been unaware with an eighth of Newcastle evacuees deficient, by the not particularly exacting standards of the Education Department, in footwear and a fifth in clothing. Evacuees had varied experiences depending on the hospitality of the households to which they were billeted; some drifted back and were said to be running wild as little educational provision was available for them. The blackout descended and probably did more harm than good; only petrol rationing prevented the rate of road accidents climbing to astronomical proportions. As everywhere there was rationing and a haphazard supply of everyday goods; shortages of beer were considered bad for morale and the Newcastle police force found itself in the unusual position of criticising pubs which closed early after selling off their limited supplies of beer quickly. Food rationing was as widely affirmed in principle as it was evaded in practice; shopkeepers and suppliers were accused of profiteering, especially at Christmas, and of favouritism while the 'black market' flourished.

There is much truth in the hallowed view of a public united behind the war effort and cheerfully putting up with adversity but there are many holes in it. The days of work lost through strikes in Britain were higher every year from 1941 to 1945 than in the last year of peace although many of the stoppages were brief. As about three-quarters of strikes were in the four trades of shipbuilding, coal, metals and engineering, Tyneside had more than its share of them. There was a strike of dockers on Newcastle Quayside in May 1942 over the pay rates for the unloading of a damaged American ship, SS *Winoma*, and, though illegal, the strike spread along the Newcastle waterfront. Other significant strikes were

the Total Time strike by engineering workers in 1942 and a strike by shipyard apprentices in 1944. Strikes were generally opposed by the leadership of the unions and even, after Germany's invasion of Russia, by the Communist Party but divisions between the union leadership and shop stewards were fanned by various Trotskyists and other leftist groups and by some members of the ILP, one of whom, T. Dan Smith, later a leader of Newcastle City Council, was a prominent supporter of the 1944 apprentices' strike. Wartime industrial relations were by no means always harmonious and as well as strikes there were allegations of absenteeism, poor work discipline and lucrative sidelines in the yards, such as the making of toys and cigarette lighters during working hours.[53]

It was by no means only workers who could be criticised. Wartime regulations, shortages and emergency administrative systems provided scope for many rackets by businessmen and officials. Newcastle's most spectacular contribution to the rich history of wartime scandals was the story of the missing fire engine which led in February 1944 to allegations of corruption at the very highest levels of the City Council. Two fire appliances had been disposed of by Newcastle ARP. One went to a company, the Premier Welding Electric Company, that Councillor Embleton, the Deputy Controller of the ARP, had an interest in for a price of £15; it was not replaced. Workers from the same company had also removed a fire pump from Fire Brigade Headquarters and cut it up for scrap. It then transpired that, when a suitable vessel for use as a fire float on the Tyne had been required, Councillor Embleton's company had purchased a vessel and hired it out to the Corporation. Questions were asked in the House of Commons, a Home Office enquiry was instituted and major wrangles on the City Council followed. Mr Crawley, the Chief Constable and Controller of the ARP, became implicated as he was ultimately responsible for the running of the ARP and Fire Service. It was clear that he had been close to Councillor Embleton, who had been allowed to stable his horses and those of his friends at the Police Stables free of charge. Both Crawley and Embleton had eventually to resign from their ARP positions and Embleton from the Council, while in April Crawley retired as Chief Constable and was thanked by the Watch Committee for his years of service.[54]

What merchant seamen in damaged ships, which limped into the Tyne only to find that stevedores were on strike, the trawlermen, who risked their lives every time they went to sea, or servicemen home on leave, made of the poor

industrial relations or the fire engine scandal can only be imagined. Nevertheless, despite problems, Tyneside's yards and factories made a large contribution to the machinery of Britain's war, shipyard workers took pride in the warships they produced and productivity improved after disasters such as the sinking of the *Prince of Wales* and *Repulse*, bombing did not seriously weaken morale, and the majority of public servants managed, with integrity, to maintain essential services.

At the sharp end of the war, the local regiments of Tyneside and Newcastle were, as in the previous war, to be found on almost every front. The Northumberland Fusiliers served with the British Expeditionary Force in France in 1939–40, in North Africa, Singapore, Italy and then in France again in 1944. The 9th Battalion had a particularly dreadful war; they arrived in Singapore, after many weeks at sea, only weeks before the British surrender, and some 800 men spent the rest of their war working on the infamous Burma Railway. The Durham Light Infantry is naturally associated with County Durham but many a Newcastle man served with them and, like the Fusiliers, the regiment served in every important campaign: battalions were at Dunkirk and in North Africa, Sicily, Italy and Burma, while from D-Day to VE Day they advanced through France and into Germany. The 15/19th King's Royal Hussars, whose HQ was at Newcastle, suffered severe casualties and was badly mauled in France in the early summer of 1940. The Tyneside Scottish were also in France in 1940 and again after D-Day. The yeomanry regiment, the Northumberland Hussars, formed an artillery unit in the Middle East and were involved in the campaigns in Greece and Crete, the invasion of Sicily and the Italian mainland before being part of the forces that landed in France on D-Day. The area's maritime tradition meant that many Tynesiders served in the Royal Navy, the RNR and RNVR, while they were also represented in the RAF. Just as important to the war effort, however, were the area's merchant seamen, manning the ships which brought supplies to the beleaguered island, and the trawler crews who, with little protection, set sail from North and South Shields.

8

NEWCASTLE 1945–PRESENT

For Britain the impact of the Second World War was to set back the economic and social transition that had marked the late 1930s which had been moving the country towards a consumer economy and a more open society. On Tyneside this process was particularly marked. The war had temporarily revived heavy industries and stimulated the demand for coal while it had ossified social change. It was not until the late 1950s that the direction apparent in the 1930s gained force again and then the pain and difficulty of change was increased by the very strength of the wartime and post-war revival of an older economy and society. In the 1960s and 1970s Newcastle was struggling towards a new identity against the background of industrial decline, the latter marked most noticeably by a scarred urban landscape on the riverfront, where shipyards and factories lay idle and decayed and surrounded by crumbling housing. The brutal remodelling of the city during these decades added to demoralisation. From the 1980s, however, the outlines of a revived city become discernible and Newcastle in the early twenty-first century was vibrant, sociable and confident.

Newcastle emerged from the war a rather shabby and threadbare town but a busy one. Unlike the period after the end of the First World War, there was no short-lived boom on Tyneside followed by a sharp decline in the demand for ships and coal and instead twenty years of steady demand for the products of heavy industry. Shipbuilding held up well with orders for warships and liners providing plenty of work for Newcastle's shipyards during the late 1940s and 1950s. Walker Naval Yard produced a number of stately passenger liners – *Queen Monarch* (1951), *Empress of England* (1956), *Empress of Canada* (1960) – cargo vessels for the Blue Funnel Line, and oil tankers. Swan, Hunter and Wigham Richardson's Neptune Yard was also kept busy with Royal Naval and civilian orders. The onset of the Cold War and the Korean War meant that government

demand for tanks kept the Vickers-Armstrongs plants at Elswick and Scotswood working constantly and the firm remained the city's largest employer.

There were, however, worrying signs for Newcastle's manufacturing sector and for its traditional trading position. The city continued to depend on the industries that the war had revived, but the wartime governments had not allocated it or Tyneside new factories for modern weaponry, the sort of factories that elsewhere were later converted to the manufacture of other products. The Northern Industrial Group (NIG) headed by Viscount Ridley was concerned about the fate of smaller companies and stated in 1945 that, 'with their undeveloped plant they could not return to their obsolete products, and they did not have the necessary capital with which to start new lines of production'.[1]

There was a degree of inevitability about the decline of Tyneside's industries. The war had artificially revived them and post-war world shortages of ships, together with government demand for armaments, made for a postponement of decline. The general worldwide process was, however, one of the transfer of industries with well-established technologies and dependent on large workforces from high-wage to low-wage economies, and shipbuilding, like cotton manufacture, had no great future in Britain. Japan outpaced Britain in shipbuilding as early as the mid-1950s and, as Japanese wages rose, Japan's shipbuilding was also to decline in the face of competition from other Asian nations. Nevertheless, the record of British shipbuilding in the 1950s and 1960s was far worse than that of many other European shipbuilders with Swedish and German output far outdistancing Britain's. The question remains whether a much smaller shipbuilding industry but one advanced in design and technology could have not only survived but flourished. Poor and unadventurous management is one reason put forward for the premature death of Tyneside's and, indeed Britain's, heavy industries. In shipbuilding there was a failure to embrace new methods of construction (sticking to riveting, while competitors were using new welding techniques), a slow response to the demand for the large oil tankers, and a hesitation in adopting marine diesel engines. Another factor was the short-sighted actions of trade unions, blighted by demands for higher wages not justified by productivity, by sectionalism and 'Who does what?' strikes, and reluctance to embrace new building methods when firms belatedly came round to introducing them. Central government had little appetite for slimming down

and consolidating heavy industries and, often for electoral reasons, spread its order book too thinly and erratically.

Electrical engineering had been the most modern and innovative of Newcastle's heavy industries in the first half of the century. During the 1950s and 1960s Reyrolles Parsons did well and in 1968 employed 22,000 workers but the market for its turbines and power stations declined in the 1970s. It has been suggested that it concentrated too much on its Commonwealth markets, though it's easy to be wise after the event and those markets proved very profitable for decades. In 1977, it was forced by declining markets at home and abroad for heavy electrical equipment into a defensive alliance with Clark Chapman and became part of NEI Parsons. It managed to secure orders for its turbine generators from India and China in the early 1980s but was unsuccessful in the market for nuclear powers stations. In 1997 the German firm Siemens Power Generation Ltd bought Parson's Heaton Works.

Even the long-standing trade in coal which had seemed to epitomise Newcastle was on the way out. The coal mines were of course nationalised in 1947, much to the mortification of those coal companies which had modernised and owned efficient pits with good deposits of coal, and to the relief of others who pocketed the surprisingly generous compensation for mines with little future. There were no working mines left in Newcastle but the coal trade was still important to it. After 1954 there were no significant shipments of coal to destinations outside Europe and in 1964 no coal left the Tyne for France or Germany. The trade with London held up better with London taking 6.5 million tons of Tyneside coal in 1952.[2] After years of 'smog', however, London was gradually transformed into a smokeless zone around 1960 and its demand for coal for domestic fires and manufacturing came to an end and with it what had for long been Newcastle's most important trade.

From the 1960s Tyneside was to endure the steady demise of the industries which had been the basis of its economy since the late nineteenth century. Efforts by governments to encourage new industries to locate to the North East had a limited success but too often branches of firms with their headquarters elsewhere were liable to be the first to be closed in periods of economic downturn. Newcastle retained the advantages which had allowed it to weather the pre-war depression better than the rest of Tyneside and, having never had more than a minority of

its workforce engaged in manufacturing, was able, in the long run, to return to its traditional position as a centre of administration, commerce and retailing with the additional reinforcement of higher education. A combination of the increase in heavy industry within the old city boundaries and the expansion of the boundaries since the early nineteenth century had, however, led to an increase in the percentage of the city's population employed in manufacturing to about 29 per cent in 1961, a figure that was to shrink to less than 13 per cent by 1991. The consequences of this steep decline in manufacturing were social and cultural as well as economic.

The nationalisation of shipbuilding in 1977 did nothing to slow down the decline of the industry and by 1985 Newcastle's shipbuilding industry came to an end. After the loss of a key government order in 1993 Swan Hunters at nearby Wallsend, re-privatised in 1993, went into receivership although it won a reprieve in 1995 and under its Dutch owner, Jaap Kroese, was to exist in an attenuated for another eleven years. There was a long list of final milestones. The Walker Naval Yard launched its last passenger ship, *Northern Star*, in 1962 and its last vessel, the refrigerated container ship *Dunedin* in 1980. The aircraft carriers *Illustrious* and *Ark Royal* were fitted out during 1980s but when *Ark Royal* departed in 1985 the Naval Yard fell silent. Today the site is an industrial estate, Walker Offshore Technology Park. The last ship to be built at the Neptune Yard was the Type 22 frigate HMS *Chatham*, launched in 1988.[3]

Both the west and east ends of the town had developed economies in which a skilled male workforce worked in shipbuilding and armaments manufacture. Wages had traditionally been high and status and self-respect had been based upon work. Even in the 1930s such workers had been reluctant to look for other work and preferred to wait for 'normal' times to return, as indeed they did between the late 1930s and the 1960s. As shipyards closed, the Vickers-Armstrongs' Elswick works employed fewer men. In the early 1970s the site of the engineering works was sold to Vickers Property Ltd to be converted into warehouses and offices, although Alvis Vickers continues to make tanks and mobile guns on the riverbank where there was once the shipyard farthest from the sea at Scotswood. The end of shipbuilding and the decline of armaments manufacturing meant the passing of a way of life and a distinctive culture and was to have disastrous social consequences for riverside communities where work had largely dictated the social structure and permeated leisure.

By the mid-1970s the percentage employed in all manufacturing was in decline and in the 1980s the decline became a steep fall. In many ways this can be seen as a return to the trajectory of the 1930s which had been interrupted in the wartime and immediate post-war periods. Newcastle was about to become what has been described as 'a city providing employment in tertiary and quaternary activities in shops, offices, schools, colleges and hospitals'.[4]

Newcastle's history as a city with about a quarter of its workforce engaged in heavy industry had been comparatively brief and in many ways its new economic structure was, for the city as a whole, a continuation of its traditional role, though for the east and west ends of the riverside it was a traumatic reversal. The end of shipbuilding was accompanied by the attenuation of Vickers-Armstrongs while, at the same time, the Quayside and maritime commerce so central to the city throughout its existence came to an end as the coal trade petered out and the import and export of other goods were handled lower down the river. The move of the town away from the riverside accelerated; the Swing Bridge rarely swung, Quayside offices became redundant and shabby and few ships were seen on the polluted river.

The manufacturing of ships, tanks and turbines had provided well-paid work for working-class men with specialist skills who had served apprenticeships, with entry into the trades determined more by workers than management. Neither workers nor management could control the availability of work but the workforce had a large say in who did it and how it was done. What new work was available in manufacturing, usually in light industries, tended to be located on the fringes of or outside Newcastle with a resultant outflow of skilled workers from the old industrial suburbs.

Many of the jobs created in the rather loosely-defined service sector, which by the end of the century was by far the biggest sector, were taken by women and white-collar male workers. By the end of the 1970s the largest employers in Newcastle were the City Council with over 18,000 employees and the Department of Health and Social Security at Longbenton with over 11,000, but higher education expanded rapidly as an employer in the last decades of the century as did shopping and leisure with which Newcastle became identified. One problem the city faced was that it failed to develop as a financial centre. It had its branch of the Bank of England and a successful banking history but,

after the incorporation of local banks into the large national banks' head offices tended to be based elsewhere and most Newcastle banks answered to Leeds as their northern centre. The Newcastle Stock Exchange amalgamated with other northern exchanges to form the Northern Stock Exchange in 1965 but then, like all regional exchanges, was swallowed up by the London Stock Exchange, an inevitable development which foreshadowed the 'big bang' of the deregulation of stockbroking and the domination by large global financial centres.

THE BRASILIA OF THE NORTH

What the *Luftwaffe* failed to do, the city fathers did. Newcastle had escaped the worst of the bombing and had to wait until the 1960s and early 1970s to suffer real damage at the hands of the City Council. As Faulkner has reminded us, 'Newcastle's city centre, largely undamaged by bombing, had survived almost unchanged as a coherent expression of Georgian and Victorian classicism. Unfortunately, far from being valued as an outstanding example of "heritage", it was in the main perceived as an area "ripe for development".'[5]

Outside the city centre, the industrial suburbs still displayed their terraces of Tyneside flats, their corner shops and pubs. The 3-mile-long Scotswood Road remained a street full of people, not just of motor traffic, with its small shops and dozens of public houses named after trades and past and present means of employment: the Mechanics' Arms, the Hydraulic Crane and the Crooked Billet. To the east, Byker and Walker were also communities whose reason for being was largely the shipyards, which regulated the pace of life with their sirens marking the stages of the working day and whose hierarchies and values permeated social life. To an extent, there were two separate problems or opportunities for planners, the city centre and the industrial suburbs, but any grand plan would have to encompass the relationship between them.

S. Middlebrook's *Newcastle upon Tyne: Its Growth and Achievement* (1950) ends with an epilogue which constitutes a primary source for what an intelligent observer in the immediate post-war years and an authority on the city's past thought about its future development, though it is also an example of the dangers of concluding a history with thoughts about the future. Like most contemporaries,

Middleton realised that the traditional heavy industries of Tyneside were no longer able, 'so entirely', to be relied upon to provide the livelihood of the area, but, as the caveat 'entirely' suggests, his generation could not, understandably, foresee a post-industrial economy. He accurately saw the need for new trunk roads crossing the river and, drawing on the report of the City Council's Town Planning Sub-Committee's plan of 1945, predicted, in outline, the future road communications network, and, though the trolley bus, rather than the Metro, figured in his vision of future transport arrangements, he mentioned, as a 'bold' proposal, plans to develop Woolsington Airport for Continental service. Although he was careful to make a plea for 'what is valuable in the city's inheritance to be spared', it is clear that, though he included in this the architecture of the Grainger period and most of the more ambitious buildings of the first half of the twentieth century, he had little time for most of the late Victorian buildings: 'the heavy, ornate, stone-built chambers and office-blocks which appeared so "palatial" and impressive to the Victorians – and seem so dull, pretentious and pointless to us – had given place to a more functional type of building which both in the materials used and in methods of construction was a better expression of a mechanised age'. It is not clear, however, how even the buildings he approved of could have survived his support for 'heroic' measures that would involve 'civic design for the city as a whole'.[6]

Despite being the capital of a Labour heartland, Newcastle, in part because it had experienced less bomb damage than many major cities, had seen little in the way of redevelopment in the immediate post-war period. Its attempt at a 'New Jerusalem' came late in the day during the 1960s and 1970s and was marked by an insistence that bureaucrats, councillors and planners knew best. The main architects of the destruction of many of the city's finest features were T. Dan Smith – charismatic but corrupt and addicted to Corbusian fantasies, who was Leader of the Council (1958–66) – and the city's first specialist Planning Officer, Wilfred Burns, incorruptible but similarly addicted to modernism. The support they had from the Council had much to do with a post-war *zeitgeist* which elevated planning into a god and had little respect for the past or tradition. Perhaps little respect for the people as well, for one of the worst aspects of the plan was the slum-clearance programme.

Newcastle had, indeed, much poor housing. Along with Wearside, Tyneside had 42 per cent of occupied dwellings without a fixed bath and 19 per cent

without the exclusive use of a lavatory in 1951 and Newcastle had its share of them. The Council was petitioned in 1952 by 458 'residents of dilapidated and insanitary property'. The recently elected T. Dan Smith made an eloquent plea for slum clearance:

> Whether we like it or not, there are thousands of houses in this city without baths and water … With rat-ridden houses, houses without water, people living four and five in a room and conditions in which people suffer from tuberculosis, we, as public representatives, cannot be complacent. We say we want a plan and we must get on speedily.[7]

Plans came and went and though some of the worst slums were cleared and pockets of new public housing built in the 1950s, it was not until the 1960s that Smith was in charge of a plan he and Wilfred Burns could implement.

When the opportunity came, the tragedy was that so little had been learned from the experience of other cities in the 1950s. There were real 'slum areas' and many of the houses that were demolished were beyond redemption but much of the old housing stock was sound enough but lacked modern amenities and could have been refurbished. The re-housing into tower blocks showed little sensitivity to what people wanted. Wilfred Burns admitted that forcing people to move considerable distances would have a devastating effect on communities, but thought that 'the task is to break up such groupings, even though the people seem to be satisfied with their miserable environments.'[8]

The great delusion was the image that so many of the planners and sociologists had of the working class, an image that unaccountably they were able to pass on to many councillors who came from working-class backgrounds. It was axiomatic to intellectuals and the new public professionals that the middle classes, from whence most of them came, were beyond redemption in their liking for suburbia, semi-detached houses and privacy. The workers were, they thought, a different matter; their values were collective and communal and they would be entirely happy in high-rise flats with provision for communal facilities and community centres. In fact the aspirations of most workers were not so different to those of the middle classes. If those who lived in crowded quarters enjoyed little privacy, it was not because they did not value it. They had developed their own institutions

and socials lives, exercising choice within determined circumstances, and were not looking forward to the joys of provided community centres. Few planners thought in the 1950s and 1960s of the refurbishment of streets of terraced housing or of building new terraces and only two options were considered seriously: the dispersal of much of the inner-city populations to suburbs or new towns or the building of tower blocks. Early Newcastle plans had envisaged decreasing residential density by dispersion to the suburbs, though dispersion to Longbenton did involve multi-storey flats, but the plans of the T. Dan Smith era were for high-density tower blocks within the city boundaries. Burns was echoing Le Corbusier in his view that new architecture would result in a new people. The great guru had declared, 'Architecture has for its first duty that of bringing about a revision of values. We must create the mass production spirit. The spirit of constructing mass production houses. The spirit of living in mass production houses.'⁹

There can be little doubt that there was a need for changes to ameliorate the city's growing traffic congestion, that new civic buildings were required, that much of the architectural fabric was shabby, that some areas were semi-derelict, and that, despite the council estates built in the inter-war years, there was a need to improve the housing in which many of the poorest still lived. There was a series of development plans, the 1945 Plan, that of 1950 and then the 1963 Plan, the one that was finally implemented, each in turn more ambitious in its aims. Many of the problems these plans sought to address were real enough. Upper Pilgrim Street and Northumberland Street could clearly not continue to be major shopping streets and carry the traffic of the Great North Road, any more than The Side could have been left to bear it in the late eighteenth century. Though the textbooks of planners, convinced of the beneficent impact of the profession and of the need for government to direct land use, led to a determination to divide the city into discrete areas for retailing, offices and residence, commercial forces had already done much to establish such demarcations. The plan to segregate traffic and pedestrians as far as was possible made sense in outline, even if the central motorway should have been built further east and the desire to accommodate motor traffic led to pedestrians being forced to use bleak overhead walkways. There was a need to underpin Newcastle's pre-eminence as the retail centre of the North and the Eldon Square Shopping Centre was a commercial

success and reinforced the position of Northumberland Street, though it also speeded the decline of Grainger Street's stores. The attempt to both control and accommodate the motor car was of its time and the Metro, the first section of which only opened in 1980, was a late addition to the city plan.

The terms renovation, regeneration and conservation tended, however, to disguise what turned out to be an insensitive attitude towards the city's past which involved the destruction of fine buildings and the brutal insertion of major highways and new buildings which were not in harmony with the surrounding architecture. The strange idea that people should be happy to live much of their lives at least one storey above the ground was omnipresent and is exemplified in the Princess Square development onto which the 1960s Central Library faced. Two strains of thought came together: modernist schools of planning and architecture which believed in functionalism, high density and 'dynamic contrast' between the old and the new; and a psychological cringe which, though it boasted of local pride, felt in reality shame that Newcastle had the wrong image, was old-fashioned and could only be taken seriously if it was relentlessly modernised. The notion that Newcastle should become a 'Brasilia of the North' epitomised this attitude, though all that Brasilia had to recommend it was that it was totally new and had modern buildings. The occasional obeisance to the city's early nineteenth-century development, which the planners claimed to be emulating, even to the extent of naming a boring highway John Dobson Street, could not disguise the contempt for classical Newcastle.

Most of the central city's existing buildings were in need of renovation rather than destruction and others should have been replaced by shops, offices or housing that were in scale and style sympathetic to the existing townscape. The civic-educational complex was a qualified success and the Civic Centre, with its tower bedecked with castles, seahorses and a carillon which plays folk songs, came to inspire some affection. It was also well built and has stood up well over nearly half a century. Though the first Polytechnic buildings were drab and characterless, the incorporation of older buildings into the developing campus worked well. The real disaster lay in a craze for modernism which ignored the lessons that could and should have been learned from the experience of other cities and a philistine lack of care for the finest buildings of the city's past.

Newcastle was, of course, not alone in destroying many magnificent buildings

such as the Royal Arcade and Eldon Square, indulging in the architectural fashion for 'dynamic contrasts' as with the insertion of MEA House into gracious Ellison Square, and placing a brutal block opposite the cathedral or, as with the Norwich Union building, now happily demolished, jutting into Westgate Road, and the Commercial Union building intruding into Pilgrim Street, unhappily not yet demolished; nor was Newcastle unique in eradicating great swathes of working-class housing in the suburbs which could have been refurbished or replaced by housing of a similar scale and instead rehousing the inhabitants in grim blocks of flats.

The post-war redevelopment of the heavily bombed Coventry and Plymouth was a warning that utopian planners could create dystopias, while the redevelopment of much of London and Birmingham provided many lessons in what not to do, and a glance across the river to Gateshead already demonstrated by the 1960s what a real horror of a town centre you can create if you really try.

The nadir of Newcastle's redevelopment came with the destruction of the Royal Arcade and Eldon Square. Opposition to the destruction of the former came from the Minister R.H. Crossman, the Royal Fine Art Commission, and the Georgian Group, as well as many concerned Novocastrians, but the Council and, to its shame, the local press went along with the parrot cries about 'not standing in the way of progress' and the need for brilliant men of the present to be as self-confident as Grainger and Dobson in the past in their reshaping of the town, while in any case as one councillor put it there would still be 'plenty of Dobson Grainger architecture left' after the arcade had gone. The demolition of two sides of Eldon Square was the occasion of yet a more amazing comment from a terminologically challenged councillor: the square would be maintained because 'it is only the buildings surrounding the square that will be removed'.[10] The existing town hall was now redundant but the opportunity of creating a vista of the cathedral and castle by leaving the site as an open space was missed and mundane buildings were erected in its place.

Such vandalism, together with increasing evidence that few enjoyed living in the new high-rise housing, which replaced many of the old terraces in the suburbs, seems to have marked a turning point. Much praise was lavished upon the Byker estate and its centrepiece the 'Byker Wall', a five-storey complex of flats and maisonettes which was built after consultation with local residents, but

most of the praise seems to have come from the architectural establishment and by 2001 a council report was pointing to problems. A significant volte-face was under way by the 1980s and new social housing belatedly went along with the much criticised taste of the English for low-rise housing. Perhaps, also, the jailing of the enthusiast for the 'Brasilia of the North', T. Dan Smith, for corruption in 1973 had something to do with the end of a dream of a concrete utopia. There have been attempts at a reassessment of both Smith and the transformation of Newcastle.[11] He was certainly a bold visionary, most of the corruption he was involved with took place away from Newcastle and the man who was named Planner of the Year by the *Architectural Review* in 1962 was going with the tide of professional opinion. How much blame should be attached to him personally may be contested for the urban landscape continued to be debauched for years after his time, but there can be little doubt that the 'New Brasilia' was a disaster and the now renamed Swan House and many other buildings are there to remind us of it.

Local Government

The 1973 Local Government Act can be seen retrospectively as inspired by that post-war spirit which exalted grand plans embodying planners' visions of the logical and the modern and was impatient with the boundaries and institutions of the past. It dismembered old counties and created new ones and drew lines intended to replace those that had been drawn by the incremental and organic growth of centuries. Newcastle had since 1400 been a county in its own right but had rather anomalously been at the same time the effective capital of the County of Northumberland. The castle garth had, as we have seen, been legally part of Northumberland and this was reified by the County Court and County Hall, while the few people who lived within the castle area voted in both local and parliamentary elections as Northumberland rather than Newcastle residents. The 1973 Act created the new county of Tyne and Wear. This amalgamated all of North and South Tyneside and Wearside into one county, thus taking vast tracts of land and large numbers of people away from Northumberland and Durham and incorporating Newcastle as well as the erstwhile county boroughs

of Sunderland, Gateshead, South Shields and Tynemouth into Tyne and Wear. The county was a structure planning authority with a second tier of five Metropolitan Borough Councils providing local planning and services and the logic was in many ways impeccable: a bird's eye view of the new county was of a conurbation with a linking pattern of housing development and declining industries in need of new communications and joint services. It nevertheless overrode interests, rivalries and identities built up over time. The Tyne and Wear headquarters was situated in Newcastle but the city lost much of its autonomy. As a political unit the new authority lasted just over a decade before being reduced to a number of unitary authorities of which Newcastle was one, although these separate authorities combined together for a number of functions with, for instance, Newcastle becoming the headquarters for a combined public transport authority and Gateshead the administrative centre of the combined police force, Northumbria Police. This was, perhaps, a sensible compromise, retaining a combined responsibility for essential common structures with the maintenance of Newcastle's civic identity. Tyne and Wear remained, however, a county with a Lord Lieutenant, leaving Durham and Northumberland Counties considerably attenuated and with Northumberland moving its County Hall to Morpeth.

The political complexion of Newcastle City Council had in the immediate post-war years moved from a short-lived period of Labour from 1945 to 1949 back to a period of a Progressive majority. The Progressives were primarily an anti-Labour alliance and one which enabled Conservatives and Liberals to co-operate in wards which might otherwise have gone to Labour though the parties also put up Conservative and Liberal candidates in other wards. Alderman William McKeag, a leading Newcastle Liberal, having been elected as a Liberal councillor several times, was by the 1950s standing as a Progressive.

Labour regained control of the Council in 1958 and was to exercise a hegemony for the rest of the century, save for an administration led by the Conservative Alderman Grey in the 1970s. If T. Dan Smith's meteoric rise and spectacular fall made national headlines, his five years as Leader of the Council was comparatively short in comparison with that of the seventeen years of Jeremy Beecham who led the Council during most of the period after its reconstitution in 1974. 'New Labour' before the term was invented, Beecham represented the problem-ridden

Benwell (later Benwell and Scotswood when the two wards were amalgamated in 2004) while living in the middle-class suburb of Gosforth.

The Liberals in Newcastle were always, even in the period of the party's reduction to a couple of taxi loads of MPs, a potential force in Newcastle's local politics and, when the 1960s saw a modest Liberal revival in national politics and the various groupings of Progressive and Rate-Payers parties in local politics began to be replaced by the Westminster party labels, Newcastle saw the emergence of separate Liberal and Conservative candidates for council elections. The first Liberal councillors appeared in 1973 and in 1975. By the 1980s, however, the Council was Labour-controlled and Conservative representation dwindled and by the end of the century was non-existent. These developments were mirrored in most major northern cities but few saw such a complete end to Conservative representation. The Liberals became the opposition party on the Council and after several years of steady gains wrested control from Labour in 2004. They retained this majority until 2011. Perhaps nothing better exemplifies the fact that local politics really are local than the contrast between Newcastle and surrounding areas. One might scarcely notice the demarcation line between Newcastle and North Tyneside but there Conservatives compete with Labour for control of the Council and there is a directly elected, while Gateshead and South Tyneside remain in Labour hands.

PARLIAMENTARY POLITICS

In terms of parliamentary representation Newcastle continued after 1945 to be divided into four parliamentary seats, though boundaries and even the names of the constituencies changed with Newcastle East becoming Newcastle and Wallsend, only to revert to being a purely Newcastle seat, and Newcastle West becoming Tyne Bridge. Successive boundary reviews have resulted in an ever-changing map of constituencies and the 2010 general election saw Newcastle returning three Members of Parliament for Newcastle North, Newcastle Central and Newcastle East, all covering very different areas to their predecessors with those names.

In general Newcastle became ever more markedly Labour territory in the last half of the twentieth century although Newcastle North continued to be a Conservative seat until 1983 and both Newcastle East and Central returned Conservatives on single occasions (Newcastle East in 1959 and Newcastle Central in 1987). Newcastle MPs have included such prominent Labour ministers as Arthur Blenkinsop and Edward Short while in until May 2010 Nicholas Brown was Government Chief Whip and Regional Minister for the North East.

If Newcastle North was for long a Conservative seat, it proved to be a problem for the Conservative Party due to dissensions and splits with the local constituency organisation. Sir Nicholas Grattan-Doyle had held the seat since its formation in 1918 and on his retirement in 1940 attempted with the support of the local association to secure the succession for his son, Howard Grattan-Doyle. This prompted a revolt by a number of members, who formed a rebel association and adopted Sir Cuthbert Headlam as an Independent Conservative candidate. In the circumstances of the wartime electoral truce there were no other candidates and Headlam won a convincing victory and then took the Conservative whip. Relations with the Newcastle North Association were ostensibly patched up but Grattan-Doyle's erstwhile supporters continued to be hostile to Headlam and attempted to have him deselected in 1945 and 1950. They were led by Alderman William Temple, a barrister, who, according to Lord Lambton, 'was a ludicrous figure and always walked about Newcastle with a huge number of briefs, or so-called briefs, slung over his shoulder';[12] Temple was probably after the candidacy for himself, but Lambton's comment points to the bitterness between the factions. Continued dissension led to the formation of a breakaway association which was then recognised by the National Union of Conservative Associations, which expelled the former association. Essentially this was a split between the regional Conservative organisation in the hands of party grandees, such as Viscount Ridley and Lord Lambton, and Newcastle Conservatives. On Headlam's retirement in 1951, the constituency association adopted Gwilym Lloyd George (David Lloyd George's son and a National Liberal) and the now disaffiliated association put up a young local candidate, Colin Gray (later a Labour councillor). Lloyd George was elected but that the Independent Conservative saved his deposit pointed to the degree of discontent among local Conservatives. This was not quite the end of the matter, for William McKeag, who had been National Liberal MP

for Durham (1931–5) and had stood as a Liberal for Newcastle North in the 1945 election, was nominated as a candidate by the disaffiliated Conservative Association for the 1957 by-election after Gwilym Lloyd George was made a peer. In the event, however, his candidature was not proceeded with.

Newcastle played a part in that fascinating event, which at the time seemed likely to lead to a reconfiguration of British politics, the formation of the Social Democratic Party. Mike Thomas, who had been elected as the Labour MP for Newcastle East in 1974 was one of the founders of the SDP and played a significant role in the organisation of its launch in 1981, a well-organised affair which gave the new party considerable lift-off. As is well known, the SDP foundered, due in large part to a division among its leaders as to whether it was a modernised version of Labour or a vehicle for transferring Labour votes to the Liberal Party. Thomas was of the former persuasion and a particular bête noire of Roy Jenkins; he lost his seat at the 1983 election to the future Labour minister Nick Brown.

Parliamentary elections in the early twenty-first century saw Labour in a seemingly unassailable position but with Liberal candidates often pushing Conservatives into third place, thus raising the question as to whether the parliamentary constituencies of Newcastle might follow the Council in falling eventually into Liberal hands.

DEMOLISHED & DEMORALISED

The nadir of Tyneside and its capital came in the 1960s and 1970s. The confidence of the early twentieth century may have been shaken by the inter-war Depression but there had always then been the belief that the carboniferous and shipbuilding economy would recover, while by the 1960s it was clear that a scenario of decline, closures and redundancies marked its end. Newcastle, as the consumer, retailing and administrative capital, may well have fared better than other Tyneside towns, but the cultural shock was ubiquitous. The anomie that resulted was reinforced by the destruction of much of the city's past as a well-known, if shabby and blackened, environment was destroyed and replaced by dreary modern buildings and brutal highways.

A pervasive sense of economic decline and a half-demolished townscape resulted in reactions that mixed nostalgia with anger. Railing against ineluctable economic change is thankless and blaming local employers or trades unions awkward, so a narrative had to be constructed, a narrative that saw Tyneside as victim: a salt of the earth society with a natural community spirit had had its birthright taken away by capitalism, governments and the wicked South. This was, inevitably, a socialist tale, which underestimated the entrepreneurial spirit that had created the dynamic late nineteenth-century economy, but it was not a confident one for it involved betrayal. Labour governments seemed as impotent as Conservative ones to be able to rescue Tyneside from decline and the Poulson–T. Dan Smith scandal pointed to a widespread corruption, which involved local Labour politicians as well as architects, developers and a Conservative Cabinet minister.

One response was a fascination with a passing way of life and produced much valuable work on the history, largely the labour history, of Tyneside, though it often overestimated the role of more extreme radical movements in this history. Novels and plays dealing with working-class life and culture appeared. The works of Catherine Cookson – almost a new genre of romantic fiction dealing with the contrast between the lives of the rich and poor, upstairs–downstairs relationships and the stigma of illegitimacy – gained a national readership and became bestsellers. Jack Common's two novels based on his childhood and youth in the Newcastle of the early twentieth century, *Kiddar's Luck* (1951) and *The Ampersand* (1953), were not timely for his own chances of literary success, but were immensely influential on Tyneside writers of the next generation and were republished in the 1960s and 1970s. Arthur Barton's much underestimated *Two Lamps in Our Street* (1967), set in the Jarrow of the 1920s and early 1930s, was of a similar ilk, a thinly disguised autobiography describing in affectionate but unsentimental detail a culture and way of life. Sid Chaplin was also in the tradition of the novelist of working-class life, as exemplified in his *The Day of the Sardine*. His stories of mining life, *The Thin Seam* (1950), provided the inspiration for the musical play *Close the Coalhouse Door*, by Alan Plater and Alex Glasgow.

Much of cultural life in the Newcastle of the period seemed to suggest mixed attitudes of affection for the passing of aspects of a particular working-class way of life that had to be evoked before it was too late and anger at the failures of the socialism that writers saw as central to it. As much of Scotswood and Byker

came crashing down, so the photographs of Jimmy Forsyth and Sirkka-Liisa Konttinen recorded what was still, for the moment, familiar.

Social realism characterises much of the work of this period. The image of Newcastle that became predominant was, both morally and aesthetically, black and white. Like the monochrome photographs of Forsyth and Kontinnen, the films produced by Amber Films, a film-makers' co-operative based in The Side, were rarely in colour and owed much to the British documentary tradition of the 1930s and 1940s. The dominant image was of an almost exclusively working-class society, a landscape of closed shipyards and factories and once vibrant communities living out their last days as demolition approached.

One problem with much of this work was that it concentrated by its nature on certain strands of Tyneside history and society which were already the dominant images of the area as seen from outside and turned them into a monolith. Far from the modern progressive city that Smith and Burn had sought to create, Newcastle was the 'other England' and, as Geoffrey Moorhouse put it when describing the Quayside Sunday market, 'Everything here has seen better days. The shoppers mostly look as if they haven't.' True enough, but Jesmond or Gosforth would have provided a different picture and few writers or film-makers cared to dwell on the more prosperous areas of Newcastle.

CARRY ON GEORDIE

The concept of the distinctiveness of the North East was deeply embedded in many accounts of local culture and was intimately linked to the concept of the 'Geordie'. There is much debate over its origins with various claims such as that it described supporters of the Hanoverians at the time of the 1745 Jacobite rising or is associated with George Stephenson. A persuasive theory is that it was a term used by others, primarily Londoners, to describe the Tyneside seamen who worked on the colliers taking coal down the east coast. J.B. Priestley does refer to 'Geordies' in his *English Journey* (1934), if not in a very complimentary way: 'these Geordies, stocky toothless fellows in caps and mufflers, cursing in their uncouth accent'. The term was, thus, in use before the mid-twentieth century but achieved a more widespread currency during the Second World War when

army life encouraged the use of nicknames for everyone and everything. It was taken up by the BBC for its *Watcheor Geordie* programme after the war and thereafter became a popular name used by both locals and outsiders. Exactly to whom it refers is debatable. To use it as describing the whole of the North East is clearly wrong for few inhabitants of Alnwick or Sunderland would use it to describe themselves (indeed Wearsiders distinguish themselves as overtly not Geordies with the name 'Mackem'[13] and purists would argue that it is reserved for those who live on the lower reaches of the Tyne as far up as Prudhoe and Wylam and in the now ex-pit villages close to the Tyne. Clearly then the name includes Newcastle people but is not exclusive to them while Novocastrian is, but the latter, though much used earlier in the twentieth century, is a rather formal Latinism which sits well with alumni of the Royal Grammar School or Newcastle University but lacks the demotic touch. A previous generation of local patriots had tended to associate Newcastle and Tyneside with a vision half-Camelot and half-sturdy Saxon, or even, inappositely given Newcastle's opinion of Tynedale and Redesdale, a glamorised version of turbulent border history.

It is significant that Geordie came to be generally used during a period of economic decline on Tyneside. It was not much used when great ships were being built and skilled workers were earning wages far higher than equivalents in the south, but became part of common parlance when shipyards were closing. It therefore became associated with a sort of cultural defensiveness as expressed by the comedian Bobby Thompson, who became very popular in the 1950s and 1960s; we are a decent people with no airs and graces, exceptionally friendly and very definitively not 'posh', but we have been treated badly. The journalist Chris Iley, after interviewing the Wallsend-born pop star Sting (like most successful Tynesiders a rare visitor to his place of birth), wrote that:

The Geordie persona as I have known it – because I was born there too – is someone who is not at ease with oneself, who is a little defensive, and who can express sentiment but not emotion. If the north-east had a season it would be winter, many layers and wrappings, because we would rather cover things up.[14]

The Geordie concept has real roots in mining communities, in the showmen of the early nineteenth century and in the music halls but it bundles up diverse

factors into an artificial cohesion. It suggests a monolithic and totally working-class culture and overrides many differences: between Newcastle and the rest of Tyneside, between riverside towns and the adjacent mining communities, and between Tyne and Wear. The dominance of the mining dimension is particularly significant when it comes to Newcastle and indeed other riverside towns. To Newcastle, miners were, for the most part, familiar outsiders who contributed to the town as regular visitors bent on pleasure and spending money. They therefore contributed to the town and gave it something of its leisure ethos but were not of the town and were, indeed, regarded by most workers, as well as middle-class residents, with mixed regard as a well-known 'other'. If 'Bob Cranky' contributed much and rather too much to the image of the miner in drawing attention away from the 'respectable' and orderly side of mining villages, the figure of the miner has tended to be over-represented in the composite that became the Geordie image. As most commonly used, it elides the very separate identities of the miner, the shipyard worker and the seaman and it leaves out the lawyer, the entrepreneur and the clerk and the schoolteacher. It corrals a rich and complex history into a simple story, which ignores Newcastle's history as a northern fortress, its pre-industrial success as merchant town with a polite society, its intimate links with London, and its position in relation to the four Northern Counties as opposed to the North East. Above all it airbrushes out the middle orders and the role of the urban and the rural gentry, save as villains of the piece. One historian has written almost approvingly: 'Even today, a middle-class Geordie sounds wrong.'[15] If this is so, it demonstrates the strength, but not the accuracy, of the Geordie version of history.

A natural reaction to the standardisation of life, as every high street acquired the same shops and people in all parts of Britain watched the same television programmes, was to assert the local and the particular. On Tyneside the cultural reactions ranged from the elegiac to the folksy and whimsical. Scott Dobson's *Larn Yersel Geordie* (1970) was an amusing book, which encouraged further study of the Tyneside dialect but also perpetuated the Bobby Thompson stereotype of a world of stottie-cakes, brown ale, leak clubs and 'netties'.

The historian D.J. Rowe has dismissed, rather boldly, local culture as a 'well nurtured myth'.[16] Rowe had good grounds for his impatience with what threatened to become a tribal cult but, if Geordieism was in many ways an example

of the invention of tradition, like most of such inventions there was straw in the bricks. The late nineteenth century had seen, in all major urban conurbations, the emergence of what were not necessarily synonymous, a working-class and a popular culture. Was Tyneside merely one example of such societies and cultures or was its distinctiveness, accent, tradition and ethos such as to set it apart? There can be little doubt that there was a great deal of romanticism and whimsy in the celebration of the Geordie but a paradox in the development of an essentially national society was the sub-theme of local distinctiveness; just as the development of the music hall had been a national development with famous performers admired throughout the country, so it had provided space for essentially local comedians and singers. At times, however, the romantic proponents of Geordieism have come close to denying that the area was English and seen an unlikely future in which the North East was a social democratic component in a northern arc within a federal Europe.[17] There was a strong case for the argument that industrial Tyneside had developed a society and culture that had roots in its pre-industrial past but the mistakes were the separation of that development from the worlds of commerce and entrepreneurship and amnesia as to the prosperity of the industrial period at its peak. There's nothing wrong with the name and it is established so that we are all Geordies now, but we need to be careful its associations for a particular type of interpretation can, in its defensiveness, represent a denial of Tyneside's and Newcastle's considerable contribution to English history and culture.

The Changing World of Leisure

Amid the destruction and the rebuilding, changes in the city's lifestyle were taking place. The Newcastle of the 1940s and early 1950s had not been able to claim a vibrant nightlife. Only a few hotels served meals after the early evening when Carrick's cafés, which did good comforting high teas with waitresses in aprons bustling as they served the mixed grills and placed the metal teapots on the tables, closed. There were cinemas aplenty, the remaining theatres of variety (the Empire, the Palace, and the Grand at Byker), and drama at the Theatre Royal, the Flora Robson and the People's, while the City Hall provided a venue

for classical music and, adventurously, jazz. There was also a large number of pubs but, apart from jars of pickled eggs, 'suspicious pies', and crisps, few served food. The first Chinese restaurants made a cautious appearance in the early 1950s and, like the fish and chip shops, daringly stayed open until after the 10 o'clock closing time of the pubs, but the Italian and Indian restaurants were a decade away.

In most public houses and clubs beer was consumed with reverence and decorum. Especially in the centre of the city, pubs were still unadorned temples of Bacchus where most of the devotees were men, though wives might join husbands and take a glass of stout, a port and lemon or even a Babycham. The jukebox was an American innovation which had not yet made its way from the milk-bar into the public house and 'musak' was happily yet to come. This allowed pubs and clubs to be about drink and conversation, either earnest and sometimes heated or consisting of gossip and chat, as men unwound after the day's work, especially in 'men only' bars or buffets presided over by matriarchal barmaids.

Youth culture was, however, beginning to emerge and was generally disapproved of by both Left and Right. Those 'juke-box boys' described by Richard Hoggart[18] were around in the Newcastle of the early 1950s and that other threat to civilisation, the Teddy Boys, were, with their drape jackets and crepe-soled shoes, ubiquitous on Tyneside and seem to have lingered longer there than in most parts of the country. Dance halls were more popular than ever before, and the Oxford in particular was an important centre of leisure life; waltzes and quicksteps were increasingly less popular as jitterbug gave way to jive, and rock 'n' roll came along in that year of cultural transition, 1956.

There were two revolts going on: that of working-class youth, dissatisfied with going from childhood to adulthood without a break before following in father's or mother's footsteps, and determined to make a splash in adolescence; and that of middle-class young. For most of the latter, jazz and tweed jackets were the thing, a modest revolt against convention, but for the intellectually ambitious it was jazz and a dark shirt and a corduroy jacket, which went along with contemporary novels, existentialism and a desire to transfer the Left Bank of Paris to the north bank of the Tyne. The concept of the student rather than the undergraduate became dominant. The students' union at the university became a vibrant social centre while the art students from Clayton Road took over the pubs of Brandling Village.

Of course, these developments, if forms of modernism, went against the grain of those who wanted to create a rational modern world, a planned and concrete Newcastle in which people would lead orderly communal lives. The new youth culture, however, found its centres, not in the concrete blocks, but in corners of the old Newcastle: in Nelson Street or the Royal Arcade, before it was pulled down, and, later, in the Handyside Arcade. Creativity and exuberance found its homes in the old Newcastle and it was here that were located the jazz clubs and the late-night coffee bars with their hedonistic sociability and heady, if sometimes pretentious, intellectualism, a new old world that recalled the coffee house and pubs frequented by the eighteenth-century artists and literati of the old town. This made for an odd, contradictory, but vital Renaissance of intellectual life.

The 1960s saw the emergence of a more varied nightlife. Some of it was brittle if colourful. Changes to licensing and gambling laws saw the coming of clubs like the Dolce Vita, Billy Botto's, the Picadilly and the Cavendish that provided roulette and blackjack tables, dancing, and late-night drinking and even the working men's clubs had their 'one-armed bandits'. Though the new nightspots provided a touch of glamour and adventure to an evening out, the profits generated by gambling attracted a criminal element and not one confined to the North East. They helped inspire a harder image of Newcastle associated with nightclubs and the control of gambling empires and with the corruption of local politicians and speculators and from the crime.

The film *Get Carter* (1970) may well have been inspired by the murder in 1967 of Angus Sibbert, a collector of the proceeds of one-armed bandits, and it portrayed a bleak urban landscape and a society of hard, ruthless men. The grim multi-storey car park in Gateshead from the top of which Carter (Michael Caine) throws the slot-machine king symbolises the stark desolation of the area and society. In the early twenty-first century the brutal outline of the disused car park still stood, the Manichean twin of the *Angel of the North* a mile to the south of it, and had begun to inspire an ironic affection before its long-delayed demolition began in 2009. As late as 1996 Newcastle's post-war history was to be the basis of the television drama serial *Our Friends in the North*, with its mixed tale of thwarted socialism, destroyed communities, political and business corruption and a criminal subculture.[19]

'Few cities,' Dominic Sandbrook has written in respect to *Get Carter*, 'felt more remote from the gaiety and glitter of Swinging London.'[20] Yet Newcastle

had always been more in touch with metropolitan taste and fashion than most provincial towns. There was more than a flash of the psychedelic in Newcastle and Pop Art had one of its first practitioners in Richard Hamilton, who taught in the Fine Art Department of Newcastle University in 1950s. In The Animals, Tyneside produced one of the leading pop groups of the early 1960s. That acme of musical and sartorial sophistication, Brian Ferry, studied under Hamilton, and founded Roxy Music at the end of the decade.

The influence of the counter-culture is in general much overestimated and can scarcely be said to have made a major impact upon Newcastle but it found its niches in the Handyside Arcade and its shops selling psychedelic posters, while at the Morden Tower, the variety of poets assembled by Tom Pickard included the 'Beat Poet' Allen Ginsberg, though a more important achievement of Pickard's was the rediscovery of Basil Bunting, at once of the area and a major figure in modernist poetry. There was even an echo of Les Evenements of 1968 as students in the Fine Art Department of the university encouraged by some junior lecturers staged 'sit-ins' and demanded a curriculum-free educational experience. For the most part, however, the counter-culture in Newcastle was about play, dressing up and smoking a bit of marijuana.

The fortunes of football clubs have come to be seen as a means of testing the temperature of cities. Newcastle United did not achieve much in the 1960s and 1970s. The team won the Inter-City Fairs Cup in 1969 and got to the FA Cup Final in 1974 only to be soundly beaten by a Liverpool team at its peak. The old enemy Sunderland had won the cup in the previous year and this may have deepened the rivalry between the two clubs, leading to the birth of a bitter mutual antipathy. The dominant narrative sees a previously friendly rivalry with fathers taking sons to see whichever team was at home transformed in the age of 'Mods and Rockers' into paramilitary conflict between gangs of supporters seeking set-piece fights, the harbingers of the extreme football violence of the 1980s. Perhaps this view underestimates earlier evidence of football hooliganism but it seems clear that, although Newcastle–Sunderland conflict was far from the worst example of football violence, a new hard-bitten bile was evident. More civilised accommodation for fans, sermons from the Football Association and government, and tougher policing of matches have calmed things but in the 2000s Northumbria Police still have to make elaborate arrangements to contain violence between gangs of fans.

Broader changes and more important changes were transforming the social and cultural life of the city. There were suddenly numerous places in which to eat that stayed open till later hours. By the end of the decade Chinese restaurants, though flourishing, were not the only choice for a late-night meal and they had been supplemented by Italian restaurants and steak houses. Indian cuisine (quite a lot of it in Newcastle is actually Bangladeshi) was to become so popular that some came to think that curries were a traditional Tyneside dish. Couples and families that had rarely eaten out before and had always had dinner at noon were venturing to restaurants like the Red House at the Sandhill and to pubs that did bar-meals and eating at eight. The Bigg Market was reclaiming its traditional position as a centre for often rowdy sociability, while the Cooperage public house and Julie's nightclub were harbingers of the later importance of the Quayside to social life.

The town was regaining in the 1960s the reputation it had had in the 1930s for its fashionable shops. The town's major department stores had always prided themselves on being up to date with the leading London fashions and now the new fashion outlets for the 'trendy' young, boutiques like Bus Stop, where you browsed for clothes while listening to the latest hits, opened. The number of hairdressers multiplied and were often daringly unisex, encouraging Newcastle males, hitherto the raw-necked victims of barbers, to have their long locks styled in once female sanctums. Models strutted in Fenwick's and Binns and by the 1970s Newcastle was not just an importer but an originator of style as the new Polytechnic's fashion department established itself as an important contributor to the national clothing industry.

The lightest of media images of Newcastle was to be found in the television comedy series *The Likely Lads*, first broadcast in 1964. It may well have pointed to more important social changes than more earnest endeavours. In many parts of Tyneside and in Newcastle the dominant urge on new private housing estates was to aspire to a 'modern' lifestyle, a semi-detached house, a car in the garage, Formica in the kitchen, a holiday abroad and a dinner party or a meal out with prawn cocktails, a steak and a bottle of Blue Nun. The tussle for Bob's soul between Hilda, the wife of Bob, and Bob's friend Terry, the unreconstructed working-class Tynesider, described in comic terms a central social development of the late twentieth century.

The 1960s picked up where the 1930s left off, moving Newcastle towards a future as a centre of administration and education, with the shopping centre and playground for its hinterland.

The New Newcastle

From the early 1980s a reaction against the planning and architectural vision of the post-war years was under way. The inhuman scale and brutal functionalism of the buildings, the urban flyovers and motorways which left parts of cities only accessible via pedestrian subways and bridges, and the destruction of familiar environments began to be regretted. This was a national mood but few cities were to reverse their planning policies as rapidly as Newcastle.

Although an early indication of a changed policy was the conservation and renovation of some of the city's historic buildings such as the much dilapidated Blackfriars, positive action on any scale was delayed by economic recession in the early 1980s and Newcastle scarcely felt the wind of the national economic recovery of the later years of the decade. During this period as the concrete of the recent buildings turned grey and water-stained the juxtaposition of that fine Victorian building, the Union Club, standing vacant and forlorn beside the horror of the Norwich Union building (in the early twenty-first century perennially in the top five of the buildings people would most like to be demolished) summed up the state of Newcastle. The Law Courts on the Quayside was one of the few imaginative and imposing buildings of the time.

It was from the 1990s that a regeneration which was sympathetic to the city's past got under way. 'Dynamic contrast' gave way to the construction of new buildings which were harmonious in texture and scale to those around them and the renovation of old buildings which could be put to new uses. These years saw also the abandonment of tower blocks and the refurbishment of some terraces in the ex-industrial suburbs, while new housing tended to accept the popularity of the hitherto derided terrace.

Much of the new approach was consciously historicist. The kernel of Grainger's development of central Newcastle had escaped destruction and was now busily cleaned and refurbished, while what was added, such as Monument Mall at the top

of Grey Street, was designed to be in harmony with its surroundings. The name of Newcastle's most successful developer was utilised for the Grainger Town Project, established in 1997, the aim of which was the refurbishment and redevelopment of an area stretching to the west of the city centre. The 1970s restoration of Black Friars was followed by new uses for the old buildings as the rehabilitation of the ancient fabric was combined with a restaurant and craft shops, while the new Jacobin's Court provided functional small apartments. Luckily, T. Dan Smith had, in a rare conservationist moment, preserved the Holy Jesus Hospital, though it requires perseverance to find it via an underpass beneath a busy road. The cleaning of the stonework in many of the city's finest streets was as important as more fundamental restorations. If often it is only the facades of buildings that have been preserved, this at least maintains the appearance of classical Newcastle.

The Centre for Life complex around Millennium Square is intended to encourage the development of Newcastle as a centre of science and technology, though its coloured shed-like buildings, though reflecting the railway tradition of the area, do rather jar with its surroundings and with Dobson's Weigh House preserved in their midst. The complex does, however, provide the city not just with a Bio-Science Centre, an Institute of Human Genetics and the Life Science, but with a square on the line of the old Scotswood Road. Newcastle, a sociable city, is distinctly short of those ambiences for public leisure, squares and, if not a very *square* square, the area with its bars and cafés and ice-skating in the winter months makes for a much-needed public space.

Central Newcastle was, though the damage done by the modernists could not be wished away, both conserved and revitalised by 2000 but the most important revitalisation was taking place on the riverside.

The Return to the River

Newcastle was in step with other major British cities, most obviously London, in turning back to its riverside. As urban riversides ceased to be centres of trade with shipyards, docks, busy quays and associated offices, and as rivers became cleaner, so they became the location of leisure, finance, prestigious business headquarters and desirable places to live.

Newcastle owes its existence to the Tyne but since the eighteenth century it had been gradually turning its back on the river and moving northward, a move first discernable when the wealthier inhabitants deserted their riverside homes. By the late twentieth century even industry and business had left the riverside. Few ships came up river as far as Newcastle and the river as a whole was no longer so busy; the shipping offices along the Quayside closed and there were derelict warehouses on both the Newcastle and Gateshead side of the river. It was not a promising area for redevelopment or regeneration until the river itself was cleaned up. Who would have wanted to live alongside a stinking and heavily polluted river or sit in a restaurant or public house and watched the sewage go by?

The state of the Tyne had not, since the mid-nineteenth century, been simply Newcastle's responsibility and the cleansing of the river passing the city's waterfront had, with the extent of the Tyne's tidal reach, to be either a joint enterprise by the riparian councils or a by a single body with responsibility for the whole river. The decline of riverside industries had meant a sharp fall in the amount of industrial pollution but the amount of sewage entering the river had been increasing for over a century, in part because the provision of piped water to most households had led to the ubiquitous water-closet discharging into sewage systems, themselves discharging into that convenient receptacle, the river. There had been talk about doing something to clean up the river since the 1920s when a River Tyne Pollution Sub-Committee was set up by the Ministry of Agriculture and in the 1930s a Joint Committee of local authorities had pursued further research. The Commissioner for Special Areas had proposed a scheme for dealing with pollution in the estuary in 1936; its plans for sewage treatment were estimated to cost £2.25 million. It was not until 1973, after many other joint boards had deliberated and made proposals which had come to nothing, that under the aegis of the Tyneside Joint Sewerage Board work began on an Interceptor Sewer and on a treatment centre at Howden upstream from North Shields. Since then progress has been relatively rapid with an important landmark being reached in 1995 when Northumbrian Water was given responsibility for both the provision of piped water and sewage disposal.

A cleaner river was the major inducement to the development of a riverside that would be a mixture of the residential and the recreational. The riverside had

been selected as ripe for regeneration as early as 1963 when it was proposed in the redevelopment plan of that year but nothing had been done by the 1980s when Newcastle began to realise that the river, its banks and its bridges were its greatest asset. Not just Newcastle because, of course, rivers have two banks and provide a means of communication as well as division.

A major part was played by a Gateshead Council made much richer and more powerful by its expansion under the 1973 Local Government Act. Gateshead had exemplified most of the worst mistakes of post-war planning in the 1950s and 1960s. Rows of terraced housing were demolished and tower blocks erected, and, although the fine Victorian Town Hall and adjacent public buildings were left intact, they and the rather bleak separated levels of the new town centre were marooned by major highways. From the 1970s, however, under the leadership of a formidable and imaginative duo, the Town Clerk Leslie Elton and Council Leader George Gill, Gateshead Council reversed many of its former policies, and was in many ways ahead of Newcastle in conservation and restoration, promoting the arts and culture, combining support for public services with attracting private businesses and capital. The new Civic Centre is not a grand building but it is friendly, practical and harmonious. New housing developments were in scale and in harmony with the view from the pavement as tower blocks were exchanged for urban villages.

Above all, Gateshead Council realised the potential of the riverside. The Council had in 1986 opened in partnership with private enterprise, the Metro Centre, claimed to be the largest shopping centre in Europe. Essentially pragmatic – the Metro Centre was after all built in one of the Conservative government's 'enterprise zones' – the Labour Council proceeded in conjunction with private enterprise and skilfully utilised every available government grant to oversee the regeneration of great stretches of the riverbanks. The Gateshead Quays organisation redeveloped a run-down stretch below the Tyne Bridge into a major centre for the arts, St Mary's church was restored and became a heritage centre, while the once notorious Bottle Bank acquire the Hilton Hotel and restaurants, bars and nightclubs.

The regeneration of the riverside involved not just the two councils, far from harmonious in their relationship, for Newcastle initially saw the Metro Centre as a threat to its retailing position, for a third party, the Tyne Wear Development

Corporation, had been set up by central government to develop land on the banks of the Tyne and the Wear in 1987. Not surprisingly this body, given sweeping powers by a Conservative government, was resented by Labour councils but the Corporation, born of Michael Heseltine's aim of transforming urban areas, played a crucial role. Gateshead kept it at arm's length, but Newcastle, like most Tyne and Wear councils, provided representatives on its board and co-operated with it. Although much criticised as essentially a land developer interested mainly in housing, business and leisure development, the Corporation contributed immensely to the new busy and prosperous riverside, bringing in the private capital that was necessary for its success. The physical and cultural Renaissance of the riverside would not have come about without it.

Large sailing vessels participating in the Tall Ships Races visited the river twice in the 1990s and in 2005 around a hundred sailing ships from many different countries competing in the race were moored in the Tyne, their graceful presence evoking the river's and Newcastle's history as many came from countries which had traded with town and river for centuries. The Millennium Bridge and the Quayside's bars, restaurants and Law Court provided the background of contemporary Newcastle. The bridge in particular pointed to the new relationship between the two banks of the river. Much more the icon of the new Tyneside than the Angel of the North, the Millennium Bridge epitomises the return to the river and, along with the Swing Bridge, provides the opportunity to cross it without first climbing away from it. Although Gateshead, justifiably, emphasises the bridge's south bank origins, its effect is to make the riverside as a whole one social and cultural centre.

There are some similarities between the two sides of the river in that both have made use of erstwhile industrial buildings, the Baltic Flour Mill on the south bank, now an art gallery, and the Co-operative Flour Warehouse on the Newcastle side, now the Malmaison Hotel. The differences are more striking. Which one prefers is a matter of taste but both have an integrity. The Newcastle side retains many of its historic buildings from the Cooperage to Sandgate and the Guildhall, the nineteenth-century development after the 1854 fire, and further east the eighteenth-century Custom's House; even the new Law Courts in Sandgate are in architectural union with Newcastle's past. Essentially the Newcastle side maintains a continuity with the city's history and with the classical tradition. By

contrast, most of the Gateshead side, with the exception of St Mary's church, is relentlessly modern and is dominated by the rather too dominant presence of the great slug in a glass and metal carapace that is the Sage Music Centre; controversial though its outward appearance may be, it provides a fine auditorium with magnificent acoustics. The public sphere dominates the south bank with, in addition to the Sage and the Baltic, an education precinct, though there is also to be a business park. The north bank has hotels (one, the Copthorne, on the site of the old Mansion House), the Live Theatre and a host of restaurants and wine bars, though it is the Law Court which has made solicitors and barristers emigrate there from the upper town. Increasingly, however, the drinking and clubbing nightlife has found southern outposts on the other side of the Swing Bridge and the lower reaches of Bottle Bank. An essential peregrination is the circular route from Sandgate down to the Millennium Bridge and via it back through the Sage to the Swing Bridge.

Further downstream, the Ouseburn would only a few years ago have seemed an unlikely site for an ambitious plan designed to turn it into an urban village beside a clear stream, the sort of area in which people might stroll, sit outside pleasant pubs and visit art galleries and craft workshops. The Ouseburn, a tidal stream in its lower reaches, had for centuries been the scene of a dynamic but increasingly filthy economy and a vital but unhealthy society. In 1900 it had still a number of sizeable firms, steel and iron forges, potteries, a flour mill, lead and glass manufacturers, while the Newcastle Co-operative Society's new slaughterhouse had just been built. Plenty of employment was provided but the tenements were as crowded and as unsanitary as those in Sandgate, and the stream was foul.[21] By the 1990s the industry and the people had largely gone, leaving some desolate scrapyards and some decent pubs. The pubs remain but the customers look out upon a transformed scene. Yet another flour mill has been converted into Seven Stories, the national centre for children's literature. Leisure, the arts, riverside flats, and yachting marinas make not only the Ouseburn but much of the banks and inlets of the Tyne pleasanter than they have been since the sixteenth century and the days when Dorothy Lawson looked out over meadows from her mansion at St Anthony's.

A Postmodern City

The economy of the Quayside reflects that of Newcastle as a whole for here is a city which is largely dependent on the public sector and on leisure and retailing. In this perhaps it reflects the Newcastle of the past more than many realise for, as we have seen, the town always depended to a great extent upon its position as the capital and administrative centre of Tyneside and the place where money earned elsewhere was spent. Yet sceptics, who remember that coal was traded here, that ships came and went loading and unloading cargoes, and that great warships, armaments and enormous turbines were made here, persist in wondering whether this spendthrift party city has solid foundations. Can you have tertiary and quaternary layers of the economy without the primary and secondary layers or is this a house without first and second floors? Are wine bars, cafes and art galleries a sustainable substitute for shipyards and docks? Is it just government grants that kept a dependent economy moving? Never mind, economists say, shopping, leisure and entertainment are as useful as shipyards. They have certainly have deep roots in Newcastle's past.

Newcastle has rarely appeared more prosperous. Visitors to the city expecting a blunt workaday industrial town are amazed as they encounter a world of wine bars, restaurants and art galleries and a renewed riverside of pedestrian precincts. In the centre of the town there was rebranding as well as redevelopment as historicism gilded an emergent lifestyle not just preserving the past but playing tricks with it. This is a post-modernist city, a city of references rather than blunt statements. It makes the most of its topography and is full of eye-catchers, teasing public sculpture and paradoxes: flourmills have been turned into art centres and hotels, banks into wine and vodka bars, and there is an international melange of Irish pubs and Spanish tapas restaurants. Only a few old pubs remain with their original interiors but if others are exotically 'themed' some, once 'modernised', are now ersatz Victorian or Edwardian. Newcastle's face to the world has changed kaleidoscopically in a half-century. 'Sorry for itself' and embittered Newcastle gave way to hard Newcastle and now there is fashionable and party Newcastle. Students from the south of England and abroad are attracted, not just by the academic merits of the universities but by the appeal of Newcastle's nightlife. Almost every part of the city seemed to have been refurbished, the changes of the last decades eradicating many of those made earlier in the twentieth century.

Thus on the Manors–Sandyford border a massive railway goods station built in the early 1900s was succeeded in the 1980s by a multi-screen cinema, itself now replaced by the new East Campus of Northumbria University; a successful development with its steel-clad glass buildings and courtyard, it is reached from the main campus by a graceful footbridge which does much to mitigate the divide of the urban motorway. The Gate at Newgate is a microcosm of the city's entertainment and shopping persona, a high glass-fronted building housing cinemas, restaurants and a casino; it has established itself as the town's major nightspot. The new City Library together with the glass-bowed entrance to the Laing Art Gallery have a common frontage to a pedestrian precinct and this works well, even if the 'Blue Carpet', composed of blue glass from sherry bottles, is rarely properly blue. This is a fashionable and self-confident city.

The appearance and the feel of streets at ground level give cities their personalities. The mix of old buildings conserved and given new uses, new buildings disguised as old, and post-modernist buildings raiding time, produce the right backdrop for a boisterous, dynamic and irreverent society. Echoes of the past are loud and the strongest are those from eighteenth-century Newcastle, for the combination of sociability, a vital and a raw hard-drinking populism, a confident and esoteric intellectual and cultural life and an unabashed fondness for sartorial display recall the paradoxes and exuberance of that long century.

Contemporary Newcastle is a youthful city. The expansion of Newcastle University (previously King's College), which became independent from Durham University in 1963, the foundation of the Polytechnic (1968) and its development into a major national university together with the enlarged Newcastle College have set their stamp on the city, physically with the buildings of their campuses, but also economically and socially. The pre-war plans for an educational complex around Barras Bridge and the Haymarket have been translated beyond the modest expectations of the 1930s, while the economy has come to depend upon the numbers of students, lecturers and researchers who need not just lecture rooms and laboratories but accommodation, shops, pubs and clubs. Their needs are satisfied as entrepreneurs identify them and they have played a central role in Newcastle's social and cultural renaissance.

The developing culture of Newcastle has disappointed those who thought that a provincial city should develop an artistic and literary life independent

from, even opposed to, that of London, a bottom-up rather than a top-down culture. In practice late twentieth-century Newcastle, as in the past, was engaged in a dialogue with national culture but was essentially part of it. Novelists and playwrights might utilise their town's history, local life and their own experiences, just as did those from London, Bristol or Edinburgh, but few desired to be known as 'provincial writers' and, along with successful artists or actors, most made for London like their eighteenth-century forebears. What was beginning to emerge, due to the expansion of the universities and the increased number of theatres and art galleries, was a critical mass in intellectual and cultural life which created an ambience that was neither dustily and sentimentally provincial nor a passive recipient of culture from without but a vocal element in Britain's cultural life. Much the same was true of popular culture. Soaps with provincial settings became part of national culture and as *Hollyoaks* was to Chester so *Byker Grove* was to Newcastle, the latter bequeathing Ant and Dec to a no doubt grateful national audience, while Cheryl Cole epitomises the Tyneside girl made good via a national talent show.

To the visitor, Newcastle in the evening may seem a seamless, if rather alarming, social whole, but there are many distinctions. As those who have been to the Theatre Royal, ventured across the river to a concert at The Sage, or dined at the more decorous restaurants depart, the noisy crowds who make their way round clubs and bars are just starting their night out. Far from undifferentiated, they are made up of different tribes: tastes in music provide one set of distinctions, students tend to circulate around one set of bars, there are gay bars and hard bars, and the Bigg Market tends to attract a different crowd to the Quayside or Osborne Road. The tribes sometimes clash and the unwary student who finds himself in the wrong place may be in trouble for being a southerner; he's probably from Manchester.

Newcastle has experienced no great crises in terms of racial relations. Some put it down to the welcoming and anti-racialist nature of Tynesiders but more probably it is because recent immigrants make up less than 10 per cent of the city's population[22] and because no single group of immigrants are preponderate among the ethnic minorities. Pakistanis make up the largest single minority but this is only marginally larger than the Indian population. A section of both groups, but Indians in particular, have moved smoothly into the professional and

business classes, tend to live in Gosforth or Kingston Park, send their children to the city's independent schools, and in general have followed the path, previously followed by Jewish immigrants, of melding in with the middle classes, while maintaining their religious traditions. Only along the West Road is there a sense of a Newcastle where there is a large Asian presence. Chinese were a rarity until the 1950s but now make up more than 1 per cent of the population. Almost entirely from Hong Kong or refugees from Mao's China escaping via Hong Kong, the great majority are still involved in the restaurant business where they first made their mark in brightening up Newcastle's nightlife. When restaurant proprietor Peter Chen first opened the Happiness Inn in Percy Street, he was a bold pioneer but, decades later, nearby Stowell Street has become the centre of an expanding Chinatown. This closely knitted community may still be largely associated with restaurants but the move of the younger generation into the professions, academia, finance and IT seems ordained. An exotic claim to fame is that Newcastle has more Bolivians than almost any other British city, almost 2,000 by the last count.

There are, however, problems as in all British cities. Much of the east and west ends of the town have not recovered from the decline of the industries which largely created them, nor from the developments of the 1960s and 1970s which sort to remodel them. Away from the riverside, whole stretches seem post-industrial in a purely negative way and just a short distance from the city centre are inner-city housing estates where this means unemployment and specifically no decent jobs for men, welfare dependency and family structures that have collapsed or are shaky.

The café society might look decorous enough in the afternoon but the old drunken Adam and a newly legless Eve tend to take over later in the evening. The Newcastle young are a hardy lot, the men in shirt sleeves and the women in short skirts with bare midriffs even on freezing February evenings, and a good-humoured bunch as they down their first pints and cocktails under the solemn gaze of the portraits of old Newcastle worthies in what was formerly the Union Club before setting off on an extended pilgrimage of bars and clubs. Later on, whether in the Bigg Market or Quayside, they stagger a bit, became more raucous and more amorous and the occasional fight breaks out. To some this seems the harmless, vibrant spectacle of the young enjoying themselves, to

others a Hogarthian nightmare, a return to Gin Lane. The comic magazine *Viz* portrays this world well with its splendidly politically incorrect portrayals of the 'Fat Slags', Sandra and Tracey, 'Sid the Sexist', and '8-Ace', known for his daily consumption of eight cans of extra-strength lager. In 2007, Chief Constable Michael Craik proclaimed 'The party's over' and more arrests for drunkenness and disorder followed. The shade of Cuthbert Ellison (see page pp. 68-9) cracking down on the antics of long-haired apprentices must have nodded in agreement. The party continued with, it was hoped, a little more decorum.

Not all was rosy in the late 2000s. The collapse of Northern Rock, a business which had grown rapidly from a modest provincial building society into a bank with national ambitions and which appeared a model of the new financial services economy had a dampening effect. Financial services was a sphere in which Tyneside was otherwise weak and Northern Rock was not just a major employer but was important both as a financial powerhouse and via its foundation, which received 5 per cent of the Rock's pre-tax profits, a major supporter of the arts, sport and charities. The queues outside its branches as rumours of its debts spread in the late summer of 2007 were to be found all over Britain but the epicentre was in Newcastle, where its Gosforth headquarters was even then expanding. Adam Applegarth, who had spent almost his entire career with the firm and become its chief executive at the age of thirty-nine in 2001, had increased its lending between 2003 and 2007 from £42 billion to £113 billion on the back of the credit boom. The bank's business model largely relied on funding from wholesale money markets and when banks stopped lending to each other there was no 'Plan B'. The world, as Applegarth put it, had suddenly changed with the collapse of inter-bank lending. Northern Rock's chairman, Matt Ridley, declared, the crisis was due to an 'unexpected and unpredictable concatenation of events'. Northern Rock was only the first of many financial institutions to be overwhelmed by this concatenation and perhaps suffered unfairly by being the first. Newcastle banks and companies had ever been confident and dynamic; sometimes too much so.

The blow to the North East and to Newcastle was, however, shattering. During recent decades the town had become increasingly a branch economy. The heavy industries which had their headquarters there had gone, many banks had moved their northern headquarters to Leeds, and even the utilities, gas, electricity and water were no longer under local ownership. Northern Rock's fall seemed to

leave the IT firm Sage as the only Newcastle-based business with a national reputation, though Greggs have expanded from a small bakery in Gosforth into a large national chain of shops. This setback to the new Newcastle was followed by the final rites for an older institution as in 2009 the history of Swan Hunter came to its end. Its great cranes were dismantled and shipped to their new owners, Bharati Shipyards of India, leaving a gap in the landscape and a regret for a past economy just as faith in a new one was weakened. The demand for oil platforms was weakening; could wind-farm manufacture, proposed at Walker Offshore Park, take its place?

What you see as you approach Newcastle from the south are the castle keep, the cathedral, All Saints *and* St James's Park with its massive concrete struts which to many is the most popular image. In 2009 Newcastle United dropped out of the Premier League. The club had enjoyed no great triumphs in recent years but had always been there as one of the great English football teams – twice second in the league in the 1990s and with two FA Cup finals, both lost. To those uninterested in football, the psychological blow of a setback to a football team largely composed of players with no connection with Newcastle is difficult to comprehend. Some acquaintance with the team and its fortunes had, however, become almost obligatory for anyone professing local patriotism. Politicians, business leaders and university vice-chancellors found it essential to make some jocular reference to Newcastle United in their speeches, while lawyers and executives had rejoiced in the corporate hospitality provided in the boxes at St James's Park. Did relegation matter little, or was Newcastle United in its Northern Rock shirts, playing in a stadium up for rebranding, the canary in the cage for the new Newcastle? Happily for the city's self-confidence, the team were soon back in the Premier League.

The region as a whole seemed dangerously reliant on government spending. The proportion of regional Gross Domestic Product that came from this source in the North East was, at 66.4 per cent, the highest in England. Unlike some other northern towns, Newcastle was not quite what the press termed a 'Soviet Town' with the vast majority of its workforce employed by the state, though many of the 13,400 employed by the Department of Work and Pensions work and live in Newcastle and the universities and local government are dependent on central government grants. A reduction in government spending could hit Newcastle hard.

Dire prophesies are, however, usually wrong and, viewed from the Pitcher and Piano, an elegant bar and restaurant opposite the Sage, or from busy Northumberland Street, Newcastle appears vigorous. The erstwhile monochrome town has become colourful and dynamic. Its fortunes have varied since the Romans built a bridge and a fort, but it is one of England's great cities and it has demonstrated over the centuries that it is adaptable, resourceful and creative. It remains what Camden called it, 'Ocellus, the eye of the north'.

NOTES

1 THE EARLIEST ORIGINS OF NEWCASTLE

1. D.H. Heslop, 'Newcastle and Gateshead before AD 1080', *Newcastle and Gateshead before 1700*, eds Diana Newton and A.J. Pollard (2009), pp. 7–8.

2. Nick Higham, *The Northern Counties to AD 1000* (1986), p. 147.

3. It is noteworthy that each of the forts at the east end of the wall – those at South Shields, Wallsend and Newcastle – had harbour facilities capable of accommodating seagoing vessels.

4. See 'Museum Notes, 1976' by Clair Caplan and T.G. Newman, *Archaeologia Aeliana*, 5th series, vol. 4 (1980). Altars to Oceanus are rare as he was not usually worshipped and of the traces of statues or inscriptions surviving most come from the shore of the Northern Ocean.

5. Margaret Snape and Paul Bidwell, 'Excavations at Castle Garth, Newcastle upon Tyne, 1976– 92, the excavation of the Roman Fort', *Archaeologia Aeliana*, 5th series, vol. 31 (2002), p. 25.

6. We know of the presence of Trajan's Own Cugerni from an inscription expressing loyalty to the Dowager Empress Julia Domna set up by this legion in AD 213. See Charles Daniels and Barbara Harbottle, 'A New Inscription of Julia Domna from Newcastle', *Archaeologia Aeliana*, 5th series, vol. 8 (1980). The later presence of the Cornovii is attested to by the Notitia Dignitatum, a fifth-century source.

7. Henry Bourne, *The History of Newcastle upon Tyne, or the Ancient and Present State of that Town* (1736), p. 4.

8. At Benwell there was a temple to Antenociticus, probably a local god, which housed his statue. The remains of the temple can still be seen and the head and legs of the statue are in the Museum of Antiquities at Newcastle University.

9. N. Pevsner and I. Richmond, *The Buildings of England: Northumberland* (2nd edn, 1992), p. 42.

10. Raphael Holinshed, author and compiler of *Chronicles of England Scotlande and Irelande* (1577).

11. Bourne, *A History of Newcastle*, p. 9.

12. Ibid, p. 6.

13. R.A. Lomas, *North East England in the Middle Ages* (1992), p. 15.

14. S. Middlebrook, *Newcastle upon Tyne: Its Growth and Achievement* (1950), p. 9.

15. *Newcastle's Changing Map*, eds M. Barke and R.J. Buswell (1992), p. 15.

16. R.J. Charleton, *Newcastle Town* (1885), p. 15.

17. Nick Higham, *The Northern Counties to AD 1000* (1986), p. 313.

18. J. Hodgson Hinde for instance argued that Pandon had a continuous existence from early Anglian times but that the area of the Roman fort was unoccupied until the building of the castle.

19. F.W. Dendy, 'The Making of Newcastle' in *Three Lectures Given to the Literary and Philosohical Society of Newcastle* (1921), pp. 4–5.

2 Medieval Newcastle

1. Robert Fulton Walker, *The Origins of Newcastle upon Tyne* (1976), p. 2.

2. The Black Gate was built just before what had been seen as the great age of castle design, with the most magnificent examples being those built by Edward I in North Wales between 1280 and 1300 (Conway, Beaumaris, Caernarvon, Harlech, etc.). The great gatehouse at Dunstanburgh Castle 1314 exemplifies a further stage in the development of castle architecture. Here the massive gatehouse takes the place of a keep altogether.

3. See, for instance, Middlebrook, *Newcastle upon Tyne*, p. 34.

4. Barbara Harbottle, 'The Medieval Archaeology of Newcastle' in *Newcastle and Gateshead before 1700*, p. 24.

5. Walker, *The Origins of Newcastle upon Tyne*, p. 42

6. R.B. Dobson, 'Urban Decline in Late Medieval England', *Transactions of the Royal Historical Society*, 5th series, vol. 27 (1977).

7. C.M. Fraser and K. Emsley, 'Law and Society in Northumberland and Durham 1290–1350', *Archaeologia Aeliana*, 4th series, vol. 47 (1958).

8. R.F. Walker, *The Institutions and History of the Freemen of Newcastle upon Tyne*, p. 6.

9. J.R. Boyle and F.W. Dendy (eds), 'Extracts from the Records of the Merchant Adventurers of Newcastle, vol. 1', *Surtees Society*, vol. xciii (1895). Matt Ridley, *A History of the Merchant Adventurers of Newcastle upon Tyne* (1998).

10. R. F. Walker, *Freemen*.

11. Boyle and Dendy, p. xxiii.

12. Matthew Holford, Andy King and Christian D. Liddy, 'North East England in the Later Middle Ages', in *Regional Identities in North-East England 1300–2000* eds Adrian Green and A.J. Pollard (2007), p. 37.

13. There were goldsmiths in the town by at least the thirteenth century, for a mandate of Henry III commanded 16 provincial towns, including Newcastle, to set up mints to produce new coinage, and without the existence of goldsmiths this would not have been possible. The Newcastle Mint seems, however, to have soon died out. Margaret Gill, 'The Newcastle Goldsmiths and the Capital', *Archaeologia Aeliana*, 5th series, vol. 8 (1980).

14. J. Conway Davies, 'The wool customs accounts for Newcastle upon Tyne for the reign of Edward I', *Archaeologia Aeliana*, 4th series, vol. 32 (1954), pp. 277–8.

15. In the 1390s there was a brief period when English ships managed to get into the Baltic but, after the *Good Year*, owned by Roger Thornton and other merchants, was seized in a dispute over custom dues demanded by Rostock and Wismar, Newcastle merchants and ships' masters were understandably chary of entering the Baltic. Leslie W. Hepple, *A History of Northumberland and Newcastle upon Tyne* (1976), p. 55.

16. Ibid, p. 54.

17. 'The customs accounts of Newcastle upon Tyne 1454–1500', ed. J.F. Wade, *Surtees Society*, vol. ccii, 1995.

18. R. Welford, *History of Newcastle and Gateshead*, vol. 1, p. 11.

19. The Cale Cross is first mentioned in early fourteenth century records. It was taken down in 1773 and then rebuilt in 1783 by Sir Matthew White Ridley. Having become an inconvenience to traffic, it was re-erected in the grounds of Blagdon Hall in the early nineteenth century.

20. As has been noted population figures depend upon an extrapolation from the numbers of heads of households paying taxes. What the average size of a household was is debatable while the poor did not pay taxes. Most historical demographers believe that the mid-fourteenth century. Black Death reduced the population of England by two-fifths and it dwindled further thereafter. A decline in Newcastle's population from about 5,000 in the late thirteenth century to some 4,000 in the late fourteenth century seems therefore modest and it may be that it has been underestimated.

21. Welford, *History of Newcastle and Gateshead*, p. 67.
22. Ridley, *Merchant Adventurers*, p. 21.
23. A full account of the Denton affair is contained in Constance Fraser, 'The Life and Death of John Denton', *Archaeologia Aeliana*, 4th series, vol. 37 (1959), pp. 303–325.
24. Leslie W. Hepple, *A History of Northumberland and Newcastle upon Tyne* (1976), p. 64.
25. It has been suggested that the word 'chare' comes from the Saxon 'cerre' meaning turning or bending. P. Winter, D. Milne, J. Brown and A. Rushworth, *Northern Heritage: Newcastle upon Tyne* (1989), p. 64.
26. A.J. Pollard, *North Eastern England during the Wars of the Roses* (1990), p. 43.
27. M. Threlfall-Holmes has demonstrated that Durham Cathedral Priory, a substantial local consumer, was able to purchase nearly all its requirements from Newcastle merchants. See 'The Import Merchants of Newcastle upon Tyne, 1464–1520: Some Evidence from Durham Cathedral Priory', *Northern History*, vol. 40 (2003), pp. 71–88.
28. W.G. Hoskins argued that it was among the first four provincial towns in the 1520s. See 'English Provincial Towns in the Early Sixteenth Century', *Transactions of the Royal Historical Society*, 5th series, vol. 6 (1956).

3 Tudor Newcastle

1. J.R. Blake, 'The medieval Coal Trade of North East England: Some Fourteenth Century Evidence', *Northern History*, vol. 11 (1967), pp. 3–26.
2. McCord and Thompson, *Northern Counties from AD 1000*, p. 131.
3. Maud Sellers, 'York Merchant Adventurers', *Surtees Society*, vol. cxxix (1917), p. xxiii.
4. Ibid, pp. 141–2.
5. A. Osler and A. Barrow, *Tall Ships Two Rivers* (1993), p. 11.
6. Osler and Barrow, *Tall Ships*, p. 12; Dendy, *Newcastle Merchant Adventurers*, vol. 2, pp. 160–1.
7. Charleton, *Newcastle Town*, p. 34.
8. Sutton owed the grant of lease of the coal-rich manors to the patronage of the Dudley family into which he had married. Despite having to sell the lease to the Newcastle consortium, he died a very rich man and his will laid the foundations of the major charitable trust of Charterhouse.
9. R. Lomas, *North East England in the Middle Ages* (1992), p. 90. The Durham Chancery Court lingered into the twentieth century.
10. L.W. Hepple, *A History of Northumberland and Newcastle upon Tyne* (1976), p. 53.
11. Diana Newton, 'The Clergy, Identity and Lay Society in the Diocese of Durham, 1561–1635', *Northern History*, vol. 44, 1 (2007), pp. 35–54.
12. Rosamund Oates, 'Catholicism, Conformity and the Community in the Elizabethan Diocese of Durham', *Northern History*, vol. 43, 1 (2006), pp. 53–76.
13. Newton, 'Clergy, Identity and Lay Society', p. 44.
14. Welford, vol. 2, p. 288. This seems to contradict Welford's later comment that John Knox was going to be offered the proposed bishopric of Newcastle (p. 299).
15. See Oates, 'Catholicism, Conformity and the Community'.
16. Welford, vol. 3, pp. 57–8. Longstaffe in *Memoirs of Ambrose Barnes, Surtees Society*, vol. 50, (1886), p. 92, says that the book Udale was accused of writing was one of those written under the nom-de-plume 'Martin Marprelate'.
17. See Christine Newman, 'The Reformation Era in Newcastle, 1550–1662', in *Newcastle and Gateshead before 1700*, and Rosamund Oates, 'Catholicism, Conformity and the Community', for contrasting views.
18. Welford, vol. 3, pp. 137–143.
19. In 1623 the Corporation voted against the King's candidate and appointed John Gray, who was related to many of the town's principal families.

20. According to Bourne, *The History of Newcastle upon Tyne, or the Ancient and Present State of that Town* (1736).
21. Roger Howell Jr, *Newcastle-upon-Tyne and the Puritan Revolution* (1967), p. 45.
22. Ibid, p. 47.
23. Welford, vol. 3, p. 145.
24. The ancestry of the Ellisons has not been traced very far back. Such excellent historians as Hodgson and Surtees, respectively the historians of Northumberland and Durham, concluded that the Ellison pedigree could only be definitely traced to Cuthbert Ellison of Newcastle who was born in the early sixteenth century. Welford mentions one 'Rob fil Elye' listed in the pipe rolls of the reign of Henry III: R. Welford, *Men of Mark 'Twixt Tyne and Tweed* (1895), p. 145. The *Northumberland County History* mentions a Thomas Elyson who appears in the 'Black Book of Hexham' as a Priory tenant in 1479 and a John Ellison, Vicar of Chollerton in 1485. *Northumberland County History*, Vol. III, p. 148 and Vol. IV, p. 267.
25. A.W. Purdue, *Merchants and Gentry in North East England 1650–1830* (1999), pp. 18–19.
26. 'An Acte for the Apparel of Apprentices', 14 November 1554. Boyle and Dendy, *Records of Merchant Adventurers*, vol. 1, pp. 20–2.
27. Welford, vol. 3, p. 61.
28. Ronald Hutton, *The Rise and Fall of Merry England: The Ritual Year 1400–1700* (1994), p. 95.
29. Ibid, p. 115.
30. Howell, *Newcastle and the Puritan Revolution*, p. 28.
31. Sparhawk was a point at sea beyond the harbour bar and Tynemouth Priory.

4 NEWCASTLE 1603–1688

1. Charleton, *Newcastle Town* (1882), p. 209.
2. Gray, *The Chorographia or Survey of Newcastle upon Tyne* (1649), p. 84.
3. Roger Howell Jr, *Newcastle-upon-Tyne and the Puritan Revolution* (1967). See also Professor Howell's 'Newcastle and the Nation: The Seventeenth Century Experience', *Archaeologia Aeliana*, 5th series, vol. 8 (1980).
4. Roger Finch, *Coals from Newcastle* (1973), p. 41.
5. Quoted by Middlebrook, *Newcastle upon Tyne*, p. 83.
6. Grey, *Chorographia* (1649).
7. Keith Wrightson, '"That Lamentable Time": Catastrophe and Community in the Great Newcastle Plague of 1636', in *Newcastle and Gateshead before 1700*, p. 253.
8. Welford, vol. 3, p. 160.
9. Welford, vol. 3, p. 252. The Riddells were to become squires of Swinburne, Cheeseburn Grange and Felton and were to maintain their Catholicism until the present day.
10. Newton, 'Clergy, Identity and Lay Society', p. 42.
11. Middlebrook, *Newcastle upon Tyne*, p. 71.
12. See, for instance, A.J. Fletcher, *The Outbreak of the English Civil War* (1981) and C. Russell (ed.), *The Origins of the English Civil War* (1975).
13. J.C.D. Clark, *Revolution and Rebellion: State and Society in England in the Seventeenth and Eighteenth centuries* (1986), p. 54.
14. John Brand, *History of Newcastle*, vol. 1 (1789), p. 460.
15. Charles R. Humphrey and Chris Brown, 'The Defences of Newcastle upon Tyne in the Civil War' (unpublished paper, Centre for Lifelong Learning, University of Newcastle upon Tyne) Part One 1638–42, p. 2.
16. Ibid, Part Two 1642–44, p. 23.
17. C.J. Bates, *History of Northumberland* (1895), p. 249.
18. Middlebrook, *Newcastle upon Tyne*, p. 71.

19. Howell, *Puritans and Radicals in North England* (1984), pp. 9–10.

20. The suburbs of Newgate and Sandgate were burned down on Marley's orders as the houses afforded the besiegers too much cover.

21. Brand, *History of Newcastle*, vol. 1, p. 233.

22. Howell, *Newcastle and the Puritan Revolution*, pp. 342–3.

23. Alfred J. Ellison, 'Ellison Portraits 1510–1936', typed manuscript, South Tyneside Central Library (1936), p. 45.

24. Marley was sent to London to be imprisoned in the Tower but managed to escape on the way and get to France.

25. Richard Welford, biographical article on Robert Ellison in *Newcastle Weekly Chronicle*, 16 May 1891.

26. See Howell, *Newcastle and the Puritan Revolution*, pp. 182–4.

27. J.P. Cooper, 'Social and Economic Policies under the Commonwealth', in *The Interregnum: The Quest for Settlement*, ed. G.E. Alymer (1972), p. 137.

28. A point between Wylam and Ryton that marks the tidal limit of the river.

29. *Memoirs of Ambrose Barnes*, ed. W.H.D. Longstaffe, Surtees Society (1867), p. 215.

30. Bourne, *History of Newcastle*, p. 11.

31. Roger Howell, *Puritans and Radicals in North England* (1984), p. 24.

32. Bourne, *History of Newcastle* (1736), p. 173.

33. E. Mackenzie and E. Ross, *An Historical, Topographical, and Descriptive View of the County Palatinate of Durham*, vol. 1 (1834), p. 15.

34. *Memoirs of Ambrose Barnes*, p. 173.

35. Howell, *Newcastle and the Puritan Revolution*, p. 186.

36. For the Blacketts, see A.W. Purdue, *The Ship That Came Home: The Story of a Northern Dynasty* (2004).

37. H. Roseveare, *Markets and Merchants in the Late Seventeenth Century* (1987), pp. 66, 280, 55, 88.

38. Ibid, p. 84.

39. *Memoirs of Ambrose Barnes*, pp. 176–7.

40. *The Records of the Merchant Adventurers of Newcastle upon Tyne*, 4 May 1686, vol. 1, p. 231.

41. Ibid, 25 June 1686, pp. 231–2.

42. Ibid, 18 September 1688, pp. 235–6.

43. Charleton, *Newcastle Town*, p. 67.

44. Eveline Cruikshanks, 'The Revolution and the Localities: Examples of Loyalty to James II', in *By Force or by Default?* ed. Eveline Criukshanks (1989), p. 39.

45. Leo Gooch, *The Desperate Faction?* (2001), pp. 13–14.

5 NEWCASTLE IN THE 'LONG EIGHTEENTH CENTURY'

1. 'Obsequies of certain of the family of Blackett in Newcastle', in M.A. Richardson, *Reprints of Rare Tracts* (1847).

2. The Act was designed to prevent a reoccurrence of the long Cavalier Parliament of Charles II. It was superseded by the Septennial Act of 1716 but during its lifetime there were ten general elections.

3. W.A. Speck, 'Northumberland Elections in the Eighteenth Century', *Northern History*, vol. 28 (1992), p. 166.

4. Leo Gooch, *The Desperate Faction?* (2001), p. xxi.

5. Daniel Szechi, *1715: The Great Jacobite Rebellion* (2006), p. 251.

6. James eventually landed at Peterhead in December 1715 accompanied by two attendants.

7. J.D. Oates, 'Northern Responses to the "15"', *Northern History*, vol. 43, 1 (2006).

8. Ibid.

9. J.D. Oates, 'Jacobitism and Popular Disturbances in Northern England, 1714–1719', *Northern History*, vol. 41, 1 (2004), p. 126.

10. Henry Liddell to William Cotesworth, 19 June 1716, *Liddell–Cotesworth Letters*, ed. J.M. Ellis, Surtees Society (1985), p. 240.

11. In 1716, the Septennial Act was passed, making the maximum term of a parliament seven instead of three years and thus there were general elections in 1715, 1722, 1727, 1734 and 1741.

12. Frank O'Gorman, *The Long Eighteenth Century* (1997), p. 148.

13. Many potential voters, around 30 per cent in 1774, according to a manual analysis of poll books, were outvoters, freemen of the town who lived elsewhere, a factor that may help account for comparatively low polls.

14. J.C.D. Clark, *English Society 1688–1760* (1985), p. 132.

15. Charlton, *Newcastle Town*, p. 269.

16. Speck, 'Northumberland Elections', p. 168.

17. T.R. Knox, 'Popular Politics and Provincial Radicalism: Newcastle upon Tyne, 1769–85', *Albion*, 2 (1979), p. 226.

18. Jenny Uglow, *Nature's Engraver: A Life of Thomas Bewick* (2006), p. 82.

19. Paul Langford, *A Polite and Commercial People 1727–1783* (1989), p. 721.

20. Marat is supposed to have saved the life of James Losh, when, full of revolutionary sympathies Losh visited Paris in 1792 and was in danger of being executed because of his aristocratic appearance. The story is retold by Stephen Harbottle, *The Reverend William Turner: Dissent and Reform in Georgian Newcastle* (1997), p. 64, who doubts its authenticity.

21. P.M. Horsley, *Eighteenth-Century Newcastle* (1971), pp. 209–10.

22. *Cecilia: The Life and Letters of Cecilia Ridley, 1819–1845*, ed. Viscountess Ridley (1958), p. 45.

23. Bowes went on to lead a spendthrift life and became notorious for his cruelty to his wife, whom he kept a virtual prisoner while he went through her money. When she ran away he kidnapped her from a London street, but he thus went too far and she eventually succeeded in gaining a divorce. He died, in his own words, 'stoney broke'. See Ralph Arnold, *The Unhappy Countess* (1957) and Wendy Moore, *Wedlock* (2009).

24. A.W. Purdue, *Merchants and Gentry in North-East England 1650–1830* (1999), pp. 95–6.

25. *Diaries of James Losh*, Surtees Society, vol. clxxi (1961). Entry for 18 March 1820.

26. Welford (ed.), *Men of Mark 'Twixt Tyne and Tweed*, p. 151.

27. P.D. Brett, 'The Newcastle Election of 1830, *Northern History*, vol. 24 (1988), pp. 110–13. Ridley was not so open-handed as his predecessors. His agent also complained that he hadn't refreshed the London outvoters.

28. Middlebrook, *Newcastle upon Tyne*, p. 175, suggests 3,000 as the number qualified to vote but this leaves out the outvoters. Many of the latter lived close to Newcastle with considerable numbers in North Shields and Hexham but the number of outvoters resident in London was substantial at about 9 per cent of the total electorate.

29. Charleton, *Newcastle Town*, p. 319.

30. Joyce Ellis, 'Cartels in the Coal Industry on Tyneside 1699–1750', *Northern History*, vol. 34 (1988), p. 148.

31. Bill Purdue, 'Ralph Carr: A Newcastle Merchant and the Baltic Trade in the Mid-Eighteenth Century', in *Britain and the Baltic*, eds Patrick Salmon and Tony Barrow (2003).

32. Accurate estimates of coal cargoes are made impossible as the size of keel boats and chaldrons varied over time.

33. B. Dietz, 'The North-East Coal Trade, 1550–1750', *Northern History*, vol. 22 (1986), pp. 280–94.

34. See William J. Hausman, 'Size and Profitability of English Colliers in the Eighteenth Century', *Business History Review*, vol. 51, 4 (1977) and Simom Ville, 'Total Factor Production in the English Shipping Industry: The North East Coal Trade 1700–1859', *Economic History Review*, vol. 39 (1938).

35. Finch, *Coals from Newcastle*, pp. 68–75.

36. Tony Barrow, *The Whaling Trade of North East England 1750–1850* (2001).

37. F.W. Dendy, *Extracts from the records of the Company of Hostmen of Newcastle upon Tyne*, Surtees Society, vol. cv (1901), pp. 160 and xxxv.

38. Some historians have favoured 1688 as the starting point for this revolution (see P.G.M. Dickson, *The Financial Revolution in England: A Study in the Development of Public Credit, 1688–1756* (1967)) while H. Roseveare, *The Financial Revolution 1660–1760* (1991) argues that the reign of Charles II saw the beginning of the radical transformation of the financial system.

39. Col. R.E. Carr, *The Family of Carr*, vol. 1 (1893), p. 46.

40. J.M. Ellis, 'The Decline and Fall of the Tyneside Salt Industry 1660–1790: A Re-examination', *Economic History Review*, vol. 33 (1980), pp. 45–48.

41. McCord and Thompson, *The Northern Counties*, p. 211.

42. John Hodgson, *History of Northumberland* (1820–40) vol. 2, p. 272.

43. Joyce Ellis, '"The Black Indies". The Economic Development of Newcastle, c. 1700–1840', *Newcastle upon Tyne: A Modern History*, eds Robert Colls and Bill Lancaster (2001), p. 8.

44. N. McCord, *North East England: The Region's Development 1760–1960* (1979), p. 75.

45. This rather ambitious project was briefly revived in the 1990s.

46. P.J. Corfield, *The Impact of English Towns* (1982); P. Clark, *The Transformation of English Provincial Towns* (1984); P. Borsay, 'The English Urban Renaissance: The Development of Provincial Culture, c. 1680 – c. 1760, *Social History*, 5 (1976–7).

47. Bourne, *History of Newcastle*, p. 81.

48. *Newcastle's Changing Map*, eds M. Barke and R.J. Buswell (1992), p. 27.

49. Ibid, p. 26.

50. John Hodgson, *Picture of Newcastle*, p. 66.

51. M. Sil, 'Growth of Newcastle in the 18th and early 19th centuries', in *Newcastle's Changing Map*, p. 24.

52. E. Hughes, *North Country Life in the Eighteenth Century: The North East 1700–1750* (1952), p. 30.

53. Lorna Scammell, 'Was the North-East Different from Other Areas? The Property of Everyday Consumption in the Late Seventeenth and Early Eighteenth Century', in *Creating and Consuming Culture in North-East England, 1660–1830*, eds Helen Berry and Jeremy Gregory (2004).

54. Paul Langford, *A Polite and Commercial People* (1989), Table 5 (b), p. 402.

55. J.H. Plumb, *The Commercialisation of Leisure in Eighteenth-Century England* (1973), pp. 17–18.

56. Helen Berry, 'Creating Polite Space: the Newcastle Assembly Rooms', in *Creating and Consuming Culture in North-East England* (2004), p. 124.

57. Ibid, pp. 125–6.

58. Rosemary Baird, *Mistress of the House* (2003), p. 187.

59. Berry, 'Creating Political Space', p. 136.

60. The anomaly of the presence of a small area of the County of Northumberland in the midst of the town, itself a county, must have been trying for the Corporation. It was an enclave in which the town's writ did not run, and not only entertainments but political and religious meetings of which the Corporation disapproved could be held there with relative impunity.

61. Quoted in P.M. Horsley, *Eighteenth-Century Newcastle* (1971), pp. 236–7.

62. Purdue, *The Ship That Came Home*, p. 94.

63. The upper orders were somewhat allergic to going by sea, though the majority of Newcastle people who came to London, and many did, took passage on colliers.

64. John Brewer, *The Pleasures of the Imagination* (1997), p. 495.

65. Roz Southey, Margaret Maddison and David Hughes, *The Ingenious Mr Avison: Making Music and Money in Eighteenth-Century Newcastle* (2009).

66. He is said to have been the model for the pompous surgeon in Smollett's *The Adventures of*

Peregrine Pickle.

67. Paul Usherwood, 'Art on the Margins: from Bewick to Baltic', in *Newcastle upon Tyne: A Modern History*, p. 246.

68. Maurice Milne, *Newspapers of Northumberland and Durham* (1971), pp. 35–6, points to the first Newcastle paper as being the short-lived *Newcastle Gazette* published by a bookseller, Joseph Button, in 1710 and notes that the *Newcastle Advertiser* did not close in 1814 but transferred to Durham where it was refounded as the *Durham County Advertiser.*

69. John Brewer, *The Pleasures of the Imagination* (1997), p. 529. Brewer devotes a chapter, 'The Poet Who Lives by the Banks of the Tyne', to Bewick. See also Jenny Uglow, *Nature's Engraver: A Life of Thomas Bewick* (2006).

70. Usherwood, 'Art on the Margins', pp. 248–9.

71. Nicholaus Pevsner, *The Buildings of England: Northumberland* (1957), p. 56.

72. Quoted in Helen Berry, 'Creating Polite Space', p. 134.

73. Annabella Carr to John Carr, August 1781, Carr–Ellison MSS, Northumberland Record Office.

74. Rebecca King, 'The Sociability of the Trade Guilds of Newcastle and Durham, 1660–1750: The Urban Renaissance Revisited', in *Creating and Consuming Culture in North-East England*, p. 58.

75. Roy Porter, *Enlightenment: Britain and the Creation of the Modern World* (2000), p. 38.

76. D. MacRaild, *Faith, Fraternity and Fighting* (2005), p. 44.

77. *Diaries of James Losh*, vol. 1, Surtees Society, vol. clxxi (1961).

78. Stephen Harbottle, *The Reverend William Turner: Dissent and Reform in Georgian Newcastle upon Tyne* (1997).

79. Geoffrey Holmes and Daniel Szechi, *The Age of Oligarchy: Pre-Industrial Britain 1722–1783* (1993), p. 123.

80. Richard Sharp, '100 years of a lost cause: non-juring principles in Newcastle from the revolution to the death of Prince Charles Edward Stuart', *Archaeologia Aeliana*, 5th series, vol. 8 (1980), pp. 35–55.

81. Harbottle, *William Turner*, pp. 48–9.

82. Nicholas Pevsner, *The Buildings of England, Northumberland,* (rev. edn, 1992), p. 419.

83. Richard C. Allen, 'An Alternative Community in North-East England: Quakers, Morals and Popular Culture in the Long Eighteenth Century', in *Creating and Consuming Culture in North-East England*, p. 111.

84. John Brand, *Observations on Popular Antiquities including the whole of Mr Bourne's Antiquitates Vulgares* (1777), p. 21.

85. Brian Bennison, 'Drink in Newcastle', in *Newcastle upon Tyne: A Modern History*, p. 168.

86. In these pubs, John Bover R.N. 'recruited' hundreds of local seamen between 1760 and his death in 1782. He had by this time become a prominent citizen and was given a civic funeral at St Nicholas'. His notoriety is commemorated in many local ballads. I am grateful to Dr Tony Barrow for this information.

87. Peter Clark, 'The "Mother Gin" Controversy in the Early Eighteenth Century', *Transactions of the Royal Historical Society*, 5th series, vol. 38 (1988).

88. J.A. Chartres, 'Spirits in the North East? Gin and Other Vices in the Long Eighteenth Century', in *Creating and Consuming Culture in North East England.*

89. P. Rushton, 'The Poor Law, the Parish and the Community in North-East England, 1600–1800', *Northern History*, vol. 25 (1989).

90. McKenzie, *A Descriptive etc. Account of Newcastle upon Tyne*, vol. 11 (1827), pp. 540–6.

91. Middlebrook, *Newcastle upon Tyne*, p. 85.

92. Cecilia Fiennes, *The Journeys of Cecilia Fiennes*, (1983 edn), p. 241.

93. Daniel Defoe, *A Tour Through the Whole Island of Great Britain* (2006 edn), p. 357.

94. H.L. Honeyman, *Northumberland* (1949), p. 129.

95. Horsley, *Eighteenth-Century Newcastle*, p. 126.

96. Purdue, *Merchants and Gentry*, p. 237.

97. *The Diary of Thomas Giordani Wright, Newcastle Doctor 1826–1829* (2001).

98. Faulkner, *Northumbrian Panorama*, p. 123.

99. Thomas Faulkner, Peter Beacock and Paul Joned, *Newcastle and Gateshead: Architecture and Inheritance* (2006), p. 86.

100. McKenzie (1827), quoted in *Newcastle's Changing Map*, eds M. Barke and R.J. Buswell (1992), p. 25.

101. N. McCord and R. Thompson, *The Northern Counties from AD 1000*, p. 2444. N. McCord, 'The 1815 Seamen's Strikes in North East England', *Economic History Review*, 2nd series, vol. 21 (1968).

102. Geoffrey Holmes and Daniel Szechi, *The Age of Oligarchy: Pre-Industrial Britain* (1993), p. 324.

103. M. Milne, 'The Tyne Mercury and Reform', *Northern History*, vol. 14 (1976), p. 230.

104. J.C.D. Clark, *English Society 1688–1832* (1985).

105. It is worth noting that in Newcastle Catholic Emancipation was opposed by the wider body of freemen, while the Common Council petitioned in favour of Catholic relief.

106. Norman Gash, *Politics in the Age of Peel* (1953), p. 94.

107. Charles Seymour, *Electoral Reform in England and Wales: The Development and Operation of the Parliamentary Franchise 1832–1885* (1970 edn), pp. 28–35.

108. Brett, 'Newcastle Election of 1832', pp. 119–20.

109. W.L. Burn, 'Newcastle upon Tyne in the Early Nineteenth Century', *Archaeologia Aeliana*, vol. 34 (1956), p. 5.

110. Milne, 'Tyne Mercury', p. 233.

111. Burn, 'Newcastle in the Early Nineteenth Century', p. 8.

112. Ibid, p. 3.

113. Joyce Ellis, '"A Dynamic Society": Social Relations in Newcastle upon Tyne 1660–1760, in *The Transformation of English Provincial Towns 1600–1800*, ed. P. Clark (1984).

114. Michael Cook, 'The Last Days of the Unreformed Corporation of Newcastle upon Tyne', *Archaeologia Aeliana*, vol. 39 (1961), p. 210.

115. Cook, 'Last Days of the Unreformed Corporation', pp. 226–7.

116. From 1836 he was known as Hodgson Hinde.

117. See Brett, 'Newcastle Election of 1830'.

118. Burn, 'Newcastle in the Early Nineteenth Century', p. 4.

6 Victorian Newcastle

1. Charleton, *Newcastle Town*, p. 263.

2. Later known as Jesmond Towers, it is now La Sagesse School.

3. L. France, 'Transport in the 19th century', in *Newcastle's Changing Map*, p. 44.

4. Mike Barke, 'The People of Newcastle', in *Newcastle upon Tyne: A Modern History*, p. 162.

5. Asa Briggs, *Victorian Cities* (1963), p. 29.

6. Graeme J. Milne, *North East England 1850–1915: The Dynamics of a Maritime-Industrial Region* (2006), p. 137.

7. From *Sketches of Public Men of the North* published by *The Northern Examiner* in 1855. Quoted in Lyall Wilkes and Gordon Dodds, *Tyneside Classical* (1964), p. 53.

8. See W.L. Burn, 'Newcastle upon Tyne in the Early Nineteenth Century', *Archaeologia Aeliana*, vol. 34 (1956). It was used as a warehouse and was burnt down in 1895.

9. N. McCord, 'The 1834 Poor Law Amendment Act on Tyneside', *International Review of Social History*, vol. 14 (1969), pp. 90–108.

10. W.H. Maehl, 'Chartist Disturbances in Northeastern England, 1839', *International Review of*

Social History, vol. 8 (1963).

11. D.J. Rowe, 'Some aspects of Chartism on Tyneside', *International Review of Social History*, vol. 16 (1971).

12. Rowe, 'Chartism on Tyneside', p. 26.

13. A.R. Schoyen, *The Chartist Challenge* (1958), p. 80.

14. Rowe, 'Chartism on Tyneside', p. 30.

15. E. Welbourne, *The Miners' Unions of Northumberland and Durham* (1923), p. 54.

16. Ben Nixon, 'Chartism – Repression or restraint', *North East History*, vol. 39 (2008), pp. 109–21.

17. See P. Brett, 'John Fife and Tyneside Radicalism in the 1830s', *Northern History*, vol. 33 (1997), pp. 184–217.

18. Burn, 'Newcastle in the Early Nineteenth Century'.

19. Oliver Lendrum, 'An Integrated Elite: Newcastle's Economic Development 1840–1914', in *Newcastle upon Tyne: A Modern History*, pp. 27, 28.

20. Osler and Barrow, *Tall Ships Two Rivers*, pp. 42–3.

21. Milne, *North East England*, p. 68.

22. Lendrum, 'An Integrated Elite', p. 28.

23. M. Phillips, *A History of Banks, Bankers and Banking in Northumberland, Durham and North Yorkshire* (1894).

24. John Banham, *Backhouses' Bank of Darlington*, NEEHI Papers in North-Eastern History, 9, 1999.

25. As demonstrated by the financial support for Northern Rock in 2007–8.

26. McCord, *North East England*, p. 64.

27. S.P. Ville, 'Patterns of Shipping Investment in the Port of Newcastle upon Tyne, *Northern History*, vol. 25 (1989).

28. Purdue, *Merchants and Gentry*.

29. C.J. Bates, *History of Northumberland*, p. 273.

30. Purdue, *Squires, Scholars and Soldiers: The Carr-Ellisons 1830–2000* (2003).

31. C.J. Bates, *History of Northumberland* (1895), p. 273.

32. T.E. Faulkner, 'Conservation and Renewal in Newcastle', in *Northumbrian Panorama*, ed. T.E. Faulkner (1996), p. 128.

33. McKenzie, *History of Newcastle*, vol. 2 (1827), pp. 540–3.

34. Burn, 'Newcastle in the Early Nineteenth Century', p. 12.

35. The piers were not in place until 1895 and after storms had destroyed part of the North Pier it had to be extensively rebuilt and this was not completed until 1909.

36. Benwell Community Project. Final Report Series No. 6, *The Making of a Ruling Class* (1978).

37. Lendrum, 'An Integrated Elite', p. 46.

38. D.J. Rowe, 'The Social and Economic Characteristics of Northumberland in the 1880s', in *A Social History of the Diocese of Newcastle 1882–1982*, ed. W.S.F. Pickering (1981), p. 21.

39. Ibid, p. 22.

40. There were a number of pioneers in several countries who were developing varieties of turbines. One was Sir Charles Mark Palmer. Parsons was responsible for the most successful turbine.

41. Whether Swan's was the first light bulb is, of course, debatable, for Edison, an American, developed a similar bulb. They eventually agreed to co-operate and formed a joint company.

42. The worries over coal reserves bear a strong resemblance to early twenty-first century concerns over oil reserves. Power from the wind, water and the sun had always been available but it was coal which had enabled rapid industrial growth to take place.

43. B. Lancaster, 'Sociability and the City', in *Newcastle upon Tyne: A Modern History*, p. 330.

44. M. Barke and M. Sill, 'Population in the Nineteenth Century: Social Geography', in *Newcastle's Changing Map*, pp. 38–9.

45. Bill Lancaster, *The Department Store* (1995).

46. P. Matthias, *Retailing Revolution* (1967).

47. Maureen Callcott, 'The Governance of the Victorian City', in *Newcastle upon Tyne: A Modern History*, p. 73.

48. For Brockett, see N. McCord, 'Gateshead Politics in the Age of Reform', *Northern History*, vol. 4 (1969), pp. 167–183.

49. T.J. Nossiter, *Influence, Opinion and Political Idioms in Reformed England 1832–74* (1975), p. 115.

50. Callcott, 'Governance of the Victorian City', p. 72.

51. Middlebrook, *Newcastle upon Tyne*, p. 287.

52. Quoted in Nigel Todd, 'His Majesty's Chief Constable: Tyneside's Chartist Policeman', *North East Labour History*, no. 26 (1992), p. 37.

53. McCord, *North East England*, p. 184.

54. D.M. Jackson, '"Garibaldi or the Pope" Newcastle's Irish Riot of 1866', *North East History*, vol. 34 (2001), pp. 49–82.

55. E. Allen, J.F. Clarke, N. McCord, and D.J. Rowe, *The North East Engineers' Strike of 1871* (1971), p. 137.

56. Callcott, 'Governance of the Victorian City', p. 85.

57. Ibid, p. 92.

58. The Tyne Improvement Act resulted in the loss of a proportion of harbour dues but coal dues continued until 1870.

59. McCord and Thompson, *Northern Counties from AD 1000*, p. 317.

60. Callcott, 'Governance of the Victorian City', p. 86.

61. Oxford and Cambridge were exceptions to this norm.

62. Benwell Tower is now a public house, 'The Mitre'.

63. Jeff Smith, 'The Making of a Diocese 1851–1882', in *Newcastle upon Tyne: A Modern History*, p. 104.

64. Peter J. Jagger, 'The Formation of the Diocese of Newcastle', in *A Social History of the Diocese of Newcastle*, p. 100.

65. *Cecilia: The Life and Letters of Cecilia Ridley, 1819–45*, ed. Viscountess Ridley (1958), p. 50.

66. T.I. Nossiter, *Influence, Opinion and Political Idioms in Reformed England, 1832–74* (1975), chapter 10.

67. Ibid, p. 39.

68. Maurice Milne, *The Newspapers of Northumberland and Durham* (1971), p. 83.

69. Roy Jenkins, *Dilke: A Victorian Tragedy* (1958), p. 99.

70. Joan Hugman, 'Print and Preach: The Entrepreneurial Spirit of Nineteenth-Century Newcastle', in *Newcastle upon Tyne: A Modern History*, p. 131.

71. His support for both Irish and Italian nationalisms led to mixed relations with the Irish on Tyneside, many of whom as Catholics took exception to Cowen's and the *Newcastle Daily Chronicle*'s support for Garibaldi, an enemy of the Pope. See D.M. Jackson, 'Garibaldi or the Pope'.

72. Ashton Dilke had Tyneside connections in that he married a daughter of Eustace Smith, Liberal MP for Tynemouth. Dilke's brother, Sir Charles Dilke, had an affair with Smith's wife, Eustacia, and it was the accusations made by Mrs Crawford, another daughter of the Smiths, that he had had an affair with her that led to the scandalous divorce case that brought about Sir Charles's political downfall.

73. Though not quite as often as the statue of George Stephenson further down the road.

74. The candidature of Ridley, the 5th Baronet and later 1st Viscount, marked a return to Newcastle politics by the head of the Ridley family.

75. A.W. Purdue, 'Arthur Henderson and Liberal, Liberal-Labour and Labour Politics in North East England 1892–1903', *Northern History*, vol. 11 (1976).

76. Percy Corder, *Robert Spence Watson* (1914), p. 267, claims that two thirds of the 'Nine Hundred' were working men. E.I. Waitt has argued that this can only be substantiated if craftsmen are included as working men.

77. A.W. Purdue, 'The ILP in the North East of England', *The Centennial History of the Independent Labour Party*, eds D. James, J.A. Jowett and K. Laybourn (1992), p. 24.

78. M. Pugh, *The Tories and the People* (1985) gives the figures for Primrose League membership in Elswick.

79. McCord, *North East England*, p. 160.

80. K. Marx, *Das Kapital*, vol. 1 (Penguin 1976), pp. 815–6.

81. 'Inquiry into the condition of the poor', quoted by Jane Long, *Conversations in Cold Rooms* (1999), p. 45.

82. Ibid, p. 46.

83. J.C. Snowden, 'Public Health in the Nineteenth Century', *Newcastle's Changing Map*, pp. 52–3.

84. Prospectus of the Whittle Dene Water Company (1845).

85. See R.W. Rennison, *Water to Tyneside: A History of the Newcastle and Gateshead Water Company* (1979).

86. J.R. Bevan, 'Public Utilities in the 19th Century', in *Newcastle's Changing Map*, p. 48.

87. Rennison, *Water to Tyneside*, p. 228.

88. C.C. Taylor, 'Types of Housing Development: 1851–1901', in *Newcastle's Changing Map*, p. 40.

89. Stephen Aris, *Building the Northern Rock* (2000), p. 55.

90. Winter, Milne et al., *Northern Heritage*, p. 159.

91. Callcott, 'Governance of the Victorian City', p. 80.

92. Lancaster, 'Sociability and the City', pp. 323–5.

93. E. McKenzie, *History of Newcastle*, vol. 2 (1827), p. 730.

94. Brian Bennison, 'Drink in Newcastle', in *Newcastle upon Tyne: A Modern History*, p. 172.

95. Ibid, p. 178.

96. Richard Holt and Ray Physick, 'Sport on Tyneside', in *Newcastle: A Modern History*, p. 193.

97. Quoted in Richard Holt, *Sport and the Working Class in Modern Britain* (1990), p. 134.

98. G.M. Trevelyan thought that 'If the French *noblesse* had been capable of playing cricket with their peasants, their chateaux would never have been burnt', *English Social History* (1942).

99. Charleton, *Newcastle Town*, p. 163.

100. Harvey Taylor, *A Claim on the Countryside* (1997), p. 162.

101. Paul Usherwood, 'Art on the Margin', in *Newcastle upon Tyne: A Modern History*, pp. 245–66.

102. E.M. Atkins, 'The Genesis of the Laing Art Gallery', in *Northumbrian Panorama*, p. 208.

103. Maureen Callcott, 'The Campaign for Public Libraries in Victorian Newcastle', *North East History*, vol. 35 (2004) pp. 99–112.

104. For Higgenbottom, see Marie Conte-Helm, *Japan and the North East of England* (1989)

105. R. Colls, 'The New Northumbrians', in *Northumbria*, ed. R. Colls (2007).

106. Quoted in Asa Briggs, *Victorian Cities*, p. 67.

7 Newcastle 1901–1945

1. Richard Welford, 'Newcastle a Hundred Years Ago', in *Lectures Delivered to the Literary and Philosophical Society* (1898), p. 214.

2. F. Harrison, *A History of Newcastle upon Tyne* (1913), p. 254.

3. As early as 1863, W.G. Armstrong had addressed the British Association for the Advancement of Science in Newcastle on the subject of the future exhaustion of the coal seams.

4. Graeme J. Milne, *North East England 1850–1914: The Dynamica of a Maritime-Industrial Region* (2006), p. 8.

5. See Marie Conte-Helm, *Japan and the North-East of England* (1989) for an account of

Armstrong's relations with Japan.

6. The best known exposition of the decline thesis is M. Wiener, *British Culture and the Decline of the Industrial Spirit 1850–1980* (1981) but it a theme that runs through many economic histories.

7. Marshall J. Bastable, *Arms and the State* (2004), p. 255.

8. Oliver Lendrum, 'An Integrated Elite', p. 44.

9. Milne, *North East England*, p. 116.

10. Sir Arthur Munro Sutherland, *Tynesider* (1947), p. 23.

11. Bill Lancaster, 'Newcastle – capital of what?', in *Geordies*, eds Robert Colls and Bill Lancaster (1992), p. 55.

12. F.W. Dendy, 'The Making of Newcastle', in *Three Lectures* (1921), p. 17.

13. Grace McCombie, *Newcastle and Gateshead* (2009), p. 263.

14. Before 1824 it had been known as the Parade Ground and it enjoyed only a brief history as a market for hay and straw.

15. Named after the 1807 military barracks.

16. Brian Bennison, 'Drink in Newcastle', in *Newcastle upon Tyne: A Modern History*, p. 176.

17. Frank Manders, *Cinemas of Newcastle* (1991), p. 12.

18. Quoted by Manders, p. 15.

19. Lancaster, *The Department Store*, p. 30.

20. Ibid, p. 177.

21. McCord, *North East England*, p. 201.

22. Yevgeni Zamyatin, *The Islanders* (1917).

23. Jack Common, *Kiddar's Luck* (1951).

24. Milne, *North East England*, p. 114.

25. See A.W Purdue, 'George Lansbury and the Middlesbrough Election of 1906', *International Review of Social History*, vol. 18 (1973), part 3. Lansbury was later to lose his seat at Bow and Bromley when he resigned as MP and sought a fresh mandate, standing principally on votes for women.

26. Martin Pugh, *The March of the Women* (2000), p. 239.

27. J.A. Jackson and D.M. MacRaild, 'The Conserving Crowd: Mass Unionist Demonstrations in Liverpool and Tyneside, 1912–13', in *The Home Rule Crisis*, eds D.G. Boyce and A. O'Day (2005).

28. George Dangerfield, *The Strange Death of Liberal England* (1935).

29. It was commissioned by Sir George Renwick, whose five sons had fought in the war and survived.

30. See, in particular, Arthur Marwick, *The Deluge* (1965).

31. Sutherland, *Tynesider*, p. 53.

32. James Hinton, *The First Shop Stewards' Movement* (1973), p. 189.

33. McCord, *North East England*, p. 222.

34. Sutherland, *Tynesider*, pp. 140–1.

35. D.J. Rowe, 'The North East', in *The Cambridge Social History of Britain 1750–1950*, ed. F.M.L. Thompson (1990), p. 431.

36. Sutherland, *Tynesider*, p. 35.

37. McCord, *North East England*, p. 223.

38. Natasha Vall, 'The Emerging Post-Industrial Economy in Newcastle 1914–2000', in *Newcastle upon Tyne: A Modern History*, p. 55.

39. Ibid, pp. 15–16.

40. They were G. Renwick (Co. U), who was thus elected an MP for the third time, N. Gratton-Doyle (Co. U), H. Barnes (Co. L) and the Rt Hon. E. Shortt (Co. L)

41. Rowe, 'The North East', p. 441.

42. See Stephen Aris, *Building the Northern Rock* (2000), pp. 66–8.

43. Contemporary description quoted by Faulkner, Beacock and Jones, *Newcastle and Gateshead:*

Architecture and Inheritance, p. 263.

44. Grace McCombie, *Newcastle and Gateshead* (2009), p. 35.

45. Frank Manders, *Cinemas of Newcastle*, p. 16.

46. Ibid, p. 163.

47. Norman Veitch, *The People's* (1950), p. 93.

48. Cheryl Buckley, 'Modernity, Femininity and Regional Identiy: Women and Fashion in the North East', in *Northumbrian Panorama*, pp. 241–72.

49. Palace of Arts, Official Illustrated Catalogue.

50. Alastair Moffat and George Rosie, *Tyneside: A History of Newcastle and Gateshead* (2006), p. 329.

51. McCord, *North East England*, p. 229.

52. Vall, 'The Emerging Post-Industrial Economy in Newcastle 1914–2000', pp. 57–8.

53. Craig Armstrong, 'Tyneside 1939–45: A Study of the Regional Impact of Total War', Northumbria University PhD Thesis (2004), pp. 45–5, 75–95. Craig Armstrong has subsequently published *Tyneside and the Second World War* (2007).

54. Armstrong, 'Tyneside 1939–45', pp. 99–107.

8 NEWCASTLE 1945–PRESENT

1. Vall, 'The Emerging Post-Industrial Economy in Newcastle 1914–2000', p. 58.

2. McCord, *North East England*, p. 232.

3. Ron French and Ken Smith, *Lost Shipyards of the Tyne* (2007), pp. 14, 54.

4. W.G.C. Watson and R.J. Buswell, in *Newcastle's Changing Map*, p. 66.

5. Faulkner, 'Conservation and Renewal in Newcastle', in *Northumbrian Panorama*, p. 135.

6. Middlebrook, *Newcastle upon Tyne*, pp. 315–7.

7. Quoted in David Kynaston, *Family Britain 1951–57* (2009), p. 276.

8. Wilfred Burns in *T. Dan Smith*, Amber Productions (1987).

9. David Kynaston, *The Age of Austerity 1945–51* (2007), pp. 609, 32.

10. Faulkner, 'Conservation and Renewal in Newcastle', pp. 141–2.

11. The exhibition, City State, at the Literary and Philosophical Society in September 2009 explored 'his era'.

12. *Parliament and Politics in the Age of Churchill and Attlee: The Headlam Diaries 1935–1951*, ed. Stuart Ball (1999), p. 30.

13. The origins of the term are obscure though one theory is that it comes from the way Sunderland people say 'make and take' – mackem and tackem.

14. 'Sting and his tale', *Sunday Times Magazine*, 18 October 2009.

15 Robert Colls, 'Born Again Geordies', in *Geordies*, eds Robert Colls and Bill Lancaster (1992), p. 23.

16. D.J. Rowe, 'The North East', in *The Cambridge Social History of Britain*, ed. F.M.L. Thompson (1990).

17. See Colls, 'Born Again Geordies'.

18. Richard Hoggart, *The Uses of Literacy* (1957).

19. See Steve Chibnall, *Get Carter* (2003).

20. Dominic Sandbrook, *White Heat* (2008), p. 613.

21. Mike Greenbatch, 'Ouseburn in 1900 – Industry, Labour and Community', *North East History*, vol. 38 (2007), pp. 143–63.

22. Rather less than the average for English towns and considerably less than the percentage in many northern cities.

Also available from Amberley Publishing

Finally lays to rest the mystery of who Jack the Ripper was

'Totally fascinating' SIMON SEBAG MONTEFIORE
'A triumph of research' ANDREW ROBERTS
'Exposes the hidden hand behind the Jack the Ripper myth' KELVIN MACKENZIE

The most famous serial killer in history. A sadistic stalker of seedy Victorian backstreets. A master criminal. The man who got away with murder – over and over again. But while literally hundreds of books have been published, trying to pin Jack's crimes on an endless list of suspects, no-one has considered the much more likely explanation for Jack's getting away with it... He never existed.

£9.99 Paperback
53 illustrations and 47 figures
256 pages
978-1-84868-522-2

Available from all good bookshops or to order direct
Please call **01453-847-800**
www.amberleybooks.com

Also available from Amberley Publishing

A Roman frontier fort on Hadrian's Wall

The beautiful site the Romans called Vindolanda lies in south-west Northumberland, in the district of Tynedale, more or less half way between the North Sea east of Newcastle and the Irish Sea to the west of Carlisle. It is just within the boundary of the Northumberland National Park, and is a part of the World Heritage Site of Hadrian's Wall. The Wall itself was built on the whinstone ridge a mile to the north, with the fort of Housesteads two miles to the north-east, and that of Great Chesters five miles to the north-west.

£16.99 Paperback
130 Illustrations (30 colour)
192 pages
978-1-84868-210-8

Available from all good bookshops or to order direct
Please call **01453-847-800**
www.amberleybooks.com

INDEX

Grainger, Richard, 7, 142, 163
Grainger Market, 301
Grainger Street, 15, 301
Grammar School, 65, 149-50
Grand Lease, 56
Gray, William, 10
Great War, 265-8
Grand Lease, 56, 63
Grey Street, 9, 164
Grindstones, 32, 50
Groat Market, 37
Guildhall, 27, 45, 65, 88, 114, 158, 162
Guilds (misteries), 28-33, 42-4

Hancock, John, 240
Hanover Square, 132
Hanseatic League, 33
Haymarket, 253
Heaton, 177
Henrician Reformation, 55-8
Henry I, 23-4, 26-7
Henry II, 25-27
Henry III, 25
Henry VII, 52, 55
High Bridge Street, 10
High Level Bridge, 191
Hodgson, John, 117
Hospitals, 35, 37, 158-9, 252-4
Hostmen, 64, 66-7, 72-3, 120, 123
Housing, 214, 217-8, 250, 276-80, 299-300

Italian merchants, 33

James I, 52, 64, 66

John, King, 25, 28-9
Jesmond, 177

Keelmen, 113-4, 120, 158, 167
Knights Templar, 35
Knott, Sir James, 248

Laing Art Gallery, 239, 281
Land reclamation, 35
Lead, 32, 49, 125-6
London, 49, 53, 75, 133
Literary and Philosophical Society, 146-7, 239-40
Lombard Street, 214
Lort Burn, 9, 15, 37, 131
Low Bridge Street, 10

Maison Dieu, 45
Mansion House, 95, 111, 158, 160
Marley, John, 82, 85, 92
Mary, Queen, 51, 57
Matilda, daughter of Henry, 1, 23-4
Merchant Adventurers Company, 29, 51-2, 66-9, 74, 123
Merz, John Theodore, 195
Middlebrook, S., 10
Military significance of Newcastle, 33-4
Mitchell, Charles, 196
Monkchester, 18-19
Mosley Street, 131, 191
Mowbray, Robert, Earl of Northumberland, 22-3